Canyon de Chelly

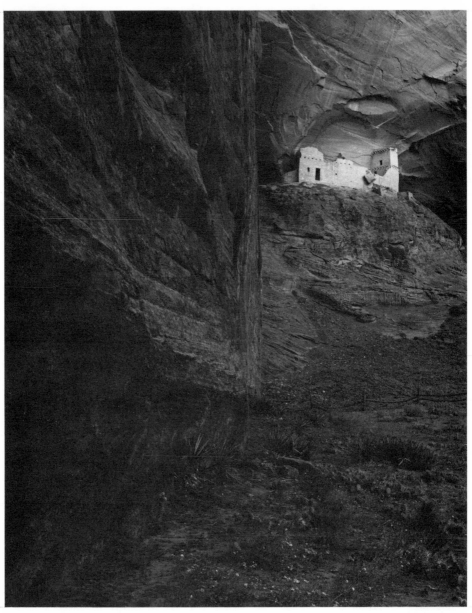

Tower at Mummy Cave

Canyon de Chelly

Its People and Rock Art

Campbell Grant

THE UNIVERSITY OF ARIZONA PRESS
TUCSON, ARIZONA

About the Author . . .

Campbell Grant was first drawn to the study of North American rock art through his interests as an artist and art historian. A research associate of the Santa Barbara Museum of Natural History, he has written many articles on the subject of rock art and is the author of five books: *The Rock Paintings of the Chumash, Rock Art of the American Indian, Rock Drawings of the Coso Range* (coauthored with James W. Baird and J. Kenneth Pringle), *Rock Art of Baja California,* and the present volume.

Front cover photo by Ray Manley
Back cover photo by Nancy Solomon

Second printing 1979

THE UNIVERSITY OF ARIZONA PRESS

Library of Congress Cataloging in Publication Data

Grant, Campbell, 1909-
 Canyon de Chelly.

 Bibliography: p.
 Includes index.
 1. Indians of North America — Arizona — Chelly Canyon.
2. Chelly Canyon. 3. Rock paintings — Arizona — Chelly
Canyon. 4. Petroglyphs — Arizona — Chelly Canyon.
I. Title.
E78.A7G72 709'.01'1 75-8455
ISBN 0-8165-0632-9
ISBN 0-8165-0523-3 pbk.

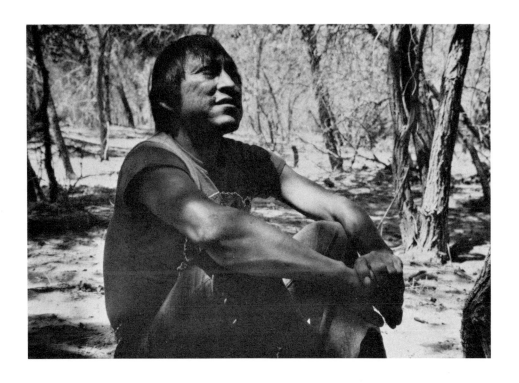

In Memory of Navajo Kee Begay

1939-1975

Contents

Maps and Figures

Part 3. *The Canyon Explorers*

Part 4. *The Canyon Rock Art*

Appendix: Survey of Canyon de Chelly Rock Art Sites

Foreword

One afternoon early in the 1960s, my husband, our little son, and I were climbing out of Canyon del Muerto on a steep, rough trail. Near the top we met a group of Navajo — a very old man, a young woman, and her two small children. The woman said they were taking the old man home. In his nineties and just out of the hospital, he had lived at the bottom of the canyon for a long time — ever since he and his family had returned from Fort Sumner when he was only three years old.

As the group continued on their way, slowly making their descent on the slippery trail, we watched them disappear around a corner. In this chance encounter, a piece of the canyon's past became alive for us. The old man was a living bridge between ourselves and the traumatic historical events which are still recounted by the Navajo who make their homes in the canyon bottom and on the mesa above. It is one of the human dimensions of Canyon de Chelly that is dealt with extensively in this book.

I believe that this is the most important published work on Canyon de Chelly. Previous literature has been sparse, in spite of the fact that the canyons have held such a prominent place in the history and archaeology of the Southwest and have long been the subject of discussion in general Southwestern references. Campbell Grant begins with a descriptive overview and continues with a section on the archaeology of the Anasazi and the history of the Navajo. Next comes a discussion of the travelers, explorers, and archaeologists who have passed through the canyon over the years. The final section consists of Grant's special contribution on the canyon rock art.

The rock paintings and petroglyphs, made over a period of two thousand years by canyon residents, at first present a confusing array of images to the casual observer and archaeologist alike. Grant orders this pictorial chaos along temporal and cultural lines, and his analysis is an important addition to Southwestern archaeological studies in general. His discussion includes an alive and

provocative interpretation of this art, made possible through his broad knowledge of the subject.

Rock art, more than any other archaeological record, is a major avenue to understanding the ritual and religion of prehistory. In the Southwest, it is a resource which is in the early stages of exploration. I believe that Grant's use of the model of shamanism to explain various phenomena in the art is a major breakthrough in interpretation, and it well fits many of the representations that date from the early years of Anasazi history.

The volume ends with an appendix which provides a comprehensive list of rock art sites recorded on Grant's various expeditions into the canyons, a section of considerable general interest and of value to rock art enthusiasts and archaeologists alike. This book in its many aspects is a timely and much-needed contribution to Southwestern literature.

POLLY SCHAAFSMA

Acknowledgments

This book would not have been possible without the wholehearted support of the National Park Service and the three superintendents of the Monument who were in charge from 1969 through 1977; Charles B. Voll, Leslie W. Carmack, and William L. Germeraad. I also owe deep thanks to Ranger Chavez, who first drove me into the stupendous canyons, and to Kevin McKibbin and David Brugge, all of whom patiently answered my many questions and encouraged me in every way.

I am likewise indebted to Polly Schaafsma, who knows more about the prehistoric paintings and petroglyphs of the Southwest than anyone I know; to Klaus Wellmann for many good suggestions; and to Don Morris of the Arizona Archaeological Center for reading the manuscript and clarifying a number of gray areas. Under his direction, Jim McDonald, Linda Popelish, and Barrie Thornton also read the material and undertook the time-consuming job of correlating my rock art site numbers with those used by the National Park Service.

Claude Britt and astronomer Crutchfield Adair were most helpful in piercing some of the mysteries of Navajo star lore. I am grateful for the help that Bertha Dutton of the Museum of Navajo Ceremonial Art gave me in identifying several of the rock paintings that resembled sand-painting figures. Edward Danson, former director of the Museum of Northern Arizona, supplied me with photographs and expertise on Anasazi pottery types, while Harold Gladwin and the late Frank McNitt both gave me encouragement at a time when the project was in the doldrums. I am indebted to Steve Jett for his fine close-up photograph of the Spanish horsemen high on that narrow ledge above Standing Cow Ruin (a climbing feat I dared not follow).

My thanks go to David De Harport, who aided me in obtaining a copy of his doctoral dissertation on the canyon from the Peabody Museum and to Alex Lindsay of the Museum of Northern Arizona for supplying me with De Harport's site map.

I salute my companions who shared with me the grueling climbs and the joys of discovery in the great canyons — Wes Buerkle, Rob Bowler, and especially John Cawley, who has been with me on countless trips into the remote areas of the West in search of our common enthusiasm.

I also thank the staff of the University of Arizona Press for its skill and cooperation in projecting the work into published form. I was particularly fortunate to have the final shaping of the manuscript in the hands of editor Karen Thure, who unwaveringly found her way through a sea of cross references, second thoughts, erasures, repetitions, and obscurities.

Finally I want to express special gratitude to our guides. On the initial survey in 1969, most of the time we were with William Tanner, Monument archaeologist, but for the final few days our guides were Navajos Ben Henry and Nelson Yellow Hair. On all subsequent trips we were guided by Kee Begay, who helped us locate some very fine sites near his birthplace in Many Cherry Canyon.

In August 1975 we made our last trip into Canyon de Chelly to secure some additional photographs for this book. Two days after we had returned to California, Kee was killed in the canyon. I hope this book may serve in some measure as his memorial.

CAMPBELL GRANT

Part One

The Spectacular Canyon

The
Spectacular
Canyon

THE FOUR CORNERS AREA OF THE SOUTHWEST is one of the most spectacular
and interesting regions in the United States. Here the borders of Utah,
Colorado, Arizona, and New Mexico join in the midst of magnificent canyon
country. The formations are mainly sandstone, and the Colorado and its
tributaries have carved an infinite number of canyons through the colorful
stratified rock. With the exception of the Grand Canyon itself, none of these
gorges is more uniquely beautiful than Canyon de Chelly in northeastern
Arizona, with its sheer red cliffs and innumerable cliff dwellings.

Early explorers were universally impressed by the gigantic gorge and
struggled with superlatives to describe their impressions. "Awesome, terrible
grandeur," and "fearful chasm," were favorite terms, but it took Lieutenant
James H. Simpson on a military reconnaissance in 1849 to hit on the ultimate
word — "stupendous." He used this adjective repeatedly in the vivid descrip-
tion of Canyon de Chelly which appears in Part Two of this book.

The name is a curious one; it does not look like an Indian or a Spanish
word. Actually it derives from the Navajo word *tségi* — roughly "rock can-
yon" or "in a canyon." *Tsé* is the Navajo word for rock, and this prefix is
utilized in many words referring to canyons or rocks. *Tsétah dibé,* for example,
means bighorn, or sheep of rocky places, while *tséta'a* means rock ledge.

Spanish military leaders and explorers of the early nineteenth century
usually referred to the Canyon de Chelly drainage by a single word — *Chelli,*
Chelle, or *Chegui,* all attempts to reproduce the sound of the Navajo name
Tségi. Dechelli (day-shay-yee) would be the closest Spanish version of *Tségi,*

and the name sometimes is found in this form in early accounts. In 1849 an Anglo-American expedition entered the canyon; their account of this visit refers to "Cañon of Chelly" and "Cañon deChai" (literally Canyon Canyon). The accepted modern pronunciation is d'Shay.

Canyon Facts and Figures

The Four Corners area is centrally located on the Colorado Plateau, a large, high region (average elevation over 6,000 feet) lying between the Great Basin and the Rocky Mountains. To the south it stretches to the Mogollon Rim and to the north includes parts of southeastern Utah and western Colorado.

Canyon de Chelly cuts through the Defiance Plateau, an eroded, gently dipping monocline separating Black Mesa Basin to the west from the San Juan Basin of New Mexico to the east. The eastern section of the uplift is the Chuska Range, rising to an altitude of 9,500 feet. The Chuska Range is made up of the Lukachukai Mountains to the north, the Tunicha Mountains in the center, and the Chuska Mountains to the south.

From the Tunichas flow the streams that have carved out Canyon de Chelly. Tsaile Creek enters Canyon del Muerto, and to the south Wheatfield and Whiskey creeks join to form Chinle Wash flowing down the main canyon below. Neither of the two big canyons carry year-round water in the lower stretches. Tsaile Creek usually flows throughout the year over rock bottom to within a mile or so of Mummy Cave *(Tsé-ya-kin)* but below that point the water is generally absorbed by the deep sand and is called Tsaile Wash. In the main canyon, Chinle Wash usually flows as far as Spider Rock. During the summer thundershower season, the streamflow often reaches the junction of del Muerto and de Chelly for weeks at a time. For brief periods the water runs past the town of Chinle, blocking the entrance to the canyon. From its head near Washington Pass, Canyon de Chelly extends almost due west to its mouth near Chinle, a distance of twenty-seven miles. Chinle Wash is then joined by Nazlini Wash to flow north into the San Juan River.

At its entrance, Canyon de Chelly looks very much like many high desert washes. The white sand streambed, over a hundred yards wide, is bordered by reddish sandstone cliffs about thirty feet high. The canyon and its tributaries wind and twist in the most tortuous manner, and seldom is more than half a mile of canyon visible at one time. With each turn the canyon becomes more impressive, and before a mile is traveled the cliffs rise sheerly from the wash to a height of over 200 feet.

A short distance above the main canyon's mouth, the first side canyon of any size enters from the left. This is Cottonwood Canyon, extending north for about two miles. Five miles from the mouth, the main canyon widens to

a quarter of a mile at its junction with its tributary Canyon del Muerto (Fig. 2.57). Here the smooth red cliffs rise to a height of 400 feet. This great canyon is eighteen miles long and structurally very similar to the main canyon. Both have innumerable small side canyons and coves. The largest of these, Black Rock Canyon, enters del Muerto from the right about four miles above the junction and is about five miles long.

Beyond the del Muerto junction, Canyon de Chelly grows deeper with every mile. Now instead of the sheer drop of the cliffs, an occasional rock debris (talus) slope affords access to some of the many caves and rock shelters (Fig. A.8). At one point called the Window, erosion has created a natural bridge high on the northern cliff face (Figs. 1.3 and A.7). The canyon begins to constrict here, and the road travels from bench to bench, repeatedly crossing the narrow stream. The immensely deep sand (up to forty feet) of the lower canyon has given way to a rocky streambed that allows the water to surface.

It is actually difficult to appreciate the incredible scale of the Canyon de Chelly cliffs without some recognizable object such as a car or horse for comparison. At Spider Rock, roughly halfway up the canyon, the rim of the plateau is almost 1,000 feet above the canyon floor (see book cover). This rock, the most dramatic geologic feature of the canyon, is a slim monolith of red sandstone more than 800 feet high. It marks the mouth of Monument Canyon, a major tributary entering from the southeast. This ten-mile-long canyon gets its name from the many rock pinnacles similar to Spider Rock that have separated from the cliffs. Close to the mouth of Monument Canyon, another sizable canyon branches due south. This is Bat Canyon and is four miles long.

Canyon de Chelly remains deep for almost the entire upper section, shallowing rapidly in the last mile or so before it disappears on the juniper and sagebrush flats near Sonsela Buttes.

Canyon Dwellings, Ancient and Modern

In addition to its beauty, Canyon de Chelly has literally hundreds of prehistoric Indian sites, including many cliff dwellings of a spectacular nature. Some sites are only recognized through pottery shards scattered on the surface, while others of well-preserved masonry construction are often visible many hundreds of feet above the floor of the canyons in shallow shelters created by the exfoliation of huge masses of rock. This rock, as it crashed into the canyons, shattered to form the talus slopes that provided access to the ledges where the ancients built their houses.

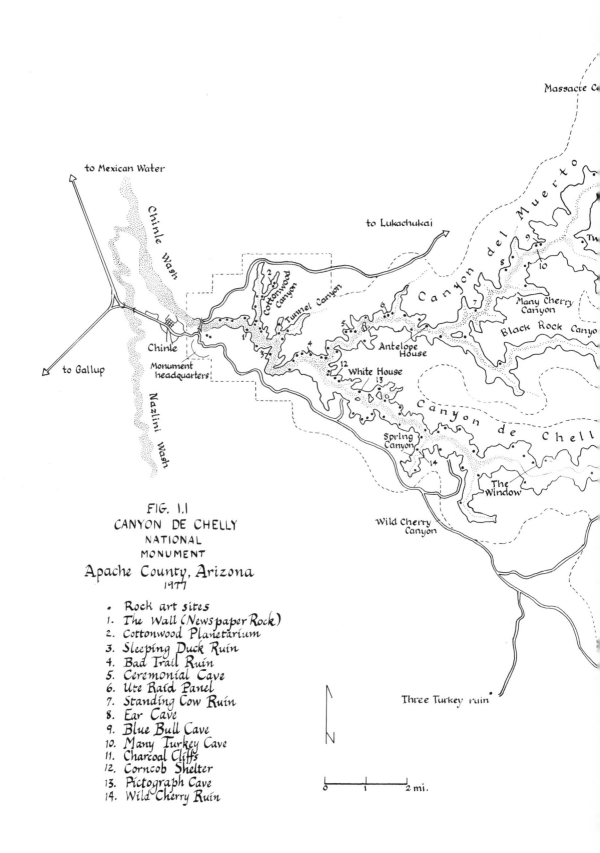

FIG. 1.1
CANYON DE CHELLY
NATIONAL
MONUMENT
Apache County, Arizona
1977

- Rock art sites
1. The Wall (Newspaper Rock)
2. Cottonwood Planetarium
3. Sleeping Duck Ruin
4. Bad Trail Ruin
5. Ceremonial Cave
6. Ute Raid Panel
7. Standing Cow Ruin
8. Ear Cave
9. Blue Bull Cave
10. Many Turkey Cave
11. Charcoal Cliffs
12. Corncob Shelter
13. Pictograph Cave
14. Wild Cherry Ruin

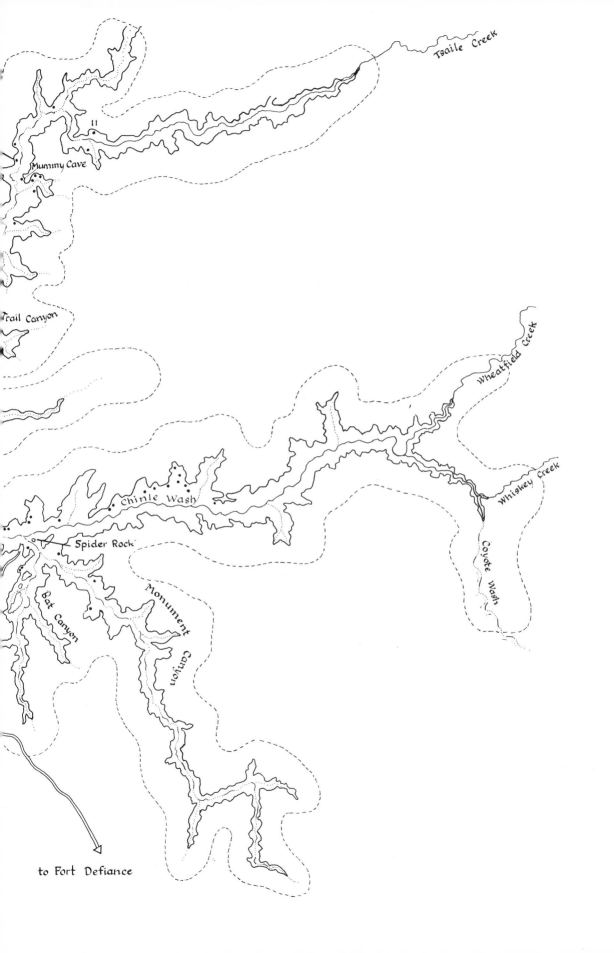

Tsaile Creek

11

Mummy Cave

Trail Canyon

Wheatfield Creek

Whiskey Creek

Chinle Wash

Spider Rock

Coyote Wash

Bat Canyon

Monument Canyon

to Fort Defiance

Fig. 1.2. The tower at Mummy Cave in Canyon del Muerto. Perhaps the final Anasazi cliff dwelling in the canyon. For another view of this structure, see Frontispiece and Fig. 2.33. For tower masonry, see Fig. 3.4.

Many talus slopes do not go as high as the building sites, and in the lower section of the canyon they are lacking completely. In such areas the almost sheer cliffs were climbed by means of pecked toe- and hand-holds and notched log ladders. Most of the log ladders disappeared long ago, and the toe- and hand-holds have been badly eroded, making it dangerous and often impossible for archaeologists to gain access to the ruins (Figs. 2.43 and A.8). The two best known ruins are White House in Canyon de Chelly (Figs. 2.29 and 2.34) and Mummy Cave in Canyon del Muerto (Figs. 1.2, 2.33, and 3.4), but

there are many other lesser sites of great interest. In some of these rock shelters, tree rings in house beams show nearly a thousand years of occupation.

Of equal interest are the countless rock paintings and petroglyphs left by the prehistoric canyon dwellers and the Navajo. Liberally illustrated in Part Four of this book, most are painted on the reddish walls of the caves or rock shelters, while others are scratched or pecked into the patinated surfaces of cliffs. They tell us much about the prehistoric people that is not revealed by archaeological excavation.

In modern times the area is seasonally occupied by several hundred Navajo Indians, and topographical maps of the canyon show about sixty of their round log or stone houses called hogans. Actually most of these dwellings are only occupied during the spring planting and later for the harvesting, as time-consuming trips into the canyon coupled with the heat of the summer and the cold of the winter make living on the rim or at Chinle more attractive.

The weather in the canyons can be very hot, with summer temperatures up to 104° Fahrenheit. The winters are very cold with strong winds. Ice on the floor of the canyon makes travel difficult and dangerous. Temperatures down to −30° have been recorded at Chinle.

Navajo often take short cuts into the canyon, using ancient trails to descend seemingly sheer cliffs. To the Anglo eye this seems impossible, but through extensive use of toe- and hand-holds and log ladders to traverse clefts and chimneys, the sure-footed and intrepid can do it.

The Navajos' crops of corn, melons, squash, and beans are grown on the alluvial benches above the flood plain or in the small side canyons and coves. In these coves are numerous peach orchards that produce a small but delicious fruit.

Canyon de Chelly National Monument

Canyon de Chelly lies almost in the center of the vast Navajo Reservation of eighteen million acres. On April 1, 1931, President Herbert Hoover announced the establishment of the Canyon de Chelly National Monument. The monument covers 84,000 acres, or 131 square miles. It is administered by the National Park Service of the U.S. Department of the Interior, working closely with the Navajo Tribal Council at Window Rock, Arizona.

For a variety of reasons, travel in the monument can be dangerous. The only route into the canyon is up the wash, and after a heavy summer rainfall the saturated sand can become quicksand, as many an unwary driver has discovered. On the other hand, a dry spell makes the lower canyons a sea of loose sand, and even a four-wheel-drive vehicle can bog down. The most dangerous factor, however, is the possibility of a flash flood, which without

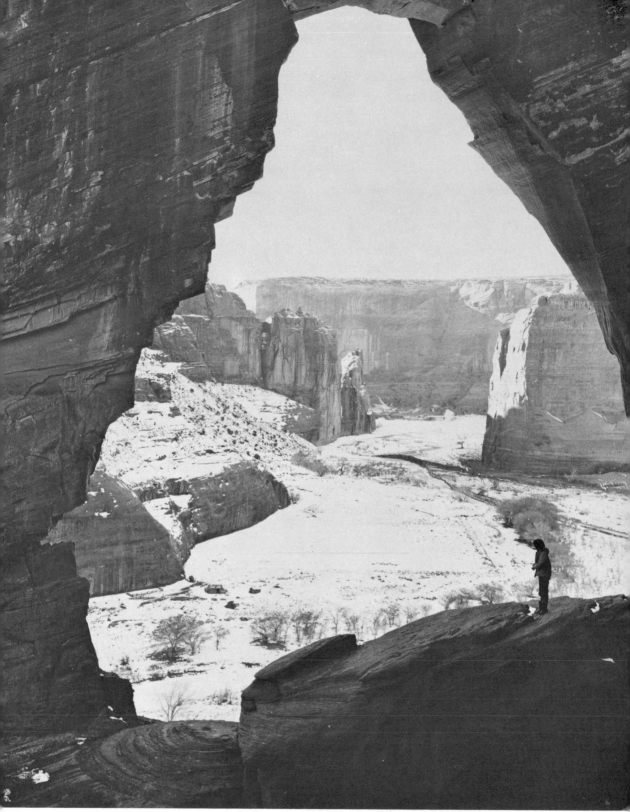

National Park Service

Fig. 1.3. Snow in the canyon, a winter scene from the
Window. For another view of this landmark, see Fig. A.7.

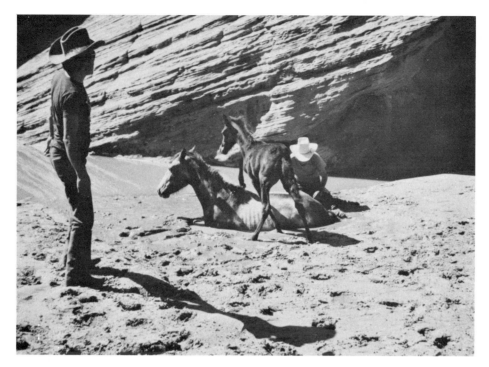

Fig. 1.4. A canyon tragedy — a Navajo mare trapped by quicksand.
Her foal stands over her, waiting to be nursed. The animal was pulled
loose with a winch but suffered a broken leg and died that night.

warning can turn the dry washes into a boiling torrent of muddy water. A
few hours after this sort of flooding, the wash is again dry, the water all
having sunk into the sand. Such a flash flood or "cloud burst" can originate
many miles to the east, while threatened canyon areas are still enjoying clear
skies and sunshine.

In addition to protecting canyon travelers from such hazards, the National
Park Service wishes to guard the fragile ruins against vandalism and to re-
spect the privacy of Navajo residents who own canyon land. For these rea-
sons, they have agreed to allow travelers into the canyon only when they are
accompanied by a park ranger or authorized Navajo guide. In 1977, the only
exception to this rule was the self-guided trail into the canyon at White House
ruin.

Canyon Plants and Animals

The vegetation of the region surrounding Canyon de Chelly is almost
entirely within the Transition Zone, ranging from desert grassland in the
Chinle Wash area to evergreen forests on the Defiance Plateau and the Chuska
Range.

Yucca, Opuntia cactus, and grama grass are typical plants of the Canyon de Chelly region, and in favorable spots there are small stands of Utah juniper and New Mexican pine. The fibers of the yucca were used by early inhabitants of Canyon de Chelly for making sandals, cord, baskets, and rough types of cloth. The seeds of the pinyon were an important fall and winter food source for the ancient cliff dwellers, as they are for modern Navajo.

The lower sections of the Defiance Plateau are dominated by the common sagebrush and Utah juniper. At slightly higher elevations, the New Mexican pinyon pine is a major tree, creating vast areas of pinyon/juniper open woodland. The Gambel oak forms dense thickets and in some locations in the upper canyons becomes a handsome tree. The scrub live oak is abundant on the mesas and canyon rims.

A great variety of plants occur in the pinyon/juniper zone, including squaw currant, service berry, and squaw bush, whose pliable stems were important in basket-making. In the spring, a great many wildflowers bloom in this zone. At 7,000 feet, the open evergreen forest is mainly western yellow pine with some Douglas fir. In the Chuskas, near the headwaters of Wheatfield and Whiskey creeks, there is Colorado blue spruce and quaking aspen.

In Canyon de Chelly, the most prominent tree is the Fremont cottonwood. Most of the stands of cottonwood have been planted since 1931 by the National Park Service to prevent erosion, although there are some gigantic gnarled specimens in the upper canyons that must be several hundred years old. Pictures of White House taken before the 1940s show no trees at all near the ruin (Fig. 2.29), while today a dense stand of cottonwoods partially conceals this spectacular site.

In the side canyons there are scattered specimens of western box elder, western chokecherry, and netleaf hackberry. To the Navajo, the chokecherry is a sacred plant; its wood is used in making prayersticks, and the black fruits are important symbols of the north in certain chants and dances.

In some of the side canyons and coves, there are patches of the showy narcotic toloache (Jimson weed), along with Opuntia cactus. The Rocky Mountain bee plant, an important source of black for pottery decoration, occurs around the Navajo cornfields. In the upper canyons, there are heavy growths of carrizo, the giant cane-like grass that furnished arrow shafts, pipe stems, cordage, matting, nets, and thatching for the Indians.

The same sequence of trees noted for the plateau occurs, although sparingly, in the canyons from the junction of de Chelly and del Muerto to their heads. Coyote willow is prominent, especially in the upper sections along the rocky streambed, and in some areas exotics have been introduced by the Park Service to combat erosion and provide shade. These are Russian olive, tamarix

salt cedar, and peach-leaf willow. An early introduction by the Hopi in the seventeenth or eighteenth century was the cultivated peach.

The fauna of the region reflects the wide range of altitudes and plant zones. The ubiquitous coyote is prevalent, and there is kit fox on the Chinle plain. The black bear is fairly common, and the mule deer ranges through the forested areas. Mountain lion, bobcat, porcupine, raccoon, badger, and spotted and striped skunk have been observed in the canyons and forest. Rodents are well represented, with both jack rabbit and cottontail occurring in abundance along with several squirrels, including the handsome Abert's squirrel and the Colorado chipmunk. Also present is that all-American animal, the pocket gopher.

Since the coming of the Anglo-Americans, a number of the larger or economically important animals have been wiped out. These include the grizzly, bighorn sheep, pronghorn antelope, Merriam's elk, and wolf. Beaver had also been exterminated until these animals were reintroduced along Wheatfield Creek. Beaver dams were observed in 1970 above Spider Rock.

Throughout the year, many birds, both resident and migratory, can be seen around Chinle and in Canyon de Chelly. Among the most conspicuous are the golden eagle, turkey vulture, raven, and great horned owl. Mallard and redhead ducks are winter visitors where there are pools or ponds. Other birds often seen are the western mourning dove, kildeer, red-shafted flicker, downy woodpecker, desert sparrow hawk, pinyon jay, western nighthawk, and cliff swallow.

Many of these birds were important to the prehistoric and Navajo people for feathers and/or food. The most highly prized of all was the wild turkey, as attested by its numerous representations in the canyon rock art (Figs. 4.20, 4.21, and 4.22). This bird, once so abundant in the region, was extinct on the Defiance Plateau early in the twentieth century, though there were still a few in the Chuskas as late as 1917. By 1930 the only native turkeys left in Arizona were in the San Francisco and White mountains. Since then, a vigorous restocking program has been successful, and turkeys once more forage in the Chuska-Defiance Plateau region.

Other residents of the canyon include five toads and frogs, five lizards (including a variety of horned lizard), and six snakes. One of the latter is the prairie rattlesnake, but it is seldom encountered.

A few fish have been recorded in the upper sections of both Canyon de Chelly and Canyon del Muerto. In Coyote Wash at the head of Canyon de Chelly, speckled dace and bluehead mountain-sucker have been seen, and trout live in the upper Canyon del Muerto. Rainbow and cutthroat trout were planted in the region in 1964.

The deepest rocks underlying the Canyon de Chelly area are the Pre-Cambrian red granites and quartzites, rocks so incredibly ancient that the mind can scarcely conceive it. Some of the Pre-Cambrian rocks are more than three billion years old. Quartzite from this period outcrops near Fort Defiance southwest of the canyon, and samples have been taken near Canyon de Chelly in oil exploration drilling cores.

The next rocks in the geologic record of Canyon de Chelly are sedimentary and were laid down during the Pennsylvanian Period, the final period of the Carboniferous Era, 255-230 million years ago. There are no sedimentary deposits recorded as lying on the basic Pre-Cambrian red granite until this time. The primordial granites in this region formed a ridge that persisted as an outcrop through at least 265 million years of geologic time, finally to be covered with the sedimentary deposits of the late Pennsylvanian Period, and the early stages of the Permian Period, 230-205 million years ago.

The eastern Arizona river-borne sediments built up a delta of alternating beds of mud and sand which we know today as the Supai red beds of shale and sandstone. Test cores from Nazilini, south of the canyon, give the formation a depth of 596 feet.

During the Permian Period, a considerable section of northeastern Arizona and northwestern New Mexico was raised as the Defiance Uplift. This uplift put the region above all subsequent advances of the inland seas.

Life at this time was still mainly restricted to the water, although the first amphibians were moving ashore to the warm, humid swamps, and many

Fig. 1.5. Tracks of *Laoparus nobeli,* a Permian reptile, as recorded in a slab of De Chelly sandstone.

Courtesy Museum of Northern Arizona

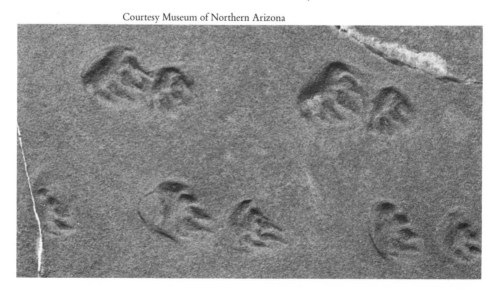

plant forms were diversifying and increasing in size. Fast-growing trees died and rotted in the boglands to reappear aeons later as coal.

In the Permian Period, profound changes in climate took place. Internal stresses within the earth buckled its surface, forcing up new mountain ranges such as the Appalachians, ranges in northern Texas, and the Urals in central Russia. The Rockies were many millions of years in the future, and the San Franciscos and other present ranges in northern Arizona did not exist. The Four Corners region must have been fairly flat, with slow, muddy rivers carrying sediments from the highlands to the floodplains and the shallow inland seas.

Immense glaciers formed, mainly in the southern hemisphere. Large sections of South America, Africa, Australia, and India were covered with ice, and there was minor glaciation in New England and England. The glacier-building removed great amounts of water from the oceans; the sea levels fell, draining the inland seas. The uplift of new mountains changed air current patterns and affected precipitation, causing much of the western part of the continent to become desert. Here the major erosion came from the blowing sand.

During the Permian, the sediments were laid down above the Supai formation that later were eroded to create the awesome cliffs of Canyon de Chelly. This is the DeChelly sandstone, and over 800 feet of it is exposed, together with a small amount of the Supai red beds near Spider Rock. Three phases of the DeChelly sandstone have been recognized. In an 817-foot exposure, the bottom 202 feet is a light-colored material in which channels and ripple marks suggest stream deposition. Above this is a narrow 45-foot bed of non-stratified, red, calcareous material that indicates low-energy water action.

The main section of 570 feet is reddish brown. It is the result of wind-blown sand, with steep cross-bedding indicating the slope of ancient sand dunes (Fig. 1.9). The footprints of small amphibians and reptiles have been preserved on the slanting beds of this formation. Impressed into wet sand, they have remained unchanged through millions of years. The cross-bedding dips in nearly every direction, with one mass wedging into the next. Between bands of strong cross-bedding are layers of nearly flat-lying beds, these sequences being repeated many times to create the upper cliff faces in the canyon.

During the Triassic Period (205-165 million years ago), the age of dinosaurs began. The weather became milder, and seasonal torrential rains returned to the Colorado Plateau. Swift-flowing streams from the south deposited alternating beds of sand and gravel over the Defiance Plateau, creating the gray Shinarump conglomerate formation that caps the DeChelly sandstone. It is a relatively narrow structure, varying between twenty and sixty feet. Much petrified wood occurs in the Shinarump formation.

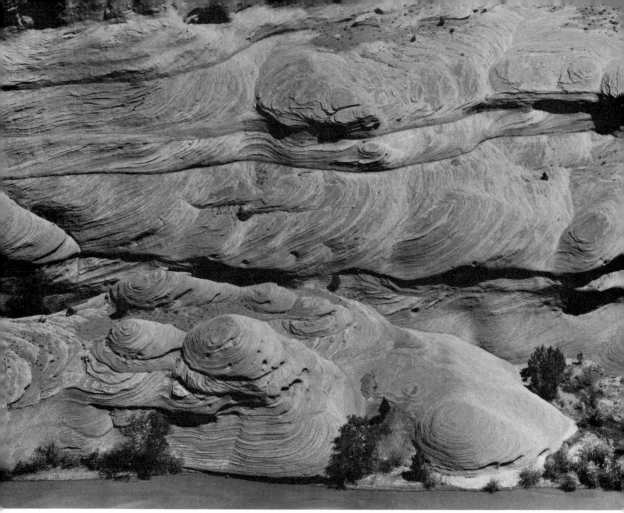

Fig. 1.6. De Chelly sandstone showing extensive wind and water erosion.

During this period of huge reptiles, northern Arizona became a vast floodplain, with lakes and swamps fed by streams from the mountains far to the south. The soft, pithy trees gave way to hardier varieties, and great forests grew up along the waterways with some very large trees such as *Schilderia* and two early relatives of our pines, *Woodworthia* and *Aracucarioxylon.* Most of these died and rotted away, but some were covered by mud, sand, and volcanic ash borne by the streams. The trees were eventually covered by thousands of feet of sedimentary material.

Water laden with volcanic ash percolating down through this sediment impregnated the buried tree trunks with silica carried in solution. The silica, in the form of microscopic quartz crystals, replaced the water and air spaces in the trunks and converted them into the petrified trees revealed millions of years later by erosion.

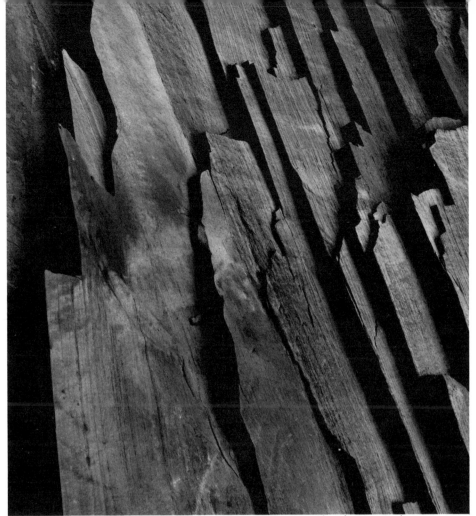

Fig. 1.7. De Chelly sandstone with sharp cleavage between layers.

The multi-colored material that buried the ancient forests is referred to as the Chinle formation. Today it is evident near Chinle at the west side of the Defiance Plateau and also at the east side of the plateau. The Chinle formation was laid down by wind and stream action. This formation marked the final rock-building period in the Canyon de Chelly area, about 165 million years ago. Any later formations that might have existed have been eroded away, leaving no trace.

The final geologic era, the Cenozoic, takes us from seventy-five million years ago to the present. The dinosaurs died out, and the age of mammals began. By the mid-Pliocene Period (six million years ago), most of the present mammals had developed, though man himself might still have been hard to recognize. During this period the Rockies were uplifted, and a few million years earlier the great Sierra Nevada block had tilted into its present position.

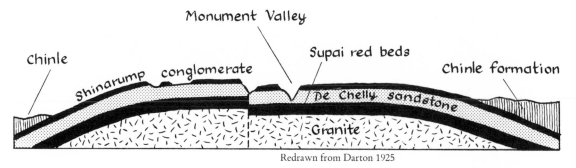

Redrawn from Darton 1925

Fig. 1.8. Cross section of the Defiance Uplift.

There was great volcanic activity in the western part of the continent starting with the Eocene Period (60-40 million years ago), and many ranges including the San Franciscos near present Flagstaff began building up.

The Great Ice Age

The last million years of the Cenozoic is the Pleistocene or Great Ice Age, and in many ways it is the most interesting and understandable of all geological periods. It vitally concerns man and most particularly the entrance of man into the New World.

The glaciation of the Northern Hemisphere was the outstanding event of the Pleistocene. All authorities are agreed that there were four great glaciations with warm wet interglacials as the ice sheets melted and retreated. (Actually we are now *in* an interglacial.)

Tremendous amounts of water were evaporated from the oceans during the Pleistocene Period to create the continental glaciers, causing major fluctuations of the sea level. At the climax of the Ice Age, the ocean level was lowered over 250 feet. During each glaciation, there was a long period when the British Isles was joined to the mainland of Europe, many of the big islands in the East Indies were joined to the Asian continent, and, most important of all, a broad land bridge, hundreds of miles wide, connected Siberia and Alaska.

All that had gone before in the shaping of the world was a prelude to the spectacular changes wrought by the Ice Age. Through the ages, enormous beds of sedimentary rocks had built up, one above another, from material eroded from the land and carried by the streams into the shallow seas and floodplains. The land had risen and sunk with the stresses within the earth. Mountains had been created through volcanism or uplift. Water and wind had done their part in leveling or modifying the mountains and plateaus. Now swiftly the Pleistocene brought great changes. South of the glaciers there was almost constant rain resulting in spectacular stream erosion. The

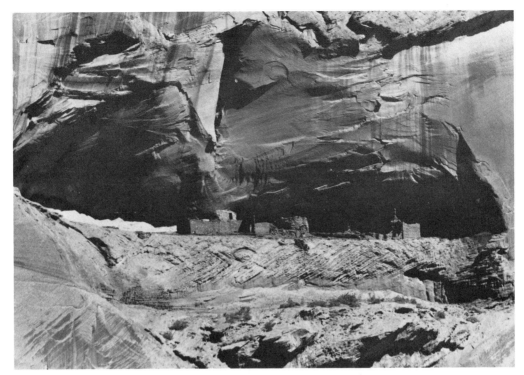

Fig. 1.9. Typical alcove sheltering the first well-preserved ruin in the lower canyon (site CDC-47). Note conspicuous cross-bedding on cliff below floor of shelter.

Rocky Mountains and many minor ranges such as the Chuskas east of Canyon de Chelly made their final uplifts. These mountains rejuvenated the sluggish rivers and prepared the way for the tremendous Pleistocene canyon-cutting.

The fluctuating periods of torrential rains that coincided with the waxing and waning of the glaciers to the north are known as pluvials. The flood waters cut through the sedimentary strata of all the geological epochs, creating badlands and immense gorges. The most outstanding example of this accelerated erosion was, of course, the Grand Canyon, where a half billion years of geological history lies dramatically exposed. The streams from the Chuskas cut through the westward-tilting Defiance Plateau, creating Canyon de Chelly.

The cutting action that creates such canyons was done by the abrasive water-borne sands and rock fragments that ground away at the rock surfaces like a giant rasp. When the flow of water was strong, the cutting was rapid, and the material, both heavy and light, was carried along by the stream. When the flow was slight or the gradient flat, the cutting was lessened, and the waste material was dropped as alluvial deposits.

Since the end of the pluvials (about ten thousand years ago), the elements have continued to alter and widen the canyon. The talus slopes below the

ledges are composed of the fallen DeChelly and Shinarump rock fragments. The roots of trees like pinyon, juniper, and Ponderosa pine still split off chunks of rock which fall into the canyon to build up the talus.

Wind and water are wearing away the rocks constantly, slowly converting them back to their original sand, to be carried down the Chinle Wash and thence into the Colorado River, eventually to settle to the bottom of one of the man-made dams on the great river and continue the endless cycle of rock-making.

Today, one can stand on the canyon floor near Spider Rock and see three of the four rock structures of the Canyon de Chelly. The Pre-Cambrian granites are hidden in the canyon itself, but a short section of the Supai red beds are visible. Above that, the sheer, reddish cliff walls of DeChelly sandstone rise to the gray rimrock capping of Shinarump conglomerate.

Formation of the Rock Shelters

The many rock shelters that occur in the DeChelly sandstone are the result of water action, and there are several theories to explain their formation. Vandiver (1937) believes that water percolating into the soft sandstone along the bedding planes weakened and dissolved the cement, causing curving sections of rock below a bedding plane to break loose and fall. Eventually the exfoliation process formed alcoves large enough to shelter the Anasazi buildings.

De Harport (1959) agrees that the rock shelters might have been formed in this way but notes that the recesses must have been formed long ago and that in only two instances in Canyon de Chelly has such action occurred since the building of the cliffhouses. In these cases, large slabs have fallen, crushing Anasazi ruins. He offers the hypothesis that the rock shelters were formed by stream action undercutting the cliffs before the canyon reached its present depth.

In my opinion, there are other factors to be considered. One is that most of the shelters were formed by water-soaking action during the Great Pluvial Period, when the rainfall was tremendous and coincided with the cutting action of the canyon stream. Also, water percolating into the bedding planes can freeze, and, through expansion, exfoliate or peel off masses of rock like layers of an onion. The dryness of the area since the end of the pluvial has slowed such action greatly.

In any case, it was the protection afforded by these rock shelters which made the canyon so attractive to prehistoric people more than two thousand years ago.

Part Two

The Canyon Dwellers

The Canyon Dwellers

MAN DID NOT ORIGINATE IN THE NEW WORLD, but arrived in a long series of migrations from Asia that might have begun more than 25,000 years ago. Some of these migrants, if they arrived during the last glaciation, could have crossed dry-shod over the great land bridge that then existed between Asia and Alaska at the present Bering Strait. Later arrivals would have had to negotiate the strait with boats or travel over ice. The distance between the two continents is only a little over fifty miles, and there are three islands on the way.

These were by no means large migrations, but tiny bands of hunters moving north and east following the game animals. For a very long time these people kept coming, eventually populating the New World to the tip of Tierra del Fuego. They continued to be hunters and gatherers with the simplest of cultures until the knowledge of corn growing spread north from its point of origin in central Mexico, breaking the ancient patterns.

Before the time of Christ, there were many Indian groups in the Great Basin region of what is now the western United States. These people originally lived in caves and open sites on the edges of the large Pleistocene lakes. As the lakes dried up, their lacustrine way of life gave way to a desert-oriented culture that was remarkably the same over a very large area. Many of the caves these ancient people occupied have been excavated. Much of our knowledge of their way of life comes from the perishable material recovered from the stratified deposits at such sites as the Lovelock and Gypsum caves in Nevada.

Archaeologists generally recognize three main aboriginal cultural divisions in the prehistoric Southwest. In the early 1930s, Harold Gladwin, working in southern Arizona, named the prehistoric people of the Gila and Salt River drainages *Hohokam,* a Piman word meaning "those who have gone." Shortly thereafter, Alfred Kidder, who was carrying out investigations in the Four Corners country, designated the early inhabitants of that area *Anasazi,* a Navajo word also meaning "those who have gone" or "the ancient ones." Another culture, the Mogollon, has been described by some as a blending of Hohokam and Anasazi. Others consider it of equal importance and classify it as a third basic American Southwest culture. The Mogollon sites are located in the San Francisco and Mimbres valleys of west central New Mexico and in southeastern Arizona.

The Anasazi occupied the Southwest plateau country. Their point of origin could well have been the Great Basin to the west. Many of their artifacts are identical with those found in Nevada caves dating from 2,000 years earlier. Seeking greener pastures and permanent water, they began settling in the canyons of the San Juan drainage.

The cultural sequence of the Anasazi was continuous, but for chronological convenience it has been divided into various periods, based on presence or absence of such elements as pottery, ceramic types, and architecture. During the early 1920s, a period of great archaeological activity in the Southwest, four such periods came to be recognized — Basketmaker, Post Basketmaker, Pre-Pueblo, and Cliff Dweller. Kidder and Earl Morris had their own variations on this chronology.

In 1927, at the first conference held at the Pecos ruins in New Mexico, a group of eminent anthropologists seriously involved in the archaeological problems of the region devised the Pecos classification for dating the Anasazi — a system that has continued to stand universally recognized. Many workers, however, use the revised system of Frank Roberts, which is basically a simplification of the Pecos classification. This is the system which has been used in this book.

Basketmaker Period, ? to A.D. 450

Canyon de Chelly's first Anasazi inhabitants had no knowledge of pottery but instead made baskets. We have no way of knowing how ancient the craft of basket-making may be, but woven baskets have been found in caves from California to Texas. In Lovelock Cave, coiled and twined basketry occurs at the earliest horizon, between 2500 and 2000 B.C. (Grosscup 1960:59).

By the beginning of the Christian era, small groups of basket-making people were occupying the San Juan River drainage. They were first de-

Fig. 2.1 SAN JUAN DRAINAGE CULTURAL CHRONOLOGIES		
Pecos Classification 1927	Roberts' Classification 1935	Date A.D.
Pueblo III	Great Pueblo	1300
		1200
		1100
Pueblo II	Developmental Pueblo	1000
		900
Pueblo I		800
		700
Basketmaker III	Modified Basketmaker	600
		500
		400
Basketmaker II	Basketmaker	300
		200
		100

Postulated Basketmaker I

scribed late in the nineteenth century from a site in Butler Wash in southeastern Utah. We know a great deal about these people and how they lived, for they were cave dwellers, and their perishable culture material has been remarkably preserved in the dry rock shelters of the Four Corners Region. The three Wetherill brothers, John, Al, and Richard, who discovered many of the most important cliff dwellings in the area, including Mesa Verde, were the first to use the term *Basketmaker*.

BASKETMAKER DWELLINGS

Early investigators found no evidence that the Basketmakers lived in houses; doubtless the first arrivals in the canyon country simply lived in rock shelters and erected the same type of flimsy brush shelters used in the Great Basin country into the historic period. Their only actual constructions were

storage cists dug into the floors of the caves and utilized for corn preservation and also for burials. These cists averaged about two feet in depth. The sides were often raised with sandstone slabs caulked with adobe and capped by stone slabs or lids of wood and adobe. Curved wooden scoops with well-worn bottom edges have been recovered in Basketmaker sites. These were probably used as crude shovels to dig the cists.

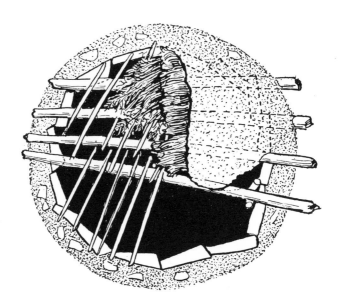

Reproduced from Kidder & Guernsey 1919

Fig. 2.2. Plan of typical Basketmaker cist, Kinboko Canyon, Marsh Pass.

Archaeologist Earl Morris, digging at Mummy Cave in the 1920s, found many storage and burial cists. The typical storage cist was two to six feet in diameter, walled with thin stone slabs, and sealed with adobe strengthened with shredded juniper bark. On top of the slabs was a juglike arrangement of adobe and sticks capped with a circular stone slab. In one cist there were 700 ears of corn, still in good condition. In another there were gourds, and in a third Morris found a type of seed which is still ground into flour by the modern Navajo.

Later investigators discovered that some Basketmakers had lived in true houses at a site at Falls Creek near Durango, Colorado. Cutting dates on beams from this site range between 271 B.C. and the first four centuries of the Christian era (Dean 1975:27-29) — a period well within Basketmaker

times. The most ancient dated houses in the Southwest, these dwellings were semi-subterranean, circular, and twenty-five feet or more in diameter, with cribbed roofs and a variety of types of storage pits. Part of each house was dug into the earth; then the wall was raised with horizontal timbers caulked with adobe, the whole slanting inward. Entrance was probably through a hole in the roof. Metates of basin-and-trough design were present.

New ideas and people were continually moving in the Southwest, and the Durango houses were an innovation that would spread throughout the Basketmaker country by the mid-fifth century. Gladwin calls these Durango region people farmers and postulates a northern origin for them.

It is important to note that a time scale like the Pecos chronology cannot be considered a precise tool. Some Anasazi groups acquired traits like house-building and pottery long before others. In a peripheral Basketmaker area, the Moapa Valley of southeastern Nevada, people were living in pit houses before the advent of pottery (Shutler 1961:13-14).

BURIAL CUSTOMS

Thanks to the burial customs of the Basketmakers, we know how they lived and much about what they looked like. The bodies were tightly flexed and tied soon after death. They were then covered with a fur blanket or deer hide and placed in a cist. Often the face was covered with a large basket.

The mortuary offerings were probably the choicest personal possessions of the deceased, including ornaments, weapons, baskets, digging sticks, smoking pipes, and the like. Almost every burial included a new pair of sandals — evidence that these people probably believed in an afterlife. Finally, the cist was lined with juniper bark or grass. Many burials are multiple, suggesting epidemics.

Youngsters often are found in the excavations; small children being buried in baskets and babies in their cradles. Even dogs, the only mammal domesticated by the Anasazi, have been found buried with their masters, indicating that they were often considered pets and not solely a food resource by these people.

In 1914 Alfred Kidder and Samuel Guernsey began their investigations of the Basketmakers in the Marsh Pass area of northeastern Arizona, and a few years later Earl Morris was making his spectacular Basketmaker finds at Mummy Cave in Canyon del Muerto. In both these regions, archaeologists excavated many so-called mummies (actually dessicated bodies preserved by the dry climate). These burials contained the personal possessions of the individual, and in many cases the preservation was so remarkable that even the hair-styling was intact.

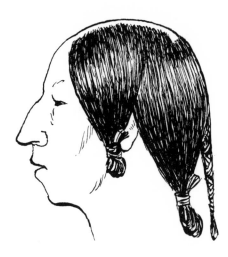

Fig. 2.3. Male hair as found on a mummy in White Dog Cave, Marsh Pass. Note the clipped crown.

Redrawn from Guernsey & Kidder 1921

HAIR STYLES, CLOTHING, AND PERSONAL POSSESSIONS

Basketmaker men wore their hair long and took much care in its arrangement. It was usually divided into three segments, two over the ears and one down the back. The segments were then bent back on themselves and whipped with cord. Occasionally the center part line was cropped short to create a tonsure with a braided queue falling down the back.

Women generally had their hair hacked off short, but whether this was done after death or whether it was a standard way for women to wear their hair is not known. In Baja California, the hair was cropped from the dead to make sacred human hair cloaks worn by the shamans (Meigs 1970:22). In Alta California, the hair of widows was cropped closely. It is quite possible that among the Basketmakers it was customary for the hair to be harvested from the females, living and dead, for use in weaving. Human hair was often used in string-making or incorporated with vegetable fiber for netting, belts, and the like.

The costume of the Basketmakers was of the simplest type. For the men there was no body clothing at all — no examples even of breech clouts have been found in burials. The women wore short skirts, or rather aprons, of yucca or cedar fiber suspended from a decorated waistband. For cold weather and night-time warmth, both sexes wore fur blankets. These were ingeniously made of yucca-fiber string wrapped with strips of rabbit fur. The fur-covered strings were tied together in parallel rows to form the blanket. Identical fur blankets were used by the desert tribes in the Great Basin. Many Basketmaker burials have been found with the body wrapped in such a covering.

These people's main footgear was the multiple-warp sandal, a necessity for travel in a stony country in winter or hot summer. These were made of

Reproduced from Kidder & Guernsey 1919

Fig. 2.4. Construction of a feather string, used in addition to the fur string, for making blankets, garments, and ornamental edging. These strings were usually made with strips of bird skin with feathers attached over yucca twine.

yucca or Indian hemp *(Apocynum cannabinum)*. The latter plant is a member of the milkweed family and makes a soft but strong cord. The typical Basketmaker sandal was double-soled, with square toes decorated with a fringe of yucca, and was fastened to the foot with heel and toe loops connected with cords, usually cords of human hair. Woven pack straps or tump lines to be worn across the forehead to support heavy back loads have been found and some of them are decorated with simple geometric patterns.

For personal ornaments, the Basketmakers had necklaces of olivella shells, seeds, and stones — particularly black lignite, quartz, and hematite. Pendants were of polished stone and abalone shell. These shells from the Gulf of California or the Pacific Coast indicate a long-established trading pattern. Feather arrangements with comblike attachments appear to be hair ornaments.

Like all North American Indians, the Basketmakers enjoyed games, particularly games of chance. Wooden and highly finished bone objects which were probably gaming pieces have been recovered in excavations.

Reproduced from Guernsey & Kidder 1921

Fig. 2.5. Basketmaker bone whistle, or flute, from White Dog Cave in Marsh Pass. For wooden flute from Canyon del Muerto, see Fig. 4.35.

Music to accompany ceremonial occasions seems to have been limited to the sounds of wooden and deer hoof rattles and the bone or wooden flute, or more properly, the whistle. A number of ceremonial articles, doubtless the possessions of shamans, were found at White Dog Cave in Marsh Pass. These included a bird-headed wand with shell and feather attachments (Fig. 4.39), a bird skin, and a deer tail.

The Canyon Dwellers 🐐 *29*

The basic weapon of the Basketmakers was the spear-thrower, or atlatl, and fine examples of this ingenious implement have been recovered from burials in the Marsh Pass region and in Canyon del Muerto. A typical example is made of oak, about twenty-four inches long, tapering from five-eighths of an inch at the handle end to an inch at the spur end, and a quarter-inch thick. The spur that engages with a depression on the butt end of the dart is recessed. In some parts of the Americas the spur is raised, but the function is identical. Leather loops for the first and second fingers of the user are present, and usually there are one or more highly polished stones of an ounce or so,

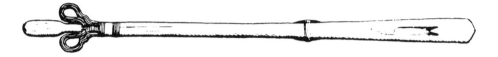

Reproduced from Guernsey 1931

Fig. 2.6. Basketmaker atlatl from Broken Roof Cave in Chinle Valley.

whipped to the weapon between the finger loops and the spur. These might have been for the purpose of giving the implement a better balance, though they may also have served as charm or good luck stones.

A few darts or spears averaging fifty-five inches in length have been re-covered. They are made in two parts. The long main shaft of some light, pithy wood is feathered, and the short (about six-inch) tapered hardwood foreshaft is inserted into the end of the main shaft. The points are much larger than arrow points; examples from northeastern Arizona average about two inches in length. This curious weapon in effect gave the hunter an extra length of arm and was the main weapon of prehistoric man for thousands of years before the invention of the bow and arrow. It was quite efficient against game such as deer, antelope, or bighorn, but only at close range — thirty to fifty feet. In the Coso Range of Inyo County, California, the bighorn sheep were driven past hunters hidden behind piled-rock blinds (Grant 1969:31, 32).

One interesting implement often found in association with the atlatls looks rather like a curved, flattened club. It is from two to three feet long with longitudinal parallel grooved lines from the hand grip to the end. Many western tribes, including the Gabrielino of California and the Hopi, used somewhat similar implements called rabbit sticks. These were utilized as throwing sticks in rabbit drives, somewhat like the Australian boomerang but without the return feature.

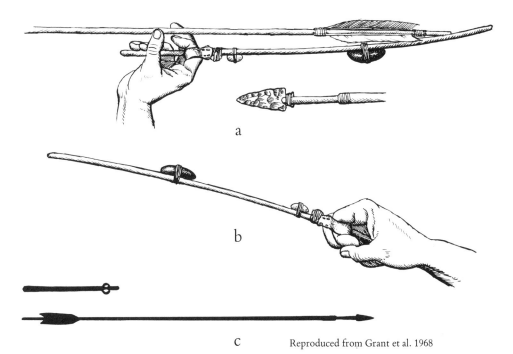

a

b

c Reproduced from Grant et al. 1968

Fig. 2.7. The atlatl in action. These drawings were made using an exact
model of a Basketmaker atlatl from a cave burial in Chinle Valley. a. Po-
sition at beginning of cast with dart gripped lightly between thumb and
first two fingers. Insert shows attachment of point to foreshaft. b. Posi-
tion at end of cast. c. Relative proportion of Basketmaker atlatl to dart.

Quite possibly the Basketmaker sticks served an additional purpose. Pre-
Columbian Mayan warriors pictured in carvings at Chichen Itzá are holding
both atlatls and curved, flattened clubs, which may have served them as "fend-
ing sticks" to deflect the slow-moving atlatl dart in battle. Though the Basket-
makers seem not to have been a warlike people, they could have been under
attack from aggressive nomads, and like people everywhere, probably fought
each other.

The bow and arrow was not unknown to the Basketmakers, although
it would not replace the atlatl as the major hunting weapon until Modified
Basketmaker times. At Battle Cove in Canyon del Muerto (site CDM-7),

Reproduced from Guernsey & Kidder 1921

Fig. 2.8. Basketmaker grooved throwing or fending stick from White Dog Cave in Marsh Pass.

Morris excavated what could be evidence of an ancient slaughter of Basketmakers by an alien people armed with bows and arrows. The remains of an elderly woman was found with an arrow foreshaft between her ribs.

Other methods of hunting included the use of braided yucca snares and large nets into which rabbits were driven and then clubbed to death. One such rabbit net was recovered in White Dog Cave in Marsh Pass. The largest piece of ancient textile net yet found in the Southwest, it measures 240 feet long and 3 feet, 8 inches wide, with a 2½-inch mesh. This remarkable net of two-ply Indian hemp is in a perfect state of preservation.

FOOD SOURCES

Excavations at Tsé-ta'a, a site occupied from Basketmaker times through Great Pueblo, give some idea of the meat diet of the canyon dwellers. Basketmaker levels yielded a few specimens of turkey, bear, deer, and jackrabbit bones. The later periods were represented by deer, jackrabbit, cottontail, beaver, porcupine, dog or coyote, fox, elk, antelope, bighorn, red-tailed hawk, golden eagle, and turkey. Nearly three quarters of all the bone material was turkey, while porcupine, elk, bighorn, red-tailed hawk, and golden eagle were represented by only one sample each. In order of importance, the turkey was overwhelmingly the chief meat resource, followed by jackrabbit and deer (Steen 1966:139-140). The bighorn, so often represented in rock art panels in sites near the Colorado and San Juan rivers, obviously was a minor meat resource and possibly did not occur in the Canyon de Chelly drainage at all, as testified by its rare occurrence in the area's rock art.

Animals and birds provided materials other than food. Skins of small animals were used in the manufacture of medicine bags, dice bags, and the like. Larger skins of deer, antelope, and mountain sheep provided materials for thongs, mantles, aprons, and large sacks. Bones were cut and ground to make awls, projectile flakers, beads, gaming pieces, and decorated tubes. Feathers were utilized for personal decoration and for fletching atlatl darts.

Basketmakers were hunters when game was available, but primarily they were semi-nomadic foragers and primitive farmers. Their corn was a small-eared tropical flint variety with twelve to eighteen rows of kernels. They also grew squash that served as a food and, when dried, as a container. Planting was done with a pointed hardwood digging stick about four feet long. This implement often had a crooked top. Such crooked sticks appear in Canyon de Chelly rock art (for example, at Sleeping Duck Petroglyphs, site CDC-34, Fig. 4.54).

Corn can be stored for winter use, and storage cists from Basketmaker to Navajo times have played a vital part in the development of a sedentary

culture in the canyons. Corn was ground on trough- or slab-shaped metates with manos. In addition, berries, seeds, nuts, roots, and bulbs of all sorts were gathered for food; in the spring plant greens were harvested. Canyon de Chelly farmers had the most ideal of growing conditions. Summers were hot, and moisture was assured through thunder showers, permanent flowing streams in the upper canyons, and intermittent water flowing the entire length of the canyons whenever there was heavy rain in the Chuskas to the east.

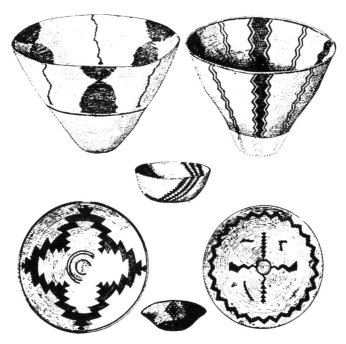

Reproduced from Guernsey & Kidder 1921

Fig. 2.9. Baskets from White Dog Cave in Marsh Pass. This cave produced the finest perishable Basketmaker material until the spectacular finds of Earl Morris in Canyon del Muerto.

VESSELS AND UTENSILS

Not surprisingly, the Basketmakers made excellent baskets and were also fine weavers. Most baskets were made by the coiling technique. By this method, the basket was constructed from the base upward by a continuous spiral coil. The coil was made of two rods of thin, pliable wood and a bundle of yucca fiber or shredded roots. These coils were bound together by a flat binding material that passed over the top coil and through the adjacent lower coil. The bone awl was indispensable in this operation.

These people also made shallow trays for seed-parching, large burden baskets, bowls, water baskets, and little trinket baskets. A small amount of basketry was made by the twining method, whereby pliable splints were intertwined with a foundation of radiating rods. The larger baskets, particularly the water baskets, were equipped with carrying loops on the sides so they could be carried on the back supported by a forehead tump strap, leaving the hands free for the laborious climbs to the high rock shelters.

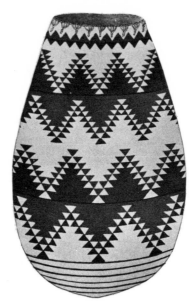

Reproduced from Guernsey & Kidder 1921

Fig. 2.10. Basketmaker twined bag from White Dog Cave in Marsh Pass.

The finest and most characteristic examples of Basketmaker weaving are the twined bags. These large, egg-shaped, seamless pouches, some over two feet in length, are woven of the soft, fibrous Indian hemp, or apocynum. These bags are usually decorated with woven or painted designs in red and black. The decorations, like those on the basketry, are very simple — zigzags and triangle formations.

The Basketmakers were not pottery-makers. They boiled their food in water-tight baskets by dropping very hot stones into the cooking liquid, repeating the process until the required temperature was reached. Excavations at Mummy Cave, however, show that sometime in the Basketmaker period these people were getting very close to the idea of true pottery.

Over ninety fragments of different unfired clay vessels were recovered. What appeared to be the oldest of these were made by molding wet clay

tempered with shredded juniper bark on the inside of a basket. In most cases, a rim several inches high had been constructed by adding rolls of clay. In some instances, lugs of clay were attached to this rim to form rudimentary handles. These handles were applied by a "riveting" technique identical to that practiced in historic times by the Hopi. The lug has a tapered end which is inserted in a prepared hole in the side of the vessel, there to be welded with the fingers on the inside (Morris 1927:138-160).

Originally, the basket-molded bowls might have been simply liners for old baskets, or, in the case of shallow trays, to allow roasting and parching of food seeds. The clay-lined shallow basket was still being used by tribes such as the Havasupai in historic times. However, the Mummy Cave vessels were removed from their basketry forms and used as food containers. All the fragments were blackened and shiny from much use. The bowls were much heavier than the true pottery of the following period, averaging a third of an inch in thickness with the added rims usually about a half-inch thick. The addition of a vegetable temper, in most cases shredded juniper but in a few instances corn tassels or grass, gave these bowls greater strength.

Somewhat less than half of the bowl fragments were not made by the basket mold method but by building up the sides with horizontal strips of clay. A few examples are tempered with sand instead of vegetable matter. It has long been accepted that fired pottery in the Southwest was an introduced idea, having its roots in Mexico. However, the San Juan Basketmakers certainly were in a position to have made an independent discovery — after you have sand temper, all you need is to have your house burn down, and your unfired bowls become fired pottery. Three unfired clay vessels were found at Dupont Cave in southwestern Utah, a very early Basketmaker site. There were no basketry impressions, and one container was decorated in black zig-zag lines and dot patterns.

In Grand Gulch, a tributary of the San Juan in southeastern Utah, some crude, decorated slate-gray pots that had been fired were discovered in Basketmaker caves (Nussbaum 1922). They were not basket-molded, and the shapes included small bowls, dippers, and vessels equipped with lugs and spouts. The decoration was red, consisting of broad lines and dots. This group of vessels appears to bear no resemblance to any other Southwest pottery, but must certainly be the earliest examples of true pottery in the San Juan drainage.

CANYON DE CHELLY BASKETMAKER EXCAVATIONS

Most of the foregoing description of Basketmaker culture has come from the publications of Alfred Kidder and Samuel Guernsey, both of whom did much excavating of Basketmaker caves in the Kayenta district, particularly

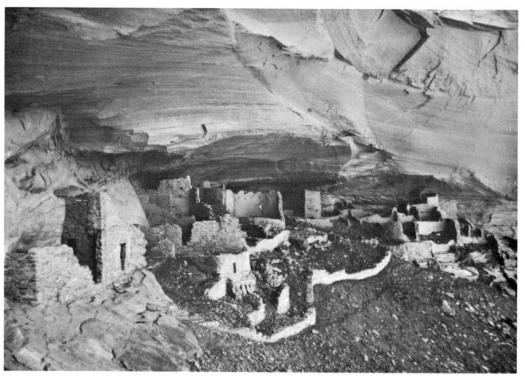

Fig. 2.11. The right alcove at Mummy Cave, site CDM-174. The talus slope below the structures was extensively excavated by Earl Morris in 1923. For more views of this site, see Frontispiece and Figs. 1.2 & 2.33.

near Marsh Pass. The only important digging done at Basketmaker sites in the Canyon de Chelly region were those excavations undertaken by Earl Morris (Fig. 3.3) beginning in 1923. Unfortunately, except for a few brief magazine articles and a popular book by his wife Ann, at the time of this writing nothing comprehensive had been published on Morris' rich finds.

Morris excavated at Mummy Cave and at Big Cave, both important Basketmaker sites in Canyon del Muerto. The former consists of two large alcoves connected by a long ledge. Both alcoves and the ledge have extensive Great Pueblo ruins, and there is a well-preserved, three-story tower on the ledge (Figs. 1.2 and 2.33). The Basketmaker and Modified Basketmaker sites were buried under an immense layer of culture-bearing debris, steeply pitched and continually sliding down onto the talus slope below. Under the sloping debris, trenching revealed a pattern of cribbed-log retaining walls constructed to increase the level living space.

One unusual burial was the dessicated body of a man wrapped in a rabbit fur blanket protected by a covering of juniper bark. The feet were in buckskin moccasins — an unusual item in a culture where the woven sandal was

the typical footgear. The man also wore buckskin leggings to the knee, and a buckskin sash that passed around his waist three times. One end clung to his thighs like an apron, while the other passed across his chest and over the left shoulder. On his right side was an atlatl and on his left wrist, a shell bracelet. On his breast was a wooden flute encrusted with white beads and a leather sack containing a smoking pipe and some bone implements.

The evidence of a few excavations and the style of rock art shows us that the Basketmaker settlement pattern in Canyon de Chelly was concentrated in the lower sections of Canyon del Muerto and the main canyon, with a few sites in the upper reaches and middle sections of both. De Harport (1950) has made estimates on the populations in the main canyon during the various periods of occupation, based on absence or presence of pottery, type of pottery, rock art style, types of construction, and numbers of sites. He recorded eighty-one Basketmaker sites in his survey. De Harport's estimate of the average population in Basketmaker times is slightly under one hundred. All of his figures can be doubled if we consider Canyon del Muerto, which was not part of his survey.

Modified Basketmaker Period, A.D. 450-700

During the Modified Basketmaker period, the three most important innovations were the house, true pottery, and the supplanting of the atlatl by the bow and arrow. The basic culture pattern remained the same as in Basketmaker times, but many influences from outside changed and modified the way of life.

The country was filling up, and the people were beginning to live a sedentary life in permanent communities. During this era and later during the Developmental Pueblo period, Canyon de Chelly people appear to have occupied the lower canyon below the junction, the middle section of del Muerto (from the junction to Mummy Cave), and the middle section of the main canyon (junction to Monument Canyon), as well as just a few sites in the upper canyons where agricultural land was almost nonexistent.

The average population in the main canyon during Modified Basketmaker times according to De Harport (1950) was about seventy, a decline from the Basketmaker period, which is a little difficult to account for. De Harport recorded only thirty-three sites as dating in this period. This may be due to the fact that Modified Basketmaker sites lack distinctive ceramics and other key dating clues. The excavations by Morris at Mummy Cave and at Big Cave in del Muerto certainly indicate intensive use during both Basketmaker periods, and it is in this great side canyon that the people of Modified Basketmaker times may have been concentrated.

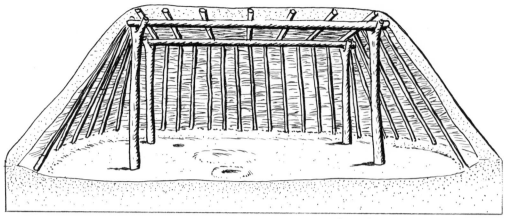

Fig. 2.12. Reconstruction of the Modified Basketmaker house in Obelisk Cave.

MODIFIED BASKETMAKER DWELLINGS

The age-old pattern of living in rock shelters continued into the Modified Basketmaker period, but now some families were building houses in the caves where the overhang would give additional protection from the weather. Others erected their houses in the open.

The typical dwelling was a pit house. These houses were built close together but never contiguous to one another. Usually a cluster of storage cists surrounded each house.

Early structures, such as some of those at Mummy Cave, were circular — twelve to twenty-five feet in diameter. The pits varied from three to five feet deep. Later the houses became oval in shape, and finally most were rectangular.

Usually the superstructure was supported by four stout posts embedded in the floor. Poles were then slanted inward from the edges of the pit, and a covering of brush or mats was placed over the poles. Finally, a coating of earth reinforced with vegetable matter sealed the exterior. The exposed part of the house looked rather like a truncated pyramid. The pit walls were often plastered or faced with thin sandstone slabs.

Archaeologist Earl Morris excavated a number of Modified Basketmaker caves in the Red Rock Valley thirty miles north of Canyon del Muerto that date from the fifth to seventh centuries. The earliest Modified Basketmaker house was found in one of these, Obelisk Cave. Tree-ring dating placed this house at about A.D. 480 (Bannister et al. 1966:49).

Such early houses were entered through a low passageway, sometimes enlarged into a small antechamber. Ventilation was provided by a hole in the roof that later became the entrance equipped with a ladder for access to the

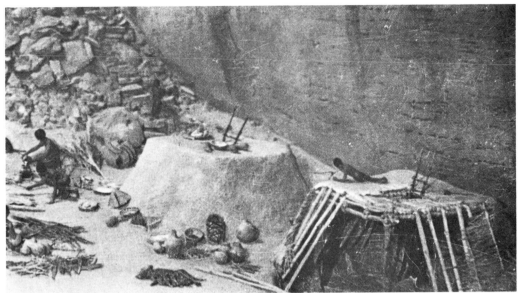

Fig. 2.13. Part of a diorama showing Modified Basketmaker pit houses.

room below. The side entrance was often retained in reduced form to afford additional ventilation. A flat stone set on edge was placed in front of this ventilating passage as a deflector to keep strong wind from blowing directly at the fire.

The floors were of clay, sometimes faced with stone slabs, and the shallow fire pit was located in the center of the room. On the south side, from the fire pit to the walls, there was usually a partition of stone or adobe, in effect dividing off the cooking or women's area from the rest of the house.

On the other side of the fire pit was the small hole in the floor known as the sipapu. This curious hole, still included in Pueblo ceremonial buildings, represents the place where, according to legend, the first people entered the earth from the underworld.

The idea of the ceremonial kiva would not develop until Developmental Pueblo times, and at this early period rituals were either conducted out-of-doors or in the homes. The great number of rock paintings near the habitation sites indicates the former as most likely.

Toward the end of the period, some surface houses with contiguous rooms were being built in peripheral areas, particularly to the northeast. This is the same general area where the first houses were found in Basketmaker times, and it was either a route through which new ideas traveled from the outside or a place in which the people had a long tradition of architectural innovation.

With the advent of houses came the appearance of the grooved maul as well as stone axes grooved for hafting. Before obtaining these most valuable tools, timbers for construction must have consisted mainly of dead wood or logs harvested by burning.

HAIR STYLES, CLOTHING, AND PERSONAL POSSESSIONS

The evidence of rock paintings and artwork on pottery shows that Modified Basketmaker women were adopting a hair style that would remain unchanged in the Anasazi country until modern times. The hair was parted in the middle and gathered in whorls or tied in bundles over the ears. A few unmarried Hopi girls were reviving this whorled or "squash blossom" hairdressing in the 1970s, although the practice had been virtually abandoned by about 1920.

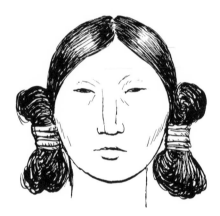

Redrawn from Guernsey 1931

Fig. 2.14. Restoration of a female hair arrangement from a Developmental Pueblo burial in Tségi Canyon.

In Modified Basketmaker times the fringed-toe sandal disappeared, and the finely woven sandals of this period are among the handsomest ever found in the Southwest. Great numbers of them have been found in Canyon del Muerto, particularly at Mummy Cave, where the typical sandal of the period is scalloped at the toe end and gathered at the heel section to keep the foot from sliding back. They were woven of the soft apocynum fiber over a yucca-cord warp and were often elaborately patterned in red and black. Pack straps were similarly decorated. The feather string blanket (Fig. 2.4), mainly made of the feathers of the turkey, began to supplant the fur string blanket.

The flute had a very special role in the Anasazi way of life, and numerous flutes appear in burials along with other cherished articles. The rock art also reflects the importance of the flute as a musical instrument and possible ceremonial object (Figs. 4.26, 4.27, 4.37, 4.47, and A.1). At Big Cave, an elaborate burial included four flutes, a very large stone pipe, and four atlatls.

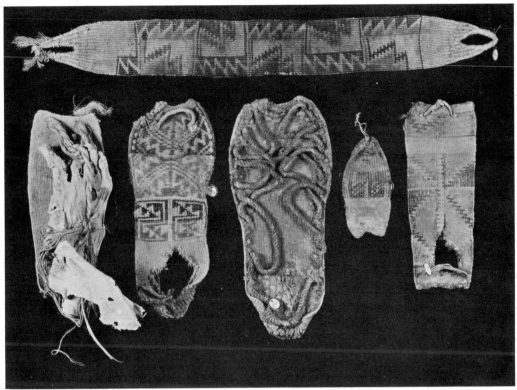

Fig. 2.15. Headband or pack strap and sandals of the Modified Basketmaker period. Notice the child's sandal and the foot still in the sandal on the left.

During this period jewelry also became more elaborate, and some splendid pendants of wood and inlaid turquoise have been found in Canyon del Muerto Modified Basketmaker burials. Fine basketry continued to be made and appeared in the burials, as in Basketmaker times.

A unique Modified Basketmaker burial was unearthed by Earl Morris in Canyon del Muerto. On a bed of grass in a cist lay two hands and forearms of an adult. No other part of the body was present. By the bones were two superb, unused pairs of sandals, decorated in red and black, and a small basket containing crescent-shaped white shell beads. Over the wrists were three necklaces, one bearing a pendant of abalone as large as the palm of a hand. Another consisted of eighteen overlapping shell rings, each nearly three inches in diameter, carefully lashed to the neck cord. Covering all was a basket, two feet in diameter. The only plausible theory that has been advanced to account for this strange and pathetic "burial of the hands," is that the person might have been the victim of a rock fall, and only the hands and forearms could be recovered.

Just how the Modified Basketmakers acquired true pottery is unknown. If we rule out the idea that they discovered it independently, there are several other possibilities. One is that somehow the knowledge of pottery-making moved north from central Mexico and eventually reached the Basketmaker country. In the lake region near present-day Mexico City, potters were at work as far back as 2000 B.C. (Lothrop 1964:11).

The earliest characteristic Modified Basketmaker pottery has been found in Obelisk Cave, where coincidently the first Modified Basketmaker house was discovered. Both basic innovations might have been acquired from the farming people of the Durango, Colorado, region, who had been making houses for some time.

Ceramics dating around A.D. 200 have been recovered from sites in the Navajo Reservoir district of northwestern New Mexico. These resemble early Mogollon types, suggesting another route for the spread of the knowledge of pottery manufacturing into the Anasazi area.

There is also the intriguing possibility that even the Mexicans did not originate ceramics. The earliest known fired pottery in the New World is from coastal Ecuador. It comes in many diverse shapes and is decorated with incised patterns of a sophisticated nature. The earliest is dated at 3000 B.C. and bears an uncanny resemblance to the Joman pottery of Japan, being produced at just that time (Meggers et al. 1965, 1969). The many reported instances of boats from the Orient drifting across the Pacific raise the possibility that a Japanese taught the New World Indians how to make and fire pottery.

The first Modified Basketmaker pottery was a rather crude medium gray ware, tempered with sand. The most characteristic shape is globular, with a vertical, slightly constricted neck and often a carrying handle. Other types are small, shallow bowls; pitchers with handles; round, olla-shaped vessels; and necked water jars with carrying lugs.

With the plain gray ware, there is an early variety of black-on-white pottery with the simplest sort of geometric decoration — zigzags (also common in the canyon rock art of the period), triangles, and parallel lines. These geometric patterns of the early Anasazi pottery derive directly from basketry designs where the techniques of weaving dictate the stepped geometric approach to all shapes. Rarely, the potters painted human or animal shapes on their vessels. Morris, who excavated much of this type of pottery in the Four Corners region, especially in Canyon del Muerto, believed that some of the pottery shapes imitated the shapes of gourds which have served primitive man as vessels from the earliest times.

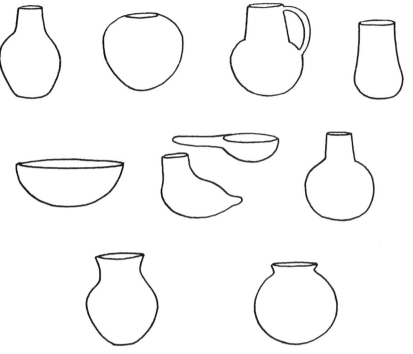

Redrawn from Gladwin 1957 and Morris 1927

Fig. 2.16. The basic pottery shapes in the Four Corners area were well established during the early Developmental Pueblo period. There was little change thereafter except in design patterns.

In Canyon del Muerto, Morris found both fired and unfired clay objects which appear to be fertility figures. The first type represents the female figure, with rudimentary breasts, facial features, and incised dots and lines representing necklaces. These figurines vary in size from 2½ to 4½ inches in length. The second ceremonial object is nipple-shaped, hollow, and incised with dot

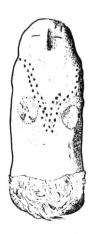

Reproduced from Morris 1927

Fig. 2.17. Female fertility figurine ceramic from Mummy Cave.

patterns. Most of these are about 2½ inches high and resemble a rather pointed thimble (Morris 1927:153-158). The clay figurine has a long tradition in the Southwest, occurring with the Hohokam in southern Arizona, the Mogollon to the east, the Fremont people of eastern Utah, at "Lost City" in southern Nevada, and with certain southern California tribes. The striking resemblances of these figurines from one area to another indicate a common origin.

FOOD SOURCES

One innovation of the Modified Basketmakers may have been the domestication of the turkey. Pinkley (1965) postulates that this might have been partly an effort at self-protection. With the establishment of agriculture, the wild turkeys must have become a major trial to farmers as they incessantly invaded the growing area to destroy young plants. Modern reintroduction of wild turkeys in the region has demonstrated that the supposedly wild birds soon encroach on planted areas and become a nuisance.

It is also possible to postulate that the newcomers who ushered in the later Pueblo era, bringing innovations discussed later in this section, also introduced the domestication of the turkey. Gladwin (1957) traces the new influences back to Mexico, where the turkey had certainly been domesticated for a very long time. When the Spanish arrived in Mexico they found only two creatures that the Indians had successfully domesticated — the dog and the turkey.

The birds were kept penned in the large rock shelters in the canyons. During Earl Morris' digging in Canyon del Muerto in the 1920s (Lister & Lister 1968:120), he found evidence of pens and an immense amount of turkey droppings at Big Cave. This is mainly a Basketmaker site, with some early Developmental Pueblo ruins. Seventy air miles to the northwest, in the Marsh Pass area, deep deposits of turkey guano were found at Turkey Cave (Guernsey 1931:57). There was evidence at this site of Developmental Pueblo and Great Pueblo occupation. In the extensive pure Basketmaker culture caves in this same region, there was no sign of turkey domestication (Guernsey & Kidder 1921:110).

Rock paintings of this prized bird began appearing during the Modified Basketmaker period, indicating that the turkey was becoming very important to the culture and economy. Some authorities maintain that the Anasazi did not use the turkey for food. However, it would seem incredible that these primitive people ignored this prime food source. The excavations at Tsé-ta'a have turned up great numbers of turkey bones to disprove the noneating theory.

The Modified Basketmaker diet was also enriched by the introduction of improved strains of corn (many corncobs from Basketmaker sites are only

a few inches long and no larger in diameter than a fountain pen) and beans, a rich source of protein as easily stored as corn. Perhaps there was also additional wild game, since the bow and arrow was a more versatile and effective hunting weapon than the Basketmakers' atlatl.

In all probability, the bow was introduced into North America from Asia long before it turned up in the Southwest. The original introduction might have been made by the Algonquian-speaking people. These Indians occupied the northern woodland country from coast to coast, and, as they never penetrated the Southwest, the knowledge of the bow had to travel from tribe to tribe.

Its first appearance in the Great Basin is in stratified material at Lovelock Cave, Nevada, around 500 B.C. Bow and arrow fragments have been found in Canyon del Muerto and at Obelisk Cave in Red Rock Valley to the north. These are dated at approximately A.D. 200. Stratification at Obelisk Cave suggests that sometime before A.D. 700 the bow had completely supplanted the atlatl. Other dates for the southward introduction of the bow are: Ventana Cave, southern Arizona, A.D. 1, Tularosa Cave, southern New Mexico, pre-A.D. 700, and Trans-Pecos area near the Texas-Mexico border, A.D. 900 (Grant et al. 1968:50-51).

The introduction and acceptance of the new weapon was a slow business, and the conservative tribesmen appear to have taken an average of 500 years to complete the weapon shift.

CANYON DE CHELLY MODIFIED BASKETMAKER EXCAVATIONS

The major digging of Modified Basketmaker sites in Canyon de Chelly was done by Earl Morris in the late 1920s and early 1930s. However, the only published excavation is that of Charlie Steen, who excavated Tsé-ta'a in 1949 and 1950. He has described two pit houses from the lowest levels. They are fourteen and seventeen feet in diameter, with the pits about four feet deep and faced with masonry of small flat stones laid horizontally. In one house, the dry masonry rests on double vertical sandstone slabs. No post holes were found, and the remaining burned timbers indicated that slanted stout poles with their butt ends embedded in earth outside the pits supported the roof. The houses have rock-lined fire pits, and one contains a stone corncrib.

There is no indication of long occupation of these pit houses, and many archaeologists have noted that in the Southwest there is a pattern of house-building and abandonment after a relatively short time — perhaps ten to fifty years. In coastal southern California, the Chumash were known to abandon their pole-and-reed houses when debris and vermin threatened to overwhelm them, and build a new house nearby.

Little was found in the two pit houses but broken turkey and dog bones and a great many undecorated gray pot shards. These non-culinary pots appear to have been painted with a fugitive red color after firing.

Developmental Pueblo Period, A.D. 700-1100

The Southwest at A.D. 700 was entering the most important century in its history. It was a time of comings and goings, a time of blending of peoples and cultural patterns. In the north, the Anasazi farmers first noted near Durango were spreading south and west into the La Plata Valley, Mesa Verde, and southeastern Utah. South of the San Juan, the Anasazi, who already had acquired a number of traits, including pottery-making and house-building, were developing communities in the Marsh Pass region, Red Rock Valley, and Canyon de Chelly. These areas acted as corridors for the passage of peoples and ideas from the north as well as the south.

The cultural traits described in this section were arrived at over a long period of time, varying from place to place. In the peripheral areas, many cultural ideas did not penetrate at all. A good example of this is the Fremont culture region of southeastern and eastern Utah, where earlier traits persisted and where the kiva, sandals, the weaving of cotton, and domestication of the turkey were unknown.

DEVELOPMENTAL PUEBLO DWELLINGS

There was a bewildering variety of building styles during this developmental period as people reacted to new housing ideas. In some regions, the pit house remained for a very long time — either the new housing styles were not reaching these people or they were resisting change.

Pit houses varied little from region to region, although some had a side entrance and others favored the combination roof entrance and smoke vent. In the early Developmental Pueblo period, people in some areas were building surface rooms — an evolvement from the surface storage room. Later, especially in open sites, jacal, or wattle-and-daub, construction made its appearance. Structures built by this method had slanted or vertical walls with pole-and-brush construction, thickly faced with adobe. Such houses were fragile, and often the lower sections were reinforced with masonry. Entrance was usually through a low passageway that also served as a ventilator.

Toward the end of the period, the typical house in the Four Corners region was of masonry with contiguous rooms. These unit-type dwellings, if in a rock shelter, were often built against the back wall of the alcove with one or more kivas in front. All such dwellings in Canyon de Chelly were

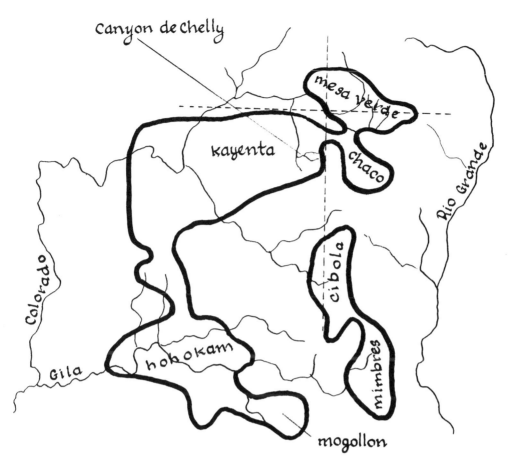

Fig. 2.18. Principal Southwest Culture Areas at A.D. 1000.
Redrawn from Gladwin 1957.

designed to fit under the overhang so there would be protection against the frequent rock falls.

The kiva, or subterranean ceremonial chamber, evolved at this time, and all the evidence indicates that this typical Pueblo structure first appeared in the Four Corners area. The round shape of the kiva clearly points to its derivation from the circular pit house. Certain features were gradually added to these ceremonial structures, and by the beginning of the Great Pueblo period the typical Anasazi kiva had certain distinctive characteristics. These included a bench running around the circumference of the kiva, a fire pit, ventilator, air deflector, and sipapu hole. Later, pilasters were added above the benches to divide the seating and serve as supports for the cribbed log roof.

A rather rigid social system probably had evolved by the end of the Developmental Pueblo period, and this in turn had its effect on the development of contiguous unit-type dwellings. Our knowledge of this social order stems

Fig. 2.19. The kiva at Mummy Cave, site CDM-174.
For details of the geometric fret pattern which decorates
the continuous circular bench, see Figs. 4.50 and 4.51.

from the historic period, but there can be little doubt that it is very old and
in general, resembles primitive social systems that are worldwide. The people
were dividing into clans, each clan being known by a name, usually that of
some animal, plant, or object. The historic Hopi recognized a great many
clans, such as Red Ant, Eagle, Bear, Badger, Rabbit, Kachina, Corn, Coyote,
and Flute. All clan members claimed descent from a common female ancestor
in matrilineal descent. Houses traditionally belonged to women, and an ex-
tended family might be made up of a woman, her husband, unmarried children,
and the families of her married daughters. Husbands were always from other
clans, and their religious connections were with their own clans. The kivas
belonged to the men, serving chiefly as ceremonial structures but also func-
tioning as clubhouses — places to get away from the women.

By A.D. 1000, the various cultural areas in the Southwest had all acquired
special characteristics, especially in architecture and pottery. These areas were
Mesa Verde, Chaco, Kayenta, Cibola (the modern Zuni area), Hohokam,
Mimbres, and Mogollon. The three that will concern us are those of the Four
Corners region — Mesa Verde, Chaco, and Kayenta, the latter embracing the
canyon country of northeastern Arizona — Marsh Pass, Red Rock Valley,
and Canyon de Chelly.

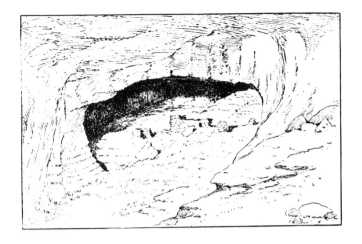

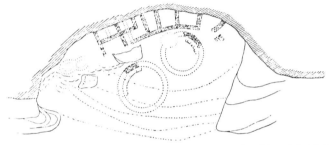

Fig. 2.20. Mindeleff's sketch and ground plan of a small ruin near the Window.

The largest structures of the Developmental Pueblo period were being built by the Mesa Verde and Chaco Canyon people. Near Mesa Verde, there is a great kiva, sixty-two feet in diameter; one of its huge roof support beams has been given a cutting date of A.D. 831. By the end of the ninth century, the Chaco people were building full masonry walls, and some pit houses had been converted into small kivas.

By A.D. 1000, scattered groups of people had begun moving northward into the sparsely settled Chaco Canyon region. They might have been under pressure from marauding nomadic Indians or they may have just been looking for a better way of life.

Something approaching a Chaco Canyon population explosion occurred during the first half of the eleventh century, when a prodigious building program created many pueblos with structures up to four stories high. Some had as many as 800 rooms.

In contrast, the Kayenta masonry buildings of the period were modest indeed. The size of the rock shelters, of course, often limited the settlements, which mainly consisted of a few contiguous or separate rooms of adobe or

adobe reinforced with stones utilizing the cliff as a back wall. If the area permitted, the kiva was in front; if the shelf was too narrow, the kiva was located at one end.

De Harport (1950) recorded most of his Canyon de Chelly sites from the Developmental Pueblo period and estimates that during this time the population rose from less than 100 to more than 500 in the main canyon; 301 sites have revealed early and/or late Developmental Pueblo occupation. The largest ruin has eight rooms and six storage chambers. True kivas were found at all of the larger sites.

During this time and to some extent during the Modified Basketmaker period, the lower canyon below the junction of the two big canyons was being occupied, although the major concentrations continued to be in the middle sections of both Canyon del Muerto and Canyon de Chelly. Additional sites were located in the upper main canyon.

There are a few Canyon de Chelly tree-ring dates from the Developmental Pueblo period. Near the junction of Canyon del Muerto and the main canyon is a small ruin with about ten rooms, one circular kiva, and a possible square kiva. A single beam specimen from this site gave a date of A.D. 1012. In Canyon del Muerto just south of Mummy Cave, a site with two pit houses dates mainly in the ninth century. In the main canyon, at the lower ruin of White House, most dates fall in the mid-eleventh century.

There is a curious situation at the Sliding Ruin in the main canyon. This is an extensive pueblo of thirty to fifty rooms, some of two or three stories, with three kivas. All the tree-cutting dates fall in the tenth century, which means that either this ruin is the most advanced example of Developmental Pueblo construction in the canyon or that later builders reused old timbers (all dates from Bannister et al. 1968).

POTTERY

Some basketry continued to be made, but in general the more durable, easy-to-make, expendable pots were supplanting the ancient craft. Pottery assumed great importance during the Developmental Pueblo period, and the Anasazi were learning much from contact with other areas. Indeed, so distinctive did pottery shapes and designs become that archaeologists have used pottery styles as partial clues to migrations of peoples.

During the Early Developmental period, new ideas in pottery design and construction were slight in Canyon de Chelly. Plain ware continued to be made, and small decorated ladles came into common use. The most interesting vessel was bird-shaped, with the neck of a highly stylized bird body serving as a pouring spout.

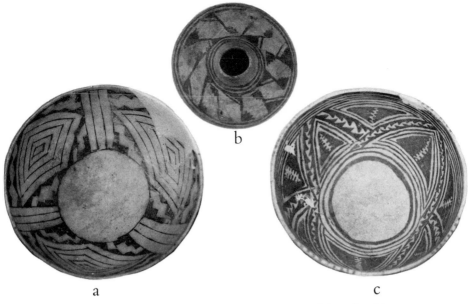

Fig. 2.21. Pottery from the Tsé-ta'a excavation. a. Kana'a Black-on-white (Early Developmental Pueblo). b. Mancos Black-on-white (Late Developmental Pueblo). c. Mesa Verde Black-on-white (Great Pueblo).

The black-on-white decorated ware of this early Pueblo phase continued to show the same simple patterns of the previous period, characterized by thin-line patterns that were often quite asymmetrical. Most of the decoration occurred on the inside surfaces of bowls, allowing the viewer to see the entire design at a glance. On the larger upright vessels, the designs were in the form of bands of decoration around the sides and necks.

This early pottery was produced by coiling. It is curious that Anasazi potters did not develop this technique earlier, as it is very similar to the method by which they had been fashioning baskets since early Basketmaker times. By this procedure, the clay was first purified and tempered, then rolled into long, thin ropes, a quarter of an inch or more in diameter. The initial strip was then coiled on itself in a spiral manner, and, as the sides of the pot began, the coils were laid obliquely, each coil overlapping the previous one. The rims were usually made of a broad strip. The coils were then welded together with the fingers, aided by smoothing tools like sections of gourd, until the surface was smooth and the coils eliminated. The walls could also be thinned during this process.

With the introduction of coiling, pottery became more symmetrical. Smoother finishes were possible through the use of slips — clay in a thick liquid form applied to the surface of the vessel.

This was the usual method of making a piece of pottery, but an entirely new idea in cooking pots was now introduced. This was corrugated ware,

in which a method quite the opposite of smoothing was employed. At first, the potters began to leave the coils forming the necks of the globular cooking vessels unfinished, instead of obliterating the coils by smoothing. This gave a certain decorative effect to the utilitarian vessel that obviously pleased the creators. Later the potters began to leave *all* the coils and modified their appearance by methodically crimping each coil, providing a three-dimensional decoration to the pot. As the walls of the pot rose, each coil was crimped with the thumbnail in close contiguous indenting, giving a very pleasing surface.

a b

Reproduced from Holmes 1886

Fig. 2.22. Corrugated pottery. a. Coiling from the base outward, exactly as in basketry construction. b. Zuni coiled cooking pot.

This crimping became very ingenious and varied. Checks and meanders were added with the thumbnail. Another favorite type was created when the crimping alternated — one coil plain, the next patterned. Many other effects were possible by using tools for patterning.

Excavations show that the pottery of the later part of the Developmental Pueblo period was predominantly of a type common to the region northeast of Canyon de Chelly and characterized by ground shard temper and rather crude geometric patterns. Canyon de Chelly was a peripheral region to the west of the immense Anasazi centers of Chaco Canyon and Mesa Verde. People there never really developed a distinctive local pottery but adopted the pottery styles of their powerful neighbors.

An extremely important new plant was first utilized by the Anasazi during this period — cotton *(Gossypium hopi)*. The knowledge of cotton and loom weaving certainly came from Mexico and probably was first passed on to the Hohokam and thence to the Anasazi by the same people who had brought them red polished ware and cranial deformation. Kilts were now woven of the new material, as well as breech clouts and blankets. Yucca and apocynum were still utilized in the making of sandals, but now round toes were in vogue.

The turkey was widely domesticated, and with surplus corn as feed the birds could be fattened as a major food source. Rock paintings and petroglyphs reached their highest point during the Developmental Pueblo period, and the turkey, particularly the turkey-headed man, occurs with great frequency, demonstrating the great importance of the big bird (Figs. 4.3, 4.4, 4.20, 4.21, and 4.22).

The atlatl finally disappeared completely, supplanted by the superior bow and arrow which allowed kills at greater distances. The trough metate was now the main implement for the grinding of corn.

No very spectacular cave burials from this period have been found in Canyon de Chelly, but the principal grave offerings are pottery. Burials are usually in debris accumulations, where digging was easier than in earth. Some interments are under floors and often, as in the past, in abandoned storage units.

One characteristic of this era is cranial deformation, probably the result of the use of a new type of rigid cradleboard, which flattened the backs of the babies' heads.

Great Pueblo Period, A.D. 1100-1300

During the last half of the eleventh century, some unusual developments began to take place in the Four Corners region. These eventually led to the abandonment of the Anasazi homelands.

For many centuries the Anasazi had led relatively peaceful lives, although there is evidence that as early as Basketmaker times raids from outside nomadic people might have begun. By the eleventh century, pressures from aggressive nonagricultural people may have commenced from the north and east. Gladwin (1957) believes such pressure was coming from the vanguard of Athapaskans — the Apache and Navajo — although others do not think these powerful groups moved down from Canada this early.

Personally, I think that some, if not all, of the northern threat was coming from the Shoshoneans, particularly the warlike Ute migrating from the western Great Basin, who would terrorize the Navajo by the 1700s. Using

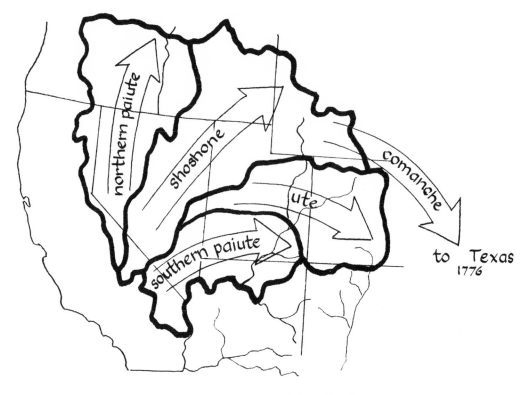

northern paiute

shoshone

ute

comanche

southern paiute

to Texas
1776

Redrawn from Stewart 1966

Fig. 2.23. The Shoshoneans fan out to the north and
east from a heartland centered in southeastern California.

linguistic studies, Lamb (1958) has theorized that about 1000 years ago the
Numic Shoshoneans began to migrate north and east from the extreme south-
western Great Basin until they dominated the entire Great Basin and the
Colorado Plateau. Lamb's postulated timing dovetails nicely with the begin-
ning of the building of large Anasazi pueblos that often look remarkably
like fortresses.

THE ANASAZI IN CHACO CANYON

The people in Chaco Canyon were the first Anasazi to build Great Pueblos,
a dramatic answer to two pressing problems — how to house multitudes of
people and how to protect them against attacks from hostile groups. What
they created in Chaco Canyon, beginning in the tenth century, was a complex
of twelve major pueblos, several of them the most impressive ruins in the
Southwest.

The Chaco Great Pueblos were all built in the open, in contrast to the
Kayenta and Mesa Verde cliff dwellings. The most remarkable is Pueblo Bonito,
built in a D-shape and in effect a sizable town in a single building. The eight

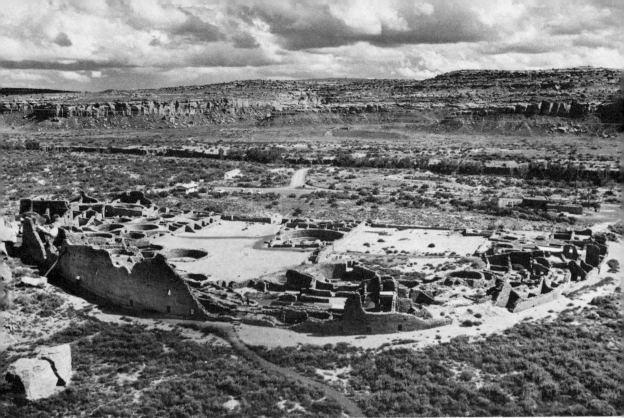

Courtesy Arizona State Museum, photo by Harold S. Gladwin

Fig. 2.24. Pueblo Bonito in Chaco Canyon area.

hundred rooms terrace back from one story facing the large court to four stories in the rear. There are thirty-two kivas, one being a great kiva that measures fifty-two feet in diameter. Another pueblo, Chetro Ketl, has an E-shaped ground plan with five hundred rooms, some of them five stories high.

It is extremely probable that these fortresslike structures were built with defense in mind. At Pueblo Bonito, the gate shows evidence of having first been narrowed and then completely closed, the only entrance then being by ladders which could be withdrawn in case of attack.

Since there is no evidence of assaults on the fortified pueblos, any pressure on the peaceful Chaco corn-growers probably came in the form of hit-and-run raids directed at groups of farmers as they worked their fields. Centuries later, similar tactics would be used by Navajo on horseback as they plundered isolated Spanish ranchos on the Rio Grande.

Chaco masonry was distinctive, with walls of rubble faced on both sides with courses of small flat stones alternated by courses of larger stones. Such walls can be seen in buildings such as White House in Canyon de Chelly. These de Chelly structures are contemporary with the Chaco pueblos, suggesting migration and/or imitation.

Fig. 2.25. Chaco-type masonry at Mummy Cave, site CDM-174.

By about A.D. 1100 the swollen Chaco population had begun to dissipate and migrate out of the region. Various reasons have been given for the disintegration of this complex of vast pueblos. Some believe the destruction of the Ponderosa pine forests was a factor contributing to land erosion and loss of arable soil. It has been estimated that at just one pueblo, Chetro Ketl, over 5000 logs were used for beam material (Anderson & Anderson 1976). Others think that arroyo cutting lowered the bed of the Chaco River so far below the floodplain farmland that it was unavailable for agriculture. In modern times the sporadic water in the river is 30 feet below the canyon floor. Nomad harassment, although troublesome, seems not to have been a major factor in the abandonment.

In any event, a variety of unforeseen developments altered the environment to the point where it would no longer support such a concentration of people. The canyon was all but empty of people by 1130, the year established as the final Chaco building date by Robinson et al. in 1974. Some headed north to Mesa Verde. Others settled on the Animas River near present-day Farmington, where they built the large Aztec pueblo. Despite seemingly ideal conditions, Aztec was abandoned soon after 1120, and the survivors continued north to Mesa Verde.

Fig. 2.26. Mesa Verde style masonry at Cottonwood Flat, site CDM-158.

MESA VERDE POPULATION PROBLEMS

Now it was Mesa Verde that had a population problem. In the eleventh century some cliff pueblos were being built, but the continuing influx of refugees from outlying areas triggered a tremendous building program. Mesa Verde was not only giving refuge to broken remnants of the Chaco branch, but also was harboring large numbers of people coming down from the north and northwest. The southern Utah settlements were all abandoned in the twelfth century, including those of the people of the Fremont Culture — Puebloid farmers and hunters who had created some of the most spectacular rock art in North America. Relentless pressure, probably by the Shoshonean Ute, broke up the small settlements, and the people fled to the canyons in the Kayenta district and Mesa Verde.

In the deep canyons and forested mesas of the Mesa Verde region, there now began a prodigious effort to house and protect the large population. It began to look like the Chaco story all over again, but the physical factors were quite different. Many of these buildings were going to be designed as fortresses first and living quarters second. Timber was no problem — unlike the Chaco area, Mesa Verde had an infinity of timber.

The problem, largely an engineering one, was to put the maximum number of people in apartment complexes on the alcove ledges of otherwise sheer

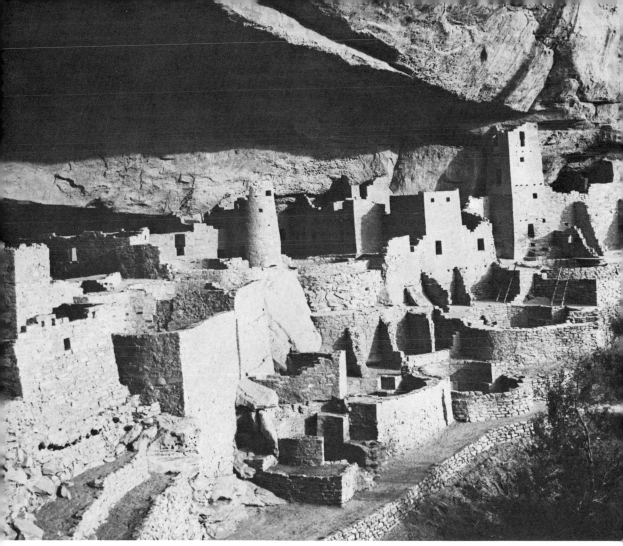

Fig. 2.27. Cliff Palace, the largest ruin at Mesa Verde, has 200 rooms and 23 kivas.

cliffs. How successful the builders were can be seen today. Most of these great ruins are still remarkably undamaged. One of the best preserved of the cliff dwellings is Spruce Tree House of over one hundred rooms and eight kivas, which once housed an estimated population of about two hundred. The Mesa Verde builders were also skilled masons, and their walls were constructed with large stones of a more uniform size than those used at Chaco. The walls were solid masonry with no rubble fill, and many of the stones were shaped by mauls. Rooms in the Mesa Verde pueblos were small and really only constituted sleeping quarters, with most activities being carried out in the open courts and on the house roofs.

Agricultural fields were on the mesa tops, and most of the cliff dwellings were approached from the canyon rims. Access to the pueblos themselves

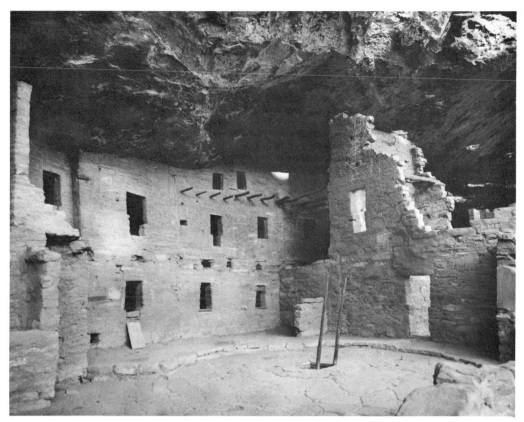

Courtesy Arizona State Museum, photo by Helga Teiwes

Fig. 2.28. Part of Spruce House at Mesa Verde. The T-shaped openings
are characteristic of the Mesa Verde buildings and also occur in Canyon
de Chelly. In foreground is a roofed kiva with entrance ladder.

was by a ladder or a series of ladders, and at some, as a further deterrent against
attack, the final entrance was by a narrow tunnel. Ladders could be removed
and such a passage blocked. The fatal flaw in this system was that the people
could not live for long in the well-protected cliff houses. They constantly
had to come out onto the mesas to tend their fields and to go down into the
canyons to obtain water. There they were vulnerable to attack.

Mesa Verde reached its peak by the late twelfth and early thirteenth cen-
turies and had at that time the largest population in the Southwest. To the
east, settlements were developing on the upper Rio Grande, and as early as
A.D. 800 they were taking in refugees from the Durango area. In the twelfth
and thirteenth centuries the Rio Grande pueblos would receive substantial
population increments from Mesa Verde and, in effect, become an offshoot
of the Mesa Verde branch.

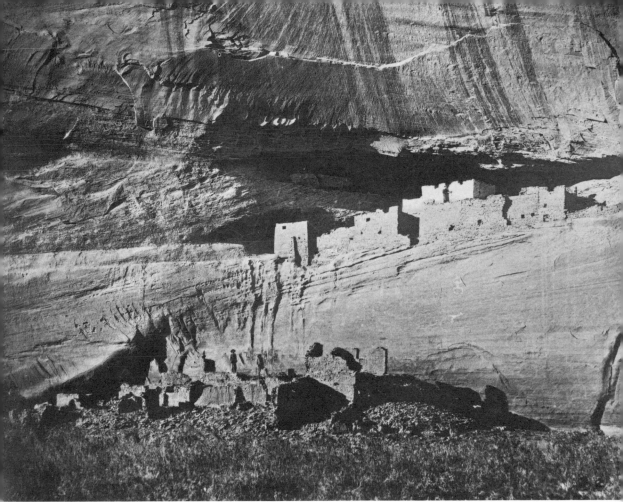

Fig. 2.29. First photograph of White House ruin, site CDC-75. It was taken by Timothy H. O'Sullivan in the mid-1870s, long before the Park Service planted the cottonwoods which grew up to hide most of the lower ruin. For another view of White House, see Fig. 2.34.

The Kayenta district, with its major concentrations of people in the Marsh Pass area and Canyon de Chelly, was also being affected by the mass movements of people. Protected as they were by natural barriers (Grand Canyon to the northwest and the Chuskas to the east), the Kayenta people were late in being affected by the pressures that had destroyed Chaco and now threatened Mesa Verde. No important Great Pueblo cliff dwellings date before the thirteenth century in the Kayenta district, although there was some building dated from the beginning of the period. At the lower ruin at White House in Canyon de Chelly, the tree-ring dates begin about 1050.

But not all newcomers were settling in the Marsh Pass region or in Canyon de Chelly. Some were drifting south to the growing settlements at Antelope Mesa, which in time would develop into the Hopi villages. Others were moving west to Wupatki.

At about 1250, the whole northern frontier began to disintegrate. Great numbers of people were pulling out of Mesa Verde and heading for the Rio Grande pueblos. Others were moving into Canyon de Chelly and to the west into Marsh Pass. Aztec, abandoned in about 1120 by the Chaco migrants, was temporarily reoccupied by the Mesa Verde people in 1225 on their flight to the Rio Grande. A few years later it was given up for the last time. The final tree-ring date from the Mesa Verde canyons is 1278 (Balcony House, Robinson & Harrill 1974). Presumably by the close of the century, the last inhabitants of the great pueblos there had vanished, and the Mesa Verde branch of the Anasazi had come to an end.

COMINGS AND GOINGS IN CANYON DE CHELLY

The 1270s and 1280s were years of growth in the Kayenta district. In the Marsh Pass region several very large cliff dwellings were built or greatly enlarged — Betatakin, with at least 135 rooms and one rectangular kiva; Twin Caves, with 60 rooms; Inscription House, with 50 chambers; and Kiet Siel, the largest cliff dwelling in Arizona, with 150 rooms and 5 kivas. Much of the latter ruin was constructed using the jacal, or wattle-and-daub, technique. The last tree-ring date in this region is A.D. 1286, recorded at Betatakin and Kiet Siel (Bannister et al. 1968).

In Canyon de Chelly, sometime around 1284, the same time as Mesa Verde was being abandoned, a three-story tower was erected at Mummy Cave (Figs. 1.2, 2.33, and 3.4). The tower masonry exhibits a strong Mesa Verde influence, and the site yielded a high percentage of Mesa Verde ceramics. The rooms are built in a previously unoccupied portion of the site, making it look like the builders could have considered themselves distinct from the other inhabitants of the pueblo. A number of bodies showing evidence of violent death were found within the tower, possibly the result of a clash between a group of the enemy people and the canyon Anasazi, who were about to abandon the region.

De Harport (1950) recorded sixty-seven masonry sites from the Great Pueblo period in the main canyon. He estimated the peak population of this canyon at more than 800.

Besides the defensive location of many of the sites (some are as high as 700 feet above the canyon floor), De Harport observed what could have been defensive walls pierced with loopholes guarding the approaches to several sites. One such location was noted in our rock art survey in Slim Canyon, just north of Canyon de Chelly.

Most of the multistory buildings of the final period in the canyon have collapsed through faulty foundations, but plastered squares high on the cliffs

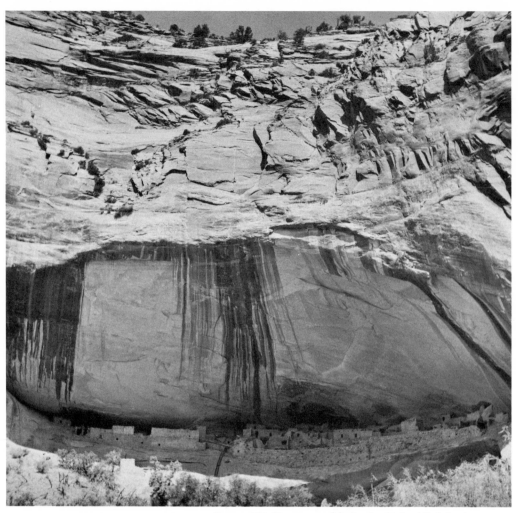

Fig. 2.30. Kiet Siel Ruin, Navajo National Monument. This Kayenta pueblo is the largest Anasazi ruin in Arizona. Notice the streaks of dark patina on the cliff.

are evidence of rooms three and four stories above the ground (Fig. A.6). The Kayenta masonry was definitely inferior to that of Chaco or Mesa Verde, with irregularly shaped stones held together with quantities of adobe.

The excavations at Tsé-ta'a (Steen 1966) revealed a sizable Great Pueblo dwelling somewhat difficult to assess, since so much of it had been destroyed by the collapsing of upper stories and by flood action. Of the remaining features, there are perhaps fifteen floor-level rooms, some store rooms, and five kivas. Plastered room-sized areas near rock paintings high on the cliff show that there were two, three, and four stories. The masonry is mainly in the styles of Chaco and Mesa Verde. The kivas are without pilasters. As the initial

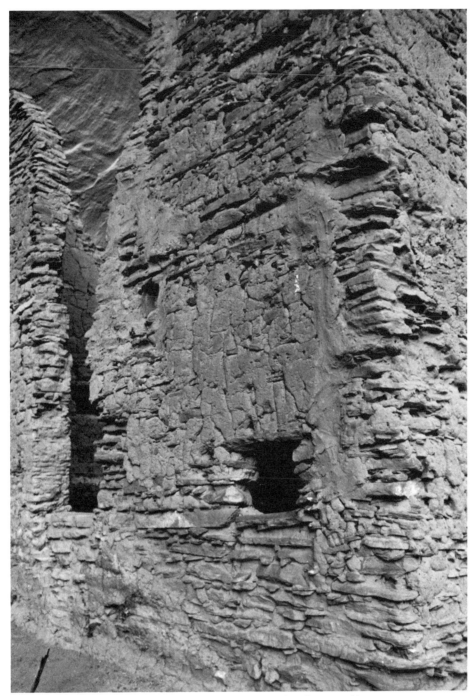

Photo by Wes Holden

Fig. 2.31. Kayenta-style masonry at Antelope House
features a combination of adobe and odd-sized stones.

Photo by John Cawley

Fig. 2.32. This loophole in an adobe and masonry
wall in Slim Canyon suggests a defensive position.

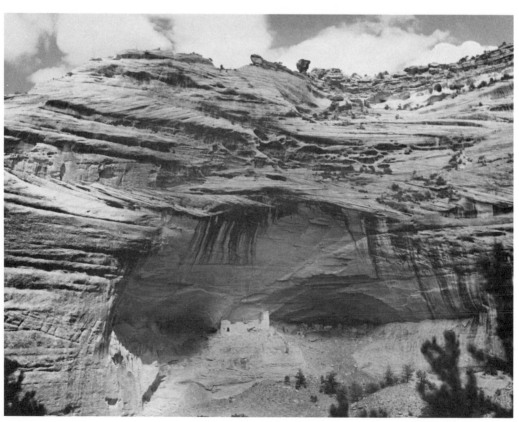

Photo by Harold Gladwin

Fig. 2.33. Mummy Cave. This photo clearly shows the right and left alcoves.
For additional views, see Frontispiece & Fig. 1.2. For tower masonry, see Fig. 3.4.

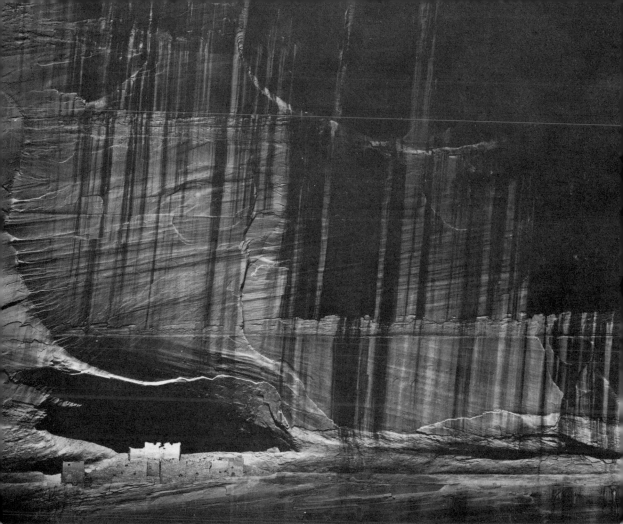

Fig. 2.34. White House ruin, site CDC-75. Note the immense streaks of brown-black patina deposited by ephemeral waterfalls and seeps during the summer thunder shower season. For another view of White House, see Fig. 2.29.

Chaco influence dates from around 1050 and Steen's postulated Mesa Verde migration is set at about 1250, the occupation of this Great Pueblo site can be roughly estimated. There were a number of burials at Tsé-ta'a — one being a young man apparently killed by a blow on the head with a stone axe.

Most of the beams in the tower at Mummy Cave date at A.D. 1284, and this is the final building date from Canyon de Chelly. Since the final dates from Marsh Pass also fall in the 1280s, it is clear that by this time the end was near. The final migrations of the San Juan Anasazi now reached a climax, and by A.D. 1300 the last of the three Anasazi branches of the Great Pueblo period had ceased to exist. The evidence of pottery types suggests that the Kayenta people mainly moved south onto the Antelope Mesa, where they triggered a major era of pueblo-building. Three very large pueblos date from

the time of this norther influx — Kikopnyama (late 1200s to late 1300s), Kawaikuh (mid-1300s to mid-1400s), and Awatovi (1300 to 1700) (Bannister et al. 1967).

EXPLANATIONS OF PUEBLO ABANDONMENT

On the basis of tree-ring evidence, some Southwest investigators think that the major reason for the abandonment of Mesa Verde and the Kayenta district was a great drought. This drought was supposed to have occurred between 1276 and 1299. However, Gladwin (1950) points out that corn-growing was mainly dependent on summer thunder showers, which have little or no effect on tree-ring growth. He also powerfully argues that the exodus from the Mesa Verde and Kayenta regions had begun long before 1276 and that drought would hardly induce people to abandon the well-watered northern plateau for the considerably drier Antelope Mesa country.

My guess continues to be that the Anasazi population shifts were caused by unendurable harassment by warlike hunter-foragers — Shoshoneans and/ or Athapaskans. Many insist that the Athapaskan Navajo and Apache were not in the Southwest at this early time, as there are no tree-ring dates to support their presence. However, the flimsy shelters built by the Athapaskans were not particularly enduring; the mid-sixteenth century is the earliest such date for a Navajo forked-stick hogan timber, taken from the Gobernador drainage of the upper San Juan.

Yet another enduring hypothesis to account for the pueblo abandonments of the twelfth and thirteenth centuries is the arroyo-cutting theory advanced by geologist Kirk Bryan. It goes like this: before the start of arroyo-cutting, most Southwest streams flowed in shallow beds lined with trees and shrubs. During high water, the streams would overflow their banks, depositing new soil as the water abated. The Indians would farm this floodwater land.

With the onset of arroyo-cutting, the water table was lowered, and the streams cut deep channels, ceasing to overflow their banks. Hence the streamside vegetation died (Bryan 1925:3338-3344). Such a development made floodwater-farming impossible, as the arroyo crops were washed out.

Bryan has suggested that slight climatic changes can cause alternating cycles of erosion and sedimentation in streambeds, with heavy runoff causing cutting, and light runoff triggering deposition of sediments. Thus, according to Bryan, the Anasazi abandoned their country during the twelfth and thirteenth centuries because of the destruction of their farmlands through arroyo-cutting.

Jett (1964:289-290) took issue with this theory, noting that in Canyon de Chelly and Canyon del Muerto contemporary arroyo-cutting has had little

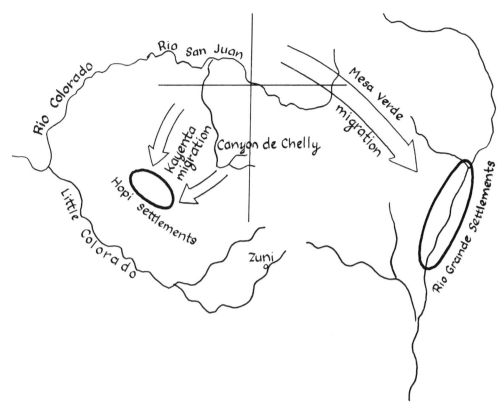

Fig. 2.35. The Anasazi abandon their cliff dwellings
in the Four Corners region to flee south and east.

effect on the extensive farmlands in the lower canyons and that there is no
evidence that any disastrous arroyo-cutting took place in the thirteenth cen-
tury. He further pointed out that the Mesa Verde would scarcely have been
affected, as most of the agriculture in that country was dry farming on the
mesa tops. A further argument can be advanced based on the fact that the
Hopis did reoccupy and farm the rich Canyon de Chelly bottomlands pre-
sumably after predatory nomads no longer constituted a threat.

GREAT PUEBLO ARTIFACTS AND CULTURE

Spectacular architecture was the most notable achievement of the Great
Pueblo period — a dramatic example of what so-called primitive man can
accomplish under pressure. In other fields, the Great Pueblo period produced
little that was new. However, the pottery of the three main branches of the
Anasazi — Chaco, Mesa Verde, and Kayenta — attained high levels of excel-
lence and strong regional differences that make them easy to identify with
their respective origins.

In Chaco Canyon, the typical ware was black-on-white, thin-walled and decorated with bold, angular patterns filled in with closely spaced hatching. An unusual type of pottery was the effigy jar, incorporating human figures.

The Mesa Verde ware was black-on-white, often polished with a smoothing stone before firing. Patterns were geometric, with stepped designs, frets, parallel lines, and the like. Distinctive types were flat-bottomed mugs and lidded globular jars. All wares tended to be rather thick-walled.

In the Kayenta district, the ware was black-on-white and thin-walled, with elaborate geometric designs covering most of the surface. In addition there was some black-on-orange and polychrome black, red, and white on yellow or orange. This pottery found in the early Hopi settlements at Antelope Mesa clearly traces the route taken by the migrating Kayenta people.

It is a curious thing that in the Basketmaker and Modified Basketmaker periods in the Kayenta district, where the estimated populations were small, we have such a wealth of perishable material preserved in the abundant burials. In contrast, during the Developmental Pueblo period and especially in the Great Pueblo period, burials of any kind are remarkably scarce everywhere on the plateau. Some burials have turned up in refuse heaps, under floors, and packed into cliff crevices. A few burials rich in grave goods have turned up. But where are the cemeteries that one would expect during this high-population era? There are a few isolated examples of cremation, but this was never the usual method of disposing of the dead.

Still, enough artifact material has been recovered to give a general picture of Developmental and Great Pueblo culture. Turkeys were kept in pens in all areas for feathers and for food. Parrots brought up from the south were also kept for their brilliant plumage. Feather-string blankets by now had largely supplanted fur-string blankets, and some basketry continued to be made. Cotton-weaving improved in quality, and some large pieces indicate that an upright loom was used. Some cotton-weaving had designs in colored yarn, while other pieces showed painted patterns.

Sandals deteriorated greatly from their high point during Modified Basketmaker times and were now coarsely woven of yucca leaves and without decoration. Twilled mats of rushes were used for roof and floor coverings. Ornaments became elaborate, and much use was made of turquoise. In Chaco Canyon fine stone pendants representing birds and animals were created. Smoking pipes continued to be made of stone, but many examples of pottery pipes are known.

Rock art in Canyon de Chelly declined markedly in quality (Figs. 4.43-4.56, A.2, A.5, and A.6). At three of the major Great Pueblo ruins — White House, Mummy Cave, and Antelope House — there are very few Anasazi

Reproduced from Guernsey 1931

Fig. 2.36. Great Pueblo mosaic of turquoise and other stones on a flint blade found in Poncho House in the Chinle Valley.

rock paintings. Part of this lessening interest in rock art during the late thirteenth century might be attributed to the fact that the canyon people were too busy worrying about survival. Another reason may have been the increased importance of the kiva as the ceremonial center and the proper place for paintings. A number of kivas in Canyon del Muerto have Mesa Verde-type geometric patterns on the walls and benches (Figs. 4.50 and 4.51). Later, long after the abandonment of the northern plateau, kivas would be elaborately painted with murals featuring humans, birds, and animals — fine early examples are from the Hopi pueblo of Awatovi and the Rio Grande pueblo of Kuaua.

By the mid-fourteenth century, the remnants of the northern plateau Anasazi had regrouped in the three regions where their descendants are found today — the Hopi pueblos southwest of Canyon de Chelly, the Zuni area of western New Mexico, and the banks of the Rio Grande in north central New Mexico.

Period of Sporadic Occupation, A.D. 1300-1750

Following the exodus of the Anasazi from Canyon de Chelly, over 400 years would elapse before the final permanent occupation of the canyon by the Navajo. In the interim, various people came and went, for the canyon was a thoroughfare between the Black Mesa area and the Chuskas, with well-watered camp spots and ample shelter in the abandoned cliff dwellings. These visitors were mainly nomadic hunters and foragers, who doubtless included some of the descendants of the very Indians who may have brought about the depopulation of the canyon.

The only sign of the passing of these transients may be some of the petro-glyphs on the bases of the cliffs, especially pictures of bighorn sheep and deer (Fig. 4.42). Deer were found in the mesa top forests, but the bighorn were concentrated in the Grand Canyon region, an area well known to the northern Shoshoneans.

HOPI FARMERS

Although other small groups of wandering agricultural people certainly used Canyon de Chelly occasionally during this transitional period, our major ethnological and archaeological evidence points to sporadic Hopi occupation. The principal physical evidence of their passing is their pot shards, which are found throughout the canyons. The wide but scanty distribution of these shards suggests a small population. During dry years, little groups of Hopi probably left their pueblos for a season or two to raise their crops under the ideal growing conditions that have always made the canyon attractive to farming people. Steen (1966:55-57) found Hopi shards at Tsé-ta'a dating from 1300 to the nineteenth century, with most from 1300 to 1700.

Part of the story of Hopi occupation of the canyon has been pieced together from Hopi informants (V. Mindeleff 1891). This account well illustrates the incessant moving about of the pueblo people, although the events are interpretive and cannot be viewed as literal history.

Four Hopi clans claim that their ancestors spent some time in Canyon de Chelly. These are the Snake, the Horn, the Bear, and the Asa. Only in the case of the Asa do we have considerable information. The Asa group is divided into the following eight clans: Black Earth Kachina, Tansy Mustard, Oak, Chapparal Cock, Magpie, Snow Bunting, Boomerang Hunting Stick, and Field Mouse.

In the early days, these Tanoan-speaking people lived near Abiquiu on the Rio Grande. At some time in the late seventeenth century, probably as a result of the Pueblo Revolt of 1680, they abandoned their homes and moved west. Before they reached the Hopi settlement of Awatovi, they stayed briefly at Santo Domingo, Laguna, Acoma, and Zuni, with some families remaining permanently at each pueblo but Acoma.

Three of the Asa clans — Magpie, Boomerang Hunting Stick, and Field Mouse — decided to stay at Awatovi with the Badger clan, which had also migrated from the Rio Grande. This turned out to be an unhappy choice — in all likelihood, they died in the senseless destruction of Awatovi in 1700 by the other Hopi pueblos. The rest of the Asa group was given farmland and a building site by the Walpi people. This was in gratitude for Asa help in repelling Ute and Navajo raids.

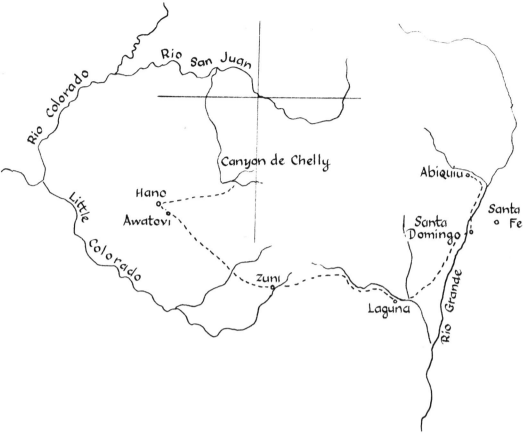

Fig. 2.37. Migration of the Tanoan Asa clan from near Abiquiu to the Hopi mesas and into Canyon de Chelly, following the Pueblo Revolt of 1680.

Soon after their first houses were built, a succession of drought years forced many Hopis to leave their homes and seek water. The Asa people moved to Canyon de Chelly, where they were well received by some Navajo living in and around the canyon. Here the Asa lived for two or three generations. It was they who planted the first peach orchards in the canyons, trees that still bear fruit. During their stay, many Asa women were given to the Navajo, and today their descendants are known as the "High-House People."

Eventually the Asa and the Navajo quarreled, and the Asa people withdrew to Walpi. During their absence their old pueblo home site, now called Hano, had been occupied and enlarged by another Rio Grande Tanoan group, who had migrated from the vicinity of the Galisteo Basin, south of Santa Fe. This migration was also triggered by the Pueblo Revolts of 1680-96, together with unbearable pressure from the Shoshonean Comanches, who raided them from the plains to the east.

Evidence to support this story came in 1904 when fragments of Kachina masks and other ceremonial paraphernalia of the Asa were found in Bee Hive

a b

Fig. 2.38. These stepped cloud and masklike designs were painted on the rocks by the
Hopi (1300 - 1750) or the Navajo, who closely copied many Anasazi symbols. a. Site
CDM-7, painted in white, gray, and black. b. Site CDC-121, painted in brown and white.

Ruin in Canyon de Chelly. In addition, at three of the canyon rock art sites
there are paintings that strongly suggest Hopi origin. All show stepped cloud
designs and have a masklike appearance. There is the possibility, of course,
that these pictures are Navajo, since these Indians borrowed freely of Hopi
ceremonial patterns in the creation of their sand paintings and used the step-
ped symbol for clouds. The design illustrated from Painted Room Ruin (site
CDC-121) is one of a line of five such motifs.

It is probable that the falling out between the Asa and the Navajo coin-
cided with the major movement of Navajo into the canyon region after 1750.
The same Ute who may have brought about the exodus of the Anasazi from
the northern plateau centuries earlier now had forced the Navajo to abandon
their old heartland, Dinétah in the Gobernador and Largo drainages of the
San Juan. Navajo have said that when their ancestors came into the canyon
they drove out various Hopi who were living there.

Another traditional story of the Hopi concerns a group of refugees of
the Rio Grande, Tano, Tewa, and Tigua linguistic groups, who fled west-
ward after the revolt to found the pueblo of Payupki near Mishongnovi.
They spent some time in Canyon de Chelly, but it is unclear whether it was
en route to the Hopi area or after the founding of Payupki. At any rate, Steen
(1966) found many shards of Payupki pottery at Tsé-ta'a and a child burial
with a Payupki bowl offering. One corncrib at this ruin appears to be of Hopi
construction, although in general it seems the Asa and Payupki people did
no permanent building but lived in the better preserved ruins. A girl killed
at Tsé-ta'a when the wall collapsed in the abandoned kiva was probably Hopi.

It is interesting to note that the only two authenticated Hopi sojourns
in Canyon de Chelly were by people who were not really Hopis at all, but
Tanoan-speaking Indians from the Rio Grande. The Asa, of course, remained
in Hopi-land and were absorbed, but Payupki was abandoned. Its people

returned to Sandia on the Rio Grande in 1746. A few years later Canyon de Chelly was permanently taken over by the Navajo.

Period of Navajo Migration, c. A.D. 1000-1539

The Navajo are members of the Athapaskan language family. They are Mongoloids who probably began arriving in the New World some time shortly before the time of Christ, give or take a few centuries, driven from their forested homeland in northeastern Asia by larger or more aggressive tribes. They settled in the woodland country of what is now Alaska and northwestern Canada, and here they are found today, embodied in such tribes as the Chipewyan, Yellow Knife, and Carrier.

Several groups later broke away from the main Athapaskan region and went further south. One offshoot that does not really concern our story settled in the coastal forests of southwestern Oregon and northwestern California. Two tribes involved in this migration were the Hupa of California and the Umpqua of Oregon.

Sometime after A.D. 1000, other bands of Athapaskans began to drift south, probably along the Great Plains side of the Rockies. These people were aggressive nomadic hunters and brought with them little besides the sinew-backed Mongolian bow and the moccasin. The migrations involved two closely related groups which in historic times came to be known as the Apache and the Navajo.

The ancestors of the Navajo began settling in Gobernador and Largo canyons, headwaters of the San Juan River in New Mexico. To the Navajo, this first homeland in the Southwest became known as *Dinétah,* and it has continued to occupy a special place in their history and mythology.

James Hester (1962) has estimated the original migrants into northwestern New Mexico at less than 1,000. There are some tree-ring dates from forked stick hogans in the 1400s and 1500s (Robinson et al. 1974) that are a clue to the earliest settlement of the Navajo, though the first sure cutting dates are in the late 1600s (Bryant Bannister, personal communication, 1971).

The Athapaskans, having only a simple hunting and gathering culture, were amazingly proficient at adopting the cultural patterns of their neighbors, and the Navajo were to prove no exception to this rule. The northern migrants saw some incredible sights in the upper Rio Grande drainage: great multistory masonry pueblos like the one at Taos and the big pueblo of Tyuonyi in Frijoles Canyon with over 400 rooms; men and women wearing woven cotton garments, sandals, and turquoise jewelry; elaborate ceremonies featuring costumes and fantastic masks. Above all, the Navajo were impressed

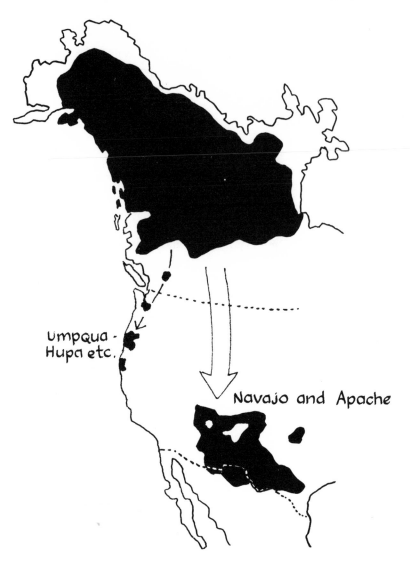

Umpqua -
Hupa etc.

Navajo and Apache

Redrawn from Sapir 1929

Fig. 2.39. Some Athapaskans move south.

by the Pueblo control of the food problem by systematic agriculture. They were especially interested in corn, that wonderful crop that could be harvested and stored for use in all seasons. To the wandering Navajo, whose hunting and food-gathering often led to feast-or-famine cycles, this was the answer. Here they would settle and put down roots.

The first decades of the Navajo/Pueblo relationship must have been uneasy. The newcomers were doubtless greatly outnumbered by the peaceful Tanoan and Keresan farmers living along the Rio Grande and on the mesas to the west and east. In the first stages of the Navajo occupation, there was

Reproduced from Morgan 1881

Fig. 2.40. Taos Pueblo around 1875.

little or no contact with the Shoshonean Hopi on the mesas west of Jeddito Wash, but this would come.

The Navajo settled into the rhythms of their new land, learning the planting of corn and beans, the growth cycle, and the harvest. The Pueblo people, however, must have looked with some apprehension at these lean and hungry newcomers with their buckskin clothing, moccasins, sinew-backed bows, and buffalo-hide shields. There is no doubt that the Navajo and their kinsmen, the Apache, along with the Shoshonean Ute, attacked the smaller pueblos and the nearby cornfields, stealing women and food. Even the larger pueblos took special measures against surprise attack. At Tyuonyi there was only one entrance into the central plaza, and this narrow passageway was further obstructed with posts set in a zigzag pattern. In addition, the typical pueblo room of this period was entered through a hole in the roof. Ladders affording access could be withdrawn in time of danger.

As the years passed, the old patterns of the Southwest remained unchanged. Man lived in harmony with nature and, more or less so, with his neighbors. Then suddenly all was changed.

Spanish Period, 1539-1821

The year 1492 was a bad one for the first Americans. This was the time when Columbus blundered into the New World on his way to India, and, through his lifelong refusal to admit he hadn't hit his goal on the first try, the Navajo and the Pueblo and all other native Americans became known as Indians. In 1519, Cortés sailed from Cuba to Mexico and his conquest of the Aztec empire. Twenty-two years later, with the gigantic spoils of Mexico only partly digested, greed and religious zeal brought the Spanish into the heart of the Pueblo country, seeking another El Dorado.

FIRST SPANISH EXPEDITIONS

In 1539 a Franciscan missionary named Fray Marcos, who had reached the edge of the Zuni pueblos, brought back the fantastic report that these settlements were larger and finer than those in Mexico. After the conquest of Mexico and Peru, with their vast treasures of gold, the Spanish were only too ready to believe any such story. An elaborate expedition at royal expense was sent to exploit the "seven golden cities of Cibola" that Fray Marcos had evolved from the simple Zuni villages.

In 1540 Francisco Vasquez Coronado led this expedition into the Pueblo country and soon discovered the truth. There were many Indian towns but no gold; Fray Marcos had to depart hastily to Mexico to escape the wrath of the disappointed soldiers. The expedition, however, turned into one of the great explorations of the New World, since Coronado took his adventurers as far as the plains of Kansas before giving up. The Spanish subdued the Zuni Pueblos and wintered in several of the Rio Grande Tigua pueblos, turning out the owners, who in reprisal stole some Spanish stock. In the subsequent fighting, nearly a hundred captives from one pueblo were burned at the stake as an example to all who resisted the Spanish crown. The Apache, Navajo, and Pueblo had had a good look at the Spanish and were doubtless relieved to see these powerful and ruthless people return to Mexico.

For many years the Spanish abandoned the northern provinces, but by 1580 a new line of approach to the pueblo country was opening up. Miners and missionaries had been pushing farther and farther into northwestern Mexico, and slave-hunting for laborers in the mines had taken the Spanish as far as the Rio Grande. This slave traffic to supply Indians for the peonage system was later to cause great trouble between the Navajo and the Spanish.

In the next several years, three missionaries reached the pueblos and were killed by their intended converts. Coronado had treated the Pueblo people harshly, and the Indians now wanted no part of the new religion and what

went with it. In 1582 Antonio de Espejo led an attempted rescue party and clashed with Apache and Navajo near Mount Taylor. This was the first recorded belligerent act between the Spanish and the Athapaskans, a hostility that would grow for nearly three hundred years and continues to be evident.

SETTLEMENTS AND BATTLES

In 1595 the king of Spain ordered the colonization of New Mexico, and three years later Juan de Oñate, the first governor, led his colonists with their horses, cattle, and sheep by way of El Paso to the Rio Grande. He founded the first settlement at San Juan between Santa Fe and Taos and sent the friars soul-hunting to the pueblos.

The Pueblo Indians did not greet the Spanish with any great enthusiasm, and in a dispute over requisitioned supplies, the Acomans killed twelve of Oñate's men. In an over-kill reprisal, the governor destroyed the village and more than half of the inhabitants. Many of the male survivors had a foot cut off, and the young women and children became slaves.

The settlers began to establish their ranchos in the sagebrush and juniper country along the Rio Grande, and almost immediately there was armed friction between the Spanish and the Apache.

At first all the Athapaskans were known as Apache after the Zuni word for "enemy" — *apachu.* The first reference to the name *Navajo* occurs in a 1626 document written by Father Zaraté Salmeron, wherein he calls these Indians *"Apaches de Nabaxu." Nabaxu* was taken from a Tanoan name for a place on the Rio Grande. All the Athapaskans called themselves *Diné,* that is, the People. In this discussion, *Diné* will refer only to the Navajo.

A Spanish record reveals that as early as 1608 Apaches were killing settlers and stealing horses. The Athapaskans were thus the first Indians north of Mexico to become horsemen, and the impact of this on their way of life was to be major. The acquisition of the horse gave the Indians great mobility, enabling them to make swift raids on the Spanish settlements.

From the beginning of Spanish domination in the Southwest, the Pueblo Indians were considered a minor problem — they were relatively docile and, as they all lived in villages, the authorities could keep an eye on them. The seminomadic Apache and Navajo were an entirely different matter. Living in small family groups in rancherías, dispersed over a wide area, they were difficult to control. Efforts made by the Spanish missionaries to induce them to live in settlements were complete failures.

The Spanish made repeated attempts to convert the Navajo during the seventeenth century. On one hand, they offered the Indians baptism and Christian redemption — on the other they condoned slaving expeditions against

the Navajo to obtain captives, especially women and children, to be sold in the settlements as menials.

The Navajo would not accept such hypocritical Christianity, but the padres had considerable success at first with the Pueblo Indians. By 1670, eleven churches had been built adjacent to the pueblos and 14,000 Indians had been baptized. This was soon after expanded to twenty-five missions serving most of the pueblos. However, each Christianized Indian was required to pay an annual tribute to Santa Fe, and this was greatly resented. In addition, the pueblos were constantly levied for manpower to work for the settlers.

The herds of Spanish horses and cattle and the vast flocks of sheep were a constant temptation to the Navajo, and great numbers of animals were stolen from the outlying ranches in reprisal for the slave-raiding. These attacks mainly originated in the upper Largo drainage of the San Juan and fell chiefly on the northern Rio Grande settlements between Taos and Santa Fe. The pattern of raids and counter-raids that started in the seventeenth century was to become increasingly savage on both sides, sowing the seeds for the bitter Navajo wars of the future.

During this period, the Navajo way of life began to change. From farmers these Indians were developing into herdsmen, creating an economy that has endured to modern times. It is easy to see the irresistible temptation the Spanish livestock offered the aggressive younger Navajo who, in a single raid, could become rich men. A Navajo's status was mainly determined by his wealth in animals, particularly horses. If a rancher resisted, he was often killed, and in time the Navajo raiders began to take Mexican women and children captives.

As the Athapaskan raids continued, there were repeated Spanish expeditions against the Indians. Ill-led and mainly ragged local militia, these posses accomplished little but always managed to bring back a few more Navajo women and children to sell into peonage.

By 1680, the Spanish population of New Mexico had grown to about 2,500, concentrated along the Rio Grande River between Isleta and Taos. It has been estimated that the Navajo population at that time was roughly the same, concentrated in the Dinétah region with a few groups near the Hopi and Zuni pueblos to the west. Doubtless the Navajo at this time knew about Canyon de Chelly, but there is no evidence that they were living in the canyon.

The Pueblo Indians had been growing increasingly restless under the heavy-handed Spanish domination, with its tribute, enforced labor, and suppression of their ancient religion. On August 9, 1680, under the leadership of Popé, a medicine man of San Juan, the Pueblo in unison attacked the Spanish. Churches, ranchos, and towns were destroyed, 400 Spaniards were

Fig. 2.41. Navajo petroglyph in Largo Canyon, northwestern New Mexico. The horned figure is the hunchbacked god *Ghána'iskidi,* who also occurs in the sand paintings. The seeds of all vegetation are carried in his hump. For additional rock art/sand painting correlations, see Figs. 4.82 & A.3.

killed, including 21 missionaries, and the remaining 2,200 people were driven from the Pueblo region and south to El Paso. This well-planned revolt, which was aided by the Navajo, was to have a profound effect on them.

During the next ten years repeated efforts were undertaken by the Spanish to reconquer the region, and in one campaign 600 Pueblo Indians were killed at Zia. In 1692, the newly appointed Governor Vargas began the reconquest of the Pueblo Indians. In the first stages the operation was peaceful, and submission was accomplished without bloodshed. The following year, however, when the soldiers and settlers began to reoccupy the region, rebellion broke out again, and there were bloody battles at Santa Fe, San Ildefonso, Jemez, and Taos. By 1695 peace was restored only to be followed by another revolt in which five priests and twenty-one settlers were killed. After each flareup of hostilities, more Pueblo fled to join the Navajo, who were active in any attempt to rid the country of the hated Spanish. The reconquest was at last completed in 1698, but the Spanish had stirred up a hornets' nest that would plague them for many years.

Through this troubled period, great numbers of the rebellious Pueblo people, seeking to escape Spanish vengeance, fled to Dinétah, where they lived with the Navajo in the Largo and Gobernador drainages. In this refuge area the two groups lived together peacefully, and it was at this time the Navajo acquired many of the advanced Pueblo cultural traits which they later developed along specialized lines. The Diné adopted a number of the Pueblo religious concepts and paraphernalia, particularly the idea of masked

ceremonial gods. The Kachina of the Pueblo became the Navajo Ye'i. The Navajo also acquired the techniques of sand-painting, rock-painting, and weaving, in time surpassing their teachers in these fields.

Some of the Pueblo refugees lived with the Navajo for many years after peace had returned to the country and intermarried extensively with the Diné. The mixture of blood can be seen on the modern-day Navajo reservation, a blend of the basically shorter, stouter Pueblo with the taller and more slender Navajo.

For a few years after the Spanish reoccupation of their Rio Grande settlements, there was peace as the settlers and Indians warily watched one another. The Spanish had been given a sobering lesson by the ferocity of the Indian resistance, while the Indians, particularly the Navajo, had discovered just how vulnerable the loosely knit Spanish settlements were to surprise attack. In addition, the settlers were understandably slow in returning to this dangerous frontier, and the weakness of the settlements was a temptation to the Navajo raiders.

The determined Franciscans again began seeking converts among the Pueblo, and in 1700 a padre visited the big Hopi village of Awatovi and baptized seventy-three Indians. This renewed effort of the Spanish churchmen to wipe out the old religion caused great resentment in the other Hopi villages. Delegations were sent to Santa Fe asking for religious toleration, but their requests were summarily denied.

The hatred of the Hopi perversely turned not against the Spanish but against the heretic converts at Awatovi. In November, large bands of men from all the other villages made a night attack on Awatovi, where most of the townsmen were assembled in the kivas. Trapped below ground, they were killed by bows-and-arrows or burned to death. Most of the remaining men, women, and children were killed and the pueblo was destroyed. The few surviving women were divided among the other pueblos. In one brutal, senseless act, a village of perhaps 800 people had ceased to exist. According to Navajo clan tradition, some survivors of the Awatovi massacre joined the Navajo, and a number ultimately settled in Canyon de Chelly.

In 1702 the Navajo resumed raiding. The pattern of raids and punitive expeditions against these Indians reached a peak of violence in 1716, when Cristóbal la Serna led an expedition against the raiders. No details are known regarding this campaign, but it must have been costly for the Navajo, as they sued for peace. Actually, both sides were exhausted from the years of violence and welcomed a period of recovery.

The 1740s were characterized by drought, and some Navajo began to drift south to the Cebolleta Mountains and the Mount Taylor region. The

Fig. 2.42. Fragment of Awatovi kiva mural.

Franciscans began to make a little headway with these Diné, establishing missions at Cebolleta and Encinal and baptizing several hundred converts. However, the Navajo never really submitted to the discipline of mission life; after two years the missionaries were driven out and the missions abandoned.

Despite the end of their brief flirtation with Christianity, these Mount Taylor-Cebolleta area Navajo remained friendly with the Spanish. As a result they came to be called "Enemy Navajo" or "Aliens." Their way of life was chiefly agricultural, while their kinsmen to the north were becoming sheep-raisers. During the early nineteenth century these Enemy Navajo were employed as guides and scouts against the raiding Navajo.

NAVAJO OCCUPATION OF CANYON DE CHELLY

During the first half of the eighteenth century, some Ute bands and their aggressive Shoshonean kinsmen, the Comanche, had been regularly raiding the upper Rio Grande settlements for horses. By mid-century, the Spanish, through gifts and concessions to the Ute, had broken the Ute/Comanche alliance and turned the Ute against the Navajo. As the Ute attacks began to force the Navajo out of their ancient Dinétah territory, a population shift started to the south and west. During 1753 and 1754, the movement became general, into the Chuska Range and Canyon de Chelly area to the west and the Cebolleta region to the southwest.

Some Navajo had been west of the Chuskas since the late 1600s, but now the heart of Navajoland became centered in the Canyon de Chelly region, and many people settled in the gorges of the spectacular and formidable Tségi, or in the juniper-pinyon forests around the rocky canyon. The ample summer water and hothouse growing conditions in the canyons made Canyon de Chelly a major agricultural center.

At this time, the Navajo population was estimated by the Spanish to be about 3,500, divided geographically into five divisions: San Matéo, Cebolleta, the Chuska Mountains, Ojo del Oso, and Canyon de Chelly. The Spanish had heard much of the famous canyon and considered it a major Navajo fortress, but there is no record of any Spaniards penetrating the great gorges before 1800. In the mid-1700s, many Hopi families left their villages due to drought and famine and took refuge among the Navajo, particularly in Canyon de Chelly. In one instance involving forty families, the Hopi men were killed and the women and children taken in.

We have few records indicating exactly the style in which the Navajo lived in Canyon de Chelly. Nearly everything we know of the Navajo people before the Anglo-American occupation comes from the many Spanish and Mexican documents that have survived. They deal almost entirely with abortive attempts to convert the Diné to Christianity and with the endless fighting. They tell us nothing of the culture of these interesting people or even how they looked. In more than two centuries of contact, there are few objective Spanish accounts of the Navajo tribe.

The Troncoso report of 1788 was an important exception. Vicente Troncoso was in charge of Indian affairs, and his report describes how he escorted the prominent Navajo leader Antonio El Pinto, who had been held in jail in Santa Fe, back to his home near Cebolleta. El Pinto had been strongly opposed to Spanish attempts to bring about a rupture in the relations between the Navajo and the Southern Apache, and he was arrested for this opposition. The report is unique in describing the appearance of the Navajo at this early period.

> . . . they took me to one of their houses (the construction of which is of earth and wood resembling a campaign tent except that it has a kind of vestibule or small square room at the entrance) in which I was lodged. . . .
>
> As for clothing, all [men] wear pants, leggings, shoes, and shirts and many have jackets, caps and hats. The women must be the best [looking] and fairest maids of any Indians I have known. Not even the Pueblos are more adorned and decorated with coral, small glass beads and shells like these; they take particular care in combing their

abundant hair daily, the same as Spanish women, and ending in a knot or roll of hair, formed over a cochinea or scarlet cloth. This dressing is called *molate*. Their dress is of two blankets of black wool with a colored, decorated border and they arrange it in the form of a blouse and skirt, only the arms remaining bare.

Their diet consists of mutton, milk, corn, chili and other vegetables which they season moderately and with great cleanliness. The women grind flour of corn and wheat in the same way as the Spanish women and they make from these two kinds of flour, atole, tortillas, and other kinds which are called Guallaves [Piki bread or "wafer bread"] and sweet bread.

The activities of the men are their plantings, raising of livestock, more sheep and goats than cattle but mainly sheep. They also raise a few horses. They hunt deer at the time when they are the fattest when the skin will be better, as it is one of their best trade items. The women are as industrious as the men, or more so. They make the finest serapes that are known, blankets, wraps, cotton cloth, coarse cloth, sashes and other things for their dress and for sale. And finally [they make] the little coiled baskets or *xicaras* that are called "Navajo," so esteemed for their beauty and usefulness not only in the Interior provinces but even in Mexico City . . . (Concha to Loyola, June 26, 1788).

FRICTION AND FIGHTING IN THE CANYON

About this time, the Spanish initiated a movement westward from the Rio Grande settlements, and land grants were made in the Mount Taylor area. Several of these grants encroached on Navajo territory, and frictions with the new settlers upset the long truce that had lasted for fifty years, from 1720 to 1770. Navajo raiding began again, and the land grants were abandoned. This was also the period in which the long friendly relationship between the Pueblo and the Navajo began to deteriorate. The reasons are obscure, but from this time on Pueblo Indians increasingly joined the Spanish against the Navajo.

In 1777, New Mexico was assigned a new governor, the tough Indian-fighter Juan Bautista de Anza. This able pioneer had earlier earned a great reputation for himself by finding a land route between Sonora and California, then leading the expedition that brought the first settlers to California in 1775. His effect on subduing the Navajo would be great, for he had a rare talent for dealing with the Indian problem and understood the power structure in the tribes.

Most of the Spanish and later the Anglo-Americans thought that in making a treaty with "chiefs" the terms would be binding on all tribal members.

They thought that there must always be some sort of top man like Monte-zuma in Mexico, who spoke for all. However, the Indians of the Southwest operated under no such system. Their headmen were simply important local men, noted for wealth, wisdom, or war prowess, whose influence might come to an end beyond the next row of hills. That is the reason why most Spanish/Indian treaties often were broken almost before the ink was dry.

After Anza was recalled to Sonora, there was a slow deterioration of relations between the Navajo and the Spanish, and by 1800 there was a state of continued strife, characterized by Navajo raids and abortive expeditions from Santa Fe.

These Spanish campaigns did little except enrage and unify the Navajo. The governor finally appealed to the authorities in Chihuahua for help, and an experienced Indian fighter, Lieutenant Antonio Narbona, was sent north with 303 Sonoran troops and Opata Indian auxiliaries to aid the ragged New Mexico militia. Narbona arrived at Zuni in late November 1804. The weather had turned bitterly cold, and snow was falling on the passes, but the lieutenant pushed on as far as Canyon de Chelly, where he attacked a small Navajo encampment, killing two and taking two prisoners. With many men suffering from frostbite, the troops returned to Laguna to recoup.

In January Narbona led his troops and the New Mexican militia along the west slope of the Tunichas and early on the morning of the 17th entered the northern arm of Canyon de Chelly, later known as Canyon del Muerto. There are two accounts of what happened in the canyon that cold January day. The Navajo story, handed down from the actual eyewitnesses, has many variations, although the main thread is the same. The other is the official report made by Narbona to the governor.

I will first try to reconstruct the event as seen by the Navajo. Word had reached the Indians living in Canyon de Chelly that Narbona and a considerable force of men had left Zuni heading toward the Tunichas and Canyon de Chelly. With little time to spare, the women, children, and old men were gathered together, and many of them took refuge in a high cave in what is now Canyon del Muerto. The cave is roughly ten miles from the head of the canyon and about 600 feet from its floor. The lower 400 feet of the slope is composed of juniper-covered talus and is very steep. Above this is a stretch of several hundred feet of bare rock that is only passable in some spots through use of ancient Anasazi hand-and-toe holds. This gives access to a narrow, boulder-strewn ledge at the south end. Above the ledge, the sheer cliff rises another 200 feet and is unscalable. The ledge is several hundred feet long, and at its northern end there is an overhang and a small cave. The ledge and cave are almost hidden from the floor of the canyon. The Navajo say that

this hideout was used on several previous occasions when the people were hiding from the Ute.

It is unclear whether any of the warriors remained in the cave to guard the women and children, but the best guess is that they did not. The shelter was strictly a place to hide and in no sense a fortress. The Navajo men and the rest of the women and children withdrew to the opposite rim, where they witnessed the grim drama about to unfold.

There are two versions which explain how Lieutenant Narbona found the Navajo in their perfect hiding place. One story tells of a young man who was angry because the headman of the canyon Navajo objected to his marrying a girl belonging to his own clan. In revenge, he led the Spaniards to the refugees. The other version describes how one of the old women who had once been a slave in the Spanish settlements could not contain herself as the troops rode along the canyon far below. Feeling safe in her lofty perch, she screamed insults in Spanish at Narbona's men, a fatal blunder — what had been a perfect hiding place became a death trap.

The assault on the ledge lasted all through the day. The troops probably worked their way slowly up the talus slope, where they were subjected to rocks and arrows from the ledge. Snipers were kept busy firing at any heads that appeared above the rock parapet on the ledge, and doubtless many of the defenders were killed by ricocheting bullets from the overhanging ledge. It is known that there were over 100 people packed into the tiny cave and the ledge nearby, and even fragments of flying rock could have been lethal. It is very possible that Navajo warriors were active on the flanks of the attack, for the Spanish suffered so many casualties that it is difficult to imagine all of them coming from the rocks and few arrows of the defenders.

According to Narbona, the final assault did not take place until the next morning. The first Spaniard to climb over the rock parapet was attacked by a young woman armed with a knife, and the two fell over the cliff to their deaths. To this day the cave is known to the Navajo as "Two Who Fell Off." The final brutal work was done with clubs, swords, and buckshot. When the last of the Narbona party had ridden off down the canyon, friends and relations of the victims climbed to the cave. Miraculously, one old man had survived. Through him, the details of the final attack became known.

We visited the site, known today as Massacre Cave, in the summer of 1970, and it was not difficult to recreate that final hour. Hundreds of bullet holes, looking remarkably fresh after 165 years, pockmark the cliff and the back of the cave; buckshot pellet dents appear low along the ledge, and in the cave are pitiful scattered bones, many of small children. The Navajo have touched nothing since the massacre, but curious whites have removed all

Fig. 2.43. Kee Begay and Rob Bowler begin a difficult descent from Massacre Cave, site CDM-176.

skulls and perishable materials. The oldest known Navajo weaving was recovered from one of the victims in the cave.

The account of Lieutenant Narbona is interesting for what it does not say about the slaughter in the canyon as well as for what it does say about the canyon itself. His 1805 report was the first to describe the visit of a Spaniard to Canyon de Chelly:

On the 17th of the current month, I managed to attack in the Cañon de Chelli a great number of enemy Indians, and though they entrenched themselves in an almost inaccessible spot, fortified beforehand, we succeeded after having battled all day long with the greatest ardor and effort, in taking it the morning after — and our arms succeeded in killing ninety warriors, twenty-five women and children, and taking as prisoners, three warriors, eight women, and twenty-two boys and girls, and capturing three hundred and fifty head of sheep and thirty riding horses; one of the warrior prisoners being the Leader, named Segundo with his wife and two children, and the total number of dead and prisoners was a hundred and forty-eight.

On our side we had the loss of the Lieutenant of the Opata Nation of the Company of Bacoachi, Don Francisco Piri, who died

Fig. 2.44. Massacre Cave, site CDM-176, where human
bones and bullet marks on the rocks still testify the tragic
outcome of the Narbona expedition in 1805.

in the skirmish, and that of sixty-four wounded among settlers, sol-
diers, and Indians, and eighty-five mounts that I had killed because
they were worn out.

The Cañon de Chelli fortress in which the Navajo Indians place
their hopes of making themselves invincible, I reconnoitered from
its beginning to its mouth, and as it is inhabited by many people
and by nature fortified by the cliffs that form it, that hope is not
without reason, and although on this occasion, I dislodged them
from it, I cannot help but make known to your Lordship as doing
my duty and without exaggeration, that if in the future it were
necessary to attack it again, it would be indispensible that it be done
with a greater number of people than those who accompanied me,
and that they take a large supply of ammunition, for that which I
brought with me from my Province, amounted to more than 10,000
cartridges and in order to get out of the said canyon, I was obliged
to use up most of them.

Its center is spacious and in it they have plenty of farmlands
which are watered by a regular river that runs through the middle,
but this does not stop the enemy from attacking from the heights

Drawn from photo by John Cawley

Fig. 2.45. Navajo petroglyph of Spanish infantry in Slim Canyon.

those who should pass below, and for this reason it becomes necessary that, besides those attacking from within, there be deployed two parties along the rims of the canyons to prevent the enemy from preparing to ambush.

Of the prisoners, I have given eleven away, that were small or wounded, to individuals of this Province and of Sonora and for this reason, I bring only 24 including the two captured in my first sortie.

The Indian Cristóbal with his followers requested a treaty of peace which I refused to grant him; but I did tell him to apply to your Lordship for a parley. He agreed to do so and asked for the freedom of Segundo and his family wherefor you should resolve whether the aforesaid Indian, Segundo, should remain in this Province. I finding myself with little ammunition, and my horses well worn out, I am preparing to leave for the Town of El Paso, at which point your Lordship if it so pleases him, can let me know his further wishes.

The sheep recaptured were consumed among the prisoners, soldiers, settlers, and Indians, and the few mounts that arrived at this town, I distributed among the auxiliary troops of my Province and the guides that your Lordship gave me. . . .

. . . The Corporal Baltasar is bringing eighty-four pairs of ears of as many warriors and the six that are lacking to complete the ninety which I report to your Lordship were lost by the man in charge of them . . . (Narbona to Chacón, Jan. 24, 1805).

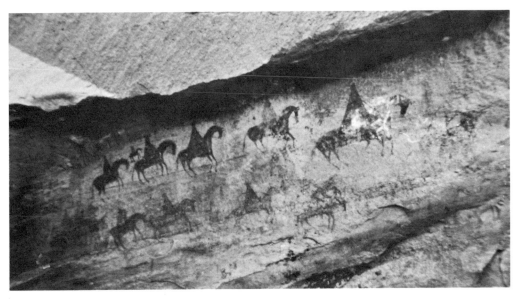

Fig. 2.46. Rock painting of the Narbona cavalcade from site CDM-158, about a mile above Massacre Cave. The foot-high figures are smaller than the Standing Cow horsemen (Figs. 4.69 & 4.70), but are more animated.

There are major discrepancies between Narbona's report and the tale that has come down from Navajo eyewitnesses. Where the lieutenant mainly speaks of battling all day with warriors, the Indians tell of old men, women, and children.

Where did all the captives come from? Either there were many survivors from the cliff massacre or Narbona picked up some strays on his way down the canyon to be awarded to individuals or sold in the slave market. The truth probably lies somewhere in between, but it is certainly likely that Narbona bolstered his gruesome battle tally with the ears of women and old men. The human ear is singularly sexless.

From Narbona's point of view, the invasion of the little-known Navajo "fortress" was a dangerous undertaking, and the Spaniards approached the attack on the cave with enormous caution. All day long, they crept up the talus firing an unbelievable amount of bullets — almost 10,000 by Narbona's own count. It is certain that they expected to find many warriors when the ledge was finally won. When they discovered who had held hundreds of heavily armed men at bay for so long, their reaction was probably particularly savage.

This bloody work of Narbona's Sonorans made any hope for conciliation between the Navajo and the Spanish impossible. For a few years Navajo retaliation was limited to small raids on herds of Spanish livestock. By about 1810, however, Spain was beginning to loose her grip on her more remote

territories due to the withdrawal of troops to Mexico, where they were deployed to control the revolution for Mexican independence. More and more local militia were replacing the professionals.

The Navajo were quick to take advantage of this situation with the resumption of massive raiding. In response, Melgares, the last of the Spanish governors, sent out three expeditions, one consisting of nearly 1,200 men. His campaigns, however, were fruitless, and the governor had more trouble with desertions and insubordination from his own militia than from the Indians.

A Yankee trader named Thomas James has given us a lively account of the situation in Santa Fe in 1821. Although this trapper had already suffered three unlucky and fruitless expeditions into Indian territory, his enthusiasm for native Americans had not been dampened. In Santa Fe, he told of talking to a band of Ute and compared their splendid appearance to the shabbily dressed Spanish. One of his stories shows just how bad the Navajo/Spanish situation had become.

> About a week after this, sixteen Navajo chiefs came into the town of St. James [San Juan] sixty miles below Santa Fe on the Del Norte, and requested the commander of the fort to allow them to pass on to the Governor at Santa Fe, saying that they had come to make peace. The commander invited them into the fort, smoked with them, and made a show of friendship. He had placed a Spaniard on each side of every Indian as they sat and smoked in a circle, and at a signal, each Indian was seized by his two Spanish companions and held fast while others dispatched them by stabbing each one to the heart. A Spaniard who figured in this butchery showed me his knife, which he said had killed eight of them (James ed. by Quaife 1966:164-165).

Although James was in error regarding the location of San Juan, which is actually thirty miles north of Santa Fe, the substance of his report probably has at least some accuracy. Another of his stories, although no doubt colored by the fact that he believed Governor Melgares had cheated him of some $200, indicates why the Navajo did not take the militia expeditions too seriously:

> The militia of Santa Fe, when on parade, beggared all description. Falstaff's company was well equipped and well furnished compared with these troops of Governor Melgares! . . . Most of them were armed with bows and arrows. A few had guns that looked as if they had been imported by Cortez, while others had iron hoops fastened to the ends of poles which passed for lances. The doughty Governor Facundo Melgares, on foot, in his cloak and *chapeau de bras,* was reviewing this noble army. . . . He was five feet high, as

thick as he was long, and as he waddled from one end of the line to the other, I thought of Alexander, and Hannibal, and Caesar, and how their glories would soon be eclipsed by this hero of Santa Fe. . . . At last when all was ready the Governor sent them forth to the war and himself went to his dinner. In the meantime where was the enemy — the bloodthirsty Navajoes? They had returned in safety to their own country with all their plunder, and were even then far beyond the reach of Governor Melgares' troops of scarecrows (James ed. by Quaife 1966:166-167).

James had a good basis for his ridicule of the New Mexicans. The area, after the occupation of over 200 years, still had the look of a rough frontier. The population, mainly illiterate, lived in adobe houses with dirt floors and the crudest of homemade furniture.

Mexican Period, 1821-46

This period saw the Navajo at the peak of power and wealth. Their herds of horses and flocks of sheep covered the rangeland. The women, with an inexhaustible supply of fine wool, were becoming the finest weavers in the Southwest. Sheep, the basis of Navajo prosperity, would eventually overgraze the bulk of the pastureland to desert, bringing on ruinous erosion, but no one thought of this at the time. The best efforts of the Spanish to pacify the Navajo or drive them away had failed, and many of the Indians actually thought the whites would soon abandon the land and go away.

NAVAJO WARS WITH MEXICO

With the passing of Spanish authority and total dependence for order in the hands of undisciplined militia, the Navajo wars took a turn for the worse. From that point on, the story is one of increased hatred and savagery on the part of both Indians and whites — of raids and counter-raids beyond number. The Navajo attacks on isolated ranchos and small settlements became ruinous. As many as 3,000 sheep were run off in a single night, and anyone who tried to stop the raiders was killed. Some Navajo raids went into Mexico itself — a long way from the heartland in the Chuskas.

Both sides over the years had taken women and children captives, especially the Spanish, but now this was often the main purpose of the raids. The Spanish were after slaves to be sold or traded at slave markets such as Taos. From 1700 until about 1870, New Mexican church records show that over 1,600 Navajo were baptized (Brugge 1968:30). These were no ordinary converts, but women and children sold into slavery as household menials.

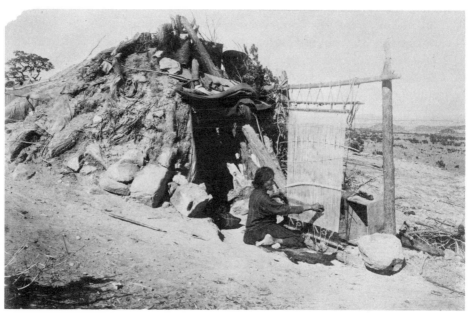

Fig. 2.47. Woman weaving in front of her forked-stick hogan sometime around 1890.

The Navajo took Spanish, Paiute, and Pueblo as slaves, to be traded for horses or used as servants, farmers, and herders. Female slaves were not taught the art of weaving, which was the sacred right of Navajo women. The captor might kill his slave or dispose of him in any manner. Upon the death of his Navajo master, the slave was usually slain.

Previously, many slaves had been brought into the Taos slave market by the Comanche and Ute. A Franciscan padre described it: "When the Comanches are on their good behavior, or at peace, they enter Taos to trade. At this fair, they sell buffalo hides, horses, mules, buffalo meat, pagan Indians (of both sexes, children and adults) whom they capture from other nations . . ." (Adams & Chavez 1956:252-253).

In the 1820s the Navajo became the major source of captives for the slave trade, and many clandestine forays were made against small rancherías by the Mexicans. In 1823, the first new governor under the Mexican government, José Antonio Vizcarra, launched an ambitious campaign to force the Navajo to agree to a proposed treaty that would have forced them to live in pueblos and accept missionaries. About 1,500 men took part in this expedition, which lasted three months and penetrated deeper into Navajo territory than any other military party from Santa Fe.

Vizcarra's account of the campaign is by far the most complete of any preserved and shows clearly why the Spanish way of handling the Navajo

problem never succeeded. For about three weeks the unwieldy force traveled west without contact with the Navajo. Then a detachment surprised a ranchería in the Tunicha Mountains (probably near Washington Pass) and killed fourteen men, women, and children.

Skirting the south rim of Canyon de Chelly, the army camped at its mouth, where they were harassed by Navajo from the rim above. Several Navajo and a soldier were killed here. There were a number of skirmishes, and when a ranchería was attacked, Indians were killed and slaves taken.

After a stay at the Hopi villages, the militia moved north, trailing the livestock of two rich Navajo, Juanico and Segundo (possibly the same Segundo captured by Narbona in 1805). In the chase to the north, twice the eager militia attacked Paiute rancherías, killing five men and wounding others before noting their mistake. Some of the Navajo livestock was overtaken near the Moenkopi Wash, and the pursuit continued over the present Utah border before turning back. On the return trip, four Mexicans were killed at the mouth of Canyon de Chelly, and Vizcarra returned to Santa Fe.

One of the oddities of this elaborate campaign was Vizcarra's failure to enter Canyon de Chelly. It would be twenty-four years before any non-Indians dared to take another look at the great Navajo "fortress," and at that time they would be Anglo-Americans. For his major expenditure of time and pesos, Vizcarra's attempt to solve the Navajo problem had reduced the livestock of several Navajo; killed thirty-two men, women, and children; and taken thirty slaves. He had lost at least ten men, including four who were poisoned by eating yerba de la yuta in the Tunichas.

Year after year, periods of raiding were succeeded by reprisals, followed by treaties that everyone knew were going to be broken, but each new governor had to find this out all over again. The Navajo were truly alone now. The Ute threatened them from the north, the Pueblo from the east, and even their Athapaskan kinsmen, the Apache to the south, were being turned against them. These allies of the Mexicans were being paid with slaves.

To a great extent, the wrath of the Navajo was falling on the slave-raiding centers — Abiquiu, Jemez, Cebolleta, and Cubero; raids all along the frontier were of almost daily occurrence. Some of the Mexican reprisals were savage. In two campaigns in the Canyon de Chelly area during 1837-38, Governor Manuel Armijo killed 98 Indians and captured 96 slaves, 9,000 sheep, and 1,200 sacks of corn.

The endless Navajo wars were ruining the country, and the local authorities were incapable of resolving the desperate situation. Only some radical new approach could bring peace to the land. The first signs of it were not long in coming. On May 13, 1846, the United States declared war on Mexico.

Anglo-American Period, 1846-Modern Times

The Mexican War is often cited as the least defensible of America's foreign adventures. President Polk and various chauvinistic "war hawks" in Congress convinced the country that it had a "manifest destiny" to expand westward to the Pacific. After an offer to buy California and New Mexico was indignantly refused by the Mexican government, an incident was contrived. U.S. troops invaded Mexico and in a swift series of campaigns smashed all resistance. Although the treaty was not ratified until May 30, 1848, American influence in the Southwest was felt much before that through a series of exploratory and military expeditions.

The booty of the Mexican War was immense. The United States acquired California and New Mexico, which at that time embraced all of present California, Nevada, Arizona, and parts of Utah, Colorado, and New Mexico. This vast territory had been loosely held by Mexico with a string of tiny settlements along the California coast and the feeble Rio Grande villages in New Mexico.

NAVAJO LIFE STYLE, 1846

What were the Navajo like at the beginning of the Anglo-American era? Their appearance was a blend of Pueblo, Plains Indian, and Spanish. Early drawings by American artists show the men with headbands, buckskin or cotton shirts, knee-length slit trousers and G-strings, dyed red buckskin moccasins, and leggings tied at the knee. The Navajo had not yet become silversmiths but greatly admired Spanish silver. The wealthy wore silver earrings and necklaces and trimmed their trousers and leggings with silver buttons. The females' costume was the woolen squaw dress similar to that of the Pueblo women. Both sexes wore figured shoulder blankets as serapes or ponchos.

The bow and arrow was still the main Navajo weapon; few guns had been acquired, for the Spanish authorities had made every effort to keep firearms out of the hands of their terrible neighbors. However, Navajo horsemen had adopted the Spanish lance as an offensive weapon.

The most important Navajo acquisition from the Pueblo people was the knowledge of agriculture. Although their long struggle with the Spanish during the Navajo wars profoundly modified their sedentary agricultural life, their enormous thefts of the Rio Grande settlements' livestock, increased over the years by skillful animal husbandry, placed them among the richest of North American Indians. The horse gave the Navajo almost unlimited mobility, and their territory expanded greatly from 1700 to 1850. At the beginning of the Anglo-American period, this powerful tribe was supremely

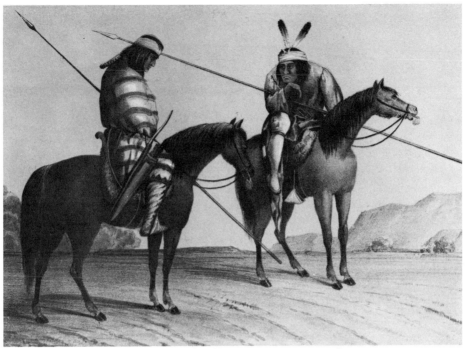

Fig. 2.48. Navajo Indians by H. B. Mollhausen. Mollhausen was an artist who illustrated government surveys in the 1850s and 1860s.

confident that it could handle the newcomers as easily as it had dealt with the Spanish and Mexicans.

The force detailed for the conquest of New Mexico and California was the "Army of the West," with about 1,700 troops under the command of General Stephen Watts Kearny. At Las Vegas in August 1846, shortly before occupying Santa Fe without firing a shot, the general informed the inhabitants that he well understood their major problem: "The Apaches and the Navajos come down from the mountains and carry off your sheep and your women whenever they please. My government will correct all this. They will keep off the Indians, protect you in your persons and property . . ." (Gibson ed. by Bieber 1935:75-76).

These were welcome words to the New Mexicans, but it would be nearly twenty years before the "Gringos" would solve the Navajo problem. Their early efforts to placate or overawe the Diné were as futile as the disorganized forays of the Mexicans. A policy of peaceful overtures — construed by the Navajo as signs of weakness — followed by shows of strength, was certain to fail, and for a time the Diné were contemptuous of the new masters of the country.

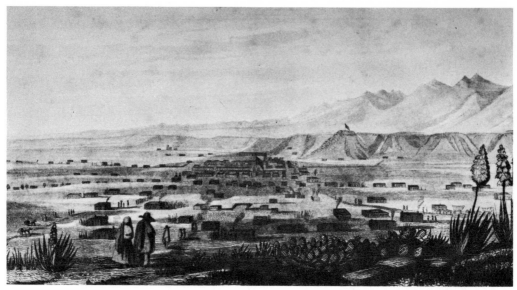

Fig. 2.49. Santa Fe in 1846. Fort Marcy flies its U.S. flag on the bluff to the right.

Kearny first established Fort Marcy on the heights overlooking Santa Fe. From this base, small garrisons were sent to Cebolleta to control the Navajo to the west. Others went to Abiquiu as a buffer against the marauding Ute from the north. The inadequacy of such measures soon became apparent, and Kearny, en route to California, sent dispatches back to Colonel Doniphan, asking him to delay his advance on Chihuahua and to make a punitive foray into the Navajo country.

EARLY AMERICAN EXPEDITIONS

In October 1846 a small advance detachment of troops under Captain Reid made contact with the Navajos at Ojo del Oso (Bear Springs), fifteen miles east of modern Gallup. Some of the headmen, including the elderly and much respected Narbona, were induced to come into Santa Fe to arrange a treaty. Several thousand Navajo were encamped around the council, and Reid and his thirty men got an impressive first look at the army's new problem. Trooper Jacob Robinson described the scene in his journal:

> The plain was covered with . . . mounted warriors, with their feathers streaming in the wind, their arms raised as for conflict; some riding one way and some another; and in the midst of these scenes they indulged in the wild Indian yell or shout of triumph, as they succeeded in capturing their prey. It was a sight unequalled in dis-

play of horsemanship; and can be seen nowhere but in the wild mountains and plains of the west (Robinson ed. by Cannon 1932: 46-47).

Narbona and the other headmen reluctantly agreed to come to Santa Fe, but before their departure Colonel Alexander Doniphan arrived at Ojo del Oso with a considerable body of troops. At the parley, the colonel tried to explain to the Navajo that the United States stood on the verge of taking possession of New Mexico and was thus obligated to protect the inhabitants against the Indians. This obligation seemed incomprehensible to many Navajo, and Zarcillos Largos (Long Earrings), a prominent headman and medicine man, stated his people's position:

> Americans! You have a strange cause of war against the Navajos. We have waged war against the New Mexicans for several years. We have plundered their villages and killed many of their people, and made many prisoners. We had just cause for all this. *You* have lately commenced a war against the same people. You are powerful. You have great guns and many brave soldiers. You have therefore conquered them, the very thing we have attempted to do for many years. You now turn upon us for attempting to do what you have done yourselves (Hughes 1847:71).

At length the perceptive headmen agreed, and both sides signed the treaty. It stated that a firm and lasting peace would be established and that all captives and stolen property in Navajo possession would be restored.

Colonel Doniphan left soon after on his long march to conquer Chihuahua and Durango, feeling pretty well pleased with the results of his diplomacy. He firmly believed, as had the Spanish, that he was dealing with powerful chiefs who could speak for their whole nation. For most of the Navajo, of course, the treaty meant less than nothing. They had learned all about treaties from the Spanish. The raiding of the New Mexican ranchos went on as before.

By September 1847 the situation had grown very bad. At length the many complaints of harried ranchers brought new action from the army. Major W. H. T. Walker, with a small battalion, invaded Navajo territory to "chastise" the nation. He penetrated the upper Canyon de Chelly for about six miles before losing his nerve and turning back. In 1848, the new commander of the New Mexican Department, Colonel E. W. R. Newby, campaigned against the Navajo, and, after a few brief brushes with the enemy, signed another treaty with a group of obliging Diné, who must have been much amused at the Anglos' faith in bits of paper.

In July 1849, James S. Calhoun arrived in Santa Fe as the first Indian agent for New Mexico. What he saw and heard in the next few weeks convinced him that the Navajo were as contemptuous of the Anglo-Americans as they were of the New Mexicans and that it would take a major effort to impress these Indians with the power of the United States.

Calhoun and the new military governor of New Mexico, Brevet Lieutenant Colonel John M. Washington, planned an elaborate expedition to the Navajo stronghold, Canyon de Chelly. The 175 troops consisted of infantry, dragoons, and artillery. In addition, a large contingent of over 300 New Mexican volunteers under the command of Captain Henry Linn Dodge were scheduled to rendezvous with Washington at Jemez Pueblo. This expedition would produce the first careful description of the Navajo heartland, especially Canyon de Chelly, and there were trained observers with the party to record everything.

The man who would write the official account of the reconnaissance, a classic of early western travel, was Lieutenant James H. Simpson. Two young Philadelphians, Richard H. Kern and his younger brother Edward M. Kern, were hired to draw pictures and maps for the inevitable government report.

The expedition left Santa Fe August 16, and during the wait at Jemez for the rest of the party, Simpson and Edward Kern saw the Pueblo Green Corn Dance. Several days later Washington's force of roughly 500 men began their movement west toward the Chuska Mountains. The chief guide for the movement into the Navajo heartland was Antonio Sandoval, chief leader of the *Diné 'Ana'i*, or Enemy Navajo. Their route took them through Chaco Canyon, a difficult route for the artillery and dragoons. The ruins in the canyon fascinated Simpson, who described them in great detail in his report. He also noticed hieroglyphics (petroglyphs) on large sandstone boulders.

On August 30, contact was made with numbers of Navajo in the Tunicha Valley, and the following day Washington began talks with some of the headmen. Among them was the venerable Narbona, a much respected leader, whom the Anglos mistook for the "head chief of the Navajo," and two other prominent men, José Largo and Archuleta, both of whom had been signers of the Doniphan treaty. Colonel Washington and Agent Calhoun asked the chiefs to assemble the leading men of the tribe at the mouth of Canyon de Chelly, where a lasting treaty of peace could be signed. All were agreeable to this, and the meeting was about to break up when an incredible incident occurred.

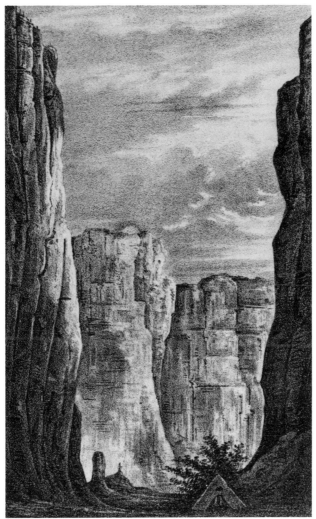

Reproduced from Simpson 1850 courtesy Southwest Museum

Fig. 2.50. Richard Kern's 1849 lithograph of Canyon de Chelly was the first drawing ever made of the natural wonder.

A Pueblo Indian irregular claimed to have spotted one of his horses in the Navajo party. On hearing this, Colonel Washington demanded that the animal immediately be returned or he would order his troops to fire on the Navajo. After receiving this hostile ultimatum, the Diné began to ride off, receiving rifle and cannon fire as they fled. The result of this unbelievably stupid move on Washington's part was that six Navajo warriors were mortally wounded and the headman Narbona was killed. From that moment, the Navajo put no further trust in the Anglo-Americans, considering them as treacherous as their ancient enemies, the Mexicans.

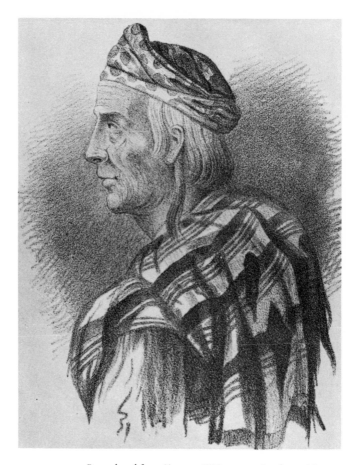

Reproduced from Simpson 1850 courtesy Southwest Museum

Fig. 2.51. Lithograph of the headman Narbona by Richard Kern.

The anti-Indian attitude of many frontier Americans is well shown by this incident. Of the half-dozen eyewitness descriptions of the shooting, all implied that the Navajo got what they deserved. Simpson described how Major Peck "threw among them, very handsomely . . . a couple of round shot." The Kerns' only regret was that they had not secured Narbona's head for a scientist friend at the Philadelphia Academy of Sciences.

The following day, the Washington expedition resumed its march to Canyon de Chelly, passing over the Tunicha Range through a narrow pass that Simpson named Washington Pass in honor of the colonel. The way then led across broad alluvial plains and along small clear streams that flowed into the great canyon.

The party halted near the head of Canyon del Muerto while a picked group, including Simpson and the Kerns, explored the rim. All were aston-

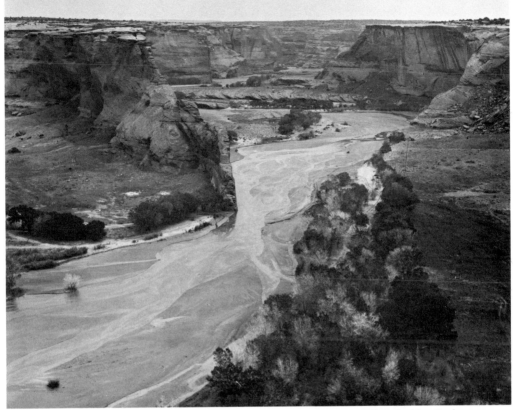

Fig. 2.52. Canyon de Chelly from the first overlook. Blade Rock dominates the upper left.

ished at the sheer 800-foot drop and the spectacular views. Simpson enthusiastically attempted to climb into the canyon but gave up after 300 feet.

On September 6 the expedition made a dry camp several miles north of present-day Chinle after an exhausting day-long march along the north rim of Canyon del Muerto. Washington let the cavalry horses graze in Navajo cornfields and set fire to the hogans in the area.

The next day a local headman, Mariano Martínez, along with a brother of Narbona, came into camp and conferred with Colonel Washington. They agreed to bring in their people for a treaty discussion. Pending the arrival of the Indian delegates, Simpson and the Kern brothers with an escort of sixty men, set off on a reconnaissance of the famous canyon. The party penetrated the main gorge to a point somewhere between Spring Canyon and Wild Cherry Canyon, and the following excerpt from Simpson's official government report is the first detailed description of Canyon de Chelly:

Reaching the mouth of the Cañon of Chelly, we turned to the left to go up it. Its escarpment walls at the mouth we found low. Its bottom, which in places is as little as one hundred and fifty feet wide, though generally as wide as three or four hundred feet, is a heavy sand. The escarpment walls, which are a red amorphous sandstone, are rather friable and show imperfect seams of stratification — the dip being slight and to the west.

Proceeding up the cañon, the walls gradually attain a higher altitude till, about three miles from the mouth, they begin to assume a stupendous appearance. Almost perfectly vertical, they look as if they had been chiselled by the hand of art; and occasionally cizous marks, apparently the effect of the rotary attrition of contiguous masses, could be seen on their faces.

At the point mentioned, we followed up a left-hand branch of the cañon — this branch [Cottonwood Canyon] being from one hundred and fifty to two hundred yards wide, and the enclosing walls continuing stupendous. Two or three patches of corn, intermingled with melons, pumpkins, and squashes, were met on the way.

Half a mile up this branch we turned to the right, up a secondary branch, the width of which was rather narrow. This branch shows rocks, probably as high as three hundred feet, almost perfectly vertical, and in some instances, not discovering a seam in their faces from top to bottom. About half a mile up this branch, in the right-hand escarpment wall, is a hemispherical cave canopied by some stupendous rocks, a small cool acceptable stream being sheltered by it. A few yards further, this branch terminates in an almost vertical wall, affording no pathway for the ascent or descent of troops. At the head of this branch I noticed two or three Hackberry trees and also the *stramonium* [Jimson weed], the first plant of its kind we have seen.

Retracing our steps to the primary branch we had left, we followed it up to its head, which we found but two or three hundred yards above the fork — the side walls continuing stupendous, and some fine caves being visible here and there within them. I also saw here some small habitations, made up of natural overhanging rock and artificial walls laid in stone and mortar — the latter forming the front portion of the dwelling.

Having got as far up the lateral branches as we could go, and not yet having seen the *famous* fort, we began to believe that in all probability it would turn out to be a fable. But still we did not know what the main cañon might yet unfold, and so we returned to explore it above the point or fork at which we had left it. Starting from this point our general course lay about southeast by east. Half

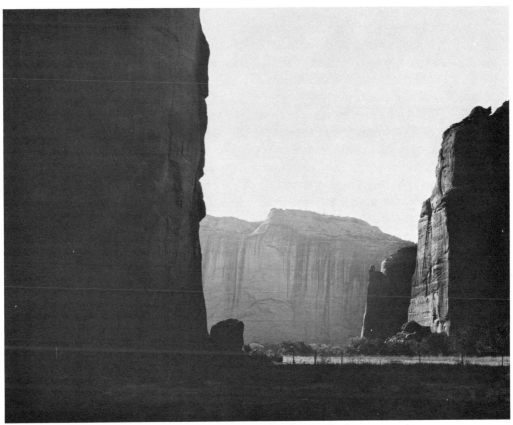

Photo by Marc Gaede

Fig. 2.53. Late afternoon in Canyon de Chelly.

a mile further, or three and a half miles from the mouth of the cañon, on its left escarpment, I noticed a shelving-place where troops (but not pack animals) could ascend and descend. Less than a mile further I observed upon a shelf in the left-hand wall, some fifty feet above the bottom of the cañon — unapproachable except by ladders, the wall being nearly vertical — a small pueblo ruin of a style and structure similar to all appearances, to that found in the ruins on the Chaco. I also noticed in it a circular wall which in all probability, has been an estuffa [Kiva].

The width of the cañon at this point [the lower section] is probably from two to three hundred yards wide, the bottom continuing sandy and level. And what appears to be singular, the sides of the lateral walls are not only as vertical as natural walls can well be conceived to be, but they are perfectly free from a talus of debris, the usual concomitant of rocks of this description. Does this not point to a crack or natural fissure as having given origin to the

cañon, rather than to aqueous agents, which at least at the present period, show an utter inadequacy as a producing cause?

About five miles from the mouth, we passed another collection of uninhabited houses, perched on a shelf in the left-hand wall. Near this place, in the bed of the cañon, I noticed an ordinary Navaho hut and close by it a peach orchard. A mile further, observing several Navahos high above us on the verge of the north wall shouting and gesticulating as if they were glad to see us, what was our astonishment when they commenced tripping down the almost vertical wall before them as nimbly and dexterously as minuet dancers! Indeed the force of gravity and their descent upon a steep inclined plane made such a performance absolutely necessary to insure their equilibrium. All seemed to allow that this was one of the most wonderful feats they had ever witnessed.

Seven miles from the mouth, we fell in with some considerable pueblo ruins. These [White House] ruins are on the left or north side of the cañon, a portion of them being situated at the foot of the escarpment wall, and the other portion some fifty feet above the bed of the cañon. The wall in front of this latter portion being vertical, access to it could only have been obtained by means of ladders. The front of these ruins measures one hundred and forty-five feet, and their depth forty-five. The style of structure is similar to that of the pueblos found on the Chaco — the building material being of small thin sandstones from two to four inches thick, imbedded in mud mortar and chinked in the facade with smaller stones. The present height of its walls is about eighteen feet. Its rooms are exceedingly small, and the windows only a foot square. One circular estuffa was all that was visible.

Half a mile above these ruins, in a re-entering angle of the cañon on the left side, are a peach orchard and some Navaho lodges. Proceeding still further up the cañon, the walls, which yet preserve their red sandstone character but which have increased in the magnificance of their proportions, at intervals present facades hundreds of feet in length and three or four hundred in height, and which are beautifully smooth and vertical. These walls look as if they had been erected by the hand of art — the blocks of stone composing them not infrequently discovering a length in the wall of hundreds of feet and a thickness of as much as ten feet, and laid with as much precision, and showing as handsome and well-pointed and regular horizontal joints as can be seen in the custom-house of the city of New York.

About eight miles from the mouth of the cañon a small rill, which below this point has lost itself in the sandy bottom of the

cañon, appears above ground, and about five hundred yards further on the right-hand side, is a lateral cañon in which we saw another peach orchard.

Having ascended the cañon nine and a half miles, the horses of the Pueblos in company with us not being strong enough for a further exploration, there being no prospect of our seeing the much talked-of *presidio* or fort of the Navahos, which had all along been represented to us as being near the mouth of the cañon, and the reconnaissance having already been conducted further than Colonel Washington had anticipated would be necessary, the expedition returned to camp highly delighted with what they had seen. We found however, the further we ascended it the greater became the altitude of its enclosing walls — this altitude, at our point of returning being (as I ascertained by an indirect measurement) five hyndred and two feet. The length of the cañon is probably about twenty-five miles. Its average width, as far as we ascended it, may be estimated at two hundred yards.

Both in going up and in returning through the cañon, groups of Navahos and single persons were seen by us, above our heads, gazing upon us from its walls. A fellow upon horseback, relieved as he was sharply against the sky and scanning us from his elevation, appeared particularly picturesque. Whenever we met them in the cañon, they appeared very friendly — the principal chief, Martínez, joining and accompanying us in our exploration, and the proprietors of the peach orchards bringing out blanket-loads of the fruit (at best of ordinary quality) for distribution among the troops. Indeed, the chief admonished his people, as they stood gazing upon us from the heights above, to go to their homes and give us no trouble.

I noticed the cross, the usual emblem of the Roman Catholic faith, stuck up but in one instance in the cañon; and this is the only one I have seen in the Navaho country.

Should it ever be necessary to send troops up this cañon, no obstruction would be found to prevent the passage of artillery along its bottom. And should it at the same time, which is not at all unlikely, be necessary that a force should skirt the heights above to drive off assailants from that quarter, the south bank should be preferred because less interrupted by lateral branch cañons.

The mystery of the Cañon of Chelly is now, in all probability, solved. The cañon is indeed, a wonderful exhibition of nature and will always command the admiration of its votaries, as it will the attention of geologists. But the hitherto-entertained notion that it contained a high insulated plateau fort near its mouth, to which the Navahos resorted in time of danger, is exploded. That they may

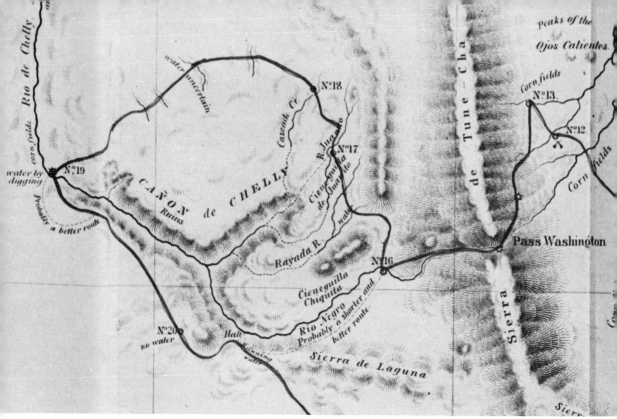

Fig. 2.54. Detail of Edward Kern map of Canyon de Chelly drawn in 1849.

have had heights upon the side walls of the cañon, to scale which would require a series of *fourteen ladders,* is indeed probable, for it would require more than this number to surmount the height we measured.

I did expect in ascending the cañon to find that the Navahos had other and better habitations than the conical, pole, brush, and mud lodge which up to this time we had only seen (Simpson ed. by McNitt 1964:90-95).

Although the obvious entrance to Canyon del Muerto lay only a short distance from the place where the party was amazed by the sight of Navajo descending the vertical canyon wall, Simpson made no mention of the immense side canyon. Perhaps he was more interested in the treaty negotiated at the end of the expedition with two Navajo headmen, Martínez and Chapiton, signing on behalf of the "Navajo nation."

It was agreed that the Navajo would recognize the United States as having jurisdiction and control over them. The Indians would return all captives and stolen property. It all had the familiar sound of numerous previously ignored treaties, but Colonel Washington was well pleased. Many Navajo then came into camp to trade with the Anglos, and Simpson noted that very

few had rifles but were mainly armed with bows and arrows, lances, and shields.

The treaty, as usual, would have little effect, but the Anglo-Americans had been to the very heart of the Navajo country. Edward Kern had produced the first fairly accurate map of the area, showing the main canyon and part of Canyon del Muerto that Simpson's party did not enter. Lieutenant Simpson had written the excellent report quoted here, and Richard Kern had illustrated the document with the first drawings of the Navajo and their land.

Before the Washington expedition reached Santa Fe, Navajo raiding had started again. Major stock losses were suffered at Zuni, San Ildefonso, Santa Domingo, and Santa Ana pueblos. The Navajo had taken note of the numbers of Pueblo Indians with the Washington volunteers.

THE SUMNER EXPEDITION, 1851

The year 1850 was bad along the Navajo/New Mexican frontier. Chapiton, one of the Navajo chiefs who had signed the Washington treaty, was murdered by New Mexicans from Cebolleta; Sandoval, the Enemy Navajo leader, was active in slaving against his own people; and the traders, although ordered not to deal with the Navajo, paid little attention to the mandate and were furnishing guns and whiskey.

In March 1851, Agent Calhoun became the first civil governor of the Territory of New Mexico, as well as superintendent of Indian Affairs. Seeing clearly that the Diné would respond only to a very tough policy, he authorized all the pueblo governors to make war on the Navajo and approved plans of the New Mexicans to raise 600 militia, to be equipped by the U.S. These irregular troops were sanctioned to take captives and any Navajo property they wished.

At the same time, the government in Washington sent a professional soldier, Colonel Edwin Vose Sumner, to reorganize the defense system in New Mexico. He was to move the troops out of the Rio Grande valley towns and set up posts deep in the hostile regions.

In mid-August, Sumner led his troops — four companies of dragoons and one company of artillery — out of Santa Fe. To ensure water and forage, he had sent ahead the two companies of infantry under Captain Lorenzo Sitgreaves. With Sitgreaves was an old friend, Richard Kern. By August 31, all the units of Sumner's command were reunited near Zuni. At Canyon Bonito, the colonel left his wagons, the infantry, and part of the artillery, while he pushed ahead to Canyon de Chelly.

At Wheatfield Creek, headwaters stream of Canyon de Chelly, Sumner talked to a group of Navajo, who warned him to stay out of the canyon.

Near the head of Canyon del Muerto, there was a skirmish with a very large group of mounted Navajo, and Sumner lost his herd of sheep. Following the same route along the north rim of Canyon del Muerto taken by Colonel Washington, the expedition camped by the Chinle Wash, about a mile and a half north of the entrance to Canyon de Chelly.

The Navajo warning to stay out of the canyon was a direct challenge to the old regular, Sumner, who charged into the canyon the following morning with dragoons and artillery, after firing several rounds of howitzer shells to announce his coming. He first put out flankers on both rims following the suggestion of Lieutenant Simpson but recalled them after going a short distance, to build up his main force.

By the time the Anglo-American troops had reached White House ruin, the Navajo, who had been following the advance along the rims, began to attack the invaders with rocks, flights of arrows, and a few musket shots. The colonel bellowed to the artillerymen to "Give them a shell!" According to Josiah Rice, a young gunner from New York State, "The shell struck apparently about thirty feet below and burst against the rocks, not touching one of them, but reports were made by them afterwards that it scart eleven of them to death" (Rice ed. by Dillon 1970:75).

After this exchange, the troops continued up the main canyon about fourteen miles and made camp for the night at a spot somewhat farther up the canyon than that reached by Simpson two years earlier. After supper, however, Sumner began to have second thoughts about his foray into the awesome and unknown canyon, and ordered a retreat. On the way out, artilleryman Rice described one more incident:

> We had marched about 8 miles when we heard, in a small cañon running into the main [one], the barking of dogs and the pow-wow of the Navajo chief calling his tribe to arms. Then all was as still as death until we were opposite the cañon which was fronted by willow. "Whang, Whang, Whang" went the rifles followed by numerous arrows which a dragoon company fired in the direction of the flame of rifles. They were a whole volley. I got shot slap-dab through my top-knot [shako] and never touched a hair. But our musician got a cut of an arrow on the left arm and one of the dragoon horses was shot through the neck (Rice ed. by Dillon 1970:76).

Several days later, Sumner began his return to Santa Fe and was soon reunited with the troops at Canyon Bonito. Here he put the soldiers to work cutting logs for the winter cabins at the new Fort Defiance.

By September 24 Colonel Sumner was back at Zuni, where Captain Kendrick was detached with thirty troopers to accompany Captain Sitgreaves

and Richard Kern on their exploring expedition down the Zuni and Colorado rivers to Camp Yuma.

In summing up his abortive campaign, Sumner complained that the Navajo would not stand and face him. He was not able to handle a foe who continually disappeared as he advanced. The result of his effort was not entirely negative, however — the mere fact that the Sumner expedition had reconnoitered their country had impressed the Navajo. The colonel also hoped that the establishment of Fort Defiance would do more to curb the Indians than any number of punitive forays.

At any rate, the Navajo headmen now seemed seriously interested in peace, and a parley was held at Jemez, where Sumner and Calhoun signed another peace treaty on Christmas Day 1851.

UNEASY TRUCE 1852-58

For awhile, things went well enough. Major Electus Backus, commander at Fort Defiance, distributed cast-off clothing and some tools to many needy Diné that came to the post. Backus, one of the first Anglos to have a close contact with the Navajo, was in sympathy with them in their troubles with the New Mexicans. About this time he wrote: "From the period of their earliest history, the Mexicans have injured and oppressed them to the limit of their power; and because these Indians have redressed their own wrongs, the degenerate Mexicans have represented them as a nation of thieves and assassins" (Backus ed. by Schoolcraft 1856:211).

Delegations of headmen visited Santa Fe and spoke hopefully of living in peace with the Anglo-Americans. Governor Calhoun appointed an Indian agent to be stationed at Jemez to help settle differences between the Navajo and the New Mexicans. Even tough old Colonel Sumner did what he could to help by giving the Diné sheep, seed, and tools from his quartermaster stores.

Shortly thereafter Henry Linn Dodge took over the Navajo agency at Fort Defiance. Dodge had been in Santa Fe in 1846, and Kearny had appointed the young Missourian treasurer of the territory. In 1849, Captain Dodge had led a company of New Mexican militia with the Washington expedition. Over the years he had had many contacts with the Navajo and was highly respected by them. They called him "Red Sleeves," and he could move safely anywhere in Navajo country.

For a time the land was quiet, and many of the Diné came into the settlements to trade. There were signs of trouble, however, for the New Mexicans were moving their sheep and cattle ever deeper into land traditionally claimed

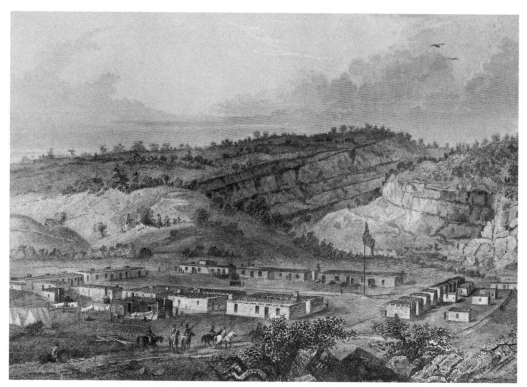

Fig. 2.55. Fort Defiance in the 1850s.

by the Navajo. Agent Dodge, after an extensive tour of Navajoland, esti-
mated the tribal livestock at over 200,000 sheep and 50,000 horses, and noted
that the Indians needed all their grassland to pasture the animals.

The next year, the Capote Ute from north of the San Juan tried to form
an alliance with the Navajo against the whites. The Navajo, however, were
enjoying their peace and prosperity and refused to cooperate. In July 1855,
New Mexican Governor Merriwether asked for a parley with the Navajo to
arrange a final treaty, to establish a permanent reservation, and to arrange
for annuities for the tribe.

This important meeting was held north of Fort Defiance at Laguna Negra
and was attended by thousands of Diné, who had come to see if this treaty
would be any different from all the others. Manuelito was chosen by his
people to be the official "chief," or spokesman for the tribe, and all listened
quietly to the governor's plan.

The most important part, of course, was that dealing with the boundaries
of the reservation. The San Juan River was the northern limit; to the west
the boundary ran south from the San Juan, near present-day Kayenta to the
vicinity of Holbrook. To the east, the line ran southwest from the headwaters

Courtesy Smithsonian Institution

Fig. 2.56. Manuelito, famous Navajo war chief
and tribal leader. This photograph was taken
in 1874 during a visit to Washington, D.C.

of the San Juan to a point just east of Zuni. All other land would be ceded
to the United States in exchange for yearly annuities, valued at $10,000. After
much discussion on the boundaries and on the stipulation that the Navajo
must turn over any wrongdoers to the Anglo-Americans for punishment, the
treaty was signed.

Then came the terrible winter of 1855-56. There was severe suffering
among the Navajo and a great loss of livestock in the mountains. Many In-
dians came down to the low country and into contact with the settlers en-
croaching from the east. Herdsmen were killed, and much stock was run off.
Manuelito made threats against the feeble garrison at Fort Defiance. As spo-
radic raids continued, the people in the Rio Grande settlements began to talk
openly about pushing the Navajo further west.

At this critical point in Anglo/Navajo relations, an event occurred that worsened the crisis. The Navajos' friend, Agent Henry Linn Dodge, was shot to death by a marauding band of Apache while on a hunting trip south of Zuni. All through 1857, the frontier moved uneasily toward a renewed outbreak. There was even trouble at Fort Defiance, where an Indian attempt to use the fort pasture led the soldiers to slaughter Navajo animals.

The situation was soon out of hand, and the decision was made to "chastise" the Navajo tribe. Lieutenant Colonel Dixon S. Miles took charge of the campaign, arriving at Fort Defiance with 124 men to augment the tiny garrison.

On September 9, Miles set out for Canyon de Chelly with a sizeable contingent of cavalry and infantry. His command made a hazardous descent into Monument Canyon, and the calvary was sent on ahead down the canyon toward its mouth. At night the troops rejoined and made camp while the Navajo taunted them from the cliff tops and rolled rocks down throughout the night.

Miles' campaign was not very successful. Large numbers of sheep were captured, and a few Navajo were killed, but the Indians were tired of being chased from point to point and sued for peace. The peace terms this time were harsh, depriving the Navajo of most of their best grazing land. Soon the raiding broke out again.

The 1859 army demonstration against the Indians was chiefly notable for another extended reconnaissance of the Navajo country. Two columns left Fort Defiance and headed for Navajo concentrations. The first, commanded by Major Oliver Lathrop Shepherd, moved west toward the Hopi villages. The other, led by Captain John G. Walker, marched north to Canyon de Chelly. In his report, Walker wrote: "The approach of the Chelly, is over an undulating tableland, unmarked by any peculiarity, with absolutely nothing to indicate the vicinity of one of the greatest of natural phenomena, until you are startled by finding yourself suddenly upon the brink of this fearful chasm, which seems to open under your very feet into the bowels of the earth" (Walker & Shepherd ed. by Bailey 1964:38).

Walker's men entered the canyon from the east by way of Wheatfield Creek and in four hours were able to reach the floor of the gorge. During the descent of the main canyon, water was running the entire length, due to rain a few days earlier. Walker noted corn and some wheat growing but made no mention of any Navajo aside from his unwilling guides. During a thundershower, he saw a spectacular waterfall dropping a sheer thousand feet somewhere east of White House ruin. He described the junction of Canyon de Chelly with another major canyon, which he called Canyon del Trigo. This

Fig. 2.57. Canyon de Chelly near its junction with del Muerto. This picture was taken shortly after a summer thunder shower, when quicksand danger is greatest.

was in fact Canyon del Muerto, which Simpson had entirely missed ten years earlier.

In three days Captain Walker had completed his exploration, becoming the first white man to travel the entire length of the main canyon. The expedition then turned north to the San Juan and returned through the Red Rock country to Fort Defiance.

Superintendent James L. Collins was impressed by the numbers and wealth of the Navajo reported by the Walker expedition and, believing the Indians to be well able to pay reparations to the New Mexicans, recommended a hard line. Army threats to destroy flocks and crops led to reprisals, culminating in an attack on the Fort Defiance cattle herd by the Navajo and the killing of three soldiers. When troops were withdrawn from the fort to build a new post at Ojo del Oso, the Indians made a massive attack on the fort itself and nearly captured it. This bold attempt galvanized the reluctant Anglos into a major attempt to solve the Navajo problem.

Colonel Edward R. S. Canby, an old Indian fighter, was selected to command the troops that were being assembled from many posts in the Southwest. About 800 soldiers advanced in three columns to rendezvous at Fort Defiance. They were augmented by 500 Pueblo Indians, 800 militia from the

Rio Grande settlements, and many Ute scouts. Canby did his utmost to bring the Navajo to a decisive encounter, concentrating on the region to the west of Canyon de Chelly. However, no matter how rapidly his troops advanced, they never seemed to catch up with anything but stragglers.

The campaign had exhausted the troops and killed many cavalry mounts, with little to show for it. Thirty-four Indians had been killed and 8,000 head of stock taken — the latter mostly by the Ute. Two of the slain Indians, however, were important headmen — Mariano Martínez and Zarcillas Largas. The latter was killed at the mouth of Canyon de Chelly.

CIVIL WAR INTERLUDE, 1861-62

Great events far to the east now occurred to completely change the New Mexican picture. On April 12, Confederate bombardment of Fort Sumter began, and for a time the Navajo problem was virtually forgotten. The Indians must have rejoiced to hear that their Anglo-American oppressors were now busy killing one another.

Shortly after the secession of the southern states, the New Mexican commander resigned his commission to join the Confederacy. Command of the New Mexican Department now fell to Edward Canby. It was his job to rebuild the disorganized troops, decimated by withdrawal and desertion, to defend the territory.

By June Confederate General Henry H. Sibley, Canby's brother-in-law, was moving on the Rio Grande with an army of 3,500 mounted Texans. To meet this threat, Canby had hastily put together two regiments of volunteers, one of which was led by Christopher "Kit" Carson, who had been the Ute agent at Taos.

Carson was a legendary figure in the Southwest. One of the most colorful of the fur-trapping mountain men, he had fought Indians all over the frontier, and had served as a guide to the best known of the Frémont expeditions. In 1862 he was fifty-three years old, a short, powerfully built man with shoulder-length, graying yellow hair.

More volunteer troops came from Colorado, as well as a brigade from California under Colonel James H. Carleton, to aid in the defense of the territory and to keep open the overland route to California. General Sibley's New Mexican campaign had some early success in the Rio Grande valley, but collapsed at his defeat in February 1862 in Glorieta Pass. This was the end of the Civil War in the territory, and Carleton, now promoted to brigadier general, replaced Canby. It was time to again tackle the neglected Indian problem, which had gotten completely out of hand since the outbreak of the War Between the States. The authorities at Santa Fe were faced with raids

Fig. 2.58. Christopher "Kit" Carson about 1863.

by Navajo, Mescalero Apache, and Comanche. As ever, the Navajo were the most troublesome, with their massive thefts of livestock.

First to feel the power of the tough new territorial commander were the Mescalero, who were attacking the Rio Grande settlements from the east. The campaign against them was conducted by such men as Colonel Kit Carson, with volunteer troops and Indian auxiliaries. It was a relentless five months' effort, with orders from Carleton to kill the warriors and capture the women and children. By February 1863 it was all over, and about 400 Mescalero who had not fled into Mexico or the inaccessible White Mountains were taken to the Pecos River in east central New Mexico, where General Carleton had established a reservation at Bosque Redondo.

The general had been advised against locating the reservation and the new Fort Sumner in such an unfavorable spot where the Pecos River was alkaline and there was little timber, but he had chosen the area for military reasons as a buffer against Comanche raids from the east.

While the Apache roundup had been underway, Carleton had been preparing for the ultimate solution to the Navajo problem. He was determined to break the tribe and remove them to a permanent reservation where they would be trained in peaceful ways, educated, and converted to Christianity. Carleton sincerely believed such a plan was the only salvation, not only for the territory but for the Navajo themselves. The plan was Canby's, but the zealous Carleton was now to carry it out with a vengeance.

In April Carleton ordered Kit Carson to take command of the Navajo campaign. The Navajo were to be harassed through the summer and fall, crops were to be destroyed, livestock captured or killed, and houses burned. This would continue into the winter until the destitute Indians surrendered and agreed to their transfer to Bosque Redondo.

The ruins of Fort Defiance were rebuilt and named Fort Canby. One hundred Ute were attached to Carson's command as scouts and trackers. Their intimate knowledge of the country would be a vital factor in the success of Carleton's plan. The general approved the use of irregular New Mexican troops to raid Navajoland from Abiquiu, Cubero, and Cebolleta. These raiders were very successful, and an Indian agent reported that hundreds of captives were taken and sold throughout the territory for servants. Carson, married into a prominent Spanish family, fully approved of these actions by the irregulars and the Ute, both because it provided them a reward for their assistance and because the famous scout actually thought that Navajo women and children would be better off in New Mexican households than at the Bosque Redondo camp. This view was quickly repudiated by Carleton, who had high hopes for his reservation plan.

By mid-summer all was ready, and on June 23 two leaders of the peaceful Navajo, Delgadito and Barboncito, were told that the war was about to start. They were given a deadline of July 20 to bring themselves and their families into either Fort Canby or Wingate for transportation to the Pecos reservation. After that date all were to be considered hostile.

Carson began the campaign with over 700 men in addition to 326 volunteer troops at Fort Wingate. Sent out in small detachments, they soon had destroyed all Navajo fields within a fifty-mile radius of Fort Canby, including two million pounds of grain. During these initial harassments, many Navajo dispersed to regions out of the reach of the Anglos, but most kept to their old familiar canyons.

In September, the "Enemy Navajo," who had been friendly with the whites for many years, were sent off to the reservation to join the Mescalero Apache already there. By mid-October, many more Navajo were feeling the

effects of Carleton's ruthless scorched-earth policy. Faced with starvation, 180 Diné had surrendered before the end of the year. The hungry Navajo had actually attacked Apache herds at the Fort Sumner reservation and waylaid a quartermaster train en route to Fort Canby.

Early in January, with deep snow on the ground, Carson was ordered to scout Canyon de Chelly. Maps of the period show that no one had a clear idea of the topography of the canyons, and Carson did not even know of Walker's exploration of 1859. The attacking party consisted of two columns. The first, commanded by Captain A. W. Pheiffer, would move into Canyon del Muerto from the east. The other contingent of nearly 400 men was led by Colonel Carson. He and his men would attack by way of the west entrance to Canyon de Chelly, thus supposedly trapping any Navajo. Actually, of course, the Diné had many trails leading out of all canyons, and Carson un-wittingly was leaving the eastern end of the main canyon and Monument Canyon unguarded.

Carson's march to the west entrance was a difficult one. The snow lay deep, and twenty-seven of the oxen pulling the supply wagons died on the trip. An advance detachment caught a party of Navajo near the mouth of the canyon, killing eleven warriors and capturing some women and children. After a brief reconnoiter of the south rim and its sheer precipices, Carson decided to divide his command, with one contingent scouting the south rim and the other the north, hoping to meet with Pheiffer's column coming in from the east. Failing to find Pheiffer, Carson returned to the entrance and there found the captain waiting for him with nineteen prisoners. The con-fusion had been due to the army's almost complete ignorance of the topog-raphy of the great canyon system. Pheiffer had gone down Canyon del Muerto, while Carson, seeking him, had gone along the main canyon of the de Chelly drainage.

Just before Pheiffer entered the canyon, he had discovered a Navajo camp with eight starving women and children, who were taken prisoners. The travel down the icy canyon streambed on January 11 had been very dif-ficult, and advance sappers were continually breaking trail for the mule train. In describing this second day in his report, Captain Pheiffer wrote:

> On the 12th inst. travelled about eight (8) miles, had several skirmishes with the enemy, Indians on both sides of the Cañon whoop-ing and yelling and cursing, firing shots and throwing rocks down upon my command. Killed two (2) Buck Indians in the encounter, and one Squaw who obstinately persisted in hurling rocks and pieces of wood at the soldiers. Six prisoners were captured on this occa-sion. . . . I encamped that evening in a secure place, where plenty

of wood was to be obtained, the remains of old Indian lodges (Pheiffer to Murphy, Jan. 20, 1864).

The location of Captain Pheiffer's second camp in Del Muerto has been located through a discovery we made during our rock art survey. On the left cliff at the entrance to Many Cherry Canyon, there is a dim inscription carved into the sandstone:

JOSE PENA
C H 1 N. M. V. &
PASO EL DIA 13
AD — ENERO DE
1864

"José Peña, Company H 1st New Mexican Volunteers passed here the 13th day of January, 1864."

In filing his final report on the campaign at the end of January, Carson noted that his troops had thoroughly explored Canyon de Chelly and that the ancient Navajo stronghold had ceased to be a mystery. In addition, the presence of so many soldiers in the very center of their world had broken the morale of the destitute Navajo. The knowledge that this time there would be no reprieve and that the Anglos were commanded by Colonel Carson, a man known to be fair in his dealings with Indians, triggered the beginning of the mass surrenders.

The Navajo war virtually ended at this point. It had been an extraordinary victory — few Navajo had been killed, but the swift winter campaign to destroy Diné sustenance had succeeded beyond any expectations. Nearly 200 years of frontier warfare had accomplished nothing toward solving the "Navajo problem." Now in a few short months it was over.

The day following the rendezvous of Carson and Pheiffer, sixty ragged Indians came into camp, willing to be taken to Fort Sumner. They stated that many of their people had died of starvation and exposure and that only the threat of being killed had prevented an earlier capitulation. They agreed to contact the rest of their band and come into Fort Canby within ten days.

Carson then departed for Fort Canby with most of his command to prepare facilities for the expected prisoners, leaving captains Pheiffer and Carey with seventy-five men to move through Canyon de Chelly, destroying the

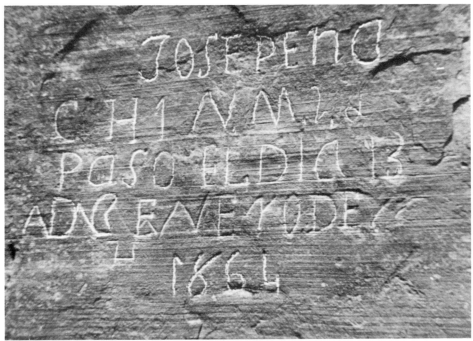

Photo by John Cawley

Fig. 2.59. The Peña inscription.
Chalked to bring out lettering.

hogans and the peach orchards. Actually, Carey and a contingent made the march through the canyon alone, while Pheiffer waited with the rest of the troops at the west entrance. Carey apparently did not go the full length of the canyon, but made his exit to the tableland by way of Bat Trail at the entrance of Monument Canyon. His report gives a fairly accurate description of the canyon topography, showing that the Anglos were belatedly getting some idea of the structure of the stupendous gorge system. Carey mentions talking to a group of over 150 Navajo who were ready to surrender but says nothing of destroying hogans or peach orchards. The task was probably just too hard under bitter winter conditions.

THE LONG WALK, 1864

Once the surrenders had started, the authorities were stunned by the magnitude of the Navajo collapse. By the first week in February nearly 800 had come into forts Canby and Wingate. Within a month this total had swelled to 2,500, with more arriving every day. Not all Navajo by any means were ready to go to Bosque Redondo, and many fled deeper into the canyon lands,

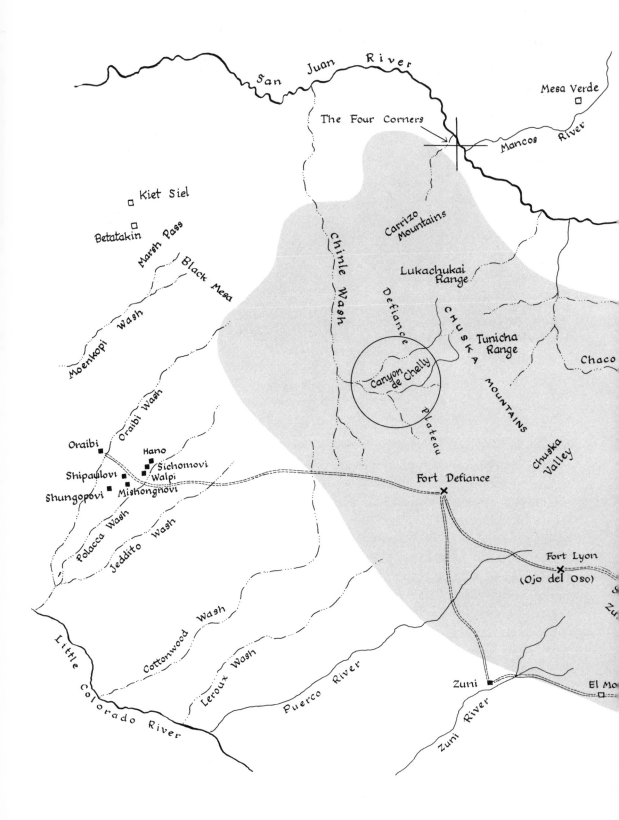

San Juan River

Mesa Verde

The Four Corners

Mancos River

Carrizo Mountains

Kiet Siel

Betatakin

Marsh Pass

Black Mesa

Lukachukai Range

Chinle Wash

Defiance

CHUSKA

Tunicha Range

Chaco

Moenkopi Wash

Canyon de Chelly

Plateau

MOUNTAINS

Oraibi Wash

Chuska Valley

Oraibi

Hano

Sichomovi

Shipaulovi

Walpi

Shungopovi

Mishongnovi

Fort Defiance

Polacca Wash

Jeddito Wash

Fort Lyon

(Ojo del Oso)

Little Colorado River

Cottonwood Wash

Leroux Wash

Puerco River

Zuni

El Mo

Zuni River

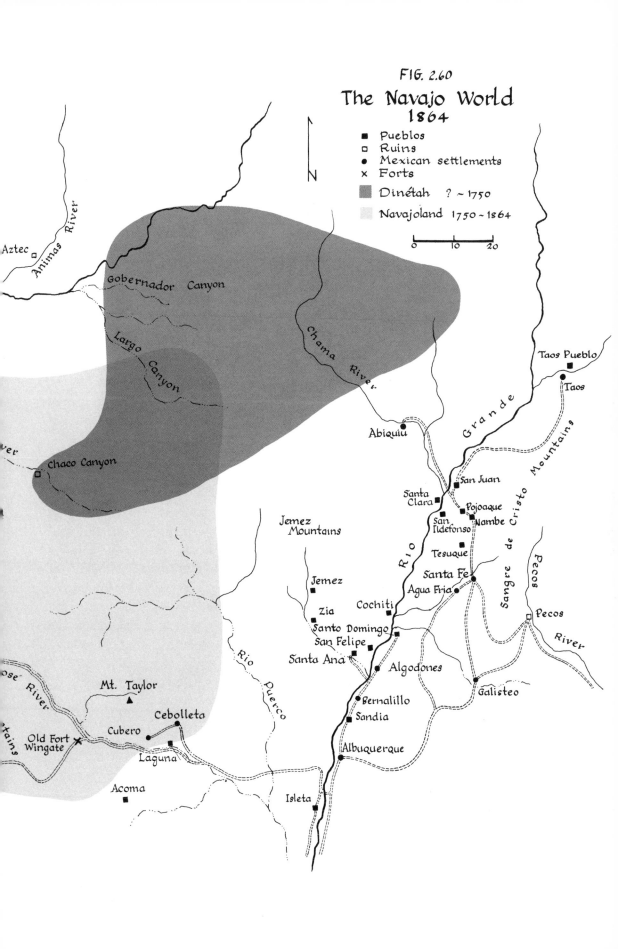

FIG. 2.60
The Navajo World
1864

■ Pueblos
□ Ruins
● Mexican settlements
× Forts

Dinétah ? ~ 1750
Navajoland 1750 ~ 1864

0 10 20

Animas River

Aztec

Gobernador Canyon

Largo Canyon

Chaco Canyon

Chama River

Taos Pueblo
Taos

Abiquiu

Grande

San Juan
Santa Clara
Pojoaque
San Ildefonso
Nambe
Tesuque

Rio

Santa Fe
Agua Fria

Sangre de Cristo Mountains

Pecos

Pecos

Pecos River

Jemez Mountains

Jemez
Zia
Cochiti
Santo Domingo
San Felipe
Santa Ana
Algodones

Galisteo

Rio Puerco

Mt. Taylor

Bernalillo
Sandia

Cebolleta

Old Fort Wingate
Cubero
Laguna

Albuquerque

Acoma

Isleta

River

crossed the San Juan to the north, or moved south to live with their Apache kinsmen.

Captain Carey was now in command of the Navajo operations, as Carson, homesick for his young family in Santa Fe, had gone on a long leave. The prominent Navajo leader Delgadito, one of the first headmen to go to the Bosque with his band, was allowed to return to Navajoland to tell his starving tribesmen of the food and comforts awaiting them at the reservation. His talks persuaded large numbers of Diné to surrender.

It is difficult to keep track of the many convoys of Navajo that made the "Long Walk" into captivity at Bosque Redondo. They were sent in batches of hundreds and then of thousands, as the incredible surrender continued. Carleton, who had been clinging stubbornly to his belief that the Navajo nation numbered no more than 5,000, worked desperately to feed the swelling population on the new reservation. The convoys suffered terribly in the winter months from the cold, and many died on the way of exposure, exhaustion, and dysentery. Many others perished at the forts while awaiting their turn to start the 400-mile trek.

In addition, their ancient enemies, the Rio Grande settlers, hung onto the flanks of the strung-out lines of Navajo, killing or capturing the unarmed stragglers. Vicious raids by slave-hunting New Mexicans continued deep into the Navajo country, becoming so widespread as to endanger the surrender program.

By mid-March the number of Navajo at the Bosque stood at over 4,000, in addition to the 400 Mescalero Apache sent the year before. Carleton now figured he could feed about 6,500, but Carey informed him that the total tribal strength would be around 12,000. A month later the Navajo population had swelled to over 6,000, and the surrenders continued. Numbers of *ricos,* or wealthy Navajo, began to come in with large flocks and many horses.

In August the peach orchards in Canyon de Chelly were finally destroyed by Captain Thompson. Approximately 5,000 trees were cut down in the two main canyons. In addition, on this foray Canyon de Chelly headman Barboncito was finally captured.

One of Thompson's troopers left his mark on a cliff wall in Canyon de Chelly (site CDC-140). Pecked into the red sandstone, near ancient Pueblo petroglyphs, is the following legend: "W. R. Dodd. Co K 1st Cavy. N.M. Volts."

November saw the last big contingent of captives brought onto the Pecos River reservation. The total now stood at 8,354. How many Navajo still remained at large will never be known, but Carson and others doubted if more than half the tribe made the Long Walk into exile.

BOSQUE REDONDO, 1864-68

The Navajo called their dreary new homeland *Hwééldi;* the New Mexicans named it *Bosque Redondo* (Round Grove of Trees). The four years the Navajo spent in exile there were years of increasing bitterness and despair.

General Carleton's altruistic dream of converting the Navajo warriors into educated Christian farmers was doomed from the start. Immense plantings were made of corn and wheat — over 6,000 acres in all — but the crops were wretched due to the alkaline water from the Pecos, the army worm that destroyed most of the corn, and hail storms that periodically decimated the wheat stands. During all four years of the Fort Sumner experiment, the crops failed, and continual use of army stores was necessary.

In the first year, Carleton's insistence on the Bosque Redondo location led to bad relations with the Department of Indian Affairs, and eventually the whole responsibility was left to the general. He attempted to force the Navajo to settle in pueblos, but they refused, moving about the 1,600-square-mile reservation in their traditional semi-nomadic fashion.

More and more of them deserted the reservation and drifted back to places west of the Rio Grande. The Apache fled the Bosque in 1865. Many Navajo sheep and most of their horses were stolen by Ute and Comanche raiding parties, giving the Diné a taste of what it was like to live in a fixed area and be subject to lightning raids by predatory Indians.

In 1866 Carleton was relieved of command, and the Bosque came under the control of the Indian Department. By now the reservation population was down about 2,000 from its peak, and the remaining 7,000 Navajo were completely discouraged and broken by their miserable experience.

Even the federal government was getting sick of the Bosque Redondo affair. Congress was balking at the high cost of supporting the reservation, when to everyone's relief a Navajo treaty was negotiated by General William T. Sherman and Colonel Samuel Tappan in May 1868. The Navajo, destitute, ridden with Anglo diseases, and terribly homesick, were ready to sign anything. What was more important, their taste for fighting the Anglos had been permanently curbed by the four wretched years at Bosque Redondo.

Twenty-nine Navajo headmen put their marks on the long document. In return for their submission, the Diné could return to their homeland. It was sadly reduced but still included Canyon de Chelly and the Chuska Mountains. The government was pledged to support the destitute tribe for ten years, by which time it was hoped that the Navajo would once more be self-supporting.

Within two weeks of the signing of the treaty in June, a ten-mile column of fifty wagons moved slowly out of Fort Sumner. The once-proud Navajo,

Fig. 2.61. Navajo silver bridle, necklace, and belt on third-phase chief pattern blanket woven sometime in the 1880s.

stripped of everything, were headed home to begin life again in their canyon country. They would never again raid the ranchos of the Rio Grande valley, and they would never forget what the Anglos had done to them.

RETURN TO NAVAJOLAND, 1868

The return of the Navajo from the Bosque Redondo took thirty-five days, but the Diné still had to spend many months camping around Fort Wingate before they were permitted to enter their new reservation of 3½ million acres. At last, in January 1869, they once more saw their beloved homeland — the tree-covered slopes of the Chuskas and the red cliffs of Canyon de Chelly.

Weekly rations of a pound of meat and a pound of flour for each weekday were handed out at old Fort Defiance, now the Navajo Agency Headquarters. However, the promised agricultural tools and wagons did not arrive for fifteen long years.

The recovery of the Navajo from their complete disaster was slow, but the ever-adaptable Athapaskans were determined to survive in their drastically changed situation. The government supplied 14,000 sheep and 1,000 goats

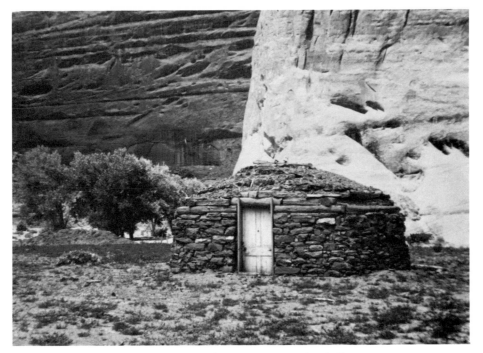

Fig. 2.62. Stone hogan in Canyon de Chelly.

to the tribe to start them out on the task of rebuilding their vanished flocks. Those who did not eat their sheep would again know security as their herds eventually expanded. In addition, other means of support were tried.

Soon after the return from the Bosque, the Navajo, who had always greatly admired Spanish silverwork, began to experiment with hammered and cast silver. They have continued to produce superb silver objects into modern times. The traders, finding a growing demand for Navajo blankets, or "rugs," encouraged the women to turn out great numbers of them. These weavings have become famous items of Southwest Indian craft art.

The old forked-stick hogan continued to be used, but other types of housing became popular after the Bosque Redondo experience. The new hogans were mainly circular, with cribbed roofs, but some were of fitted stone, similar to pueblo masonry, while others were hexagonal, notched-log structures. Some houses were built in rectangular style, like those at the trading posts.

One of the stipulations in the final treaty was that Navajo children be sent to school. However, it would be many years before the semi-nomadic Diné would take this injunction seriously.

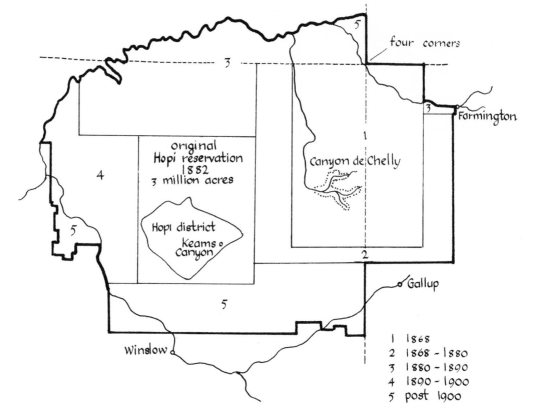

Fig. 2.63. Growth of the Navajo Reservation, 1868-1934.

THE MODERN NAVAJO

As the years passed, the Navajo tribe increased greatly in population, and the original marginal grazing land would no longer support them. Gradually the size of the reservation was increased. By 1880 it had almost doubled. By 1935 it had gone through four more major increments, bringing the Navajo holdings to the modern-day level of eighteen million acres, mainly in northeastern Arizona, but with sizable sections in southern Utah and northwestern New Mexico.

In 1923 the first Tribal Council was established, with Henry Chee Dodge as chairman. Under his wise leadership, the Navajo took a large step toward self-government. The Council would eventually play an important role in administering wealth derived from discoveries of coal and other resources on the reservation.

In the drought of the 1930s, the long years of over-grazing huge herds of sheep and goats brought about a crisis in the Navajo way of life. The land, stripped by the grazing animals, was blowing away, and heavy summer cloud-

bursts were washing precious topsoil down the arroyos into the Colorado. The government moved in to reduce the numbers of Navajo livestock radically. Thousands of animals were sold or killed — a traumatic experience for a people who traditionally looked on their herds and flocks as security and wealth.

A Navajo capital was established at Window Rock, where the operations of the Tribal Council were carried out. But still the way of life was little changed from that of 1700. It took a war to bring the Diné into the twentieth century.

Many young Navajo volunteered during World War II. In the military services, the Indians felt equal to their Anglo comrades — they traveled widely and saw a world they had not dreamed of. When they returned home, many were ready to go to school and to convince others of the importance of education.

Large royalties from reservation oil and coal built schools, a college, hospitals, and roads. As always, the Athapaskan Navajo have adopted those cultural traits which suit their life style while still clinging to many of their ancient ways. They may drive pickup trucks and dress in blue jeans, but much of their life still falls into the old rhythms. The healing ceremonies known as chants or sings that feature the famous sand paintings are still held in modern times, although Christian missionaries of various sorts have made many converts.

In Canyon de Chelly, where about 400 Navajo still live inside the national monument boundaries, Indians still go into the canyons to live in hogans during the spring planting and return for the harvest. The summer rains still nourish the growing corn; sheep and goat herders still make pictures with charcoal in the rock alcoves and on the cliff faces.

The older, orthodox Navajo and the shamans may complain that some of the young people are too modern and do not properly respect the old gods and ceremonies, but the mark of the past is still very strong in the great canyon. The ruins, the potshards, and above all the vast galleries of paintings and petroglyphs endlessly mirror the hopes and fears of the Indians who have lived in Canyon de Chelly for at least 2,000 years.

The Canyon Explorers

The Canyon Explorers

IN THE MID-NINETEENTH CENTURY, the southwestern United States was almost totally unknown to the average American. Fur trappers and traders had been traveling through its mountain ranges and deserts for many years prior to 1846, but very little had been published describing the wonders of this new land. One book, *The Commerce of the Prairies,* appeared in 1844. Written by Josiah Gregg, a Santa Fe trader and frontier scientist, it gave a good description of the Southwest and its Indians during the last years of Mexican rule. Another volume, *Life in California Before the Conquest* by Alfred Robinson, was published in 1846, offering an excellent account of the pastoral period in California.

There was an enormous curiosity on the part of the American public and the government to know just what lands had been acquired as the immense spoils of the Mexican War. Soon the scattered journals and unpublished military reports quoted in Part Two of this book were supplemented by a number of government-published explorations and surveys. In 1855 the multivolume *Reports of the Explorations and Surveys to Ascertain the Most Practical and Economical Route for a Railroad from the Mississippi to the Pacific Coast,* edited by S. W. Whipple, began to appear. Even the raiding Indians of Canyon de Chelly were beginning to be known; one volume of these well-illustrated reports included a fine painting of mounted Navajo warriors by H. B. Mollhausen (Fig. 2.48).

In 1856, in Schoolcraft's *Indian Tribes of the United States,* Major Electus Backus contributed a chapter entitled *An Account of the Navajos of New Mexico.*

In 1860, the *Report of the Colorado River of the West,* under the direction of Joseph Christmas Ives, included another Mollhausen drawing of Navajo men and women.

In the F. V. Hayden Geological Survey of 1876, there appeared the first description of the cliff ruins in Mancos Canyon and Mesa Verde, discovered by famous frontier photographer W. H. Jackson two years before. In 1879, Volume VII *(Archaeology)* of Lieutenant George M. Wheeler's *Geographical Surveys West of the One Hundredth Meridian* was published. In it there was a fine photograph of White House ruin, printed backwards, taken by T. H. O'Sullivan (Fig. 2.29).

The year 1879 was especially important in the study of the American Indian. Previously, the annual reports of the Smithsonian Institution had included occasional articles on American archaeology and ethnology, but now a special agency was created — the Bureau of Ethnology. Its first director was John Wesley Powell, a prominent geologist and ethnologist who had made a special study of the languages of the American Indians. He is chiefly remembered as the first man to run the rapids of the Grand Canyon in 1869.

The lavish annual reports of the Bureau of Ethnology were written by the top experts of the time and extensively illustrated in color and black and white. They were issued regularly until 1933, and special bulletins have continued to be produced.

Pot-Hunters, Travelers, and Archaeologists, 1879-1906

The latter half of the nineteenth century saw a growing interest in the artifacts of the American Indian, even though the settlers and the government continued to harry and dispossess the creators of these artifacts. By the 1880s, thousands of homes across the land could point with pride at pottery, baskets, and arrowheads displayed in the knickknack corner.

The popularity of Indian "curios" stimulated many to plunder prehistoric graves and ruins for salable objects, and many fine archaeological sites were damaged. By far the most successful of the pot-hunters were the Wetherill brothers, who discovered the most spectacular of the Mesa Verde cliff dwellings in the 1880s and removed many relics. For years they took vast quantities of artifacts from various sites in the San Juan basin. Important collections were sold to wealthy collectors or to museums, although much material was disposed of through curio dealers.

Not all such collecting was done solely for profit. In addition to pot-hunters like the Wetherills, there were private individuals who collected for museums and wealthy amateurs like Baron Gustaf Nordenskiöld of Sweden,

who made the earliest scientific collections at Mesa Verde in 1891 and published an elaborate book on his studies.

Unchecked looting of irreplaceable prehistoric material was slowed in 1906 by the passage of the American Antiquities Act, which made it a federal offense to injure, remove, or damage antiquities on federal land. The act proved difficult to administer, however, and some illegal collecting has continued into modern times.

COLONEL JAMES S. STEVENSON, 1879-85

Stevenson began his exploring career in the early 1870s with the Hayden Geological Survey of the Northwest, where the expedition traced the Missouri, Colorado, and Snake rivers to their headwaters. He was active in the survey of the Yellowstone region and helped promote the first national park there in 1872. Colonel Stevenson led an exploration of the Southwest in 1879, the first ever made under the auspices of the newly created Bureau of Ethnology. With him was Frank H. Cushing of the Smithsonian Institution.

Cushing devoted his time to the pueblo of Zuni, while Stevenson visited a great many pueblos, collecting artifacts, particularly pottery. He brought back twenty-one pieces of pottery from Canyon de Chelly — corrugated ware, polychrome, and black-on-white, all of which were illustrated in the *Second Annual Report of the Bureau of Ethnology.*

In 1882, Stevenson led a party of nineteen from Fort Wingate to explore Canyon de Chelly, making archaeological collections for the Smithsonian. Many ruins were examined in the northern canyon, from a headquarters camp at Big Cave about ten miles above the junction with the main canyon. Three miles beyond the ruins in Big Cave, they studied and photographed the large and well-preserved cliff settlement known today as Mummy Cave. In a burial cist in the talus below the main section of buildings, the party found two mummified bodies still wrapped in course nets of yucca fiber. From this discovery, Stevenson named the gorge Cañon de los Muertos.

Stevenson explored about fifteen miles of Canyon del Muerto, making sketches and photographing cliff ruins. In the main canyon, the expedition traveled as far as Monument Canyon. One ruin, the Casa Blanca of Simpson's 1848 exploration, was surveyed by Victor Mindeleff, topographer of the party.

In all, forty-six sites were recorded, seventeen of them in Canyon del Muerto (Powell 1886:xxxiv-xxxvii). The material collected by Stevenson was never published, although some information was incorporated into the Cosmos Mindeleff survey published by the Bureau of Ethnology in 1897.

Stevenson's last work was a detailed description of a nine-day Navajo *Ye'i Bichai* ceremony held in Keam's Canyon. Stevenson was astonished at

the rigid formalism of the complex ceremonies — the singing and dancing by masked figures accompanied by manipulation of feathers, meal, sacred sticks, and other stage properties, including the beautiful sand paintings. The ceremony was to cure an elderly Navajo suffering from inflamed eyes. Only a very wealthy man could afford such an affair. Not only did the head medicine man command an exhorbitant fee in silver, turquoise, and livestock, but the 1,200 spectators, who spent the nine days mainly in gambling and horse-racing, lived for the duration of the ceremony at the expense of the invalid. This final article by Stevenson appeared in the *Eighth Annual Report of the Bureau of Ethnology.*

COSMOS AND VICTOR MINDELEFF, 1883-97

The Mindeleff brothers, Cosmos and Victor, sons of Russian emigrants, became associated with the newly formed Bureau of Ethnology in the early 1880s. Victor, then twenty years old, accompanied the Stevenson expedition to the Southwest and Canyon de Chelly in 1882 to make a preliminary survey of the ruins. Cosmos, the younger brother, joined the Bureau the following year and was sent to the canyon to continue the studies begun by Victor. He made the first accurate map of the canyon complex and discovered many new ruins, bringing the known total to 140.

Victor Mindeleff, with the constant assistance of Cosmos, then went on to make surveys of the Hopi and Zuni pueblos, and in 1891 his monumental work on pueblo architecture was published in the Bureau's *Eighth Annual Report* (1886-87). This was Victor's last work for the Bureau; he then entered private practice as an architect and landscape gardener.

Cosmos continued his work in Canyon de Chelly and other areas, making many careful diagrams and drawings and taking photographs. One of his ground plan sketches appears as Fig. 2.20. For a number of years this skilled craftsman made scale models of prominent Southwest pueblos, which were exhibited at the Smithsonian as well as at expositions in the United States and abroad, giving the general public its first good look at these extraordinary communal buildings. Among the models were reconstructions of White House and Mummy Cave in Canyon de Chelly.

Cosmos Mindeleff did many jobs for the Bureau of Ethnology, including restoration of the Casa Grande ruin in Arizona. In 1897 the results of his long investigation of Canyon de Chelly appeared in the Bureau's *Sixteenth Annual Report* (1894-95), and this work remains the best broad study of Canyon de Chelly cliff dwellings.

Mindeleff's work contains many excellent ground plans of the ruins, detailing rooms and kivas. Much that he saw was misinterpreted, however, as

There were no archaeological guidelines to help him in the 1880s. For instance, the three-story tower at Mummy Cave (Figs. 1.2 and 2.33) was so beautifully constructed that Mindeleff thought it might have been built by Spanish missionaries. He noted the differing styles of construction and the evidence of long occupancy of the canyons; then he classified the ruins in four categories:

I. Old villages in open sites.
> Little surface remains, near streams, marked by pottery and scattered building stone.

II. Home villages on bottom land.
> Generally at base of cliffs, no defense features, not near streams, round and square kivas often present.

III. Home villages located for defense.
> Sites more or less difficult of access, round kivas always present, usually elaborate ground plan.

IV. Cliff outlooks or farming shelters.
> Location on cliffs overlooking farmland, kivas absent, construction area small.

The excellent map in the Mindeleff survey shows the floodplain, talus, arable land, and uplands. In all, there are seventy numbered sites in the main canyon and twenty-nine unnumbered sites in Canyon del Muerto.

BICKFORD, PEET, BAUM, AND PRUDDEN, 1883-1903

F. T. Bickford, an early sightseer and writer, entered Monument Canyon from the rim by way of Bat Trail, traveling down Canyon de Chelly and up del Muerto, where he visited Mummy Cave. He also entered the upper ruin at White House, which has since become completely inaccessible without long ladders.

In 1890 Bickford published an account of his trip, illustrated with woodcuts made from Bureau of Ethnology photographs. It was a popular article but not very accurate — Bickford thought the kivas were water storage tanks!

Other travelers who described the canyon during this period of awakening interest were Stephen D. Peet, a clergyman/anthropologist and publisher/founder of the *American Antiquarian,* which printed Peet's articles in 1898; the Reverend Henry M. Baum, who wrote in 1906 about the ruins in Canyon del Muerto and Monument Canyon; and Dr. Theophil Mitchell Prudden, a pathologist/bacteriologist who devoted the latter part of his life to writing on the Southwest and excavating cliff ruins. His 1903 book describes his travels into Canyon de Chelly.

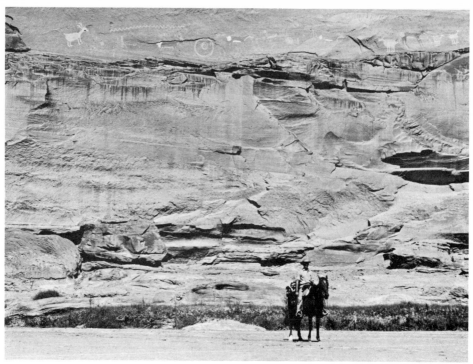

Fig. 3.1. Frederick Monsen at Antelope House paintings, 1890. Since this picture was taken, the area behind Monsen has become a dense cottonwood grove.

FREDERICK MONSEN, 1885-1903

Monsen came to the United States from Norway in the late 1870s with a background as an artist and draftsman. He worked for a time in the newspaper field and later was attached to the Geological Survey, then doing work in the Rocky Mountains. Monsen began his Southwest explorations during the Apache campaigns of the middle eighties. He was soon attracted to Canyon de Chelly and made many trips into the main canyon and its tributaries del Muerto and Monument.

He explored many of the cliff ruins, did considerable excavating aided by local Navajo, and brought back quantities of artifacts and photographs. This self-taught ethnographer lived among the natives of the Southwest for eighteen years and made a superb photographic record of the Indians and their environment.

Monsen established a private museum on Rincon Hill in San Francisco and gave illustrated lectures around the country. His entire collection, including 10,000 glass photographic plates, was lost in the earthquake and fire of April 8, 1906. A portion of his photographic collection in the form of mounted enlargements was acquired by the Huntington Library in San Marino, California, and by the Museum of the University of Oslo, Norway.

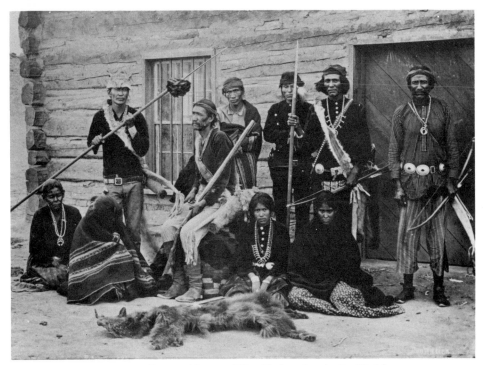

Fig. 3.2. Group of Navajo men and women in front of Sam Day's original trading post at Chinle. The facility later became a part of Cozy McSparren's Thunderbird Lodge.

SAMUEL AND CHARLES DAY, 1902-1905

Sam Day, a veteran of the Civil War, had drifted west as a surveyor and civil engineer. In 1880 he surveyed the first extension of the Navajo Reservation and stayed on to become the chief clerk of the Defiance Indian Agency, a post he held for sixteen years.

In 1902 Sam Day built a large log trading post at Chinle and was quick to realize the possibilities of selling artifacts to collectors. He and his son Charles did much excavating in the cliff ruins and removed artifacts from many sites. Their operations appeared to have had governmental blessing, as on May 8, 1903, the senior Day was appointed custodian of Canyon de Chelly and Canyon del Muerto by the U.S. Department of the Interior.

In 1904, the Days collected fragments of Kachina masks and other paraphernalia from Bee Hive Ruin (one of the very few that is entered from the rim) and sold them to Stewart Culin. J. W. Fewkes of the Bureau of Ethnology later identified the material as belonging to the Hopi Asa Clan, verifying the legend of these people's ancient sojourn in Canyon de Chelly. In 1906, the Days sold a very large and important collection of artifacts to the Brooklyn Museum of Natural History.

Day sold his trading post in 1905 and, after passing through a number of hands, it was acquired in 1923 by Cozy McSparron, who developed the property as the Thunderbird Ranch, later known as Thunderbird Lodge. About the same time, Camille Garcia purchased the original Hubbell trading post property at Chinle, still operating in 1977 as Garcia's Store.

F. M. PALMER, 1906

Dr. Palmer of Los Angeles was curator and recorder of the Southwest Society of the Archaeological Institute of America. His previous interest had been the Indians of Southern California. In 1906 he led an expedition into the canyons, an undertaking sponsored by the institute. No official account of Palmer's trip was ever published, but two anonymous articles appeared in 1907. One of these contained the first English account of the Narbona massacre of 1805 and stated that Canyon del Muerto was so named because of the slaughter at Massacre Cave. This misconception has persisted, despite the fact that the correct derivation from Colonel Stevenson's mummy discovery has been brought to light.

An Archaeological Leader: Earl Halstead Morris, 1923-32

No other archaeologist is so well known for his association with Canyon de Chelly, and particularly its main tributary, Canyon del Muerto, as Earl H. Morris. His career spanned the years when American archaeology was coming of age in the Southwest. In the nineteenth century, as the new country expanded westward, there had been a curious dichotomy in the American opinion of the Indian. The well bred, brought up on the romances of James Fenimore Cooper and Longfellow's *Hiawatha,* pictured the noble red man picturesquely gliding through the woods in his birchbark canoe.

The land-hungry settlers, pushing ever deeper into Indian territory, were killing and being killed in the process. To them, the Indian was the "pesky Injun," a dangerous animal cluttering up good farm and range land. The philosophy that "the only good Indian is a dead Indian" was almost universal in the westward movement.

As the Indian problem was "solved," and the survivors of the unequal struggle were herded onto reservations, the settlers in the Four Corners region began to discover immense amounts of ancient pottery in the innumerable ruins. As already indicated, pot-hunting became a common method of augmenting one's income.

In the late 1880s, Scott N. Morris drifted into the Four Corners area from the Pennsylvania oil fields and went to work as a teamster and freighter.

Earl was born in Chama, New Mexico, and soon afterwards the Morris family settled in Farmington. The elder Morris began pot-hunting in this area, which was rich in untouched ruins at the time. Earl accompanied his father on these digging trips as soon as he was able to walk. Several sizable collections of pottery were later sold to private individuals and to a museum.

In 1903, after spending a number of years hauling and grading in Oklahoma and southern New Mexico, Scott Morris returned to Farmington and resumed potting. The following year he was shot and killed by a business associate, leaving fourteen-year-old Earl and his mother to make out as best they could.

The early twentieth century was an exciting time for American archaeology. In 1908 Edgar L. Hewett organized at Santa Fe the School of American Archaeology (later called the School of American Research) of the Archaeological Institute of America. Hewett had been mainly responsible for the passing of the American Antiquities Act of 1906. Also through his efforts, Mesa Verde was declared a National Monument in 1906 and Chaco Canyon in 1907. An archaeological field school was set up at Page, and young Morris and Jesse Nussbaum were there, learning the difference between controlled digging and potting.

Meanwhile, at the University of Arizona astronomer Andrew E. Douglass was beginning to piece together climate patterns by studying the relative widths of tree rings. He believed that a wide ring meant a wet year and a narrow ring a dry year. Morris began to send tree-ring samples of beams from ruins to Douglass. By establishing charted chronologies from living trees and "floating" chronologies from prehistoric house beams, Douglass hoped that someday the two could be linked into a continuous sequence. Then the ancient ruins could be dated. It would be a long road.

A. V. "Ted" Kidder and Samuel J. Guernsey, sponsored by the Bureau of American Ethnology, had taken to the field in 1914 and were working in the Kayenta area of northeastern Arizona, excavating sites of a cave-dwelling people who lacked pottery but made beautiful baskets. Kidder and Guernsey retained the term first coined by the Wetherill brothers, calling these ancient people Basketmakers. After several seasons, Kidder left the Basketmaker problem to Guernsey and went to Pecos to begin his most famous dig.

Earl Morris went to the University of Colorado and took his M.A. in 1915. That year he was selected to work as an apprentice with a Museum of Natural History expedition in the Galisteo basin. His association with the museum was to prove long and fruitful.

While still at college, Morris had begun excavating in the La Plata region extending north of Farmington into Colorado. There were Basketmaker

burials there, with skulls undeformed by the cradleboards of the ancient pueblo builders, and much crude pottery. Morris was fascinated by this area and would return season after season between other jobs.

In 1916 Morris was selected by the American Museum of Natural History to head the excavation of the Aztec ruins near Farmington. The work on this site was prolonged, and Morris built a home at the ruins in which he would live periodically for seventeen years (Lister & Lister 1968:42). By 1923 the work was completed, and the imposing site was made a national monument. Wherever he went, Morris continued to supply Douglass with tree-ring cores and to watch with great interest the growing but incomplete dating chronologies.

In 1921, Morris took the step that would lead him to Canyon de Chelly. He joined one of the Bernheimer Southwest expeditions. Charles L. Bernheimer, a wealthy cotton-broker and patron of the American Museum, financed and led a series of expeditions into the more spectacular parts of the Four Corners area. During the early years of Southwest archaeology, much of the cost of excavating and publishing was met by such men of means, who were intrigued by the unfolding picture of early man in the canyon country.

Bernheimer went on all his expeditions and later wrote popular articles about the trips. That year and the following, Bernheimer, with John Wetherill as a guide, went through the Kayenta country and around Navajo Mountain and the Rainbow Bridge. In these areas there was not much of interest to Morris, and he did little digging.

The following year, however, 1923, was a major turning point in his career. He married Ann Axtell of Omaha, joined the Carnegie Institution, and began to excavate Mummy Cave in Canyon del Muerto. This magnificent canyon complex had been bypassed by serious archaeologists since the turn of the century in the belief that Sam Day and his son had so disturbed the ruins that no systematic studies were possible. Later work was to show that the Days had barely scratched the surface.

A reconnaissance was made into the canyon with Bernheimer and John Wetherill. What Morris saw at Mummy Cave made him frantic to start work before anyone else beat him to it. Later that season, armed with ample funding and accompanied by his bride, Morris began to dig.

What Earl Morris found as he worked in the talus slope below the Mummy Cave was beyond anything he had ever seen. This was not like the La Plata district or the Aztec ruins, where the open sites had given little in the way of perishable materials. Here the protecting cliff overhangs and the extreme dryness of the air had preserved the most delicate artifacts of the ancient people. Bodies were mummified with skin and hair often intact, elaborate

woven fiber sandals and tumpstraps with geometric patterns were abundant, and there were huge coiled baskets. Morris was digging into a pure Basket-maker level, although the upper ruins dated into the late 1200s. Later, tree-ring dating would show that Mummy Cave had been occupied for at least 1,000 years.

The typical burial has been described in Part Two of this book. In most burial cists, slabs were set vertically to form a circular chamber. The dead, wrapped in rabbit-fur or turkey-feather robes, were placed in these cists with their prized possessions, such as atlatls, flutes, pipes, shell-and-turquoise jewelry, and baskets. Other items were throwing sticks, snares, nets, and digging sticks with crooked ends.

Earl was not particularly interested in the abundant rock art of the area, but Ann, somewhat appalled by the pungent dust stirred by the digging and the grotesque mummified bodies that brought her husband such joy, found the curious ancient rock paintings attractive and began to make watercolor copies of them.

The excavation revealed extensive cribbed retaining walls that the Basket-makers had built to create terraces for additional living space on the steep talus slope. On these terraces were the remains of the circular Modified Bas-ketmaker houses of rock slabs, poles, and clay mortar construction.

Morris next dug into the trash deposit in Big Cave, a tremendous over-hang a few miles below Mummy Cave. This was Basketmaker again, from Early to Modified, with the beginnings of pottery. Here were the remains of turkey pens. A wooden tube was found filled with colored feathers and bird skins, and again there were ornate sandals and other artifacts similar to those in Mummy Cave.

When Morris exhibited some of his finds in New York, he became an overnight celebrity. For the first time the average person could visualize the life of the ancient pre-pueblo people and actually see what they looked like.

The following year, Morris was back at del Muerto to do some repairs on the three-story tower that separates the two halves of Mummy Cave (Figs. 1.2 and 2.33). The archaeologist noted that the foundations had been seriously undermined through erosion and that the entire structure was in danger of collapsing. With Navajo workmen, using the same tough clay mortar as the ancients, he rebuilt the foundation and added a new retaining wall.

After the repair work on the tower, Morris resumed his digging at Mum-my and Big Caves. At the latter, he discovered a burial of an important person that he called the "chief's grave." The mummy was dressed in buckskin and covered with a turkey-feather robe. With him were elaborate shell bracelets, atlatls, a pipe, flutes, and darts. It was here also that Morris discovered the

curious forearms and hands burial described in Part Two of this book. The artifacts from this expedition went to the American Museum and the University of Colorado.

That winter, the Carnegie Institution, noting Morris' skill at restoration, sent him to Chichen Itzá in Yucatán to direct the excavation and restoration of the Temple of the Warriors. Morris would continue to do this work for four more winters.

In 1925, the archaeologist was back in del Muerto, although this time Ted Kidder was in nominal charge of operations. The party was large and included George Vaillant, who was later to make a name for himself by his Aztec studies, and Harold S. Gladwin, just on the threshold of his Southwestern career. This was to be a broad survey of the canyons besides additional digging at Mummy and Big caves.

Ruins were mapped, and much exploring was undertaken. Massacre Cave, a short distance above Mummy, was visited, and fragments of Navajo weaving were recovered from the scattered bones left from Narbona's 1805 slaughter. Morris placed tie rods in the Mummy Cave tower to fasten the structure to the cliff; then the whole party moved on to White House in the main canyon.

The collapse of the five-story structure on ground level had long isolated the upper White House ruins, which were finally entered by Morris with a rope thrown over a projecting beam. The beam was strengthened, blocks attached, and the members of the party were pulled up by Morris. The name Victor Mindeleff was found scratched on a wall in the upper ruin.

At the end of the 1925 season, Kidder withdrew completely from the de Chelly investigations in favor of Morris. The following summer Earl returned to White House to survey the lower ruin and to take some measures for its protection, since the arroyo waters were periodically wetting the buildings and washing them away. The water channel was diverted from the ruin and the damage halted.

In 1927, the first Pecos Conference was held at the Pecos ruins. As noted in Part Two of this book, nearly forty Southwestern archaeologists, including Morris, on this occasion hammered out a tentative chronology for the various Anasazi cultures. The Pecos chronology has stood the test of time, although there have been modifications by later investigators, as shown in Fig. 2.1.

In 1929 Morris went on another Bernheimer expedition into southwestern Utah and later returned to del Muerto for his final five weeks of excavation. A new area was tested across the arroyo from Antelope House, which produced some interesting finds. The most intriguing were some typical Basketmaker cists which held disarticulated skeletons of a number of people who

Courtesy American Museum of Natural History, photo by E. M. Myer

Fig. 3.3. Earl Morris in Canyon del Muerto 1929
excavation, probably Battle Cove, site CDM-7.

had been killed in battle by some alien group. Jaws were broken, skulls smashed, and, in one case, part of the shaft of an arrow and arrow point was still imbedded between two ribs. As the Basketmaker people had had only the atlatl at this time, the bow-and-arrow people could only have been hostile nomads. Later these arrow fragments would be recognized as evidence of the new weapon in Canyon de Chelly. Today the site is known as Battle Cove.

During this season, Ann Morris began copying the rock pictures seriously, and her work was later exhibited at the American Museum. She did copies of the paintings at Antelope House, Pictograph Cave, and Standing Cow Ruin. In 1930, the American Museum used her pictures as the basis for a leaflet, *Rock Painting and Petroglyphs of the American Indian.* Unfortunately Ann Morris did not pursue her project, and no additional studies of Canyon de Chelly rock art were made until the present work.

A highlight of the 1929 season was an unscheduled visit of Charles and Anne Lindbergh to the dig. Earl and Ann had gone off for a short visit to Mesa Verde. The Lindberghs flew to the landing strip on the rim from Pecos,

bringing "air mail" letters from Kidder to del Muerto. After a day of exploring the area, they hiked out.

In June 1929, a major archaeological breakthrough occurred. The missing link between the Douglass dated chronology back to the thirteenth century and the undated Basketmaker and early Pueblo sequences was found by Lyndon Hargrave and Emil Haury in a rotted, burned log at a ruin near the town of Show Low below the Painted Desert. The sample gave a good overlap, and now the tree-ring count ran unbroken back to about A.D. 700.

Archaeologists dealing with the Southwest eagerly accepted the new tree-ring tool, adapting it for future work. Douglass now proposed his Great Drought theory to explain the abandonment of the Great Pueblo cliff settlements at Mesa Verde, the Marsh Pass area, and Canyon de Chelly late in the thirteenth century. Hypotheses that challenge this tenacious premise have been scribed in Part Two of this book.

In the next few years, Morris was digging again in the La Plata area and trying to write up some of his work. He also went on another Bernheimer expedition — this time into the Red Rock region of extreme northeastern

Fig. 3.4. Masonry restoration on the Mummy Cave tower (site CDM-174) supervised by Earl Morris in 1932.

Arizona. Two very important Basketmaker caves were excavated — Broken Flute and Obelisk. In the latter, evidence of the introduction of the bow was found, similar to the Battle Cove example in Canyon del Muerto.

The year 1931 saw the creation of the Canyon de Chelly National Monument, largely as a result of the publicity following Morris' discoveries there. The following year the archaeologist returned to Mummy Cave to do a thorough restoration job on the tower. Figure 3.4 shows how he applied masonry techniques he had learned at Chichen Itzá in the 1920s. This was to be his last work in the canyon he had made so famous.

Throughout the 1930s, Morris continued to dig in the Red Rock country and around Durango, always sending tree-ring samples to Douglass and to Harold Gladwin at Gila Pueblo. But by 1940 his digging was at an end. He was having domestic troubles and had lost his enthusiasm for fieldwork. The final years of his life were spent in writing reports he had put off for so long.

Writing did not come easily for Morris, who found the preparation of a formal report tedious and difficult. It was the joy of field discovery that kept him going. For all the work he did in Canyon de Chelly, Morris produced only five short papers; no major report was ever made. His important archaeological finds gather dust in several large museums, particularly the American Museum of Natural History in New York.

Clues from Tree Rings: Harold Sterling Gladwin, 1925-50

Gladwin is chiefly known for the major excavations he conducted for Gila Pueblo at the big Hohokam settlement at Snaketown on the Gila River. The Snaketown excavations, directed by Emil Haury, shed much light on the extraordinarily rich cultural material of these previously almost unknown people.

Gladwin's chief contributions to Canyon de Chelly archaeology lay in his tree-ring studies, which accurately dated some of the ruins, and in his theory explaining the abandonment of the San Juan basin, which has been summarized in Part Two of this book.

This archaeologist became interested in Canyon de Chelly following an initial visit in 1925 during Earl Morris' third season in Canyon del Muerto. During a three-week period, he explored the canyon from Mummy Cave to Antelope House. By 1930, Harold Gladwin had become intensely involved in tree-ring research and the following year led an expedition to Canyon de Chelly and Canyon del Muerto to collect pottery shards and tree-ring cores.

In 1928 Gladwin established Gila Pueblo, a rebuilt ruin near Globe, Arizona, that served as a research headquarters for his Southwest studies for more

than twenty years. The results of this work — excavations, pottery studies, and tree-ring reports — were published by Gila Pueblo in a series of scholarly reports entitled the Medallion Papers.

Not satisfied with the Douglass methods of tree-ring study, Gladwin originated procedures for preparing wood and measuring samples. The difficulty of accurate ring-counting on charcoal specimens was overcome by controlled sandblasting of end grain to remove some of the softer material between rings. Gladwin then devised a complex machine for moving the core sample automatically under a microscope camera, with the results appearing continuously on paper tape.

For greater accuracy in plotting chronologies, Gladwin worked out a new system wherein each year was rated on its variation plus or minus from a thirty-year running average. Chronologies were worked out for each major archaeological area, and these were then fitted into a master chart covering nearly 2,000 years of dated tree rings.

In 1936, Earl Morris visited Gila Pueblo, and later that year he and Haury collected wood for the Gladwin tree-ring studies in the Red Rock country. In 1940 and 1941, Deric O'Bryan was in del Muerto, the Red Rocks, and southern Utah, making extensive tree corings and collecting burned construction wood. A few years later, Gladwin was publishing the results of his tree-ring investigations and was seriously challenging the validity of some of the earlier Douglass dates.

One of the tree-ring samples brought back from Mummy Cave by Deric O'Bryan in 1940 proved to be of great importance to the tree-ring chronology of the San Juan basin. Digging in the Basketmaker talus debris, O'Bryan found a good-sized Douglas fir log about four feet from the surface. It lay horizontally behind two upright posts and had formed part of the front face of a retaining wall. Axe cuts were apparent on the log ends.

At Gila Pueblo, the outer ring was dated at A.D. 295 and the innermost ring at 59 B.C., thus extending the chronology beyond the time of Christ for the first time. In 1950, the wood was checked by the radiocarbon method at the California Institute of Technology, and approximate dating was verified. The following year, when the specimen was reexamined at the University of Arizona, Gladwin's findings were corroborated, although the cutting date was advanced to A.D. 306.

In the spring of 1950, the Gila Pueblo work came to an end. In 1957 Harold Gladwin published his last book, *A History of the Ancient Southwest*. In this work, he stated that the abandonment of the San Juan basin was not caused by drought but by intolerable harassment by warlike Athapaskan nomads, the Navajo and the Apache.

Later Archaeologists, 1941-51

W. R. HURT, JR., 1941-47

Hurt carried out an archaeological survey at Canyon de Chelly in 1941. On the spur road to the Spider Rock overlook, he investigated two groups of hogan ruins. Wood from these structures has been dated from 1794 to 1864. In 1947, Hurt was again in the canyon, excavating a number of Modified Basketmaker sites and Developmental Pueblo ruins.

DAVID L. DE HARPORT, 1946-51

De Harport is one of the most intriguing figures connected with the explorations of Canyon de Chelly. Shortly after his graduation from the University of Denver in 1945, he began his intensive surveys of the main canyon. He devoted six seasons of fieldwork to the project and spent an additional nine years writing up the 1,600-page report for his Ph.D. at Harvard.

In spite of this major accomplishment, he remains a shadowy figure. His monumental survey of the main canyon recorded 369 sites, of which 153 had rock art, ranging from large panels of painting or petroglyphs to amorphous blobs of clay paint. At this writing De Harport's thesis had not been published, and his printed works were limited to two short preliminary reports and one brief article.

In his survey the archaeologist was assisted by his father, L. A. De Harport. As they had no four-wheel drive vehicle, their work entailed hiking into the canyon from the entrance or descending by way of the ancient and sometimes dangerous hand-and-toe trails. In 1947, the survey was resumed by David alone, the effort becoming increasingly more tedious and inefficient as the survey progressed further up the canyon.

For the seasons of 1948-51, De Harport received grant support, and the work was extended to approximately two months each year. Each site was mapped and photographed; shards and chips were collected, and descriptions were made of any rock paintings or petroglyphs.

In 1950, De Harport had a jeep and the part-time help of his father and one other person. They were able to camp in the canyon, and the work progressed much faster. In 1951 De Harport again returned to the canyon for four months to recheck for any sites he might have missed in earlier surveys.

The sites, consisting of shard areas, chip-and-flake areas, masonry room complexes, slab cists, and painting or petroglyph panels, were found continuously from the canyon entrance to about six miles above Spider Rock. Beyond that point, there was a gap of about two miles and then two final isolated sites.

By 1959, the results of the survey were deposited at the Peabody Museum as De Harport's thesis in archaeology. The work ran to four large typed volumes and an extensive collection of photographs.

De Harport noted that the height of ruins above the canyon floor increased the further up the canyon he went, due to the increasing height of the talus slopes. Near the junction with del Muerto, the ruins were about 100 feet above the streambed, and there was little talus. Near the Window, about twelve miles up the canyon, the shelter ledges were about 200 feet above the canyon floor, while east of Spider Rock at about fifteen miles from the canyon entrance, the ruins were very high, from 500 to 900 feet above the streambed. Access was generally from the bottom although four sites were entered from the rim.

More than fifty of the sites in the upper canyon lacked visible structural features, and were located by shard, flake, and fire-blackened areas. Other open sites had slab cists characteristic of Basketmaker sites in rock shelters. De Harport was in agreement with Morris, who thought the canyons had been a center of Basketmaker culture.

In 1962 De Harport made a number of short trips into the canyon to record examples of vandalism or illicit excavating. His report, which he placed on file at Window Rock, indicated sixteen instances of these destructive activities.

CHARLES R. STEEN, 1949-50

For many years, Charlie Steen was employed by the National Park Service as regional archaeologist for the Southwest. He carried out excavations on the Tonto cliff dwellings near the Salt River in east-central Arizona, in addition to his work in Canyon de Chelly.

In 1949 Steen began the excavation of Tsé-ta'a for the National Park Service. This site lies about 1½ miles above White House and on the same side of the canyon. The ruins, badly damaged by floodwaters, presented little in the way of surface features at the start of the excavation, and the area was packed hard with a foot-thick crust of sheep and goat manure.

The two seasons of digging revealed a settlement dating from Modified Basketmaker times through the Great Pueblo period, with some circumstantial evidence of sporadic occupation by Hopis from the fourteenth to eighteenth centuries. Over all was heaped accumulated trash from two hundred years of Navajo canyon life — sheep bones, peach pits, and the like.

Of the two pit houses excavated by Steen, one was nearly complete, the other half destroyed by stream action. Roughly circular, one was seventeen feet in diameter, the other fourteen. Each had been excavated to about a depth of four feet by the builders, and in one case the excavation was lined

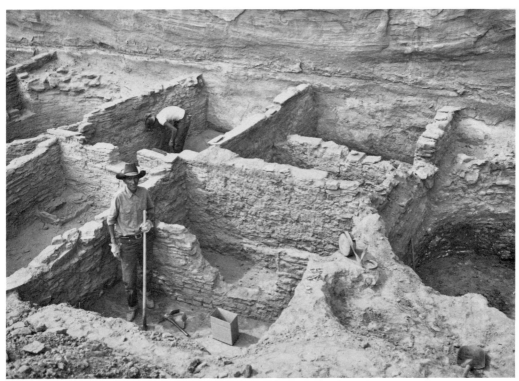

Fig. 3.5. Excavations at Tsé-ta'a (sites CDC-86 & 87) in 1950.

with horizontally laid small flat stones, plastered with adobe, and painted white. In the other, the base of the facing was vertical slabs topped by horizontal stones.

No postholes for roof supports were found in either structure, and De Harport (1953) reported a similar lack of postholes in the only other excavated pit house in the canyon. The pottery shards recovered were mainly Lino Gray, characteristic of the Modified Basketmaker period. The remains of several large charred roof beams were found in the ruins as well as broken turkey and dog bones.

Several masonry houses of the Early Developmental Pueblo period were excavated by Steen. One round structure, fourteen feet in diameter, appeared to be a primitive kiva. Again the stream had cut away half of the building, and it was impossible to say whether an antechamber had been present. Inside the structure was a large, stone-lined storage bin. A square dwelling and a square storage chamber utilized the cliff for a back wall. Kana'a Gray and Kana'a Black-on-white pottery fragments were abundant, diagnostic of the period. Numerous artifacts were recovered, including grooved axes, blades of petrified wood, hammerstones, and projectile points.

Few buildings of the late Developmental Pueblo period remained. Steen speculated that some might have been razed to provide building materials for Great Pueblo structures. Two kivas were excavated, both about twelve feet in diameter. One kiva (three-quarters destroyed by stream action) was entirely subterranean, with a three-foot-high masonry bench built around the room. The other, about seven feet high, was about half below ground level, with niches and a firepit.

The most impressive remains at Tsé-ta'a were those from the Great Pueblo period, superimposed on the remains of earlier structures. Rectangular plastered patches on the cliff wall indicated that once multistories existed, and rock paintings high above the surface could only have been placed there by persons standing on third- or fourth-story levels. Two groups of ruins were excavated, consisting of rows of houses built against the cliff and associated kivas. One had suffered severely from arroyo-cutting, while the other had not been damaged at all.

South Ruin kiva was built exactly on top of one of the kivas described for the previous period. It appears to have been about twenty feet in diameter. Adjoining the kiva was a group of thirteen contiguous rooms of varying sizes. The masonry work was described by Steen as showing Chaco and Mesa Verde influences.

North Ruin structures comprised eighteen rooms and four kivas. None of the kivas had suffered stream damage, and all features were intact. Steen noted that even taking into account the many extra rooms on the upper levels that have vanished, the number of kivas is unusual.

The Navajo remains on the top level consisted of corncribs, firepits, and remnants of old husking floors. Corncribs were often made by roofing over sections of ancient pueblo rooms. Steen discovered many abandoned Navajo metal tools at Tsé-ta'a — twelve axe heads and twenty-four grubbing hoe blades.

Part Four

The
Canyon
Rock Art

The
Canyon
Rock Art

THE SPECTACULAR GORGES OF CANYON DE CHELLY show an unbroken record of Anasazi settlement for more than 1,000 years. Thus it is not altogether surprising that this great culture contains some of the most abundant and diverse rock art ever created by the prehistoric Anasazi.

When these ancient people abandoned their Canyon de Chelly strongholds shortly before A.D. 1300, other groups began to contribute to the canyon rock art. The nomadic and seminomadic farmers and hunters who passed through the canyon off and on for more than 450 years seldom left their marks. However, we do have occasional examples of what may be Hopi rock paintings — masks, stepped clouds, and the like (Fig. 2.38). Some petroglyphs, such as the shield figures at The Wall (also known as Newspaper Rock, site CDC-16), could be evidence of the passing of the Shoshonean Paiute or Ute.

By the mid-1600s, small groups of Navajo were reported by the Spanish in the Canyon de Chelly area (Hester 1962:77-83). By the mid-1700s, these Indians were permanently settled in the great canyon. Their contributions to the rock art of the area have been outstanding.

In the following discussion of Canyon de Chelly rock art, some analysis of the meaning of the paintings and petroglyphs has been attempted. Interpretation of rock art, however, always is difficult and in many cases quite impossible. Many investigators simply make no effort to even theorize on the subject and only cautiously discuss the possible function of rock art when

[*153*]

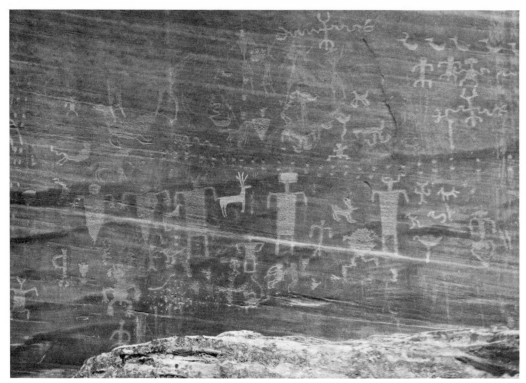

Fig. 4.1. The Wall (Newspaper Rock), site CDC-16, with many uncharacteristic design elements.

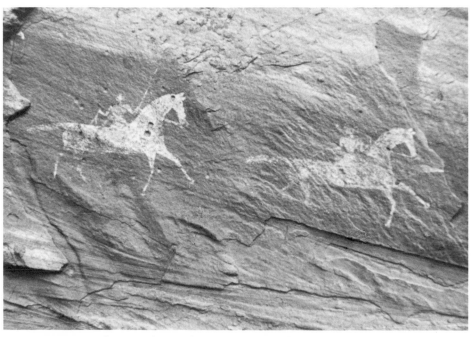

Fig. 4.2. An elegant and spirited Navajo painting of two horsemen at site CDM-221. Note the total realism of the horses and the stiff, hour-glass shaped riders.

Fig. 4.3. Headless birds at site CDM-88. The Canyon Anasazi never indicated wings, but achieved the effect of flight by angling the bird's body and extending the feet to the rear.

ethnological evidence is available. Some nonprofessional collectors of rock art data are just the opposite, readily claiming to be able to interpret the Indian "writing" with great precision (Martineau 1973; Fredericks in Waters 1963). While such attempts to "read" the ancient paintings and petroglyphs are popular with those who must have an explanation for everything, such efforts are mainly pure guesswork.

Since the 1960s, however, much new information has become available on rock art through published reports on many individual sites and regional studies. These works make it possible to set forth at least some broad conclusions.

Rock Art Techniques

Canyon de Chelly rock art falls into the two basic techniques found throughout the world wherever primitive man could find suitable rock surfaces. Whether he would choose to paint or cut into the surface with stone tools was in part dictated by the local geology. Paintings with rare exceptions were executed on light-colored rock in sheltered locations, such as a cave or

Fig. 4.4. Polychrome men with birds on heads at site CDC-74. The bi-colored left figure has lost nearly half his body because of fugitive paint or weak binder.

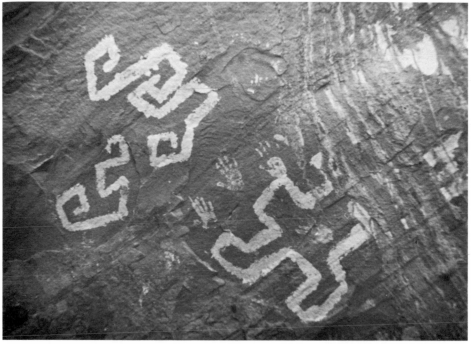

Fig. 4.5. These broadly painted fret designs from the First Ruin (site CDC-47) were probably painted with the finger.

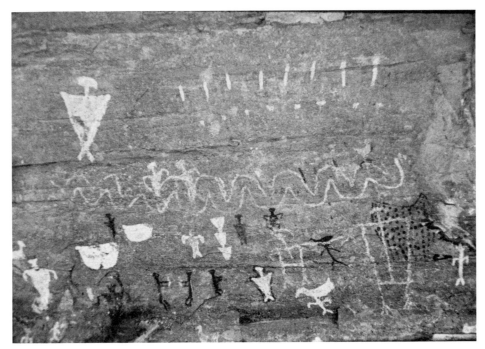

Fig. 4.6. Part of the big panel at site CDM-88 showing careful painting of small figures. The bird-headed man is about six inches high. For additional views of this handsome painted panel, see Figs. 4.3 & A.10.

shallow overhang, where the effect of wind and rain was minimal or non-existent. Given a choice, aboriginal man probably preferred to paint. Painting is far easier and faster than the laborious pecking of a design into hard rock, and much greater detail is possible.

The abundance of rock shelters in Canyon de Chelly cliffs inevitably led to painting as the favored technique. In addition, the variety of colored clays available in the region gave the artists great diversity. During our Canyon de Chelly survey, we noted the following colors: white, yellow, black, several shades of red, green, greenish white, brown, orange, gray, buff, and purple. White, greenish white, and red were commonly used, while black was rare.

Most of these colors were of mineral origin (charcoal for black being a notable exception), but there is evidence that some vegetable colors were utilized. Many of the turkeys appear to be without heads, and occasionally the missing head can be dimly seen. Bi-colored human figures, where the color division was longitudinal, sometimes appear to be only half-figures. Here, it would appear, we are dealing with "fugitive" vegetable colors, probably chosen for their brilliance, which did not stand up over the centuries.

The question of what medium the ancients used as a binder is a puzzling one, and the answer is probably that they used a variety of binders. There

a b c d e

Fig. 4.7. Variations of the Anasazi handprint drawn from Canyon de Chelly sites: a. Normal positive print; b. Negative print; c. Positive print with blank areas painted out; d. Patterned positive print; e. Positive print with grotesque overpainting, in this case, exaggerated finger length. For more examples of handprints, see Figs. 4.17, 4.18, 4.19, 4.24, 4.38, A.1, & A.6.

have been suggestions that blood might have sometimes been used as well as white of egg. Ethnological evidence from California states that the oil from certain seeds was mixed with the finely ground pigment. I have experimented with white of egg, which is an excellent binder, and also with water. Surprisingly, water worked well on a porous stone surface, and painting made with the water binder and a red (hematite) pigment proved difficult to wash or rub off. Watson (1969:4-5) has most sensibly suggested that urine was most certainly utilized. It was readily available and could be carried up and down the steepest cliff paths without danger of spilling.

The raw pigments were ground in stone mortars to a fine consistency, then at the painting site mixed with the binder for application to the cliff wall. Many of the cruder paintings appear to have the pigment applied with the fingers, while more delicate paintings indicate the use of brushes. Excellent brushes can be made of tied and shaped yucca fiber and animal hair. Fine lines are possible by fraying yucca spines and certain twigs.

The many handprints in the canyons are made in a variety of ways. The main type, the positive handprint, is produced by simply placing the hand onto a mass of wet pigment and transferring the impression by pressure onto the wall. By drawing whorls, zigzags, and straight lines on the wet palm with a stick, and then printing, strange and pleasing patterns were created. Face Rock Ruin 1 (site CDC-228) has many examples of these striated and whorled handprints; at other sites a printed hand has had the fingers elongated by painting. Sometimes entire handprints look painted rather than printed.

The negative handprint is more difficult and was not often used. Here the hand is placed in contact with the surface and the area around the hand

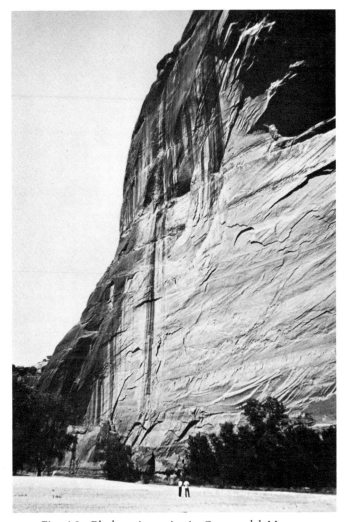

Fig. 4.8. Black patina stains in Canyon del Muerto. These stains rarely reach the canyon floor and were seldom available for petroglyph-making. Other examples of patina streaks can be seen in Figs. 2.30, 2.34, & 2.53.

carefully wetted. Then dry pigment was blown over the hand, where it only adhered to the wet surface around it. Experiments carried out by Douglas Mazonowicz, longtime student of rock art, demonstrated that this effect can be achieved in no other way.

Anyone familiar with Canyon de Chelly can understand one major reason why the petroglyph, or rock-carved design, was never very popular in this area. There simply are not very many surfaces where petroglyphs can be made. The petroglyph is created by pecking, abrading, scratching, or incising the surface of a darkly patinated rock surface so that the pattern stands

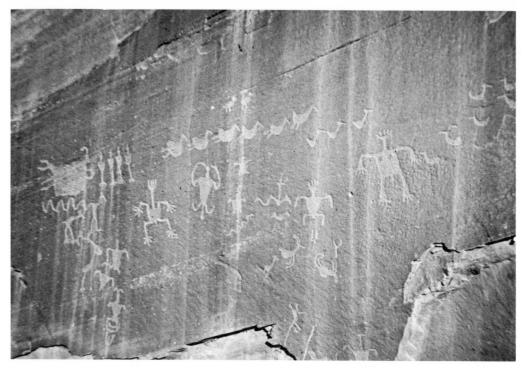

Fig. 4.9. Shallowly pecked petroglyphs of the Great Pueblo pe-
riod at site CDC-143. Note the effect of flight in the row of birds.

out as light on dark — a negative effect. Most of the brown-black patinated
surfaces in Canyon de Chelly occur as tremendous dark streaks high on the
cliffs, the result of summer thundershower runoff over super-heated rocks.
With drying, capillary attraction brings mineral material to the surface, cre-
ating over the centuries the dark surface staining, or patina. When the pecking
stone fractures the surface, the natural color of the stone is revealed. In the
breaking of the surface, the contrast is even more intense, due to the splinter-
ing of the rock granules. A similar effect can be noted when glass is fractured.

When the petroglyph-makers worked on wall faces near the bottom of
the cliffs, where patina formation was slight or nonexistent due to sand-blasting,
the petroglyphs were very deeply cut so that they would be visible (especially
in an oblique light) despite minimal contrast.

Pecking was done either directly with a pointed stone of a harder con-
sistency than the surface to be pecked or, if fine detail was to be done, indi-
rectly with a hammer-stone and pointed chisel-stone. Abrading was accom-
plished by a scraping action with the flat edge of a stone, usually to give a
tone to the body of a large figure previously outlined with the pecking stone.

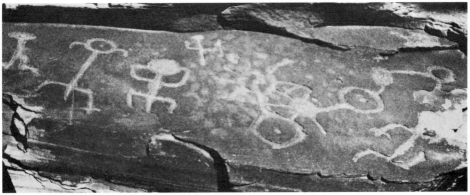

Fig. 4.10. Deeply pecked petroglyphs from a ledge above the main ruin in Three Turkey Canyon, just south of Canyon de Chelly. The ruin is Great Pueblo; probably the rock carvings are of the same era.

Incising involved an engraving or carving action with a sharp tool on soft rock. Scratching was a superficial breaking of the rock surface with a pointed tool.

Problems of Dating Rock Art

Archaeologists have been able to separate the various Anasazi periods through study of ceramics, types of masonry, architectural styles, and cultural material, but the problem of assigning rock art styles to specific archaeological periods is extremely difficult. For instance, if the artifacts in a certain area are all Basketmaker, then the associated rock pictures can be assumed to be of Basketmaker origin. Kidder and Guernsey (1919) found just these conditions in the Marsh Pass region of northeastern Arizona. However, suppose that a site has been continuously occupied from Basketmaker times through the Great Pueblo era. How do you separate the many design motifs into periods?

The dirt archaeologist can rely on stratified cultural material in his digs for relative dating and use radiocarbon or tree-ring dating for perishable material. To date rock art from such a continuously occupied site, the student has far less accurate tools at his disposal. The most valuable aid is the comparison of design elements and style with other areas, where such drawings occur in association with a known and dated culture period.

Sometimes the problem is highly confusing. At Mummy Cave in Canyon del Muerto, there are tree-ring dates from A.D. 306 to about A.D. 700 showing Basketmaker and Modified Basketmaker occupancy; tree-ring dates for

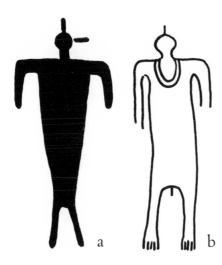

Fig. 4.11. Characteristic Basket-maker figures: a. Painted in red at site CDM-7; b. Outlined in red at site CDM-263.

the tower cluster at about 1284. Bannister (1966) thinks that it is likely there was continuous occupation at Mummy Cave for at least 1,000 years. One would expect to find a great deal of rock art at such a settlement. Actually, there is almost no rock painting at this site, and what there is appears to be of the Great Pueblo period.

As I will discuss later, I believe that the great period of rock art in Canyon de Chelly came during the Developmental Pueblo period, and, as no examples of this style of rock art occur at Mummy Cave, there is a good argument that there was no occupation at this site between the Modified Basketmaker period and the major construction of the Great Pueblo period.

As previously noted, the Pecos cultural chronology of 1927 for the San Juan drainage and Robert's 1935 modification of this chronology are arbitrary time scales designed for the convenience of investigation. Actually, no such clear-cut stages existed during the development of the Anasazi, but there was rather an unbroken sequence from Basketmaker through Great Pueblo, punctuated by influences from the outside, such as the introduction of pottery, new types of corn, true masonry, and rock-art styles.

The rock art was a part of this development and was continuous from beginning to end with remarkably little change. Canyon de Chelly rock art over a period of more than 1,000 years can be very roughly summarized as follows: first, simple beginnings at a few sites; then a high development throughout the canyons, with complex panels in great numbers; and finally a period of decadence in execution and design, possibly indicating that rock art no longer played a very important role in the lives of the canyon people, or that disruptive influences from the outside were destroying old concepts.

Basketmaker rock art exemplifies the chronology problems, for clues to dating these paintings are few. Kidder and Guernsey (1919), in their Marsh

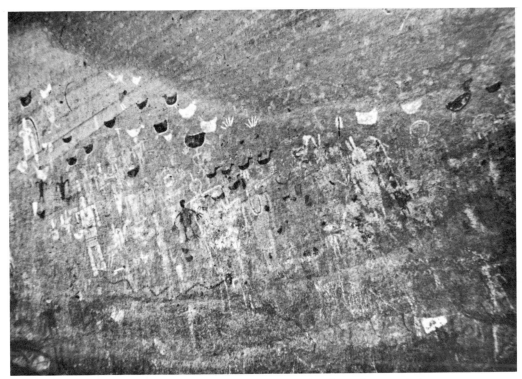

Fig. 4.12. Part of a large painted area (site CDM-263) with much overpainting and many birds. The earliest figures appear to be the large outlined humans.

Pass explorations, identified large human figures with long triangular or trapezoidal bodies with strictly Basketmaker sites. Arms and legs were long and heads small, often with indication of a feathered headdress. The only other common motif occurring in conjunction with these large figures were handprints. Basketmaker sites in southeastern Utah, such as those in the Grand Gulch area, were similar.

Thus, wherever these figures occur in Canyon de Chelly, they can be presumed early — probably Basketmaker — although the making of such paintings might have continued well into Modified Basketmaker times or even later. Where such figures are found at known Basketmaker sites, or where Basketmaker cultural material underlies that of later periods, a positive identification is possible.

So our best method of dating the early rock paintings in Canyon de Chelly is through association with artifact material of the Basketmaker period and by subject matter. Other dating methods, such as superimposition of styles and amount of erosion, can be helpful in certain situations. Often there are sharp, well-defined figures over dim, highly eroded designs. This, of course, indicates only relative chronology, but if the dim under-figures are of the

large Basketmaker human type, we can with some assurance ascribe them to that period.

Repatination of the pecked areas of petroglyphs is a good relative dating tool, as the earliest petroglyphs will often have been repatinated to the original surface coloring. However, this is no aid for Basketmaker times, since the first petroglyphs occur a little later.

The bulk of the canyon paintings fall in the longest time span — Modified Basketmaker/Developmental Pueblo (A.D. 450-1100). I have lumped these two periods together, as there seems to be no way to be more specific. Association with pottery and masonry ruins is a major aid in placing this middle period, but in the long view it is the style and subject matter of the panels that distinguish the rock art of this time span. Likewise the rock painting of the final, or Great Pueblo period, is fairly easy to identify if certain clues are present.

Basketmaker Rock Paintings, ? to A.D. 450

As described earlier, the basic Basketmaker painting was the large human figure, always front view with hands down, either solidly painted or linear with square-shouldered, tapering body, usually in conjunction with positive handprints (Kidder & Guernsey 1919:198). The colors were red, yellow, and white. Sometimes there were polychrome designs on the torsos of the figures. At other definitely Basketmaker sites, we recorded zigzags and men with necklaces or feathered headdresses. At site CDC-172, Window Rock Ruin 3, and at CDC-14, Cottonwood Ruin, there were large outlined men with handprints stamped on their torsos.

Of the bewildering variety of human forms in Canyon de Chelly, none are as curious as those at Ear Cave (site CDM-123) near Many Cherry Canyon. Here there are many large figures, apparently of Basketmaker origin, with decorated bodies and appendages on top of their heads and protruding from their left ears. These appendages vary from thick lines to ear-trumpet-appearing shapes, with a number of elipses that look like sound-wave symbols. Some have very large hands and feet. Several single instances of the "ear" figure were noted in the canyons at sites CDM-7, CDM-263, and CDC-172.

In the Canyon de Chelly area there seems to have been somewhat more variety in Basketmaker subject matter than at the Marsh Pass sites. For example, at site CDM-214, Atlatl Cave, there is a painting of an atlatl. This depiction of these primitive people's all-important hunting tool is the only known representation of a weapon in Canyon de Chelly Basketmaker rock art. Surrounding the atlatl is a row of small polychrome birds and several "looped-arm" humans.

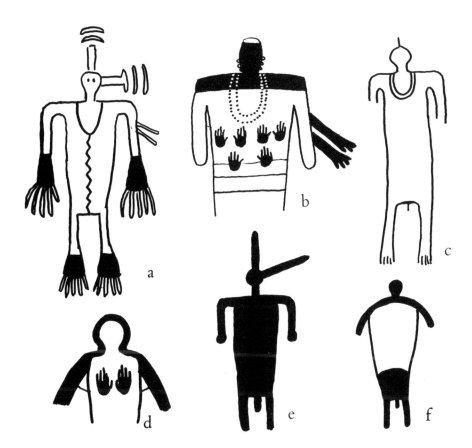

Fig. 4.13. Typical Basketmaker male figures: a. & e. Painted in red and white at site CDM-123; b. & d. Painted in red, brown, and buff at site CDC-124; c. Outlined in red at site CDM-263; f. Painted in red at site CDC-138. For photo of Drawing a, see Fig. 4.14.

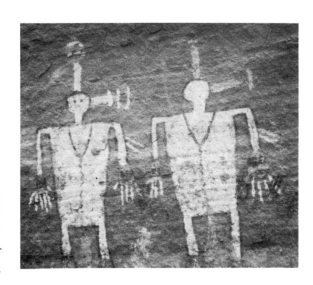

Fig. 4.14. "Ear" men from site CDM-123. The parallel lines attached to their left arms may indicate feathers. For additional examples of ear men, see Figs. 4.13 & A.11.

As noted in Part Two of this book, archaeologist Earl Morris found Basketmaker cultural material at Mummy Cave, Big Cave, and at Battle Cove Ruin in Canyon del Muerto; there were Basketmaker paintings at the latter two sites. At the fourteen Basketmaker painted sites listed below, there were only a few figures (aside from handprints) at each cave. There could not have been many people in the canyons at that early period, and their painting record is meager.

Basketmaker Painted Subject Matter

Human Types
- With headdresses
- Without headdresses
- With decorated torsos
- With handprints on torsos
- With solid color
- With left ear appendages
- With linked hands
- With large hands and feet
- Holding objects

Other Subjects
- Handprints in various colors (positive)
- Zigzags
- Atlatl

Basketmaker Painted Sites

CDC-54	Bad Trail Ruin
CDC-99	Big Yellow Man Panel
CDC-106	Dancing Man Site
CDC-121	Painted Room Ruin
CDC-174	Window Rock Ruin 1 & 2
CDC-172	Window Rock Ruin 3
CDM-3	Black Bull Cave
CDM-7	Battle Cove Ruin
CDM-123	Ear Cave
CDM-263	Blue Bull Cave
CDM-155	Big Cave
CDM-214	Atlatl Cave
CDC-14	Cottonwood Ruin
SC-1	Wild Cherry Ruin

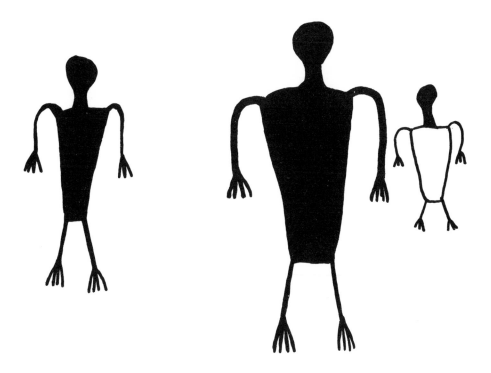

Fig. 4.15. "Loop-armed" men from shelter just east of Mummy Cave, site CDM-214.

Interpretation of Basketmaker Subjects

Primitive man had to somehow appease the unseen forces that filled his life with uncertainty and terror. The elements had to be placated lest they destroy him. The causes of sickness must be ferreted out by the shaman and exorcised by singing, praying, or using effigies and sacred objects. Life had to be prolonged and, when ended, the person had to be sent into the hereafter with appropriate ceremonies lest his spirit return to plague the living.

Somewhere along the line, early man hit on the idea of decorating his surroundings with paintings and carvings of beings and objects that would enrich and aid his religious experience. Man is still doing this in his cathedrals, synagogues, and mosques.

It would appear likely that there was ceremonial motivation behind the creation of the characteristic Basketmaker motif — the large front view human figure. These impressive paintings might have represented supernatural beings or shamans personifying such beings. Likewise, the curious appendages of the ear figures, such as those at Ear Cave, would appear to mark a special sort of being or diety. Since these strange figures appear singly at only a few sites other than CDM-123, they are probably an intrusive idea from another area, as will be later discussed.

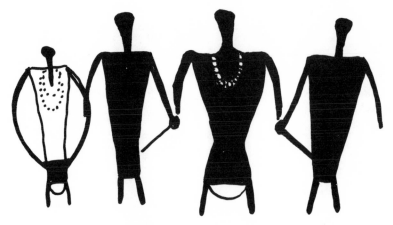

Fig. 4.16. A well-integrated group of human figures at site
CDM-123. Probably Basketmaker or Modified Basketmaker.

The other characteristic Basketmaker motif was, of course, the handprint,
that most basic of all rock art symbols. In the Paleolithic caves of southern
France and northern Spain, there are many examples of such prints, both
positive and negative. Some show finger amputation, as do some handprints
in Australia, where finger amputation as a sign of mourning for a relative
was practiced until recent times. The amputation was done joint by joint —
one for each vanished relative. No such mutilation appears, however, in Can-
yon de Chelly examples.

Handprint rock decoration appears in the canyons at all periods, and it
is not difficult to understand the reasons why. The hand is perhaps the most
useful and valuable part of man's anatomy, particularly to primitive man.
In addition, it is an identifying symbol. If I put my handprint down on paint
and then impress it on a rock surface in a sheltered spot, I have made my
mark, and it will endure long after I am gone. What is more, it is by far the
easiest kind of wall painting, no skill whatever being needed. The result is
not only instantaneous but aesthetically pleasing.

Modern Pueblo Indians consider the handprint a kind of signature. The
plasterer of a room will often mark the finished job with a print, and a cere-
monial leader on completion of a ritual might mark a wall with a clay-daubed
hand as a final touch. The pre-Columbian Maya observed the same custom,
and the erosion of stucco and plaster from limestone building stones will
often reveal the red handprint signature of the ancient stone mason. Sacred
spots were sometimes marked by a handprint so that the supernatural beings
would know who had made the supplications and offerings (Ellis & Hammack
1968:36). The handprints on the torsos of the large human figures at Window
Rock 2 (CDC-172) might represent a similar wish for identification with
the supernatural world.

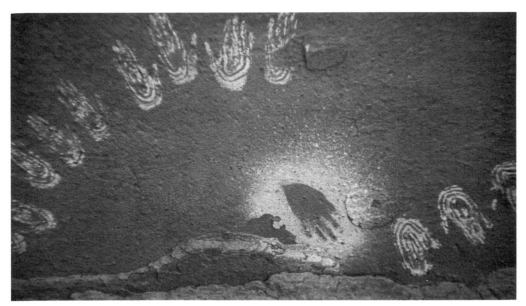

Fig. 4.17. Negative and striated handprints from site CDC-25.

Red handprints occur in connection with several figures on the Kuaua kiva murals. In one scene, the handprints are in the rectal area of a dual deity (divided in half longitudinally), and in another instance the handprint is over the same region of a duck. According to Dutton (1963:179), handprints are often an expression of sympathetic magic indicating the wish of the maker to bring forth whatever is depicted, such as clouds or deities. The red handprint is also a symbol for the elder war god. The Hopi had a Hand Kachina.

Fig. 4.18. Horned figure surrounded by handprints at Massacre Cave, site CDM-176.

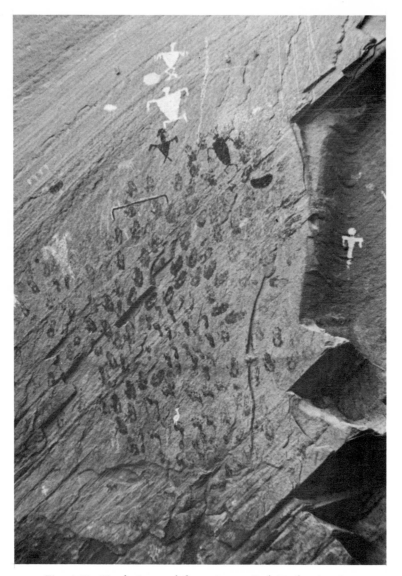

Fig. 4.19. Handprints and footprints at Bad Trail ruin, site CDC-54. The footprints are unusual. High above the floor of the alcove, these paintings were probably done from house roofs.

There was a large red-and-white hand painted on the mask of this figure. The Zuni had a similar being (Fewkes 1903).

The distinct lack of pictured hunting weapons and game animals at Basketmaker sites indicates that these early people were primarily foragers and primitive agriculturists, not hunters. The depiction of birds at Atlatl Cave may be an early indication of the later preoccupation of the canyon dwellers with birds, especially the turkey.

Fig. 4.20. Identifiable birds in Canyon de Chelly rock art: a. Red-and-white turkey at site CDC-34; b. Red-and-black duck at site CDM-263; c. Crane petroglyph at site TWT-1.

Modified Basketmaker/Developmental Pueblo Rock Paintings, A.D. 450-1100

During the long span of the middle period (Modified Basketmaker/Developmental Pueblo), about 650 years, Anasazi rock art reached its peak in the canyon and began its decline into the Great Pueblo period decadence. The panels are often large and crowded with many small figures. The workmanship is excellent, and polychrome designs are abundant. Old forms were elaborated and diversified endlessly.

After the Basketmaker period, birds became an important rock art motif in the Four Corners region. The major concentrations of painted and pecked birds are found in Canyon de Chelly. The species that can be identified with certainty are the turkey, the duck, and the crane. Ducks are fairly numerous, but cranes are rare. Turkeys are by far the most abundant birds in the rock art.

In the execution of these bird pictures, the canyon Anasazi achieved their closest approach to realism. Ducks are shown with chunky bodies and short legs and bills, while cranes are indicated with long legs, necks, and bills.

Most of the turkey pictures are located in the lower San Juan drainage, especially in Canyon de Chelly. Probably domesticated during the Developmental Pueblo era, this big bird evolved into the most intriguing of Canyon de Chelly rock art motifs.

The conventional gobbler is basically a bi-colored bird, with head and neck of one color and the body another. The beak is usually curved downward and sometimes the fleshy protuberance on the forehead is depicted. Turkeys are usually shown with two legs, never with feet, and occasionally with only one leg or with four legs! Wings are never indicated, but an effect of flight is achieved by extending the neck of the bird forward and angling the feet back.

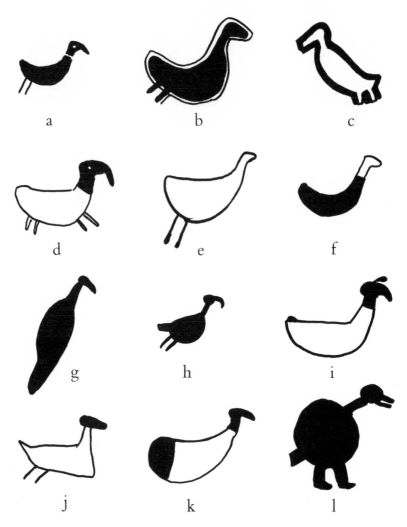

Fig. 4.21. These Anasazi turkey types are all Modified Basketmaker/Developmental Pueblo except g., h., and i., which are Great Pueblo. Note bird d., with four legs. a. & e. Painted in red and white at site CDM-88; b. & c. Painted in red and white at site CDM-123; d. Painted in gray and white at site CDM-128; f. & i. Painted in red, brown, and white at site CDC-34; g. Painted in white at site CDM-3; h. Petroglyph at site CDC-16; j. & k. Painted in red, brown, and white at site CDM-2; l. Painted in white at site CDC-229.

Often birds appear perched on the heads of humans or even in place of the human head. Not all of these perching creatures appear to be turkeys, but in a significant number of instances the big bird is unmistakable. Many of the turkeys are apparently without heads or necks, leaving only the flat-backed, round-bellied body and thin legs. However, as noted in the discussion of techniques, this headlessness is probably due to the fact that the heads

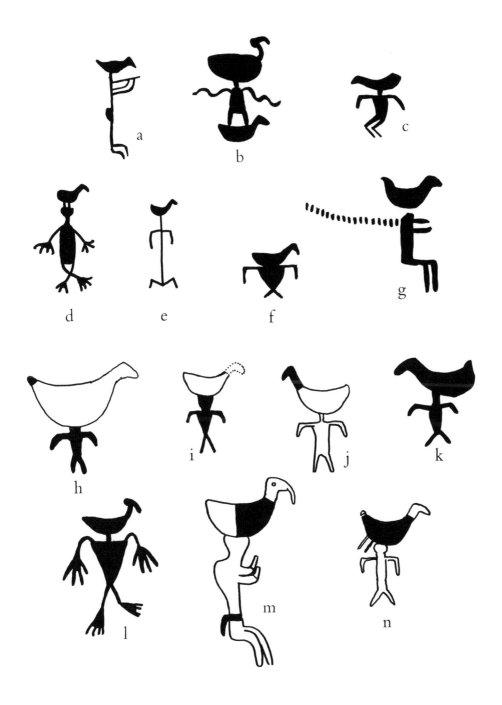

Fig. 4.22. Varieties of bird-headed human figures. The top three examples are petroglyphs; all the others are paintings. a. site CDC-16; b. site CDC-138; c. site CDC-34; d. site CDC-172; e. & f. site CDC-54; g. & n. site CDC-28; h. & i. site CDM-88; j. & k. site CDM-37; l. site CDM-123; m. site CDM-128.

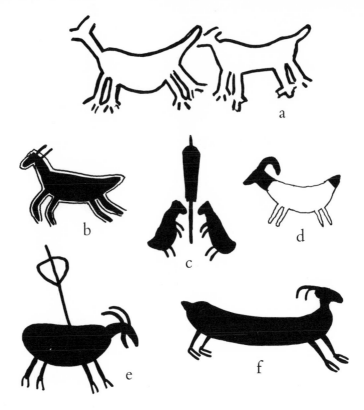

Fig. 4.23. Modified Basketmaker/Developmental Pueblo animal shapes:
a. Painted in white at site CDC-172; b. Painted in brown and white
at site CDM-123; c. Painted in white at site CDC-78; d. Painted in
red and white at site CDM-88; e. & f. Petroglyphs at site CDC-21.

were originally painted with a fugitive red color that completely disappeared
in many cases and could only be dimly seen in other instances. Much of the
Lino Gray pottery of the Modified Basketmaker period shows traces of a
similar fugitive red color, offering a strong clue to tie the "headless" birds
into the Modified Basketmaker period.

Guernsey (1931:14) noted several of these headless turkey/man combi-
nations in the Marsh Pass area and mistakenly interpreted the appendages as
baskets. De Harport (1958) made a similar misinterpretation during his Can-
yon de Chelly survey, calling them "lazy crescents."

Another significant introduction of this period is the bighorn sheep, con-
sidered in greater detail in the discussion of Modified Basketmaker petro-
glyphs. The painted animals, all in Canyon del Muerto, in the main resemble
the rock carvings, although some of the painted bighorn show a single heavy
curled horn in place of the typical paired wire-thin horns adorning the petro-
glyph sheep.

Handprints continued to be a favorite type of rock decoration, and sev-
eral new techniques appeared besides the basic, positive paint-daubed print.

Fig. 4.24. Negative handprints are relatively rare in the canyon, but at site CDC-107 there is a fine band of this distinctive motif.

Some were now done in negative, with paint blown around the hand placed against the wall. Others have had vertical line and scroll patterns traced onto the paint-smeared hand before imprinting onto rock. This latter technique continued into Great Pueblo times.

The large human figure characteristic of the Basketmaker period may have continued well into Modified Basketmaker times, but the highly stylized men grew progressively smaller, Often small humans, especially those with triangular bodies, were arranged in rows. Other round-bodied figures were holding hands in daisy-chain fashion (CDM-88). Some single figures were shown with lines of dots radiating from their heads, suggesting feathered headdresses.

There is a notable break in the strictly front-view figure of Basketmaker times, and in the climax period of canyon rock art (probably mid-Developmental Pueblo), figures are shown in profile, especially as seated humans, often playing the flute. Trial and error had shown the artists that without a knowledge of perspective the seated figure and the act of flute-playing could be depicted only in profile. They had long before adopted the convention of doing animals from this view, choosing the most obvious position to show the basic parts. In this way they were approaching in primitive fashion the solution

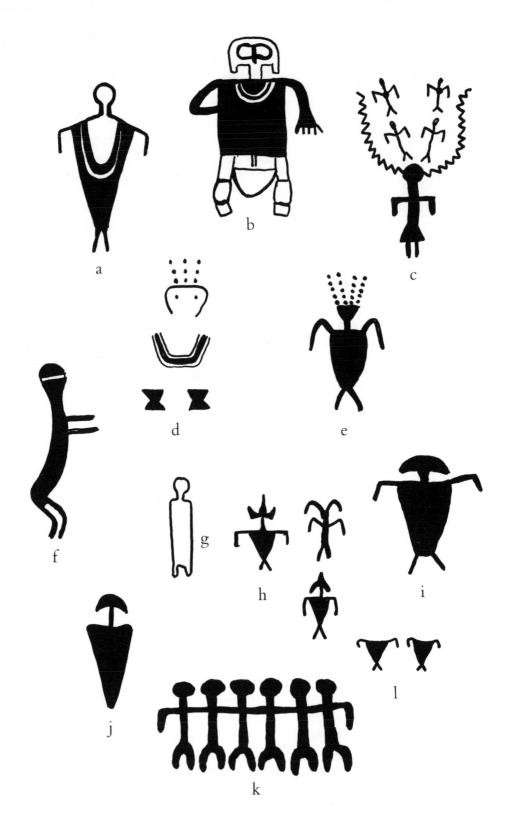

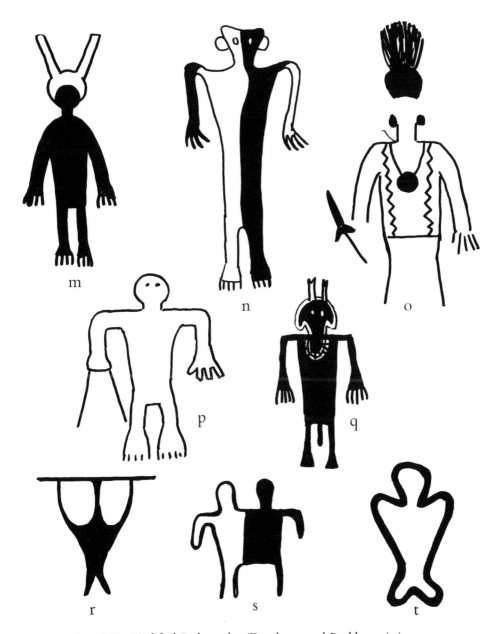

Fig. 4.25. Modified Basketmaker/Developmental Pueblo variations on the human figure: a. Painted in red and buff at site CDC-54; b. Painted in brown and white at site CDC-34; c. & d. Painted in red and white at site CDC-78; e., f., & g. Painted in red and white at site CDM-88; h. Painted in white at site CDC-54; i. Painted in red at site CDM-37; j. Painted in red at site CDC-54; k. Painted in white at site CDM-88; l. Painted in red at site CDC-174; m. & o. Painted in brown and white at site CDC-121; n., s., & t. Painted in yellow, red, brown, and white at site CDC-139; p. Outlined in white at site CDC-25; q. Painted in red and white at site SC-1; r. Painted in red at site CDM-176. For photo of Drawing c, see Fig. A.4.

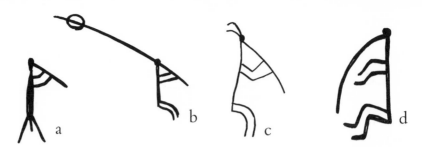

Fig. 4.26. Anasazi stick-figure flute-players. a. Painted in white at site CDC-110; b. Deeply pecked petroglyph at site CDC-40; c. Shallowly incised petroglyph at site CDC-113; d. Deeply incised petroglyph at site CDC-143.

of the ancient Egyptian artists, who, also lacking perspective, showed each part of the body in its most recognizable form, combining front and side views in the same figure. Canyon de Chelly artists also began to experiment with walking stick figures in profile (CDM-88), breaking with the long tradition of rigid, static depictions of humans.

During this period there were many examples of flute-players but none of the humped-backed recumbent flutists of the final canyon phase. Some are twinned with "rainbow" effects over their heads, as at site CDC-78, Pictograph Cave. At this same site, there are a number of unique designs, implying that rare phenomenon, an individualistic artist in a society with rigid artistic traditions. One small man has what looks like thought-wave patterns of tiny human figures coming from his head, and another composition is of two animals flanking a baton or projectile shaft in almost heraldic position.

There are few representations of women, who are always rare in rock art. Female figures are usually identifiable by square blocks alongside the head, indicating hair coiling over the ears, and sometimes by genitalia. This traditional stylization of women continued into Great Pueblo times. At one site (CDM-88) that includes many kinds of figures not found elsewhere in the region, women are indicated with hips or breasts. Phallic males are not common.

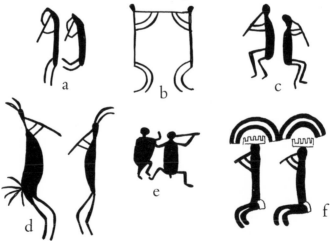

Fig. 4.27. Developmental Pueblo/Great Pueblo twinned flute-player types: a. Painted in white at site CDC-302; b. & d. Incised petroglyphs at site CDC-113; c. Painted in white at site CDC-121; e. Petroglyph at site CWC-2; f. Painted in red and white at site CDC-78. For additional twinned men, see Fig. A.2.

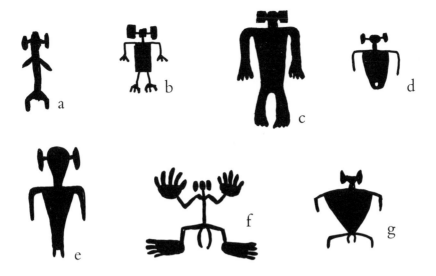

Fig. 4.28. Anasazi depictions of women. With the exception of c (Developmental Pueblo) and d (Modified Basketmaker through Early Developmental Pueblo), these figures were all found at Great Pueblo sites: a. Painted in white at site CDC-302; b. Petroglyph at site CDC-16; c. Painted in white at site CDC-25; d. Painted in white at site CDM-214; e. Painted in white at site CDC-34; f. Petroglyph at site TYK-10; g. Painted in red at site CDC-110.

Often figures, especially those arranged in rows, lack limbs or heads. The variations include every possible combination — headless, armless, legless, and so on. This convention is not unique to the Canyon de Chelly region but is widespread throughout the Southwest. The most notable example of this curious idea is found in the big anthropomorphs of Barrier Canyon, Utah, which lack arms and legs, giving the great figures the effect of mummies.

A few human figures at CDC-138 and SC-1 are in outline, with decorated bodies and headdresses of one or more crescent shapes. Other stick figures have a crescent or hammer shape for a head.

There are few abstract patterns in this period. While the principal one is the ubiquitous zigzag that occurs in all periods, artists of this time span also painted the concentric circle and the spiral.

Fig. 4.29. These unorthodox styles of representing the female form are all painted in red and white at site CDM-88.

Human Types

Triangular bodied, linear
Triangular bodied, solid
With radiating dot headdresses
Without arms
Without legs
Without heads
Rectangular bodied, linear
Rectangular bodied, solid
Polychrome (bisected longitudinally)
With ear ornaments
With crescent headdress
Hammer-headed
Impaled by arrow
With huge hands and feet
Phallic
With turkey on head
With unidentified bird on head
With turkey for head
With bighorn on head
Holding arrows
Seated
Flute-players
Females, hipped or with breasts
Females with hair whorls
Twinned figures
Twinned flute-players
In rows or with hands joined
With club
Stick men

Other Animate Types

Turkeys, four-legged
Turkeys, two-legged
Turkeys, one-legged
Turkeys, twinned
Turkeys, leaping
Turkeys, outlined
Turkeys, solid color
Turkeys, polychrome
Ducks
Birds, miscellaneous
Dogs or coyotes
Bighorn, solid
Bighorn, outlined
Bighorn, polychrome
Bighorn, impaled
 with arrow or spear
Animal tracks
Animals (deer?)
Positive handprints
Negative handprints
Patterned handprints

Inanimate or Abstract Subjects

Arrows and spears
Rows of dots
Polychrome arched lines
Parallel lines
Zigzags
Concentric circles
Spirals

Main Canyon

CDC-28	Antelope Point 1
CDC-34	Sleeping Duck Ruin
CDC-41	Wall With Lightning
CDC-49	Bighorn Ruin
CDC-54	Bad Trail Ruin
CDC-70-72	Four Hole Site
CDC-74	Cable Cave
CDC-78	Pictograph Cave
CDC-92	Deadman Cove
SC-1	Wild Cherry Ruin
CDC-112	White Sands Ruin
CDC-121	Painted Room Ruin
CDC-120	Big White Men Site
CDC-131	Bulls-eye Cave
CDC-174	Window Rock Ruin 1 & 2
CDC-172	Window Rock Ruin 3
CDC-229	Face Rock Ruin 2
CDC-302	Crawling Men Ruin

Canyon del Muerto

CDM-141	Two Spiral Shelter
CDM-128	Flute-player Cave
CDM-37	Big Hand Ruin
CDM-88	Ceremonial Cave
CDM-34	Stipple Cave
CDM-2	Ledge Ruin
CDM-3	Black Bull Shelter
CDM-237	Purple Men Ruin
CDM-123	Ear Cave
CDM-67	Many Turkey Cave
CDM-263	Blue Bull Cave
TWT-1	Twin Trail Ruin
CDM-201	Crack-in-Rock Site
CDM-155	Big Cave
CDM-168	Two Turkey Ruin
CDM-214	Atlatl Cave
CDM-176	Massacre Cave
CDM-245	Whirlwind Cave

Other Side Canyons

BCH-2	Thunderbird 2
CWC-8	Ye'i Cave
CDC-14	Cottonwood Ruin
CDC-25	Shaman Site

Modified Basketmaker/Early Developmental Pueblo Petroglyphs

Probably sometime during the Modified Basketmaker or Early Developmental Pueblo period, the Anasazi began to develop skill in a rock art technique entirely different from painting. This was the rock carving, or petroglyph. Perhaps it was introduced into the canyon by the same people who brought pottery to the Basketmakers. In the extensive Basketmaker sites in the Marsh Pass region, no petroglyphs were found (Guernsey & Kidder 1921: 113). However, at a later time, probably during the Great Pueblo period, petroglyphs became abundant.

Fig. 4.30. Petroglyph men holding stone clubs at site CDC-138. The left and right figures were made much larger than the central figures, and their clubs were greatly exaggerated in size, probably to enhance their importance, or "power." To the western eye, however, this technique gives a distinct feeling of perspective.

As mentioned earlier, petroglyph artists in Canyon de Chelly were severely hampered by a lack of accessible darkly patinated surfaces. Most of the brown-black streaks of color occur high on the rim, seldom reaching the ground. In certain protected areas not subject to sand-blasting by the wind or scouring by sand-laden floodwaters, there are many rock-carved pictures. Two narrow side canyons, Cottonwood and Tunnel, are examples of such petroglyph-rich areas. Along the canyon floors, the petroglyphs occur on small protected zones of patina or on panels where the patina is slight to non-existent.

There are not many petroglyph sites that can be attributed to this early period, and the motifs are few. The most characteristic shape is a curious bighorn sheep with gaping mouth and large hoofs that look rather like crab claws. This distinctive way of portraying the bighorn gives us an excellent dating clue for these earliest of Canyon de Chelly petroglyphs. In the 1920s,

Fig. 4.31. Crab claw bighorn petroglyph at site CDC-40.

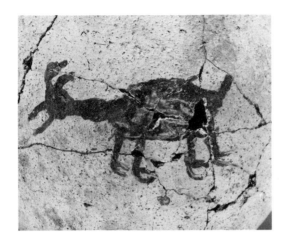

Fig. 4.32. Detail of a Kana'a Black-on-gray jar found in Mummy Cave. The crab claw bighorn is almost identical to the one shown in Fig. 4.31.

Courtesy American Museum of Natural History

when Earl Morris excavated many artifacts at Mummy Cave in Canyon del Muerto, he found a typical piece of Kana'a Gray ware from the Early Developmental Pueblo period (A.D. 700-900) decorated with a single bighorn in black. This depiction of the animal is identical with those pecked into the canyon walls.

The humans associated with the sheep pictures resemble the painted figures of the same period, but certain unique motifs are found only at these petroglyph sites. Among these are bear and bird tracks, and a vulva. Rock-carved turkey-headed humans such as those in the rock paintings also often are found in association with the crab-clawed sheep petroglyphs.

Nearly all Modified Basketmaker/Early Developmental Pueblo petroglyphs are very deeply pecked and as a rule do not occur on heavily patinated surfaces. Typically, they are found low on the canyon walls. The deep pecking allows the figures to stand out in oblique lighting, but with frontal illumination the designs become almost invisible. In contrast, the petroglyphs of the Late Developmental Pueblo period and Great Pueblo period are shallowly pecked, often occur higher on the canyon walls, and invariably are found on darkly patinated surfaces. Because of these similarities, the rock carvings of the Late Developmental Pueblo period have been included in the discussion and listing of Great Pueblo petroglyphs.

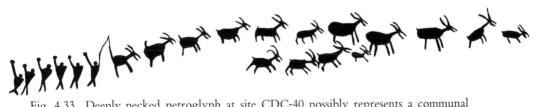

Fig. 4.33. Deeply pecked petroglyph at site CDC-40 possibly represents a communal sheep drive. The open-mouthed bighorn is typical of the Early Developmental Pueblo type.

The Canyon Rock Art 🐏 *183*

Modified Basketmaker/Early Developmental Pueblo Petroglyph Subject Matter

Human Types	Other Subjects
Triangular-bodied	Bighorn
Rectangular-bodied	Impaled bighorn
Oval-bodied	Footprints
Bird-headed	Bear tracks
Flute-players	Turkey tracks
Females with hair whorls	Snakes
	Quadrupeds
	Vulvaform
	Zigzags

Modified Basketmaker/Early Developmental Pueblo Petroglyph Sites

Main Canyon

CDC-40	Blade Rock
CDC-138	Junction Cliffs
CDC-121	Painted Room
CDC-156	Beehive Cove Petroglyphs

Canyon del Muerto

CDM-15	Junction Petroglyphs
SHP-12	East Trail Petroglyphs

Other Side Canyons

CDC-20	Tunnel 1
CDC-21	Tunnel 2

Interpretation of Modified Basketmaker/Developmental Pueblo Subjects

During this long era, the canyon people grew in numbers, with many new ideas and people entering the region. As numerous new cultural factors were added to the Basketmaker way of life, the style and subject matter of the rock art also changed greatly.

Fig. 4.34. Modified Basketmaker/Developmental Pueblo depiction which may be a shaman with a female patient. Painted in red, yellow, and white at site CDC-25.

HUMAN FORMS

Human forms, done with greater care and detail than previously, gradually grew smaller and began to appear in a great many shapes. There is no reason to suppose that the human figure motivation differed very much from Basketmaker times. Some of the depictions of people, however, now appear to represent everyday life. For example, at CDM-88, where there is a rich variety of design motifs, a male/female couple is represented hand-in-hand, walking along (Fig. 4.29). There are rows of figures with joined hands or in rows seated with hands raised. This sort of thing could represent people taking part in some ceremony. One constantly recurring figure has an inverted crescent-shaped object on his head. Bisected figures might represent supernatural dieties with dual natures.

The canyon Anasazi seldom pictured events or specific actions. An exception is found at CDC-25, Shaman Site. A woman is painted in a horizontal position. Bending over her is a feathered figure pointing a wicket-shaped object at her pelvic region. This is a very simple but graphic illustration of what is possibly a shaman exorcising bad spirits that are preventing the woman from having a child. Nearby is another figure holding a similar wicket-shaped object.

Many of the paintings of this time do not appear to have such ritualistic connection. It seems probable that as the ceremonial kiva concept gradually developed, the original motivations for rock art diminished. No kiva paintings of the Developmental Pueblo period have been found in the canyon, and the practice of making such paintings, which reached a climax in the Rio Grande kivas of the sixteenth century, quite possibly began during the Great Pueblo period.

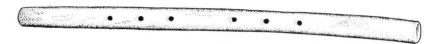

Fig. 4.35. Thirty-inch wooden flute excavated at Big Cave in Canyon del Muerto by Earl Morris in 1934. For bone flute from Marsh Pass, see Fig. 2.5.

The reasons for the popularity of the seated flute-player during this time span remain obscure. Actually, the Indian "flute" bears little resemblance to our idea of the instrument but was more like a whistle or a recorder with the musician blowing into the end. Persons talented at wringing music from this primitive flute must have been held in high regard and were pictured at ceremonial spots.

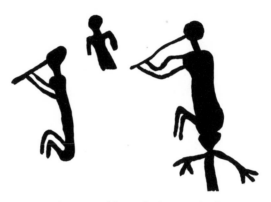

Fig. 4.36. These roughly pecked petroglyphs in Tunnel Canyon (site CDC-20) are probably Developmental Pueblo. The flute-player perched on the head of a man is unique.

ANIMAL FORMS

The most interesting Modified Basketmaker/Developmental Pueblo animal figures in Canyon de Chelly relate to the turkey *(meleargris gallopavo intermedia)*. An important source of food since Basketmaker times, the turkey became invaluable after its domestication by the Early Developmental Pueblo Anasazi.

The importance of the turkey to the canyon people is demonstrated by the great number of paintings and some petroglyphs of this fine bird. Indeed, one can theorize that a turkey cult developed. How else can the curious turkey-headed men be rationalized? In other parts of North America, much had been made of important food animals, such as the deer, bighorn, buffalo,

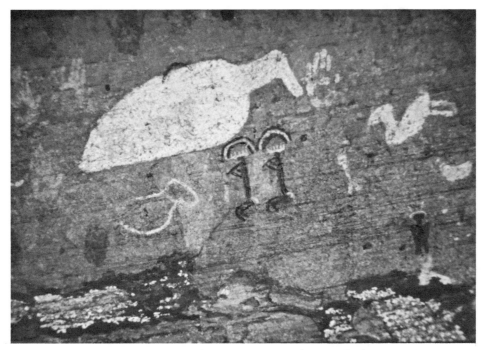

Fig. 4.37. Detail at site CDC-78. The great bird
over the two tiny twinned flute-players is unusual.

and salmon; elaborate ceremonies honoring them were part of the yearly
rituals. In the desert ranges west of Death Valley, such a preoccupation with
and veneration of the desert bighorn took the form of innumerable petro-
glyphs of sheep and representations of men wearing sheephorns.

It is interesting to compare Canyon de Chelly birdheads with various
bird-headed figures which have occurred in art forms around the world from
earliest times. It is notable that in all known instances outside the Four Cor-
ners region, only the head of the bird, rather than the entire bird, replaces
the human head. There are bird-headed female figures from Pech Merle in
southern France that date from the Aurignacian period. There is the well-
known bird-headed man with the wounded bison at Lascaux. Clay figurines
of bird-headed women have been excavated at Ur, and there are innumerable
paintings from Egyptian tombs of the falcon-headed god Horus.

The idea of the soul as a bird is widespread among primitive societies.
The Yakuts of Siberia believe that at death the souls of both good and bad
persons go up to the sky in the form of a bird (Eliade 1964:206). In many
parts of the world, shamans claim the ability to undertake magical flights,
with their souls assuming the form of birds and leaving their bodies, which
remain in a trancelike state until the soul's return. The shaman in effect is

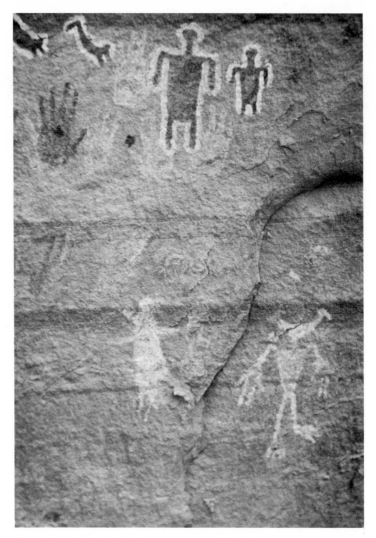

Fig. 4.38. Bird-headed figures at site CDM-123. The upper section showing two birds flying from two humans may represent a "soul flight."

symbolically dying but is able to recover his soul and return to the world of reality. Shaman costumes often incorporate bird feathers and wings, emblems of this supernatural power. A number of rock paintings in the Chumash area of southern California depict men with outstretched feathered arms wearing feathered skirts.

Kirchner (1952) related the Lascaux painting of the bird-headed man near the wounded bison to shamanism. Long thought to represent a hunting scene with the hunter gored by the dying bison, Kirchner postulated the man as a shaman caught at the moment of entering a rigid trance as his soul takes flight. The bird perched on a stick near him lends credence to this theory.

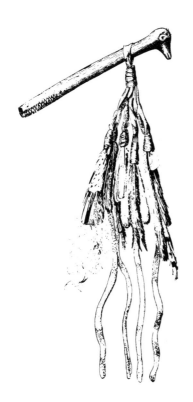

Fig. 4.39. Basketmaker ceremonial wand with bird head found in White Dog Cave at Marsh Pass.

Reproduced from Guernsey & Kidder 1921

Klaus Wellmann (personal communication 1975) thinks there is a strong possibility that the bird-headed figures from Canyon de Chelly may represent shamans capable of magical soul flights. Figure 4.40 shows a horned shaman with a bird hovering over him that graphically fits such a hypothesis.

All Indians, of course, prized the feathers of certain birds for decoration and incorporation into ceremonial costumes, and certain birds played a prominent part in Pueblo ritual and mythology. Fewkes (1903) illustrates eleven Hopi bird Kachinas — the owl, hummingbird, eagle, kite, red-tailed hawk, turkey, duck, mockingbird, roadrunner, snipe, and chicken. Turkey tail feathers are prominent in a number of Kachinas, usually in the form of a fan-shaped crest simulating the spread tail of the gobbler.

The early Spanish explorers in the Southwest noted the importance of the turkey to the Rio Grande pueblos. When Pedro de Castañeda, the principal diarist of the Coronado expedition, was in the Tewa villages in 1541, he saw many "cocks with great hanging chins." Hernán Gallegos saw many turkeys in the houses, and Antonio de Espejo was given great numbers of turkeys in the Rio Grande Piro villages.

Zuni legends describe Turkey People who could be summoned through prayer sticks bearing turkey feathers. One story tells how the son of a Rain priest was taught to plant the turkey-feathered prayer sticks using the correct

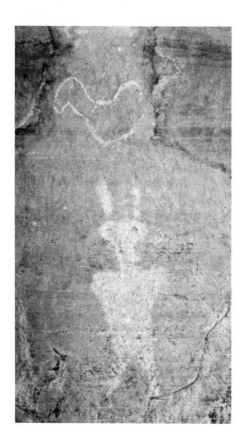

Fig. 4.40. This painting at sites CDC-70-72 possibly represents the "soul flight" idea, with a bird hovering over the horned shaman.

invocations. He planted them in an ancestral field, and that night the Turkey People came to his house while the family slept, bringing presents of buckskin, blankets, and corn.

The Zuni also had a Turkey Clan. At the ruins of Kuaua, the keeping of immense numbers of domestic turkeys is evidenced by pens, eggs, guano, and bones (Dutton 1963:7-9,67,111,201).

The duck is also an important Pueblo bird. In a Shalako ceremony at modern Zuni, the duck plays a major role. In a dramatization of the search for the lost Corn Maidens, two gods assume the form of ducks. The god Pautiwa, director of the Kachinas, commonly appeared as a duck. Several ducks can be seen in the Kuaua kiva murals (Dutton 1963:62-64). For the Hopi, duck feathers were symbols of rain, and at Zuni and Santo Domingo the Kachinas would turn to ducks and fly away at the end of the ceremony (Smith 1952:181-182).

The Indians of pre-Columbian Mexico recognized a duck-billed deity, Ehecatl, the god of the East wind, personified in the Olmec "Tuxtla statuette" and in a Calixtlahuacan life-sized statue of a naked man wearing a duck-billed mask. The duck in these portrayals is the *pato real* or royal duck (Muscovy

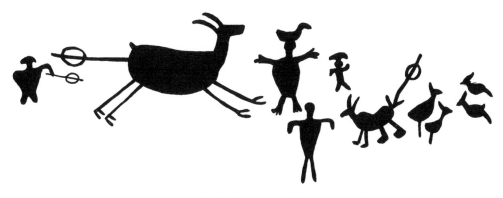

Fig. 4.41. This high, inaccessible petroglyph
panel at site CDC-139 features impaled sheep.

duck, *Carina moschata*), a species native to Mexico. This large gooselike bird
was prized for its feathers, which were used in the manufacture of feather-
work mantles. Many glyphs depicting Ehecatl show his typical combination
of symbols — the duck bill, facial caruncles characteristic of the Muscovy
duck, and the beard of Quetzalcoatl (Whitley 1973:3-7). Winning (1974:72-
73) has described a duck-headed Colima hunter figurine which holds an atlatl
in one hand and darts in the other. His duck headpiece probably represents
a decoy which enabled him to approach his quarry partly submerged.

In North American rock art outside the Southwest, representations of
birds are not quite so common. In fact, with the exception of the ubiquitous
"thunderbird," I have found bird depictions to be relatively rare. In the South-
west, and particularly in Canyon de Chelly, the reverse is true. Here the
abundant paintings and petroglyphs of birds are evidence of the great impor-
tance they were in all likelihood accorded in the ceremonial life of the pre-
historic Indian.

Another animal important in this area was the bighorn sheep. The most
intriguing subject of Modified Basketmaker/Developmental Pueblo petro-
glyphs, these representations were presumably made by a hunting people
familiar with hunting magic, as a few of the sheep are impaled with spears
or arrows. This type of sheep representation was common among the Sho-
shonean hunters of the Great Basin, especially in the Coso and Argus ranges
of Inyo County, California (Grant 1968). There the sheep are often depicted
in the immediate vicinity of piled-rock hunting blinds.

The bighorn is rare in painted form during this time and is seldom shown
transfixed by spear or arrow. It is quite possible that this animal was mainly
used as a decorative motif. On the other hand, in later, shallowly pecked
petroglyphs, the usually hoofless bighorn are often impaled.

The scarcity of bighorn as a rock art subject in the canyon suggests sev-
eral other theories — one, that the Canyon de Chelly region was not good

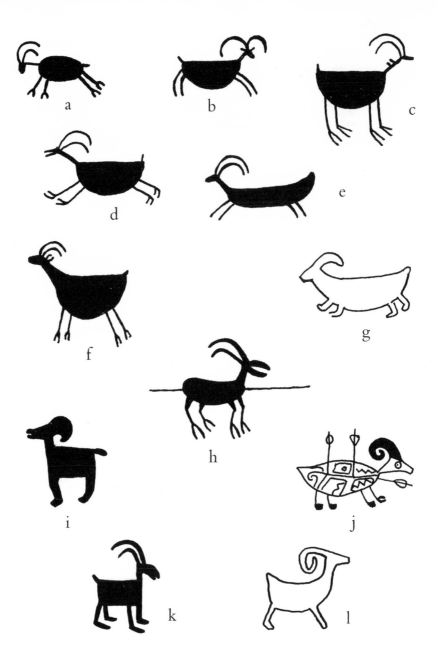

Fig. 4.42. Various ways of representing the desert bighorn sheep found throughout the Great Basin and the Southwest. All are petroglyphs but g and l. Drawings a through f and h are in the Shoshonean style, while drawings g, i, j, k, and l are in the New Mexican style. a. & b. Coso Range in southeastern California (redrawn from Grant et al. 1968); c. & d. Marsh Pass region in northeastern Arizona (redrawn from Kidder & Guernsey 1919); e. Grapevine Canyon in southwestern Nevada; f. Irish Mountain in southern Nevada (drawn from John Cawley photo); site CDC-49 in Canyon de Chelly; h. site CDC-40 in Canyon de Chelly; i. Mimbres region in southern New Mexico (redrawn from Schaafsma 1972); j. Three Rivers in southern New Mexico; k. El Morro in western New Mexico; l. site CDC-14 in Cottonwood Canyon.

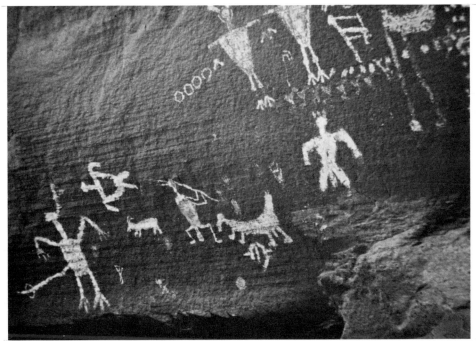

Fig. 4.43. This typical careless painting of the Great Pueblo period was found at site MCC-11, Many Cherry Canyon.

bighorn country; two, that the canyon people were farmers and only incidentally hunters; and three, that the bighorn petroglyphs might simply have been inspired by similar work to the west, toward the Colorado River, where the big game animals were abundant.

Great Pueblo Rock Paintings, A.D. 1100-1300

The paintings of the last Anasazi occupation of the canyon generally can be easily distinguished from the earlier periods. The style and technique is markedly inferior to the previous periods, with little care being taken on detail and finish. A major characteristic lies in the color. There are no polychrome paintings, and all but a very few are in white or buff. The most positive indicator of Great Pueblo work is the location of paintings on cliff faces high above the floor level, where the painter would have to have stood on a third- or fourth-story roof to reach the spot (Fig. A.6). Another important dating clue is the presence at many sites of white paint splashes, often over earlier paintings. They are deliberate and look as if someone had taken a fistful of white paint and thrown it against the rock surface.

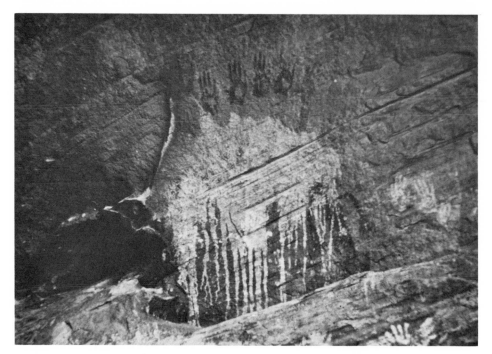

Fig. 4.44. Paint splashes of the Great Pueblo period at site CDM-7. Ritual obliteration or just the pleasure of throwing paint?

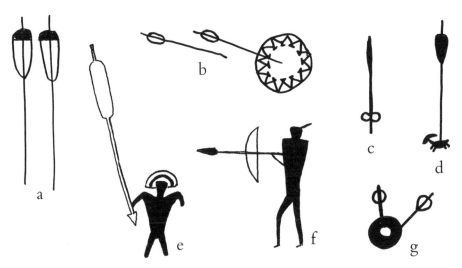

Fig. 4.45. Modified Basketmaker–Developmental Pueblo and Navajo weapons: a. & e. Modified Basketmaker–Developmental Pueblo paintings in red and white at site CDC-78; b. Navajo petroglyph at site CDW-2; c. Modified Basketmaker painting in red at site CDM-214; d. Modified Basketmaker–Developmental Pueblo painting in white at site CDC-54; f. Navajo drawing in charcoal at site CDM-6; g. Navajo petroglyph at site CDC-16.

Fig. 4.46. Great Pueblo human figures: a. Painted in white at site CDM-37; b. Petroglyph at site CDC-143; c. Petroglyph at site CDC-6; d. Petroglyph at site CDC-24; e. Painted in white at site CDC-302; f. Petroglyph at site CDC-16; g. Painted in white at site CDC-28; h. Painted in white at site MCC-11. For photo of crawling men in Drawing e, see Fig. A.9.

At this time rituals became centered around the kivas, where abstract and purely decorative paintings were now made. Hence Great Pueblo rock art was mainly confined to representations of everyday life. Human figures are abundant, and, although crudely painted, many show a much more realistic approach and livelier appearance than earlier work. Men are shown walking, running, crawling, shooting bow and arrows, and holding such objects as stone-headed clubs and crooks. The old tradition of always depicting arms in a downward-pointing position was abandoned.

a b c

Fig. 4.47. These were the only examples of the recumbent hump-backed flute-player recorded during our rock art survey. All are painted in white. a. site CDM-2; b. site CDC-6; c. site CDC-74. For photo of flute-player in Drawing b, see Fig. A.1.

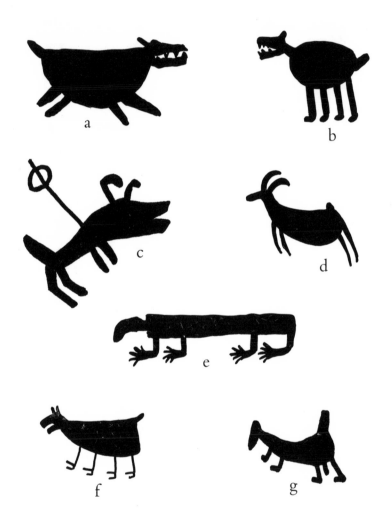

Fig. 4.48. Great Pueblo animal shapes: a., e., & f. Painted in white at site TWT-1; b. Painted in buff at site CDM-10; c. & g. Painted in white at site MCC-11; d. Petroglyph at site CDC-138.

a b c

Fig. 4.49. The double-ended, or mirror, figure. a & c are common
motifs in many parts of the world. a. Painted in white at site CDC-6;
b. Outlined in white at site CDM-2; c. Petroglyph at site CDC-9.

At twelve of the recorded sites there are horned human figures. Most
seem to be of the Great Pueblo period, although several are at Developmental
Pueblo sites. At several sites in the canyon, notably at MCC-11, Many Cherry,
there are men impaled with arrows, and at other sites such as CDC-228, Face
Rock Ruin 1, there are large shield shapes. Both of these new motifs suggest
the strife that I believe was plaguing the Anasazi of this period.

The most interesting new motif of this period is the humpbacked flute-
player. A rare figure in the canyon, he is found in the paintings and petro-
glyphs at only five sites — CDC-6, CDC-16, CDC-34, CDC-74, and CDM-2.
Four of these painted examples are recumbent, and two are phallic. The fig-
ure at CDC-16 is bird-headed.

Great Pueblo artists painted many more animals than in the past, but
most of them are so poorly conceived as to be unidentifiable. They are al-
most invariably executed in the crude manner so characteristic of this final
period. Some have round bodies, while others have square or elongated bodies.
Most are short-eared, blunt muzzled, and long tailed.

A curious design appears in canyon paintings and petroglyphs during
this period. It is the double-headed human figure which looks the same in
normal position as it does upside down. Figures with horned or feathered
headdresses are also characteristic of this time span.

The only paintings that show good craftsmanship during the Great Pueblo
era are some elaborate rectilinear abstract patterns that reflect weaving and
pottery designs. The most ornate painting is a fretlike pattern running en-
tirely around the circumference of an excavated kiva at Mummy Cave. Some
handprints are now incorporated into interesting patterned motifs.

Fig. 4.50. Great Pueblo abstract and geometric designs: a. Painted in white at site CDC-302; b. Painted in red and brown at site CDC-25; c. & e. Painted in white at site CDC-30; d. & i. Red and white kiva paintings at site CDM-174; f. Petroglyph at site CDC-9; g. Painted in white at site CDC-47; h. Painted in red and white at site CDC-24. For photo of fret pattern shown in Drawing d, see Fig. 4.51.

Fig. 4.51. A fret pattern in two shades of red and white from the bench decoration of Mummy Cave kiva, site CDM-174. For view of kiva with bench, see Fig. 2.19.

Fig. 4.52. An unusual Great Pueblo composition rendered in white paint at site CDC-107.

Human Types

Triangular-bodied
Rectangular-bodied
Round-bodied
With horned or feathered headdresses
With stone-headed clubs
Impaled with arrow
Stick men
Humpbacked flute-players, recumbent
Seated flute-players
Bird-headed flute-player
Females with hair whorls and genitalia
Twinned figures with bow and arrow
Double-ended (mirror figures)
Turkey-headed
With large hands and feet

Other Animate Types

Dogs, coyotes
Dog impaled with arrow
Dog with collar
Bighorn
Bighorn impaled with arrow
Deer
Animals, indeterminate
Tailed turkeys
Birds, miscellaneous
Bear
Handprints, positive
Handprints, negative
Handprints, patterned

Inanimate or Abstract Subjects

Dot patterns
Geometric frets
Concentric circles
Linear circles
Solid circles
Bisected circles
Zigzags
Spirals
Four-pointed star
Miscellaneous abstract

Main Canyon		Canyon del Muerto	
CDC-6	Flute-player Cave	CDM-128	Kokopelli Cave
CDC-11	Hand Cave	CDM-37	Big Hand Ruin
CDC-28	Antelope Point 1	CDM-6	Ute Raid Panel
CDC-34	Sleeping Duck Ruin	CDM-10	Antelope House Ruin
CDC-30	Antelope Point 2	CDM-4	Standing Cow Ruin
CDC-41	Wall With Lightning	MCC-11	Many Cherry
CDC-47	First Ruin	CDM-237	Purple Men Ruin
CDC-49	Bighorn Ruin	CDM-123	Ear Cave
CDC-54	Bad Train Ruin	TWT-1	Twin Trail Ruin
CDC-75	White House Ruin	CDM-155	Big Cave
CDC-76 & 77	Tsé-ta'a	SHP-11	Big Sheep Cliff
CDC-110	Calcite Ruin	TYK-8	del Muerto High Cave
CDC-113	Twin Flute-player	TYK-9	Rimrock Cave
CDC-107	Sliding Rock Ruin	CDM-174	Mummy Cave
CDC-121	Painted Room Ruin	CDM-214	Atlatl Cave
CDC-172	Window Rock Ruin 3	CDM-158	Charcoal Cliff
CDC-228	Face Rock Ruin 1	CDM-245	Whirlwind Cave
CDC-233	Spider Rock Shelter		
CDC-291	Doe Panel		
CDC-302	Crawling Men Ruin		

Other Side Canyons

CDC-24	Geometric Site
MNC-1	Two Ladder Ruin

Late Developmental Pueblo/Great Pueblo Petroglyphs

By far the majority of Canyon de Chelly petroglyphs belong to the Great Pueblo period and the era directly preceding it, the Late Developmental Pueblo period. The petroglyphs of both these time spans were rendered by a shallow pecking technique on darkly patinated rock, contrasting with the deep pecking method used by Modified Basketmaker/Early Developmental Pueblo artists (Figs. 4.9 and 4.10). The greater number of Great Pueblo and

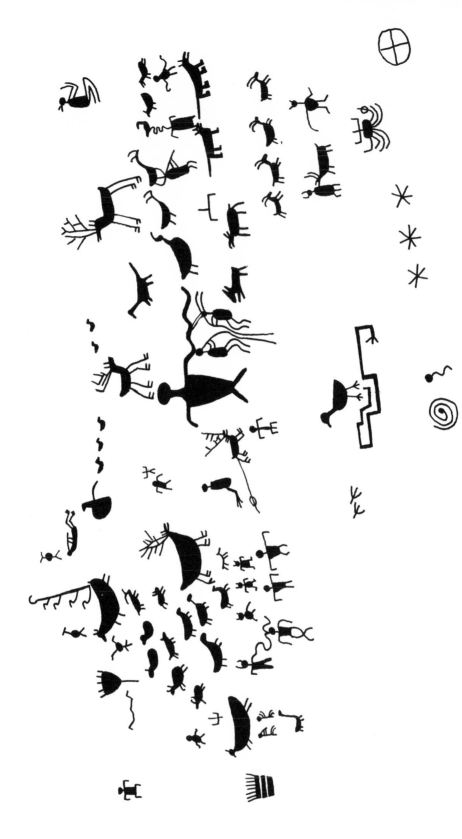

Fig. 4.53. Great Pueblo petroglyphs near Sleeping Duck Ruin, site CDC-34.

Fig. 4.54. Great Pueblo petroglyphs near Sleeping Duck Ruin, site CDC-34. Note sprouted seed at left and crooked digging sticks. The snake and rubbery legs show strong Chaco-Mesa Verde influence.

Late Developmental pecked designs mirror contemporary rock paintings. However, the execution of these petroglyph motifs is far more skillful than that of the careless paintings of the time.

Occasionally one finds subjects unique to the petroglyphs. For instance, face-to-face flutists, deer, and arrow-and-target motifs do not occur in any Anasazi canyon paintings. Some petroglyph artists achieved very decorative and often amusing effects by doubling or twinning the figures. At site CDC-113, in several instances face-to-face musicians are blowing on opposite ends of the same flute (Fig. 4.27). Some CDC-34 figures have long rubbery arms and legs. Snakes first appear in the canyon art as petroglyphs during this period.

Twelve of the eighteen petroglyph sites which appear on the list which follows were not located immediately adjacent to ruins but were placed where the best darkly patinated rock was to be found. The paintings, by contrast, were almost invariably done on the walls around the masonry structures, where they were protected from weather and rock-falls.

Late Developmental Pueblo/Great Pueblo Petroglyph Subject Matter

Human Types
- Impaled with arrow
- Flute-players
- Humpbacked flute-players
- Phallic flute-players
- Twinned flute-players
- Seated with clubs
- Holding crooks
- Turkey-headed
- Sheep-headed
- Animal-headed
- Horned or with
 - feathered headdresses
- Round-bodied
- Triangular-bodied
- Armless
- Legless
- Walking
- Double-ended
- Connected by curvilinear lines
- Female with hair whorls
 - and genitalia

Other Animate Types
- Long-legged birds
- Ducks
- Turkeys
- Birds in flight
- Four-legged birds
- Deer
- Deer, impaled

- Bighorn
- Bighorn, impaled
- Dogs or coyotes
- Snakes
- Miscellaneous animals

Inanimate or Abstract Subjects
- Spirals
- Geometric patterns
- Arrow-target motifs
- Meanders
- Crooks
- Zigzags
- Sandal tracks

Late Developmental Pueblo/Great Pueblo Petroglyph Sites

Main Canyon

CDC-3	First Petroglyph Site
CDC-9	First Planetarium
CDC-16	The Wall
	(Newspaper Rock)
CDC-139	Petroglyph Rock
CDC-34	Sleeping Duck Ruin
CDC-40	Blade Rock
CDC-49	Bighorn Ruin
CDC-78	Pictograph Cave
CDC-80	Horned Moon Panel
CDC-113	Twin Flute-player Petroglyphs
CDC-219	Face Rock Antelope

Canyon del Muerto

CDM-37	Big Hand Ruin
CDM-243	Oleson Site
CDM-2	Ledge Ruin
TYK-7	Yoke Petroglyphs

Other Side Canyons

BCH-1	Thunderbird 1
CWC-2	Cottonwood Petroglyphs
CDC-143	Tunnel 3

Interpretation of Great Pueblo Subjects

It is not possible to account for the Canyon de Chelly rock art of the Great Pueblo period without reference to what was happening to the Anasazi in the Four Corners region. This has been described in Part Two of this book, but a brief recap will be helpful.

Around 1100 the huge Chaco Canyon population began to abandon their large settlements and disperse, unable to sustain themselves in a land that was no longer productive. They mainly went to Mesa Verde, but some in all probability settled in Canyon de Chelly, bringing new pottery styles, their characteristic masonry, and their petroglyph rock art. In the Mesa Verde canyons, the local people and the Chaco refugees started building fortresslike structures. It can be supposed that some outside pressure was forcing this type of construction, and whether the danger was coming from the Apache and Navajo or the Paiute and Ute, the Anasazi seemed to be taking the threat seriously.

By the mid-1200s refugees from Mesa Verde were increasingly moving into Marsh Pass and Canyon de Chelly, bringing Mesa Verde ideas in masonry, pottery, and rock art in the form of petroglyphs, which were, not surprisingly, very similar to those of Chaco Canyon. There is reason to believe that they also brought fear and a sense of urgency. Soon the Canyon de Chelly people were building apartment strongholds incorporating much Chaco and Mesa Verde type masonry. These new structures served them only briefly and were then abandoned in the great exodus.

Thus much of the canyon Grand Pueblo rock art was made during what appears to have been a period of turmoil — a time of comings and goings of frightened, uncertain people. The execution and subject matter of both paintings and petroglyphs suggest not only a lessening of importance in the making of such pictures but a confusion of ideas that effectively destroyed what had been a highly specialized approach to rock art.

Figures of men impaled with arrows need no interpretation. They are simply evidence of what was presumably going on. A great deal of the rock art of the Great Pueblo period, as noted earlier, appears secular. However, there are exceptions, and the horned figure is the most prominent. Humans wearing spiked or horned headdresses are rare in earlier canyon rock art but are abundant during Great Pueblo times. This type of figure is found in Indian rock art over a very wide area. Mallery (1893:577) noted that a horned figure on an Ojibwa birch-bark scroll was identified by an Indian as a shaman or his guardian spirit. Waters (1963:108) illustrates several Hopi petroglyphs of horned people that he says are members of the Two Horn Society of the powerful Bow Clan. The Hopi almost certainly immigrated to their present area from Canyon de Chelly and other population centers in the Kayenta

Fig. 4.55. Horned figures from the Developmental/Great Pueblo periods: a., b., & e. Painted in brown and white at site CDC-121; c. Painted in white at site MCC-11; d. & f. Painted in white at site CDC-120. See also photo of horned shaman, Fig. A.5, and more horned figures, Fig. 4.57.

country, and the horned figures in Canyon de Chelly and in Canyon del Muerto may be early representations of Two Horn figures.

Many of the horned figures so common in rock art in many parts of the world certainly represent shamans. The idea is very ancient, first appearing in the Paleolithic caves of southern France, where a famous example is the horned "sorcerer" of the Trois Frères site. Eliade (1964:154-155) notes that the shamans of certain Siberian tribes wore caps bearing iron staghorns and that much of their power was attributed to such headgear. Similar horns were worn by Korean shamans, and possible shamans wearing bighorn sheep horns appear in the petroglyphs of some Great Basin Shoshoneans (Grant 1968:40).

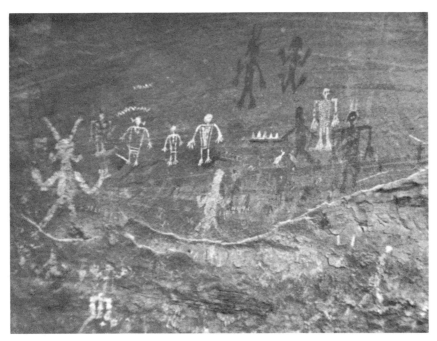

Fig. 4.56. Many-figured panel at Wild Cherry Ruin, site SC-1, including horned figures, a woman, and a skeletal being. For photo of details of this panel, see Fig. A.5.

Another fascinating new human motif used by Great Pueblo artists in Canyon de Chelly is the humpbacked flute-player. This mythological being is recognized as a minor deity by tribes from the Four Corners region to northern Mexico. He appears on Hohokam and Mimbres pottery dated at between A.D. 1000 and 1150. In modern times he appears as the Hopi Kachina Kokopelli and is the symbol of the Flute Clan. Often flute-player portrayals are phallic, for the figure is widely regarded as a symbol of fertility.

The many Great Pueblo animals, some grotesque and fanciful, are in the main puzzling. A few bighorn and deer are impaled with arrows, suggesting the old hunting magic, but motivation for the other animal drawings can only be conjectured.

Importation and Exportation of Anasazi Rock Art Ideas

It was inevitable that during the more than 1,000-year occupation of Canyon de Chelly by the Anasazi a characteristic style of rock art would develop. However, nothing remained static in the Southwest for very long, as ideas and people were continually on the move. Some of the Anasazi canyon paintings and petroglyphs reflect strong outside influences, and some Canyon de Chelly rock art ideas traveled far afield.

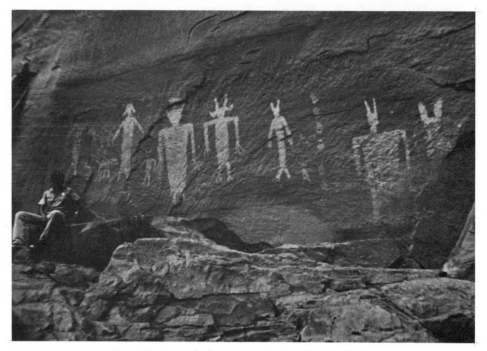

Fig. 4.57. A panel of exceptionally large human figures
at site CDC-120. They probably represent shamans.

HUMAN FORMS

In the lower Pecos region of Texas, near its confluence with the Rio Grande, there are caves decorated with large polychrome human figures similar to those of the Canyon de Chelly Basketmaker era (Kirkland & Newcomb 1967:37-111). Whatever the original impetus, whether the idea was introduced or independently devised in various widely separated areas from California to Texas, a number of aboriginal groups sharing a common basket-making trait all created conspicuous, large, featureless human figures in their caves and on their cliffs. Others who made similar figures were the Cochimi of Baja California (Grant 1974) and the Fremont Culture Indians of eastern Utah (Schaafsma 1971:6-84).

David Gebhard (1969) has recorded many large humans with decorated bodies pecked on the cliffs of the Dinwoody Valley in Wyoming that are presumably the work of the Wind River Shoshoneans, who still occupy the area. Gebhard postulates that the Dinwoody petroglyphs might have been inspired by the spectacular large human figures made by the people of the Fremont culture in eastern Utah (Schaafsma 1971:60-84). Wormington (1965:

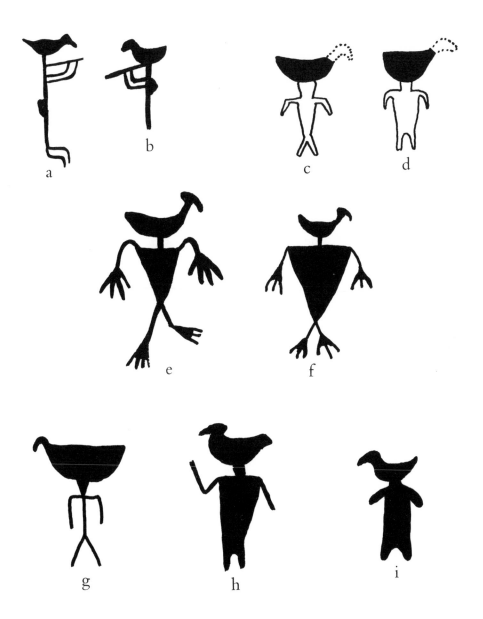

Fig. 4.58. Canyon de Chelly bird-headed man and his occurrence in adjacent areas: a. Canyon de Chelly petroglyph, site CDC-16; b. Pinta Rock near Petrified Forest National Monument (from Ike Eastvold drawing); c. Canyon de Chelly painting in red and white at site CDC-54; d. Painting in red and white in Segihatsosi Canyon, Marsh Pass area, northeastern Arizona (redrawn from Guernsey 1931); e. Canyon del Muerto painting in white at site CDM-123; f. Petroglyph in John's Canyon in southeastern Utah (drawn from John Cawley photo); g. Painting in red at Kiet Siel Ruin in Marsh Pass area (drawn from John Cawley photo); h. Petroglyph in Trail Canyon, lower San Juan River (drawn from Don Martin photo); i. Petroglyph in Natural Bridges National Monument in southeastern Utah (drawn from John Cawley photo).

176-190) thinks that the beginnings of the Fremont culture are to be found in the generalized culture of the Great Basin and that it is quite possible the Fremont people were Shoshonean.

Large Basketmaker-type figures are also common in the Great Basin representational petroglyphs (Grant 1968, created by the basket-making desert Shoshonean people. With the migration of these people to the east in prehistoric times as Ute, Paiute, Western Shoshone, and other tribes (Heizer & Baumhoff 1962:14-15), a tradition of such large human figures could have been brought into the Colorado Plateau region.

Although the large human Basketmaker figures were obviously influenced by outside ideas, the bird-headed man variation would seem to have originated in Canyon de Chelly. Despite great numbers of paintings and some petroglyphs depicting this being in the canyon, the motif is rare elsewhere. Several such figures were recorded in conjunction with men holding atlatls at the mouth of Trail Creek before it was flooded by Lake Powell. Similar birdheads occur at a site in the Natural Bridges National Monument, and again the atlatl is pictured.

The association of the birdheads with the atlatl certainly suggests an early beginning for this motif, although crude representations of the figure persist occasionally into Great Pueblo times. Since the bow and arrow appeared in the Four Corners region about A.D. 200 and probably supplanted the atlatl as the prime weapon several hundred years later (Grant 1968:50-51), we can postulate a beginning for this motif in Late Basketmaker or Early Modified Basketmaker times.

There are a few more examples of bird-headed humans in the Marsh Pass area. Guernsey (1931:14, 20) reports them from Cave 4, Segihatsosi Canyon, and in High Cave, Tségi Canyon. Schaafsma (1966:20) notes several from the big ruin of Kiet Siel and at Inscription House. One has been noted on the Rio Puerco, north of Petrified Forest National Park (Ike Eastvold, personal communication 1973). John Cawley (personal communication 1974) has recorded bird-headed men in John's Canyon, southeastern Utah. Most occur in the San Juan River drainage of northeastern Arizona and contiguous canyons in Utah.

The large legless and/or armless triangular-bodied humans such as those at sites CDM-245 and CDC-98 also indicate the constant borrowing of ideas in the ancient Southwest. Although the Canyon de Chelly forms are invariably small and solidly painted, the effect is quite similar to the armless, legless Fremont humans from eastern Utah (Schaafsma 1971:7-20). This convention might have begun in the Canyon de Chelly region but reached its highest development with the Fremont people north of the San Juan River.

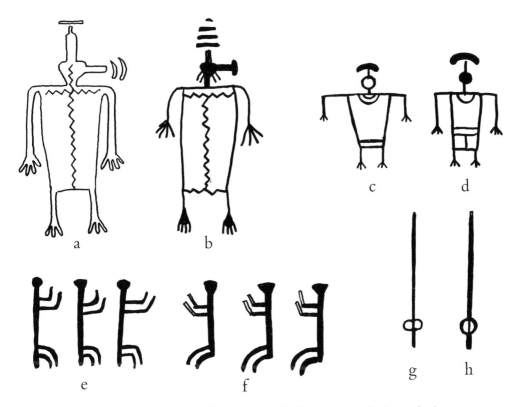

Fig. 4.59. Relationships of Canyon de Chelly designs with those of other areas: a. Canyon del Muerto painting in white at site CDM-123; b. & c. Petroglyphs from Butler Wash in southeastern Utah (drawn from Dean Blanchard photo); d. Canyon de Chelly petroglyph at site CDC-16; e. White painting in Parunweap Canyon, Zion National Park, southwestern Utah (drawn from Ben Wetherill photo); f. Canyon del Muerto painting in red, yellow, and white at site CDM-88; g. Canyon del Muerto painting of an atlatl in red at site CDM-214; h. Petroglyph of an atlatl from Valley of Fire in southern Nevada. For comparison of bighorn sheep designs, see Fig. 4.42.

Most provocative of the canyon Anasazi paintings are the large human figures with top-of-head ornaments and left ear appendages. Identical figures are found in petroglyph form in the Butler Wash area of southeastern Utah. The Butler Wash figures include bighorn sheep that appear contemporaneous. There are many Basketmaker and Modified Basketmaker sites in this region, and the petroglyphs of the large human figures with ear ornaments seem of the same period. John Cawley (personal communication 1974) reports the ear appendage petroglyph figures from both sides of Butler Wash and on the south bank of the San Juan River. One of these had the ornament protruding from its right ear, but all the rest were left-eared. The number of such figures in a small area in southeastern Utah suggests this as the point of origin of this curious figure. There is considerable evidence indicating a flow of

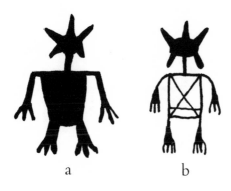

Fig. 4.60. Almost identical figures from two widely separated areas: a. Canyon de Chelly painting in white at site CDC-121; b. Petroglyph from Butler Wash, Utah.

ideas between Butler Wash and Canyon de Chelly — for example, there are horned figures in the wash that are identical with those in the canyon.

Handprints, both positive and negative, are found everywhere in the Four Corners country. Striated and whorled prints such as those at Canyon de Chelly have been noted about 30 air miles to the north at the Painted Cave in Hospitibito Canyon (Haury 1945:64-71). At the same cave (occupied in the Basketmaker and Great Pueblo periods), there are many large outlined humans with interior patterns that are quite similar to Basketmaker figures in Canyon de Chelly. Large outlined human figures also occur in the Marsh Pass area, Butler Wash, Grand Gulch, and other Basketmaker canyons (Kidder & Guernsey 1919:197-198).

The human figures with inverted crescentlike headdresses which decorate many Canyon de Chelly sites are also found in southern Utah and at other areas in northwestern Arizona. They seem to occur in all periods, but most are associated with Basketmaker or Modified Basketmaker paintings. At site CDC-34, there are petroglyphs of humans connected by random, curvilinear lines. This is a characteristic of Anasazi petroglyphs in the Chaco and Mesa Verde areas.

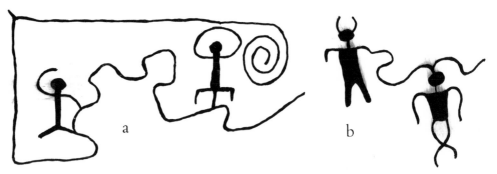

Fig. 4.61. These petroglyphs with connecting, or "power," lines are common in the Mesa Verde area, although there are only a few examples from the Great Pueblo period in Canyon de Chelly. a. Navajo Canyon, Mesa Verde, southwestern Colorado. b. Canyon de Chelly site CDC-34.

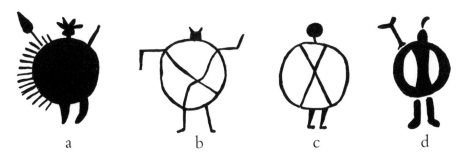

Fig. 4.62. The shield figure occurs in many parts of western America: a. Canyon del Muerto painting in white at site CDM-229; b. Canyon de Chelly petroglyph at site CDC-16; c. Petroglyph from Writing-on-Stone Park, Alberta, Canada; d. Petroglyph from Grapevine Canyon in southwestern Nevada. See Fig. 4.83 for more shield motifs.

The shield figure is widespread throughout the West, with major concentrations in the Great Plains region, although only a few examples occur at Anasazi sites in Canyon de Chelly during the final years before abandonment. The classic shield figure is a human with the torso represented by a decorated shield. Head and legs are shown, but no arms. A weapon or implement appears angling from the right shoulder at the eleven o'clock position. In the Four Corners area, the shield is usually shown alone, without appendages.

One shield figure about three feet in diameter at Great Pueblo site CDC-229 is similar in size and style to several large shield figures at Bat Woman House and at Betatakin in the Tségi Canyon region (Schaafsma 1966:13,15). These examples suggest that the shield idea had entered the Kayenta region at the end of the Great Pueblo period. Similar shields are found in southern Utah, especially in the Glen Canyon region. Shield figures of many types are abundant in eastern Utah and are credited to the Fremont people, who had a puebloid, corn-growing culture from A.D. 950-1150 (Gunnerson 1969: 167-170), and who produced superb rock paintings and petroglyphs.

Probably the earliest appearance of the humpbacked flute-player in the Southwest is at Snaketown in southern Arizona (Gladwin 1937:pl.CLVIII), where he appears on Hohokam pottery around A.D. 1000. The humpbacked flutist occurs sparingly in the Four Corners region during the Great Pueblo period, before the great exodus, but later became quite popular as a rock art motif in the new homelands of the Anasazi, particularly along the Rio Grande.

There is a bird-headed Kokopelli identical to the one at Canyon de Chelly site CDC-16 at Pinta Rock on the Rio Puerco near Petrified Forest National Park. The humpbacked musician also appears in Chaco Canyon and was probably introduced from there into the Kayenta region by refugees from

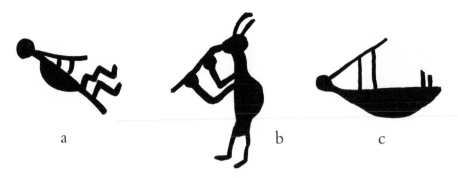

a b c

Fig. 4.63. The humpbacked flute-player occurs in many areas of the Southwest: a. Painted in white at Canyon del Muerto site CDM-2; b. Petroglyph near Guique on the Rio Grande; c. Petroglyph in the Marsh Pass area, Arizona.

that Great Pueblo complex sometime after A.D. 1100. Kidder and Guernsey (1919:193-196) record Kokopelli from some Marsh Pass petroglyph sites; Schaafsma (1966) notes the humpbacked flutist in Tségi Canyon. Turner (1963: 54) illustrates one example from Trail Canyon in the San Juan drainage.

This latter example appears to be about the northernmost appearance of this fertility symbol, and its origin must be looked for far to the south. The flutist motif does occur rarely north of the San Juan, but not the classic humpback. At the Sand Island petroglyph site near Bluff, Utah, there are some notably phallic flute-players and one bighorn blowing on a flute. Far to the north in Dinosaur National Monument, Schaafsma (1971:23) illustrates two highly stylized flute-players, one with a square hump that is very different from the Anasazi type.

At CDM-88, Ceremonial Cave (Figs. 4.3, 4.6, and A.10), there are a number of figure arrangements and details that are rare or nonexistent in other parts of the canyon system. In one instance there are eight humans seated in profile, one behind the other, with hands extended before them. On the same panel there are figures with headdresses indicated simply by rows of radiating dots. Both of these arrangements occur at sites in Zion National Park, Utah (Schaafsma 1971:116-117; Wauer 1965:57-84). Schaafsma has called this the Cave Valley style and notes its occurrence in Utah as far east as the Kanab region.

Also found at CDM-88 are rows of hand-holding humans, very similar to the Rosa-style petroglyphs in the Navajo Reservoir region of northern New Mexico. The Rosa Phase, from A.D. 700-900, corresponds roughly with the Early Developmental Pueblo period (Schaafsma 1963). At about the same time, small stick figures, flute-players, birds, and bighorn which are remarkably like examples at CDM-88 were being painted in the caves of the Animas Valley in southwestern Colorado (Morris & Burgh 1954).

The scarcity of bighorn sheep paintings and petroglyphs in Canyon de Chelly is not surprising. No sheep have been recorded in the region in historic times, and if they were present during Anasazi occupation, they were too scarce to have had much impact on the canyon dwellers. Most of the northern Arizona bighorn bands must have been concentrated in the rough canyon country of the Colorado and lower San Juan rivers. Excavations at Tsé-ta'a turned up only two bighorn bones from the Developmental and Great Pueblo periods (Steen 1966:140-153).

Bighorn depictions which do occur in Canyon de Chelly represent intrusive influences. They may relate mainly to hunting expeditions to distant areas by canyon people or were perhaps created by transient Indians who once lived in bighorn country. Figure 4.42 indicates the various ways the bighorn was represented throughout the Southwest.

In southern Utah and in the Marsh Pass region west of Canyon de Chelly, there are abundant bighorn petroglyphs. This is good sheep country, and the occurrence of the bighorn pictures there is to be expected. The representations are of the classical Shoshonean type, with boat-shaped bodies, thin stick legs, and wire-thin paired horns. This is a well-known method of representing the bighorn throughout the Great Basin as far west as the Coso Range of Inyo County, California, where there is an immense concentration of such sheep. This highly stylized creature occurs wherever the Shoshoneans are found (Grant 1968).

Some of the Canyon de Chelly forms strongly resemble this Shoshonean type, as do almost all bighorn representations in southern Utah and northeastern Arizona. However, some of the painted bighorn in Canyon del Muerto wear a single curved horn, reflecting a type found far to the southeast of Canyon de Chelly in the Three Rivers area and the Mimbres Valley of southern New Mexico. Here the numerous sheep petroglyphs attest the presence of this prized big game animal (Schaafsma 1972:102-119). These bighorn usually appear with a horn shown in profile as a single spiral and with characteristic massive thickness. The body is predominantly square and often patterned.

The crude, often unidentifiable animal representations typical of the Canyon de Chelly Great Pueblo period strongly resemble the animal forms from Chaco Canyon and initially were probably the product of refugees from that region who were moving to the Mesa Verde settlements and west into the Kayenta region. Canyon de Chelly absorbed numbers of these people, as attested by the frequent occurrence of Chaco-type masonry in the Great Pueblo period (Fig. 2.25). Other motifs associated with this time span are human figures with rubbery arms and legs, double-ended human figures, and the

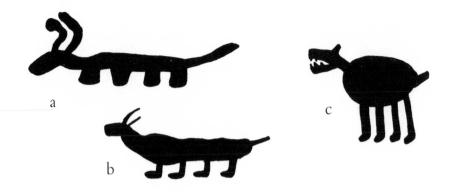

Fig. 4.64. Animal stylization is similarly grotesque in several areas:
a. Petroglyph from Chaco Canyon; b. Petroglyph from Mesa Verde;
c. Canyon del Muerto painting in buff at site CDM-10.

snake, all common in the Chaco Canyon petroglyphs. Schaafsma (1966:Chart 1) records the latter two motifs from Tségi Canyon, and they also occur in Mesa Verde petroglyph panels.

ABSTRACT DESIGNS

Purely abstract and geometric patterns are rare in the canyon if we eliminate the ubiquitous zigzags, concentric circles, and spirals. The elaborate geometric border in the Mummy Cave kiva (Figs. 4.50 and 4.51) strongly resembles Great Pueblo patterns from Mesa Verde as well as Turner's Style 4 from the Glen Canyon region (Turner 1963:50,58,65). Other late Anasazi abstract patterns occur at CDC-24, CDC-9, and CDC-28.

Typical Mesa Verde masonry (Fig. 2.26) occurs during the Great Pueblo period in the canyon, and refugee masons brought along some of their rock art ideas. Petroglyphs at CDC-9 (Figs. 4.49 and 4.50) and paintings at CDC-24 (Fig. 4.50) strongly resemble pottery border patterns and geometric weaving designs. Such subject matter was unknown in the canyon rock art before the Mesa Verde influence late in the Great Pueblo period.

Navajo Rock Paintings, Mid-1700s - Modern Times

Navajo rock art in the canyon all dates from historic times, beginning with the migration in the late 1700s of large numbers of Navajo from the Largo-Gobernador drainage of the San Juan River in northwestern New Mexico to the Canyon de Chelly/Chuska Mountains area. Most of the paintings and petroglyphs date after 1775, although some may be earlier.

With few exceptions, the Navajo paintings are strongly realistic and dynamic as compared with the long Anasazi tradition of static, highly stylized

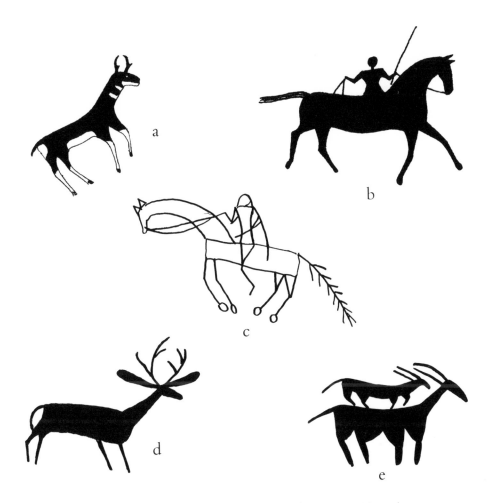

Fig. 4.65. Navajo paintings and petroglyphs: a. Black, white, and brown painting at site CDM-263; b. White painting at site CDM-221; c. Scratched petroglyph at site CWC-12; d. Red painting at site CDC-80; e. Deeply incised petroglyph at site CDC-34.

execution. The Diné mainly painted subjects that were part of their daily lives — horses, horsemen, antelope, deer, and cattle. Although the horses are executed in a lively and lifelike manner, the riders are stiff and doll-like, often with triangular or hour-glass bodies perched on the horse's back with no attempt to indicate that the rider rode astride his mount.

Few Navajo paintings in the canyon depict supernatural and mythological figures, although the earlier Diné rock art in the Largo and Gobernador drainages often featured elaborate Ye'i figures (Schaafsma 1966). Those that do exist include CDC-73 (a stepped tabla-like figure and a figure resembling Female God of the Night Chant); CDM-158 (Ye'i figures); CWC-8 (Ye'i figures); Slim Canyon (Ye'i mask); CDM-263 (feathered Ye'i); and CDC-80 (horned moon).

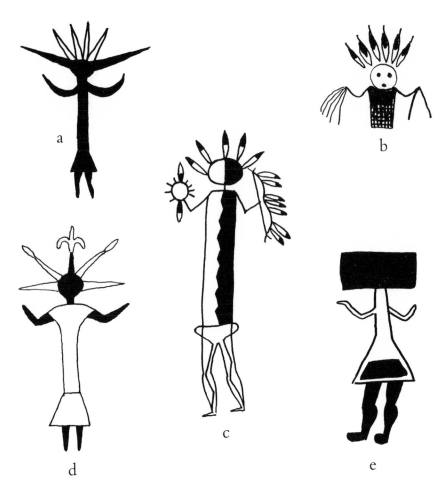

Fig. 4.66. Navajo Ye'i paintings: a. & d. Painted in black, white, green, and buff at site CDM-158; b. Painted in black, white, and buff at site CWC-8; c. Painted in black, red, and white at site CDM-263; e. Painted in red at site CDC-73. Navajo stylization of female deities such as that in Drawing e may stem from the Anasazi method of showing female hairdressing as rectangular (see Fig. 4.28). For a photo of female deity in Drawing e, see Fig. A.3.

An interesting motif occurs at CDM-263, a panel featuring Spanish horsemen, antelope, and other dynamic subjects. This is a doll-like man astride a creature that we at first identified as a horse, although it appeared quite unlike any Navajo horse we had seen before. In fact, it is remarkably like a sandpainting character that Bertha Dutton (personal communication 1974) has identified as Kicking Monster, a highly stylized bison that occurs in the Big House Branch of the Male Shooting Chant (Fig. 4.82).

The only other ceremonial elements in Navajo rock paintings are the unique and fascinating star panels, which De Harport (1953) has called planetaria. Invariably occurring on the flat surfaces of cave ceilings, often ten

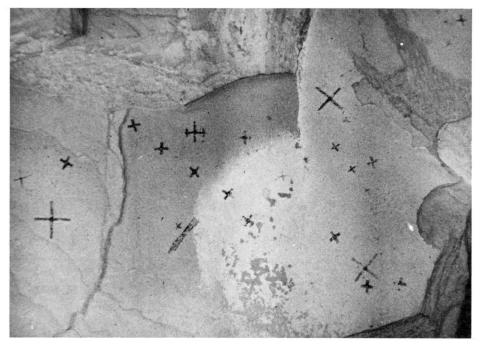

Fig. 4.67. Part of a large planetarium panel in Cottonwood Canyon, site CWC-13.

feet or from from the floor, these paintings are notable for the extreme regularity of the star shapes, suggesting that they may have been stamped on the ceiling with wooden patterns mounted on long poles.

The patterns obviously represent star groupings and constellations. Stars are shown as four-pointed crosses, from one to six inches in length, and there are a number of variations in their design. Occasionally the star is circled, and at one site (CWC-13), there are a number of small, possibly anthropomorphic figures that appear to be part of the star patterns.

Most of the stars are done in black, and the majority are painted with great care, almost appearing to have been ruled with a straightedge. Sometimes the arrangements consist of only a few stars, but at CWC-13 there are about seventy, and at CDC-95 there are over ninety.

During our 1969-70 rock art surveys, we recorded eight planetarium sites, all in the main canyon or its side canyons, with none in Canyon del Muerto. De Harport (1951:35-48) noted ten such star panels. Claude Britt, Jr. (1973:5) has seen fourteen star ceilings, with concentrations of them in Cottonwood Canyon and at the junction of Canyon del Muerto with the main canyon. Britt, a seasonal Canyon de Chelly ranger/archaeologist, states that one Navajo who has lived in the area all his life claims to know of thirty-two planetarium locations.

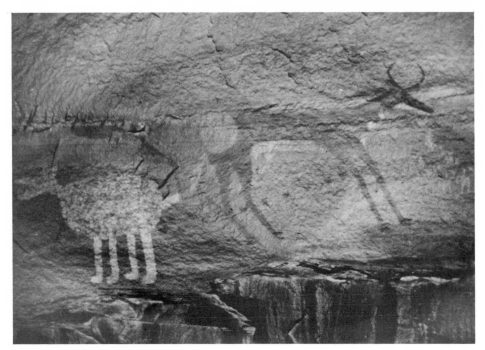

Fig. 4.68. Life-sized antelope high on a cliff (site CDM-10) near Antelope House ruin. The antelope is Navajo, while the crude animal to the left is typical Great Pueblo.

The antelope was a favorite subject, and particularly handsome life-sized figures of this animal appear on a cliff just west of Antelope House. Antelope were abundant in the plains southwest of Canyon de Chelly until the arrival of the Anglo-Americans, and a few are still found in areas near the Navajo Reservation.

The absence of Navajo bighorn paintings is interesting. It implies that by the late 1700s this animal no longer inhabited the region, the bighorn bands having become concentrated where they are found in modern times, in the almost inaccessible cliff and canyon country of the Colorado River. At a few sites in the canyons — CDC-141, CDM-4, CDM-3, and CDM-263 — there are life-sized paintings of cattle, all done with a high degree of realism. No small paintings of cattle have been recorded.

There are Navajo paintings of Spanish horsemen — the most outstanding example being the panel of a Spanish cavalcade high on the cliff above the Standing Cow Ruin in Canyon del Muerto (CDM-4). The musket-bearing riders are represented wearing cloaks and flat-brimmed hats. There are a number of Indians in the panel, but these figures are not easily visible from below. Several are shield figures, and one, possibly a Ute guide, is mounted on a

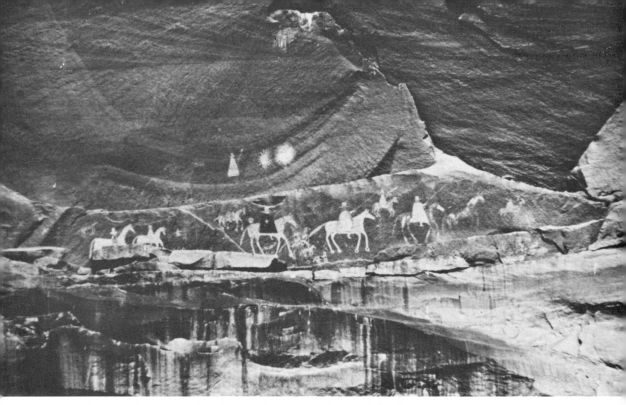

Fig. 4.69. Spanish cavalry of the Narbona expedition (1804-1805) painted on a ledge high above Standing Cow Ruin, site CDM-4. The three-foot central figure with the black cape and cross may represent the Spanish leader. For a drawing of this figure, see Fig. 4.82; for photo of Narbona's cavalrymen, see Fig. 4.70; for additional Spanish cavalry depictions, see Figs. 2.45 & 2.46.

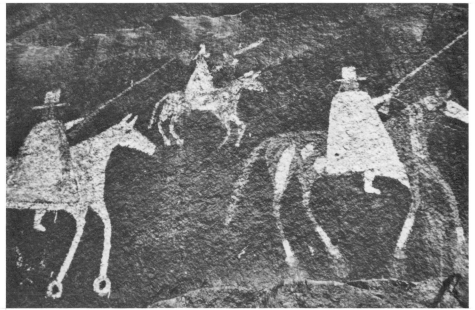

Photo by Stephen Jett

Fig. 4.70. Detail of the Narbona cavalcade at Standing Cow Ruin, site CDM-4. The cavalrymen wear the flat-brimmed hats characteristic of the period along with long winter capes. The lead trooper on the pinto mount appears to have arranged his hair in a queue.

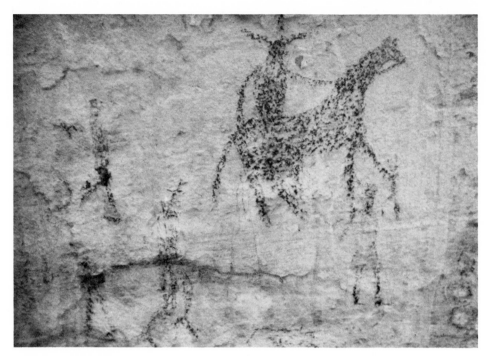

Fig. 4.71. Navajo charcoal drawing of a Mexican horseman at site CDM-158. For another Navajo charcoal drawing, see Fig. 4.45; for a paint-and-charcoal rendering, see Fig. 4.73.

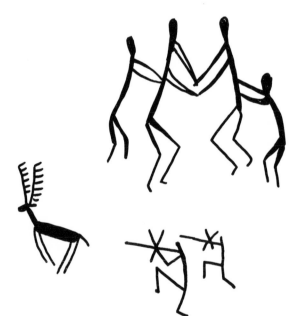

Fig. 4.72. Navajo drawings in charcoal at site CDM-158.

pinto pony. Another is a feathered Navajo shooting at two men mounted on a single horse.

According to Ann Morris (1930), this painting was made by a Navajo named *Dibé Yazhi* (Little Sheep, or Lamb). Little Sheep's Pueblo mother came to the canyon from Jemez Pueblo sometime before 1804 and married a Navajo. In 1976 her descendants were still living in hogans directly beneath the famous painting.

It is likely that other Navajo paintings in the canyons with very similar style are also the work of the gifted Little Sheep. In fact, he may have set the very distinctive Canyon de Chelly style of rendering animals, especially horses, that has continued almost to modern times. Horses and horsemen also have been found in the Largo-Gobernador area, but there they are petroglyphs.

There is another painting of a Spanish cavalcade at CDM-158, quite close to Massacre Cave. This example is rendered in black, and the horses are the finest examples of Navajo draftsmanship in the canyon.

Navajo Charcoal Drawings and Petroglyphs

Some of the Navajo rock paintings were combined with charcoal; many unfortunately were done entirely in this ephemeral medium. The practice of making rock pictures with charcoal continues into modern times.

Some of the charcoal drawings were probably done by shepherds to while away the time. They depict hunting scenes with deer, dancing figures, and the inevitable horse. Humans are often depicted as stick figures or with stiff, hour-glass shapes, but the horses are always done as realistically as the artist could make them.

The most interesting of the charcoal compositions is in Canyon del Muerto at site CDM-6, the Ute Raid Panel. This spirited drawing contains forty horses and horsemen, galloping or trotting from left to right opposed to thirty-seven unmounted people, some of whom bear shields, spears, and bows and arrows. About half the mounted warriors have fringed shields attached to their saddles, which are painted in black, as are the bridles. All other detail is in charcoal, and much has eroded away. Seven of the defenders are "shield" figures (Figs. 4.62 and 4.83), such as are found painted and incised in many western states. Other shield figures occur at sites CDM-229, CDM-4, CDC-229, and CDC-16.

In contrast to the rock paintings and charcoal drawings, Navajo petroglyphs are few. Where they are found, they follow the style and subject matter of the paintings and drawings. Britt (1973:6-11) has described one instance dating from the post-1868 period, when petroglyphs were used as trail-markers.

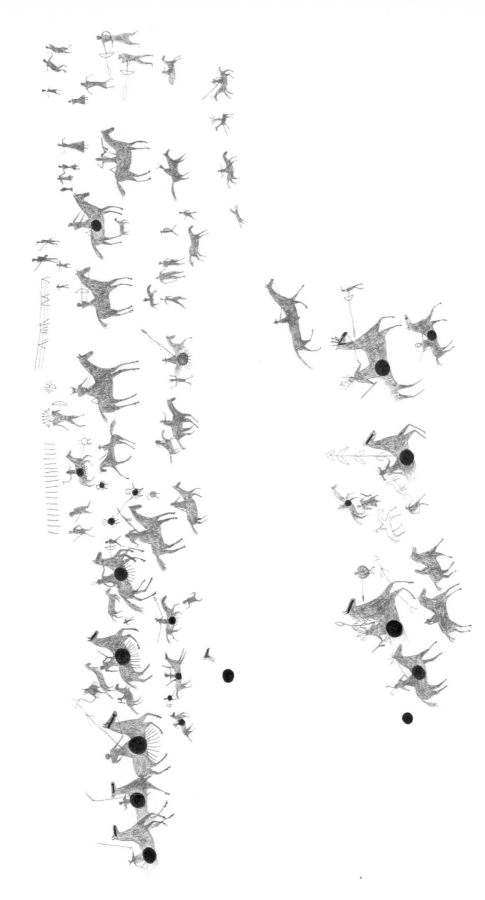

Fig. 4.73. The Ute Raid Panel, rendered in paint and charcoal at site CDM-6, chronicles a battle between the Ute and Navajo that occurred in January 1858.

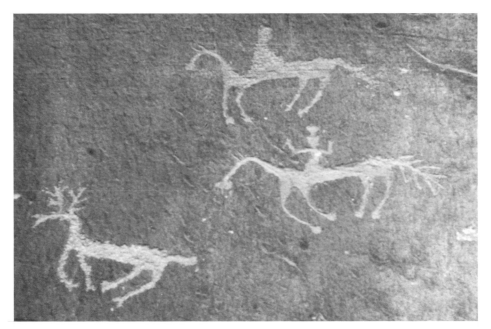

Fig. 4.74. Navajo petroglyph of rider and deer at site CDC-
139. Such pecked petroglyphs are rare at Navajo sites.

Fig. 4.75. Recent shallowly pecked Navajo
petroglyph of a horse at site CDC-96.

Examples of these can be seen on one major trail that proceeds from Fort Defiance to Chinle and continues along the south rim of Canyon de Chelly. Whenever the trail crosses extensive bedrock, petroglyphs have been deeply pecked in the sandstone to mark the route. Such markers are in the shape of horse hoofprints, footprints, horse heads, cattle brands, and various animal tracks.

There are some quite recent-looking paintings, petroglyphs, and charcoal drawings that show much realism in saddle and bridle details. These were probably influenced by attendance at Anglo schools.

Navajo Rock Art Subject Matter

Paintings

Horses
Cattle
Antelope
Deer
Spanish horsemen
Spanish soldiers
Shield figures
Spanish cowboys
Female
Ye'i figures
Horned moon
Concentric circles
Circles
Suns
Stars
Miscellaneous abstract

Charcoal Drawings

Horses
Cattle
Deer
Indian horsemen
Hunting scenes
Battle scenes
Dancing figures
Shield figures

Petroglyphs

Deer
Goats
Horses
Spanish horsemen
Spanish soldiers
Ye'i figures
Miscellaneous abstract
Shield figures

PAINTINGS AND CHARCOAL DRAWINGS

Main Canyon

CDC-9	First Planetarium
CDC-70-72	Four Hole Site (planetarium)
CDC-73	Corncob Cave
CDC-92	Deadman Cove (planetarium)
CDC-141	Two Steer Panel
CDC-80	Horned Moon Panel
CDC-96	Navajo Squares Site
CDC-98	Sheep Cliff
CDC-142	Big Deer Site
CDC-95	Round Cave Ruin (planetarium)
CDC-101	Leaping Deer Ruin
SC-2	Spring Canyon Planetarium
CDC-112	White Sands Ruin
CDC-219	Face Rock Antelope
CDC-233	Spider Rock Shelter (planetarium)

Canyon del Muerto

CDM-242	Goat Ledge
CDM-6	Ute Raid Panel
CDM-3	Black Bull Cave
CDM-221	White Horse Panel
CDM-10	Antelope House Ruin
CDM-4	Standing Cow Ruin
CDM-68	Pena Inscription
CDM-229	Shield Cave
CDM-155	Big Cave
SHP-11	Sheep Point
CDM-244	Navajo Corral
CDM-158	Charcoal Cliff
CDM-245	Whirlwind Cave

Other Side Canyons

CWC-8	Ye'i Cave
CWC-13	Cottonwood Planetarium

PETROGLYPHS

CDC-16	The Wall (Newspaper Rock)
CDC-139	Petroglyph Rock
CDC-34	Sleeping Duck Ruin
CDC-80	Horned Moon Panel
CDC-151	Corn Shrine Petroglyphs
CWC-12	Navajo Rider

Interpretation of Navajo Subjects

In interpreting the Navajo paintings, drawings, and petroglyphs, we are dealing with the historic period, with its concomitant documentary and ethnographic evidence. Paintings of subjects such as horses and antelope appear to have been made for the pure pleasure of representing these graceful animals, and the Navajo did them very well. There seems to be no suggestion of hunting magic, although there are a few hunting scenes done in charcoal.

Other paintings were done to record important events. Two memorable and traumatic experiences in Navajo canyon history have been the subjects of the most elaborate of these Indians' compositions. The first is the Ute Raid Panel (site CDM-6, Fig. 4.73). This paint-and-charcoal composition illustrates an actual battle and thus can be dated precisely. The encounter occurred in January 1858 and is described in a U.S. army report sent from Fort Defiance which in part specifies, "In January a party of Utahs, 40 in number, crossed the Rio Colorado below the mouth of the San Juan into this country and came as far as the Cañon de Chelly and there killed Pelon, a Chief of considerable property. From this it would seem that no general peace can be looked for between the two tribes . . ." (Brooks to Nichols, March 20, 1858).

The second major event is chronicled in the painting of a Spanish cavalcade on the cliff at Standing Cow Ruin (site CDM-4, Figs. 4.69 and 4.70). This very large panel is the record of another raid against the Navajo — the Spanish expedition commanded by Lieutenant Narbona in the winter of 1804-1805. This was the foray that led to the tragic slaughter at Massacre Cave described in detail in Part Two of this book.

Fascinating though the historical paintings might be, the most intriguing subjects of the Navajo artists are the star panels, for they appear to be unique in North American rock art. Father Berard Haile, who lived among the Navajo for many years, has described Navajo star lore and their considerable knowledge of the constellations (Haile 1947). Besides appearing on the ceilings of caves, the stars and constellations are pictured on ceremonial prayer sticks, gourd rattles, and particularly in sandpaintings. In the Night Chant ceremony, *Haskéshjini* (Black God, the god of fire and creator of the constellations) is represented with the Pleiades painted on his left forehead or cheek. Other sand-painting ceremonies featuring stars are Big Star Chant, Wind Chant, Shooting Chant, Night Chant, and Hail Chant.

The Navajo recognize thirty-seven constellations, many of which are involved in their legends and mythology. Although many of them bear no resemblance to the Anglo constellations, both systems are alike in that human and animal names are used to identify them. Some of the exclusively Navajo formations are *dasani,* the porcupine; *'anłt'ánii,* the corn beetle; *sash,* the bear;

Fig. 4.76. Navajo Ye'i petroglyph with star formation on the left side of face. Black God was often depicted with such a star arrangement, usually the Pleiades. This example is from Largo Canyon, New Mexico.

and *tłiishtso,* the horned rattler. Navajo star lore recognizes several prominent stars, such as *so' tso tigai,* big white star; *so' tso łitso,* big yellow star; *so' tso łizhin,* big black star; and *so' tso deshjah,* pronged star. Prominent stars are indicated on the star panels as very large four-pointed or circled stars. The big yellow star is represented in a circle in the star formation at CWC-13.

Among the Navajo constellations that agree exactly or partially with the Anglo constellation system are *náhookos bikhá'i,* the Big Dipper; *náhookos ba'áádi,* Cassiopeia; *hastiin skai* with *dilyéhé,* the Pleiades; *so' hotsii,* Aldebaran; and *atseéts'ósi,* a star in Orion. *Yikáísdáhi* is the Milky Way, and *atsétso* is a star in Scorpio.

Correlation by Crutchfield Adair

Fig. 4.77. Pisces and part of the Great Square at Navajo planetarium site CWC-13.

I have shown a number of the Canyon de Chelly star panels to Santa Barbara astronomer Crutchfield Adair, and he was able to identify several additional star formations, including the large "summer triangle," and Pisces.

Pleiades was an important time-marker for those Navajo who understood the movement of the stars, and its appearance in the eastern skies was an indicator that the first frosts were at hand, time to start the Night and Mountain Chant ceremonial season.

There are many Navajo myths about the people in the constellations. One concerns Orion and Pleiades, who had twin daughters, *Sạ'ạ Naghaí* (Old Age That Goes About) and *Bik'e Hozhó* (On the Trail of Beauty). The shamans sought to relate the stars to the human condition, especially in the matter of long life and happiness, and most Navajo ceremonies are for the purpose of prolonging life to old age.

According to one of Father Haile's Navajo informants, star lore was quite unknown to the average Navajo; only a special few of the ceremonial singers had this knowledge. Such information was taught from generation to generation to those who would perform in rituals concerning the heavens.

According to Britt (1973:11), the traditional Navajo are extremely reluctant to talk about the star panels to Anglo-Americans, for they are considered special places. Modern-day shamans still visit the planetarium sites to leave offerings, sometimes in the form of prayer sticks, on behalf of their patients.

The practice of star-gazing developed among the Navajo following their return to their homeland from Fort Sumner in 1868. Persons claiming the

Correlation by Crutchfield Adair

Fig. 4.78. The large "Summer Triangle" at Navajo planetarium site CWC-13.

Antares

so' tso łitso
(big yellow star)

Correlation by Crutchfield Adair

Fig. 4.79. Atséetso (the first big one), part of the constellation of Scorpio, at Navajo planetarium site CDC-95.

ability to receive messages from the stars would be paid by anxious customers to read the causes of various misfortunes, especially disease, to identify witches, or to aid in the recovery of stolen property. The gazer would observe the stars through bits of glass or quartz crystals. There are records of several instances wherein "witches" were so identified and summarily killed.

Britt (1973:8) believes that most if not all of the star panels in the canyon date from the early nineteenth century to 1864, when the major part of the Navajo nation was rounded up and sent to Bosque Redondo. He bases this mainly on the care with which the stars are drawn as contrasted with the often careless recent Navajo drawings. This may well be so, but the star ceilings were painted by, or under the direction of, shamans who continue to do beautiful work with sand paintings. The often spirited but rudely executed charcoal drawings that are found throughout the canyons are in the main creations of herdsmen, farmers, or children, amusing themselves with no serious purpose in mind.

Origins of Navajo Rock Art Ideas

The Navajo rock pictures in Canyon de Chelly have their roots in northwestern New Mexico, where the early Navajo homeland (Dinètah) centered around a number of tributaries of the upper San Juan River, particularly Pine River, Gobernador Canyon, Largo Canyon, and Carrizo Creek. Navajo paintings and petroglyphs occur abundantly in all these areas. There is evidence that as late as the 1950s Navajo traveled to rock art sites at the confluence of the Pine and San Juan rivers to hold ceremonies. It is certain that other such sites had been used as sacred places for many years (Schaafsma 1963:64).

The practice of making rock paintings and petroglyphs was learned from the Pueblo, from whom the Diné also had borrowed knowledge of corn-growing, weaving, and many religious beliefs and practices. The Navajo probably adopted their neighbors' rock art ideas sometime after the Pueblo Revolt of 1686, when the Pueblo fled to the San Juan Valley to live peacefully with the Diné already there. Dittert et al. (1961:245) have called this period the Gobernador Phase, which lasted from 1698-1775.

Among the religious concepts borrowed from the Pueblo were supernatural beings personified by ceremonial dancers called Kachinas. These became the Navajo Ye'i figures. In the Largo/Gobernador region, there are many paintings and petroglyphs of Ye'i, some closely resembling modern figures in sand paintings, but not so highly stylized. Oddly enough, there are no close counterparts for these Ye'i figures in Canyon de Chelly, although there is a single elaborate feathered Ye'i at CDM-263. Other feathered Navajo figures appearing at CDM-158 are quite unlike those from the Gobernador/Largo country and also quite unlike sand-painting Ye'is.

In addition to the Ye'i, several other motifs may indicate Navajo interaction with the Pueblo people (Fig. 2.38). The elaborate design at CDC-73 resembles a Hopi tabla. As all other motifs at this site are Navajo, it may show a very close borrowing of Pueblo design, or it may actually be Hopi. At the same site there is a representation of a Navajo woman with the conventional square head indicating her sex (Figs. 4.66 and A.3). This convention may have had its beginning in earlier Pueblo stylization — at CDC-25, Shaman Site, there is a Pueblo woman with a rectangular head, derived from combining head and hairdressing over ears (Fig. 4.28).

The paucity of depictions of supernatural and mythological figures in Canyon de Chelly would indicate that after 1775, when most of the rock art was being made, illustration of such ceremonial figures had become almost completely confined to the sand paintings. Only an occasional such figure appears in both the rock art and sand-painting media. At CDC-80, where the most prominent painting is a large antelope, there is a horned moon, a

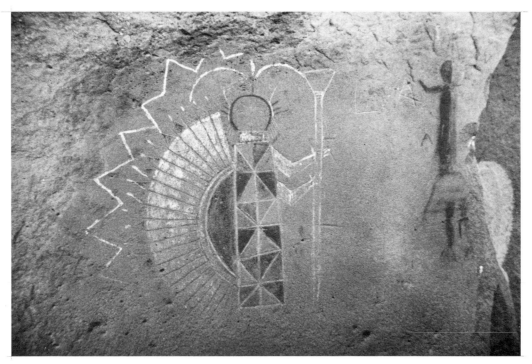

Fig. 4.80. Navajo humpbacked deity from the Gobernador drainage of northwestern New Mexico.

motif that also appears in a number of sand paintings. At CDC-139, there is a Navajo petroglyph that resembles *Do'tso,* the Messenger Fly, also often pictured in sand paintings. At CDM-263 and CDM-158, Ye'i figures with attenuated bodies and feathered headdresses suggest sand-painting deities. Some Navajo abstract motifs may have symbolic religious significance.

The gradual change from exclusively religious subject matter to predominantly secular themes in rock art had its beginnings in the Largo/Gobernador area before the Navajo moved to Canyon de Chelly. Horsemen and cattle depicted in petroglyphs in Largo Canyon probably antedate such subject matter in Canyon de Chelly. They are far clumsier in execution and concept that the early nineteenth century examples in Canyon de Chelly and Canyon del Muerto.

Schaafsma (1972:56) thinks that the switch to secular subject matter might have resulted from the increased white contact and a reluctance on the part of the Navajo to depict ceremonial figures in a permanent form. There are many fairly recent petroglyphs and charcoal drawings in Canyon de Chelly that are rather crudely executed and suggest strong Anglo stylistic influence (Fig. 4.75). Similar figures occur in Chaco Canyon.

Most of the classic shield figures in the canyon appear to be of Navajo origin (CDM-6, CDM-4, CDM-229, CDC-16), reflecting strong influence

Fig. 4.81. Navajo miscellaneous and abstract designs: a. Painted in red at site CDC-80; b. Painted in white at site CDM-158; c. Rendered in black paint and charcoal at site CDC-92; d. Petroglyph at site CDC-139; e. Painted in black at site CDM-158.

from north and east. Many shield figures occur in Fremont Culture rock art in Utah (Schaafsma 1971); in New Mexico there are Navajo and Pueblo examples (Schaafsma 1972:45,146; Grant 1967:123). There are great numbers of such figures in the Great Plains from Colorado to Alberta (Gebhard 1966: 721-732; Dewdney 1964:22-29).

This curious design motif, usually associated with warfare (for example, site CDM-6, the Ute Raid Panel, Fig. 4.73), had its origin in the northern Plains according to Wormington (1955:186) and spread later into the Great Basin. There is a fine example in Grapevine Canyon in southern Nevada.

A later writer (Buckles 1964:182) reverses this theory and has the shield figure originating in the Great Basin and later appearing in the Great Plains. Gebhard has found the figure as far afield as Rhode Island, and it would appear that the point of origin is a complex matter. In any event, the Canyon de Chelly examples are late and would appear to be a Plains influence. Several of the Ute Raid figures are in a fighting position, wielding short spears, exactly as similar petroglyph figures are posed at the Writing-on-Stone site in southern Alberta (Dewdney 1964:23).

At the Wall (site CDC-16, also called Newspaper Rock, Figs. 4.62 and 4.83), the shield figures may antedate the Navajo canyon occupation and

Fig. 4.82. Some Navajo stylistic relationships: a. Painted in black and white at site CDM-263; b. Sand painting of Kicking Monster from Male Shooting Chant; c. Petroglyph at site CDC-9; d. Petroglyph from Largo Canyon in northwestern New Mexico; e. Painted in white and brown at site CDM-4; f. Petroglyph from Largo Canyon.

Fig. 4.83. Shield motifs: a. Painted in white at site CDM-229; b. & c. Drawn in charcoal at site CDM-6; d. Painted in yellow and gray at site CDC-229; e. Petroglyph at site CDC-16; a, b, and c are Navajo; d is Great Pueblo, while e is possibly Shoshonean. For more shield motifs, see Fig. 4.62.

closely resemble the Plains-type figures. These are possibly the work of no-madic bands entering the canyon after the Anasazi exodus.

The numerous planetaria in Canyon de Chelly suggest this area as the center if not the point of origin of the Navajo star charts. There are five other such sites in New Mexico, three of them in the upper San Juan drainage, one near Gallup on the Puerco, and one near Cuba (Schaafsma 1972:38). The stars in the Canyon de Chelly planetaria are all in black, but the sites described in northeastern New Mexico are mainly red and orange (Schaafsma 1962). At the Cuba site, the stars are in red, white, black, and gray (Schaafsma 1972).

Despite man's rock-painting and petroglyph-making, his building and his battles, the immense red canyons of the Canyon de Chelly system appear today much as they must have looked when the first groups of Basketmakers began farming there. Gazing into the canyons from the rim, the viewer is barely conscious of even the most extensive ruins — they appear totally in-significant, clinging to the alcoves in the towering cliffs.

To escape from the overpowering presence of the canyon itself, one must go into it, stand next to the masonry ruins, and view the scattered evidence of ancient man — his pottery, his timbered retaining walls, his cliff paintings. Even in this more intimate setting, the spectacular canyon evokes a feeling of quiet awe. Likewise, to the Indian who lives in its twisted gorges, Canyon de Chelly remains a center of mystery and legend — a sacred place where modern man can never be more than an intruder.

Supplementary
Material

Appendix

SURVEY OF
CANYON DE CHELLY
ROCK ART SITES

Our survey of the prehistoric and historic paintings and petroglyphs of the canyon began in August 1969 and continued for a two-week period. We returned in July 1970 for an additional two weeks and again in 1975 for a week to get more photographs and record a few other sites. In the total five weeks, we explored the two major canyons and all the side canyons except Black Rock and Monument. These latter we penetrated for a distance of about a mile, but the dearth of rock pictures discouraged us from further work in these areas.

Our initial party consisted of myself, John J. Cawley, and Wesley Buerkle of Bakersfield. Ranger/archaeologist William Turner spent the first ten days with us, locating the main ruins and rock art sites and giving us an indoctrination course on the tortuous geography of the canyon system.

Our daily schedule consisted of Turner's 6:00 AM arrival at our trailer loaned by the National Park Service. Loaded with maps, camera equipment, food, and plenty of water, we drove up the Chinle Wash in our four-wheel-drive Jeep Wagoneer. This type of car is indispensable in the lower gorges, where the danger of being trapped by quicksand is ever-present.

After a spot check of both canyons from end to end, we methodically began to record the rock art sites upstream from our point of entry. We broke into two teams, one working on the left side of the canyon and the other on the right. A complete photographic record was made of each site. We also

took ample descriptive notes and plotted locations on our topographical maps. We used excellent U.S. Geological Survey maps drawn to a scale of 1:2400, which actually showed every hogan in the canyons.

Binoculars were indispensable, saving us many a hard climb to a barren site. Although rock art in the lower canyons is located in alcoves reasonably close to the canyon floors, or, in the case of petroglyphs, along the bases of the cliffs, the height of the ruins rises dramatically by mid-canyon, and in the upper reaches cliff houses are from 500 to 700 feet above the streambed. Climbs to them are exhausting and often quite dangerous due to deterioration of the ancient hand-and-toe holds and the steeply tilted and often-crumbling ledges. De Harport's notes on the main canyon saved us many fruitless climbs, as he always specified whether rock paintings were present or not. (De Harport's work has been described in detail in Part Three of this book.)

After Ranger Turner finished his work with us, we completed our first season with two Navajo guides, Ben Henry and Nelson Yellow Hair. These local Navajo were very familiar with the canyon, but, as they had never taken any particular interest in rock art, they rarely knew more than a few locations.

During the second season we had the good fortune to have Kee Begay as our guide. Born in Canyon del Muerto, he knew some fine sites near his family property. That year our party included John Cawley and Robert Bowler of Carpinteria, California. We concentrated our efforts in the upper sections of the two main canyons, where the cliffs reached their greatest heights of about 1,000 feet near Mummy Cave in del Muerto, and near Spider Rock in de Chelly. Beyond these points, the canyons grew narrower and shallower. All-year streams flowed over bedrock, arable land grew scarce, and rock art became rare. The final week of fieldwork in 1975 was carried out by the author, John Cawley, and Kee Begay.

Visitors to Canyon de Chelly cannot hope to see more than a tiny fraction of the sites recorded in this survey. Restrictions on travel, not only for the safety of tourists, but also to protect the fragile ruins and the privacy of the Navajo, permit access only to such prominent ruins as Antelope House, Standing Cow Ruin, Mummy Cave, and White House.

However, from the list of sites which follows, the reader can learn about more than one hundred locations in the two main canyons and in a number of side canyons. Although this by no means represents all of the rock art sites, it does encompass the major locations and provides an ample beginning for a study of Canyon de Chelly Anasazi and Navajo rock art.

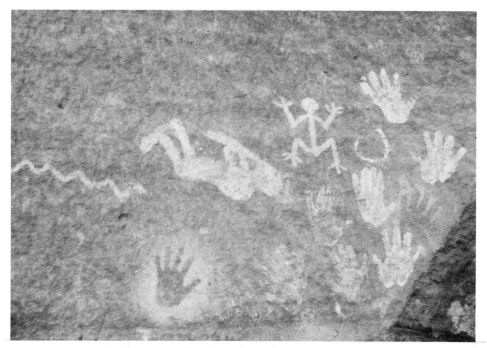

Fig. A.1. Recumbent humpbacked flute-player with positive and negative handprints at Great Pueblo site CDC-6.

Mindeleff's 1897 report on the ruins in Canyon de Chelly is still the best published work on the subject, but he makes only the most casual reference to rock paintings and petroglyphs. De Harport's unpublished 1959 thesis is the most complete record of the main canyon sites, but del Muerto was not included in his study. A total of 153 of De Harport's 369 sites contain some form of rock art. Wherever possible I have relied on this source for occupancy periods at sites in the main canyon. De Harport's dating is based on known pottery types (or, in the instance of Basketmaker, on absence of pottery), types of houses, and masonry. In Canyon del Muerto and at most petroglyph sites, I have relied on style and subject matter for approximate dating, along with masonry types and scanty excavation records.

The first sites were recorded roughly opposite the point where the road from Chinle enters the Chinle Wash, about a third of a mile above the bridge. A few minor sites between the bridge and the wash road were not recorded.

The Western Archaeological Center of the National Park Service has established a site numbering system based on the work of David De Harport, and this is the system used in the listing below. In addition, the letter *L.* or *R.* preceding each item indicates whether the site is on the left or right wall of the canyon facing upstream. The number following the left- or right-hand code indicates the height of the rock art above the canyon floor.

CDC-3, First Petroglyph Site. L. 8 feet. Shallowly pecked and incised. Stick-figure humans, meanders, abstracts. Painted birds and zigzag. Great Pueblo.

CDC-6, Flute-player Cave. L. 15 feet. A divided rock shelter. In left section, pecked sandal tracks, large horned human figures, grinding grooves. In right section, humpbacked recumbent flute-player, positive and negative handprints (one mutilated), figure with bird on head. Colors: yellow, buff, white. Great Pueblo. See Figs. 4.46, 4.47, 4.49, & A.1.

CDC-9, First Planetarium. L. 30 feet (above sloping ledge). Small Navajo star map (planetarium) on underside of overhanging rock. Below this is a small panel of petroglyphs typical of Great Pueblo period — squares with geometric patterns, stick men with raised arms, a hammer-headed man, and long-legged birds. Planetarium color: black. See Figs. 4.49, 4.50, & 4.82.

CDC-11, Hand Cave. L. 30 feet. Positive and negative handprints, seated flute-player, double-ended man, connected concentric circles, quadrupeds (dogs?), sheep with hoofs, stick men and rectangular humans, one with raised club. Color: white. Great Pueblo.

CDC-16, The Wall (Newspaper Rock). R. 20 feet. This is by far the largest petroglyph panel in the canyons, covering an area about seventy-five feet across. Access to the panel is by a narrow sloping ledge. Subjects include phallic stick figures, legless triangular-bodied humans, ducks, turkeys, deer, bird-headed men, flute-players, and spirals. The workmanship on these is fair to poor and is probably Great Pueblo. Pecked and scratched horsemen and shield figures probably of Navajo origin. See Figs. 4.1, 4.21, 4.22, 4.28, 4.45, 4.46, 4.58, 4.59, 4.62, & 4.83.

CDC-139, Petroglyph Rock. L. 50-60 feet. These petroglyphs are on a large (about 100 feet high) monolith standing between the entrances of Cottonwood and Tunnel canyons. The Anasazi figures are about sixty feet from the ground and are reached by a dangerous series of stepped ledges. Subjects include impaled sheep, square and triangular-bodied humans, concentric circles, and deer. Probably Great Pueblo. Around the base of the rock are Navajo pecked and incised petroglyphs — horsemen, deer, dot patterns, and abstract figures. See Figs. 4.74 & 4.81.

CDC-28, Antelope Point 1. L. 50 feet. Large ruin with low masonry walls and part of kiva visible under a thick layer of sheep dung. Negative and positive handprints, quadrupeds, stick figures, round-bodied humans, birds, bird-headed man, side-view men walking, Navajo horsemen, zigzags. Most of the painting is quite crudely done and in white only. Some of these rough figures are superimposed over carefully painted square- and triangular-bodied, armless human figures rendered in purple and green. Colors: white, buff, purple, red, green. Developmental and Great Pueblo. See Figs. 4.22 & 4.46.

CDC-34, Sleeping Duck Ruin. R. 50 feet. Large ruin above talus slope. Developmental and Great Pueblo occupation. Only slab-lined cists, fragments of masonry and many grinding grooves remain of the settlement, but paintings and petroglyphs are abundant. This site has a number of children's rock slides. Positive and negative handprints, lines of small humans, humpbacked, square, and bi-colored humans, polychrome impaled quadrupeds, turkeys and other birds, checkerboard, and wavy lines. Some of the paintings are high, suggesting that they were painted inside rooms or from the tops of buildings. Colors: black, white, red, yellow, green.

At the lower levels, there are cliff and bedrock petroglyphs. These are deeply incised on unpatinated rock. Petroglyph subjects include bighorn sheep, round-bodied humans, dogs, and goats. The latter are rendered in the Navajo style.

There is also a large petroglyph panel several hundred feet north of the ruin, about thirty feet above the canyon floor. Repatination of the designs is nearly complete, and motifs are difficult to see without oblique light. There are phallic flute-players, a humpbacked flute-player, men with crooks, dogs, bird-headed figures, an animal-headed figure, deer, snakes, and miscellaneous abstracts. See Figs. 4.20, 4.21, 4.22, 4.25, 4.28, 4.53, 4.54, 4.61, & 4.65.

CDC-30, Antelope Point 2. L. 150 feet, opposite CDC-34. Positive handprints, stick figures, quadrupeds, spirals, elaborate thick-line geometric designs, paint splashes. Color: white. Great Pueblo. See Fig. 4.50.

CDC-40, Blade Rock. L. 5 feet. On eastern base of Blade Rock. Deeply pecked petroglyphs. Procession of bighorn sheep followed by row of triangular-bodied men with raised right arms. Bird-headed men, hoofed bighorn with open mouth, impaled flute-player, impaled bighorn, turkeys, zigzag. Modified Basketmaker/Developmental Pueblo. Between these petroglyphs and the southwest tip of Blade Rock is another large panel of petroglyphs. They are high above the wash on a bench. There is no patina, and the incised patterns

are quite invisible. They can only be seen when there is a strong oblique light. Human types: stick figures, horned flute-player. Also birds, animals, zigzags, spiral. Great Pueblo.

Midway between the above two petroglyph panels is another group of inaccessible rock carvings high above the wash on fairly dark patina. Subjects include humans, animals, and miscellaneous abstracts. Great Pueblo.

CDC-41, Wall With Lightning. R. 75 feet, opposite CDC-40. An inaccessible site due to deterioration of foot- and hand-holds. Long panel is dominated by a very large white zigzag that gives the site its name. A large chunk of the panel has broken off since the time of painting. Various human types: flat-headed, armless, holding arrows, horned, seated flute-player. Single-legged birds, various zigzags, arrows. Colors: white, yellow, green. Crudely painted Great Pueblo work over earlier small anthropomorphs.

CDC-47, First Ruin. L. 75 feet. This site, usually referred to as the first ruin is not, of course, the first ruin in the canyon, but is the first site visible from the canyon floor with well-preserved rooms. This large ruin is approached by a hand-and-toe trail over precarious crumbling rock ledges. There are two kivas and about ten rooms of the Mesa Verde masonry type that occurred during the Great Pueblo period. Most of the motifs here are of the white, thick-lined type, executed quite carelessly, typical of those usually found at Great Pueblo sites. These are positive handprints, thick-lined humans, stick men, zigzags, four-inch-wide geometric fretlike patterns, paint splashes. There are a few earlier small horned human figures, quadrupeds, and birds. Colors: white, red, gray. See Figs. 1.9, 4.5, & 4.50.

CDC-49, Bighorn Ruin. L. 100 feet. Just east of CDC-47. Positive handprints, small rectangular and stick men, quadrupeds, and birds. Developmental Pueblo and Great Pueblo. A few petroglyphs depict bighorn and triangular anthropomorphs. Colors: white, red, yellow.

Twenty-five feet above the petroglyphs are inaccessible paintings of large outlined humans with antenna headdresses, small red stick men, concentric circles, and abstracts. Colors: white, red. Modified Basketmaker through Developmental Pueblo. See Fig. 4.42.

CDC-54, Bad Trail Ruin. L. 50 feet. In Bad Trail Cove just before the entrance to Canyon del Muerto. Site divided into two painted areas. There are a single kiva, eight or nine rooms, and several slab-lined cists of the Developmental Pueblo period. Human types are legless, armless, hammer-headed,

Fig. A.2. Unusual Developmental/ Great Pueblo twinned figures with feathered headdresses at site CDC-54.

bisected polychrome, with body decorations, horned, flute-players, bird-winged, and bird-headed. There is a very large positive handprint panel that also includes footprints, unusual in the canyons. There are 166 handprints and 39 footprints of both adults and children. In addition there are brown turkeys with reddish fugitive painted heads, brown outlined squares, zigzags, and impaled bighorn. Crude small white human figures and paint splashes are characteristic of the Great Pueblo period. Colors: white, black, brown, red. See Figs. 4.19, 4.22, 4.25, 4.45, 4.58, & A.2.

CDC-138, Junction Cliffs Petroglyphs. L. 8 feet. These petroglyphs are scattered along the lower faces of cliffs between the entrance to Canyon del Muerto and Canyon de Chelly. They are Developmental Pueblo through Great Pueblo. Human types: horned, with antenna headdresses, bird-headed, round-bodied, seated with large clubs. Bighorn sheep, one impaled, turkeys, ducks, four-legged birds. Developmental through Great Pueblo. See Figs. 4.22, 4.30, & 4.48.

CDC-140, The Dodd Inscription. L. 10 feet. About 500 feet southwest of CDC-73, just at the point where cliff turns sharply, there is a scratched inscription by an American cavalryman on a mission to destroy the peach orchards in the canyon in August 1864. "W. E. Dodd. Co K 1st Cavy. N. M. Volts."

CDC-70-72, Four Hole Site (Planetarium Site). L. 30 feet. Just around point from CDC-140, above a rocky bench. Four small caves with round entrances, eight to ten feet in diameter. Two of these little caves were in accessible without scaffolding, but paintings, including a small planetarium, were seen. The northern-most caves were entered. They contained a number

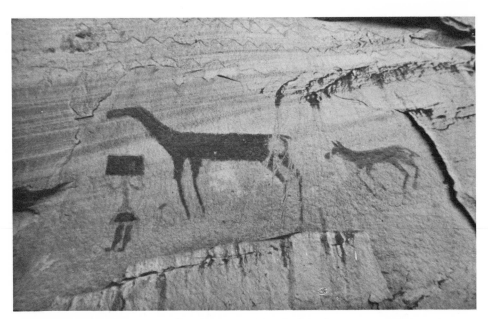

Fig. A.3. These Navajo horselike animals and female deity from site CDC-73 are similar to certain sand-painting figures. Dim Anasazi petroglyphs can be seen at upper left.

of outlined, headless birds, a horned shaman with a bird above his head, and a small planetarium in black and white. Colors: black, white, red, yellow, green. Navajo and Anasazi, probably Developmental Pueblo. See Fig. 4.40.

CDC-73, Corncob Shelter. L. 75 feet. Access to site by hand-and-toe trail over ledges. Navajo storage bins. Site named for great numbers of corncobs near bins. There are a few Anasazi design motifs here, including petroglyphs of stick men and zigzags, but most of the paintings are Navajo. Spanish horsemen, a woman, antelopes, arrows, and an elaborate stepped cloud design which may be Hopi in origin. Colors: white, yellow, red, brown, gray. See Figs. 4.66, 4.69, 4.70, & A.3.

CDC-74, Cable Cave. L. 125 feet. Slightly to the east of CDC-73. Access by hand-and-toe trail. Human types: polychrome turkeys on heads, feathered, armless and legless, humpbacked flute-player; quadrupeds, bighorn sheep, deeply pecked petroglyphs of hoofless sheep. Colors: white and brown. Modified Basketmaker through Developmental Pueblo. The flute-player is Great Pueblo. See Figs. 4.4 & 4.47.

CDC-75, White House Ruin. L. 40 feet (to upper ruin). Very big ruin with a lower section built against the base of the cliff at one time connected with

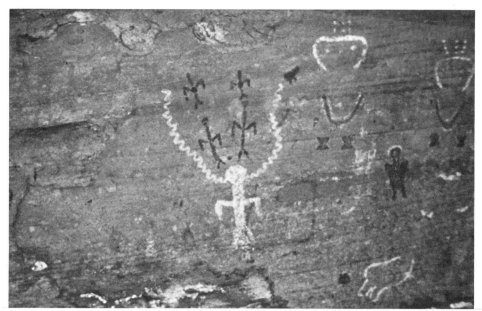

Fig. A.4. This unusual Modified Basketmaker/Developmental Pueblo painting at site CDC-78 possibly represents power lines and spirits emanating from the head of a shaman.

upper ruin by a four-story building. The lower ruin had from forty-five to sixty rooms with one kiva, while the upper ruin had over ten rooms. Mindeleff (1897) estimated that White House would have accommodated from ten to twelve families, or from thirty to forty people. He noted Navajo burial cists in both sections; this type of cist location is common throughout the canyons. Much of the construction is of the Mesa Verde type, placing the ruin in the Great Pueblo period. There is very little rock art at this site — a few abstract motifs, concentric circles, a star shape, and a man with raised arms on the cliff behind the lower ruin. The upper ruin was not examined due to its inaccessibility. Colors: white, red. See Figs. 2.29 & 2.34.

CDC-78, Pictograph Cave. L. 35 feet. This site is in a small canyon just east of White House and is approached via a steep slope. Part of the floor is tilted sharply, creating a well-used children's slide, and there are traces of construction. The rock paintings are of the climax period in the canyons; this is a major site. There are positive and striated handprints; human types include armless, with spear, bird-headed, beneath polychrome curved bands (rainbows), and twinned flute-players. There are dogs, twinned quadrupeds, turkeys, and zigzags. Colors: white, green, red, brown. Petroglyphs include sandal tracks and deer. Modified Basketmaker through Developmental Pueblo. See Figs. 4.25, 4.27, 4.37, 4.45, & A.4.

CDC-92, Deadman Cove (Planetarium Site). R. 50 feet. In deep cove directly opposite CDC-78, and near White House trail. Access is by hand-and-toe trail up steep rock. Developmental Pueblo paintings: rectilinear humans, polychrome concentric circles, a "rainbow," and a zigzag. Navajo paintings: elaborate abstract, planetarium on roof of shelter. Colors: white, red, black, yellow. See Fig. 4.81.

CDC-141, Two-Steer Panel. L. 3 feet. Along cliff face east of CDC-78. Two life-sized steers, one with head turned to the side, a rare thing in rock art. Colors: black, white. Navajo.

CDC-80, Horned Moon Panel. L. 15 feet. In next cove east of CDC-141. Navajo paintings and petroglyphs on rock mass separated from main cliff. Paintings: large circle and horned moon, positive handprints, stick figures, deer, antelope (one life-sized antelope dominates the panel), horses, linear abstractions. Colors: white, red, black. There are a few crude petroglyphs on narrow ledge below paintings. See Figs. 4.65 & 4.81.

CDC-96, Navajo Squares Site. R. 8 feet. Across canyon from CDC-80. This masonry rock ruin against the cliff was used as a Navajo corral and is largely covered with sheep and goat dung. There are a few dim Anasazi paintings, but the rest are Navajo. Three designs are geometric and abstract, including triangular and square forms; there is also a modern horse. Colors: red, black, white. See Figs. 4.65, 4.75, & 4.82.

CDC-98, Sheep Cliff. R. 25 feet. In cove just east of CDC-96. Paintings are on cliff face above a narrow ledge. Five Navajo life-sized sheep or goats, large split disks, and a small Ye'i with raised arms. Color: white.

CDC-142, Big Deer Site. R. 6 feet. Further east along the same cove as CDC-92. A life-sized abraded Navajo deer.

CDC-76 & 77, Tsé-ta'a. L. 15 feet. This large ruin opposite CDC-142 has suffered severely from stream cutting. It was the first canyon ruin to be systematically excavated. Steen (1966) describes layers of occupancy from Modified Basketmaker through Great Pueblo. The first period is represented by two pithouses. The final occupancy in the Great Pueblo period was in two sections: the South Ruin of seven rooms and a kiva and the North Ruin of fourteen-plus rooms and four kivas. Plastered squares on the cliff face indicate that some rooms were on third- and fourth-story levels. There are few

paintings connected with the Tsé-ta'a site, although high above the ground there is a painting in red of an archer confronting a buck and a doe that could only have been painted from a high roof top. Great Pueblo. See Fig. 3.5.

CDC-110, Calcite Ruin. L. 50 feet. On opposite side of cove from CDC-86 & 87. An unusual site in that all the paintings are covered by a deposit of translucent calcite up to a quarter of an inch in thickness. Human types: phallic, with flutes, female with hands raised, triangular, rectangular bodied — all figures small. Dots in lines, positive handprints, quadrupeds (deer)?, a few geometric. Colors: brown, red, white. Great Pueblo. See Figs. 4.26 & 4.28.

CDC-113, Twin Flute-player Petroglyphs. L. 25 feet. At top of low talus slope of cliff. Stick figures, feathered, paired, flute-players, tracks, dot patterns, zigzags. Subject matter and execution suggest Great Pueblo period. See Figs. 4.26, 4.37, & 4.59.

CDC-95, Round Cave Ruin (Planetarium Site). L. 25 feet. Directly opposite mouth of Spring Canyon, this ruin is in a unique location. A large rock mass stands out from the cliff, and in this rock is a fairly deep, semi-circular cave forty-five feet in diameter and twenty feet high. A small ruin with two kivas and over a dozen rooms and storage areas occupies all available space. The shape of the cave has led to its use as a Navajo sheep corral. On the high cave roof there is a Navajo planetarium. Color: black. See Figs. 4.38 & 4.79.

CDC-99, Big Yellow Man Panel. R. 50 feet. This panel is located across the canyon from CDC-95 and on the right-hand cliff entering Spring Canyon. It is in a rock shelter above talus. Life-sized human figures, small stick men. Colors: yellow, red. Basketmaker through Modified Basketmaker.

CDC-101, Leaping Deer Ruin. R. 5 feet. Located along cliff base in Spring Canyon south of CDC-99. Navajo charcoal drawings. Deer in circle, steer head in circle, owl, horsemen, bear. A few faint Anasazi paintings. Colors: red, white. Probably Developmental Pueblo.

SC-1, Wild Cherry Ruin. R. 20 feet. In Spring Canyon south of CDC-99 and on the same side of the canyon. There are some masonry fragments and many Anasazi paintings. Human types: hammer-headed, with fingers and toes, horned, with eyes and body-dotting, with semi-circular headdresses, female. There are also positive handprints, quadrupeds, turkeys, crested birds, rows of polychrome rectangular and triangular shapes, and zigzags. Colors: red,

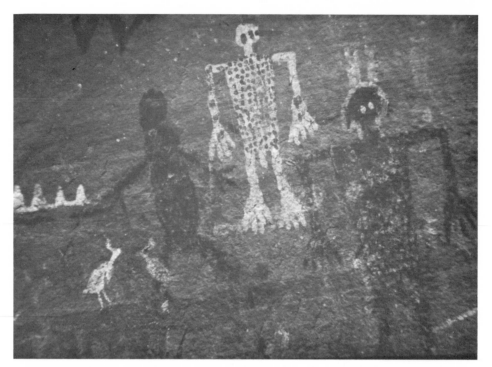

Fig. A.5. These Developmental/Great Pueblo figures are probably supernatural beings or shamans at site SC-1. Note the skeletal effect on the central figure in white.

white, brown, yellow, green. Basketmaker through Developmental Pueblo. See Figs. 4.25, 4.56, & A.5.

SC-2, Spring Canyon Planetarium. R. 10 feet. Small rock shelter at the head of Spring Canyon. Navajo planetarium on roof of shelter. Color: black.

CDC-106, Dancing Man Site. L. 35 feet. An inaccessible site due to weathering of hand-and-toe trail. Human types: large rectangular, small turkey-headed; quadrupeds. Colors: white, yellow. Basketmaker through Developmental Pueblo.

CDC-107, Sliding Rock Ruin. L. 150 feet. A large ruin in the cove to the east of CDC-95, approached by hand-and-toe trail at west end. There are two sections of the ruin — the smaller was a settlement of at least six rooms and one kiva, while the larger had from thirty to fifty rooms and three kivas. There is evidence on the cliff wall that some of the structures were three stories. Many of the cliff shelter sites have outward sloping floors, and the ancient builders often had serious engineering problems in supporting multi-

Fig. A.6. These painted walls on the cliff face at site CDC-121 were once part of the decoration of a second-story Great Pueblo room. For additional paintings at this site, see Figs. 4.25, 4.27, 4.55, & 4.60.

storied buildings on a tilted surface. Sliding Ruin is a fine example of the problem. There are holes bored in bedrock for vertical posts to brace log and rubble terraces. Sometimes the masonry houses were built directly on loose trash. Over the centuries, great numbers of the Canyon de Chelly cliff dwellings have collapsed and tumbled into the canyon through foundation failure. Stick flute-player, negative and positive handprints, quadrupeds, birds. Color: white. Great Pueblo. See Figs. 4.24 & 4.42.

CDC-112, White Sands Ruin. R. 100 feet. In the cove directly opposite CDC-107. The approach is up a steep talus slope and along narrow ledges. A small Developmental Pueblo ruin with several rooms and a kiva. There are also a few Navajo burial cists. Humans in dancelike positions, quadrupeds, circles, zigzags, Navajo horse. Colors: white, brown, red.

CDC-121, Painted Room Ruin. R. 150 feet. This once was a considerable Great Pueblo settlement, but little surface material remains except slab-lined cists and some Navajo construction. Four plastered and decorated squares on the cliff show location of former rooms up to the three-story level. There

are grinding grooves in the bedrock. Human types: feathered, horned, hammer-headed, turkey-headed, feathered flute-player. Positive handprints, large clawed quadruped (bear?). Colors: white, green, red, black. There is a deeply pecked petroglyph of a line of twenty birds over some of the early paintings and a row of five stepped Kachina masks which may be Hopi in origin. Basket-maker through Great Pueblo. See Figs. 2.38, 4.25, 4.27, 4.55, & 4.60.

CDC-120, Big White Men Panel. L. 65 feet. This site is approached over steep, crumbly ledges by hand-and-toe trail. Seven large human figures (some life-sized), horned and hammer-headed. Also positive handprints and toothed quadruped (bear?). Color: white. Developmental Pueblo. See Fig. 4.55.

CDC-131, Bull's-eye Cave. L. 10 feet. In next cove east of CDC-120. A rock shelter near the canyon floor. Heavy deposit of sheep dung hides all but traces of masonry. Rectangular humans lacking feet or hands, polychrome turkeys, big white concentric circles. Colors: white, brown. Developmental Pueblo.

CDC-156, Beehive Cove Petroglyphs. L. 5 feet. At base of cliff on right side of Beehive Cove — next cove above CDC-131. Human types: triangular bodied, legless, horned, bird-headed. Impaled bighorn sheep, row of sixteen ducks, spiral, and other abstracts. Developmental Pueblo.

CDC-151, Corn Shrine Petroglyphs. L. 5 feet. On cliff on the left side of the cove just west of Beehive Cove. Incised design of masked Ye'i between two stylized corn plants. Navajo.

CDC-174, Window Rock Ruin 1 & 2. R. 300 feet. High ruin of about seven rooms with no outside entrances. All but one are very small and could hardly have been lived in. Access to the narrow ledge and the ruin is up forty feet of almost vertical slabs of rock by hand-and-toe holds. We found it inaccessible, but Mindeleff made it in the 1880s. Most of the rock paintings are very fresh-looking and of the high period of canyon painting, presumably Developmental Pueblo. Human types: outlined, feathered, with raised arms. Many small, triangular-bodied anthropomorphs in rows. Some of the figures are crudely painted in white and are of the Great Pueblo period. Colors: white, yellow, green, red, brown.

On a narrow bench about fifty feet below the ruin there are a few small rooms and vestiges of a possible kiva. Human types: very large, outlined, with handprints symmetrically placed on chest areas, feathered, hammer-headed.

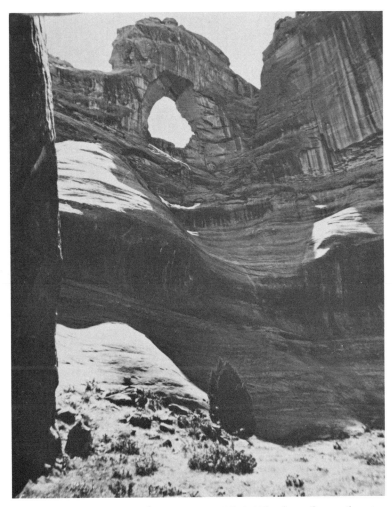

Fig. A.7. The Window, near site CDC-172, about four miles west of Spider Rock. Many important sites are clustered near here.

Zigzags. Colors: white, brown, yellow. Basketmaker through Developmental Pueblo. See Figs. 4.13 & 4.25.

CDC-172, Window Rock Ruin 3. L. 150 feet. At the end of the first cove east of Window Rock. Some remains of slab-based structure. Human types: with left ear ornament, birdhead, headless and triangular-bodied, feathered, horned, hammer-headed, miscellaneous small crude figures. Quadrupeds, solid and outlined (one dog with collar), four-pointed stars. Colors: white, red, yellow, green. Several deeply cut petroglyphs of rectangular anthropomorphs on flat bedrock. Modified Basketmaker through Great Pueblo. See Figs. 4.22, 4.23, & A.7.

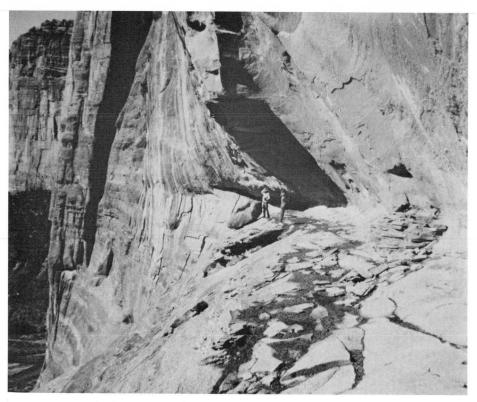

Fig. A.8. Face Rock Ruin, site CDC-228. This high site near
Spider Rock is approached over the talus slope to the right.

CDC-219, Face Rock Antelope. L. 20 feet. At foot of cliff about 200 feet
west of Face Rock. Four Anasazi petroglyphs — rectilinear and oval-bodied
humans. Life-sized Navajo antelope. Colors: red, buff. Probably Great Pueblo.

CDC-228, Face Rock Ruin 1. L. 600 feet. High ruin approached up talus
slope from the right. Some Navajo masonry and slab-based structures. Posi-
tive handprints, some with whorled and striated patterns applied. Snake, birds,
crude quadrupeds, concentric circles, thick-lined geometric, paint splashes.
Colors: white, green, yellow, brown, buff. Great Pueblo period. See Fig. A.8.

CDC-229, Face Rock Ruin 2. L. 650 feet. Rock shelter fifty feet above and
to the right of CDC-228, directly above the talus slope. A thick layer of sheep
dung covers much of the ledge surface. Slab cists, a kiva, and several masonry
structures are visible. Human types: round-bodied, with headdresses, big shield
figure. Also small rectilinear quadrupeds, dog with collar, birds, paired turkeys,
two rows of turkeys, parallel lines, zigzags. Colors: white, yellow, brown.
Paint splashes. Great Pueblo over Developmental Pueblo. See Figs. 4.21 &
4.83.

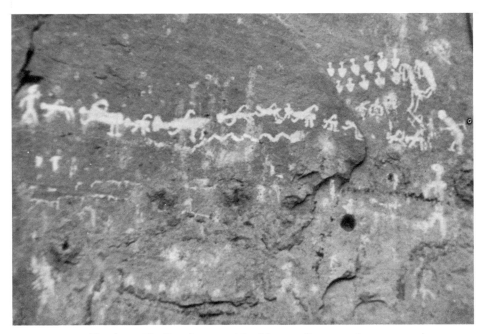

Fig. A.9. The Developmental Pueblo crawling men that gave their name to site CDC-302. The curious figures in the upper right appear to be highly stylized men with arms and legs removed.

CDC-233, Spider Rock Shelter (Planetarium Site). R. 40 feet. Small site across canyon and directly south of Spider Rock. Raised-arm Great Pueblo anthropomorphs, positive handprints, paint splashes. Color: white. Small Navajo planetarium panels on roof of shelter. Navajo charcoal horses.

CDC-291, Doe Panel. L. 100 feet. About two and one-half miles east of Spider Rock. The paintings are above a narrow ledge with the remains of a masonry wall. Outlined anthropomorphs, bighorn sheep, antlerless deer, zigzag. Color: white. The poor conception and workmanship suggest the Great Pueblo period.

CDC-302, Crawling Men Ruin. L. 400 feet. Three-fourths of a mile east of CDC-291 and lying quite far back from the canyon floor. Approached by a gradual talus slope. Two kivas of the Developmental Pueblo period. Human types: crawling, armless, legless, round-bodied, with arms raised, female. Negative and positive handprints, quadrupeds, a few geometric and abstract motifs. Colors: white, red, green. Developmental Pueblo through Great Pueblo. See Figs. 4.27, 4.28, 4.46, 4.49, 4.50, & A.9.

Canyon del Muerto

CDM-15, Junction Petroglyphs. R. 20 feet. On horizontal band of black patinated sandstone. Human types: triangular-bodied, bird-headed, stick figures. Quadrupeds, bighorn sheep and lamb. Developmental Pueblo.

CDM-141, Two Spiral Shelter. R. 50 feet. In cove east and across from Junction Ruin. No talus; the approach is over ledges. Phallic human figures, polychrome turkeys, miscellaneous birds, spirals. Colors: white, green, red, brown. Developmental Pueblo.

CDM-128, Kokopelli Cave. L. 60 feet. West of CDM-141 across canyon. Accessible by hard climb over loose shale ledges. Navajo rock and mud storage cists, round and square. Human types: seated flute-players, polychrome seated with turkey head, with arms up, upside down. Quadrupeds (deer?), positive handprints of adults and children, four-legged polychrome turkeys, arrows, zigzags, paint splashes. Colors: white, brown, red. Deeply pecked pits. A few polychrome early Developmental Pueblo; the balance are Great Pueblo. See Figs. 4.21 & 4.22.

CDM-37, Big Hand Ruin. L. 75 feet. A big ruin at the eastern edge of the same cove as CDM-128, reached by hand-and-toe trail over ledges. No talus. Vestiges of masonry but high inaccessible paintings suggest former multi-story structures. Human types: bird-headed, outlined, with necklace and belt, triangular-bodied, armless, with oversized hands, triangular-bodied, hammer-headed. Positive handprints, some with striated patterning, turkeys, paired vulva motifs, polychrome concentric circles, paint splashes. Colors: white, red, brown, yellow. Mainly Modified Basketmaker through Developmental Pueblo with some Great Pueblo. On a higher ledge there are a few petroglyphs — sandal tracks and a spiral. Grinding grooves. See Figs. 4.22, 4.25, & 4.46.

CDM-88, Ceremonial Cave. L. 40 feet. Long, low shelter in an area of conspicuous cross-bedding. In next cove, northeast of CDM-37. No Anasazi structures, but a number of round Navajo mud and rock cists. The painted panel is about sixty feet long and is the most diverse and interesting painted site in any of the canyons. The figures without exception are small and carefully painted. All seem to have been done at roughly the same time. Human types: in rows, with joined hands, bird-headed, in rows seated, twinned, bi-colored,

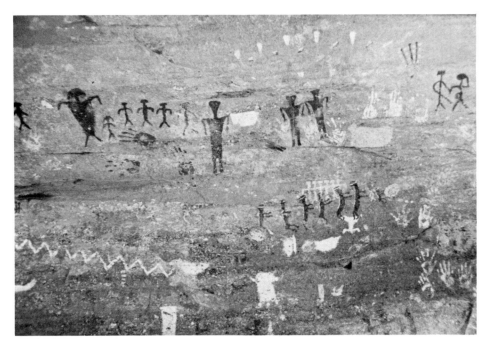

Fig. A.10. This sixty-foot long Early Developmental Pueblo painted panel at site CDM-88 is the most diverse and interesting painted site in any of the canyons. For additional views of it, see Figs. 4.3 & 4.6.

with dot headdresses, in rows alternating male and female (femaled indicated by big hips, not by genitals or hairdress), hammer-headed, stick figures. Positive handprints with whorled designs, outlined zigzags, various dot patterns. Turkeys: monochrome, polychrome, leaping. Bighorn sheep: legless, bicolored. Animal tracks, miscellaneous abstract. Modified Basketmaker through Early Developmental Pueblo. See Figs. 4.3, 4.6, 4.21, 4.22, 4.23, 4.25, 4.29, & 4.59.

CDM-23, Stipple Cave. R. 60 feet. In a cove directly opposite CDM-88. Access to this small site is up a very steep rock slope. Carefully painted red anthropomorph outlined in white, one arm raised, sandal tracks, abstract dot patterns. Colors: white, red. Modified Basketmaker through Early Developmental Pueblo.

CDM-243, Oleson Site. L. 20 feet. On end of rocky point just beyond CDM-88. Petroglyph spirals. Great Pueblo.

CDM-242, Goat Ledge. L. 5 feet. At foot of cliff in next cove beyond CDM-88. Navajo horses and horsemen in white and charcoal.

CDM-2, Ledge Ruin. L. 40 feet. Small, well-preserved ruin in next cove beyond CDM-242. Approached up ledges to the left. Human types: triangular-bodied, polychrome with necklaces, humpbacked flute-player. Two-legged bighorn sheep and lamb, bi-colored turkeys, leaping turkeys. Outlined birds, rows of parallel lines. Colors: white, red, brown. A few petroglyphs — double stick anthropomorphs, abstracts. Developmental Pueblo through Great Pueblo. See Figs. 4.21, 4.49, & 4.63.

CDM-6, Ute Raid Panel. L. 5-10 feet. Around the point from CDM-2. The panel is on a slanting surface in a shelter with the low end to the left. About thirty feet long. Navajo record of a Ute foray into the canyon in 1858. Forty Ute horsemen armed with lances or guns. Thirty-four Navajo on foot armed with lances and bows and arrows. Six of the latter are shield figures. The shields are carried by the horsemen, who also have bridles. Some of the details are in white and black paint, but the remainder unfortunately is in charcoal and rapidly deteriorating. See Figs. 4.45, 4.73, & 4.83.

Slightly to the right of the charcoal drawing is a small Anasazi panel featuring a large-headed anthropomorph with raised arms and various quadrupeds, one of which appears to be a bear. Color: white. Great Pueblo.

CDM-3, Black Bull Cave. L. 30 feet. Anasazi and Navajo paintings. Human types: large outlined, phallic, with patterned body. Positive handprints, birds, turkeys, zigzags. Colors: white, yellow, red. Basketmaker through Modified Basketmaker. Two life-sized Navajo black bulls. See Figs. 4.13 & 4.21.

CDM-221, White Horse Panel. R. 5 feet. Opposite and south of CDM-3, Two Navajo paintings of Spanish horsemen. Color: white. See Figs. 4.2 & 4.65.

CDM-10, Antelope House. L. 20 feet. In next cove opposite CDM-3. Large ruin built against base of cliff. Considerable wall structure still standing, including a four-story section with plastered interior walls. Paintings high on cliff at fourth-story level. Double-ended anthropomorph, quadrupeds, birds, children's positive handprints, swastika. Color: white. Great Pueblo.

Just west of the ruin is an important painted panel above a narrow ledge twenty-five feet from the base of the cliff. Great Pueblo paintings: outlined human types, stick figures, quadrupeds, turkeys, concentric circles. Navajo paintings: four life-sized antelopes, horses. Colors: buff, white, black. See Figs. 4.48, 4.64, & 4.68.

CDM-7, Battle Cove Ruin. R. 15 feet. Across canyon from Antelope House. Small eight-room masonry structure at base of cliff built over Modified Basketmaker slab rooms. Basketmaker cists were excavated here by Morris in 1929. Human types: long-bodied, feathered, with ear appendage, bi-colored. Colors: white, yellow, green, red. Basketmaker through Early Developmental Pueblo. White paint splashes and few abstracts, Great Pueblo. A Kachina mask may be Hopi in origin. See Figs. 2.38, 3.3, 4.11, 4.13, & 4.44.

CDM-4, Standing Cow Ruin. L. 15 feet. A very big ruin on canyon bottom under huge overhang. About one mile above the entrance to Black Rock Canyon. Mindeleff (1897) called it one of the largest ruins in the canyons. Remains of walls cover an area 400 feet long by 40 wide. The structures were built partially around immense boulders that had fallen from the cliff. There are about sixty rooms and three kivas. Several Navajo log-and-earth storage cists. Anasazi and Navajo paintings. Great Pueblo renderings: stick anthropomorphs with raised arms, hunchbacked archer, quadrupeds, many concentric circles. Colors: white, yellow, black. The most interesting Navajo painting is located above a fifty-foot-high ledge near the west end of the site. Accessible by a narrow sloping ledge, it should only be attempted by the most fearless of climbers. A procession of Spanish horsemen, horses, and dogs. Two fringed shield figures and a horned moon. An armed Indian is riding with the Spaniards, while two Spaniards mounted on a single horse are shooting at an Indian. The Spanish are wearing flat-brimmed hats and long cloaks and are armed with guns. This panel is believed to represent the soldiers of Lieutenant Antonio Narbona who fought the Navajo at Massacre Cave in 1805. Along the base of the cliff there are more Navajo paintings, including the life-sized "Standing Cow," horses, horsemen, and a charcoal drawing of a mounted U.S. cavalryman of the 1860 period. Colors: white, red, black. See Figs. 4.69, 4.70, & 4.82.

CDM-68, The Peña Inscription. R. 5 feet. Left side entrance to Many Cherry Canyon. Navajo charcoal drawings of goats. Incised inscription in Spanish by volunteer calvaryman in Colonel Kit Carson's 1864 expedition into the canyon. Translation: José Peña Company H 1st New Mexican Volunteers passed by here the 13th day of January, 1864.

MCC-11, Many Cherry. R. 400 feet. Upper end of Many Cherry Canyon on left side. Well-preserved panel of Great Pueblo period. Only structure a storage or burial cist. This is an interesting site, including the only Anasazi

paintings indicating warfare. Human types: phallic, feathered flute-player, impaled with arrows, triangular bodied, horned, outlined. Fanciful quadrupeds, impaled bighorn sheep, impaled dog or coyote, impaled bird, crane, dot patterns, concentric circles. Colors: white, tan. A few geometric petroglyphs. Great Pueblo. See Figs. 4.43, 4.46, 4.48, & 4.55.

CDM-237, Purple Men Ruin. R. 175 feet. A small high rock shelter one-half mile beyond Many Cherry Canyon. Approached by a very steep talus slope. Masonry cists, some crushed by rockfalls. Human types: phallic, rectilinear, triangular bodied, recumbent, female. Positive handprints with striated patterning, hunchbacked figure procession, dog on hind legs, other quadrupeds, turkeys, zigzag. Colors: purple, white, green, red. Developmental Pueblo through Great Pueblo.

CDM-123, Ear Cave. L. 100 feet. In next cove above Many Cherry Canyon, accessible across steep talus and crumbly ledge rock. One of the most interesting sites in the canyons. The cliff face is dominated by many curious, large human figures with top-of-head and left-ear appendages. There are a few isolated figures of this type in the canyons, but only this single concentration. Human types: with head appendages, triangular-bodied, horned, turkey-headed, with necklaces, crooks, in rows, holding objects. Polychrome quadrupeds, polychrome leaping turkeys, positive adult, children's handprints with striated patterning. Colors: white, red, purple. Basketmaker through Modified Basketmaker. A few crude Great Pueblo. See Figs. 4.13, 4.14, 4.16, 4.21, 4.22, 4.23, 4.58, 4.59, & A.11.

CDM-229, Shield Panel. L. 5 feet. On the cliff face under a low overhang. Directly across from CDM-237. Navajo paintings of warrior with bow and two fringed shield figures. Similar to the two fringed shield figures in the Standing Cow panel. Color: white. See Figs. 4.62 & 4.83.

CDM-67, Many Turkey Cave. L. 50 feet. About one-half mile beyond CDM-229 in a cove. The site is inaccessible. The only motif visible from the ground is the turkey, although other birds may be represented. Monochrome and polychrome. Colors: white, brown, red. Developmental Pueblo.

CDM-263, Blue Bull Cave. L. 20 feet. A large painted site in two sections. Below and to the right of CDM-67. Anasazi and Navajo. The left panel is Anasazi, including the following human types: rectangular-bodied, outlined,

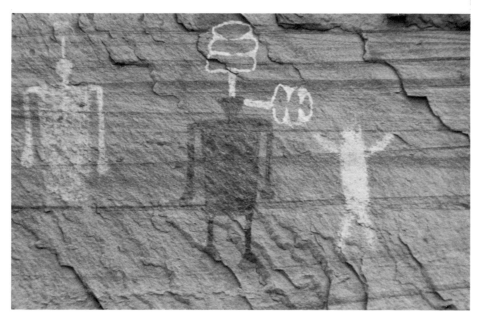

Fig. A.11. One of the curious "ear" figures from Ear Cave, site CDM-123, with elaborate top-of-head and left-ear appendages. These Basketmaker/Modified Basketmaker devices may have been connected with shamanistic attributes, indicating "power" of some sort. For additional ear figures, see Figs. 4.13 & 4.14.

hunchbacked, with necklaces, horned, hammer-headed, with left-ear and top-of-head ornaments. Positive handprints, some upside down, polychrome turkeys, ducks, zigzags, concentric circles. Colors: white, brown, red, yellow, gray. Basketmaker through Developmental Pueblo.

The right panel is Navajo. Below and to the right of the Anasazi paintings, there is a large blue-gray bull. Above the bull is a polychrome painting of a feathered Ye'i holding a feathered bow. At the extreme left of the overhang there is a small panel with Spanish cowboys and horses. The scene shows considerable action, and the men are on foot or mounted. Most are polychrome. There are also antelope and miscellaneous quadrupeds. The execution is in paint and charcoal and appears to be mid-nineteenth century. Colors: black, red, white, gray, brown. See Figs. 4.11, 4.12, 4.13, 4.20, 4.65, 4.66, & 4.82.

TWT-1, Twin Trail Ruin. R. 350 feet. On left side of Twin Trail Canyon, about one mile above CDM-263. Accessible over rough, rocky talus slope. Ruin consists of slab-lined cists, many masonry walls and two well-preserved kivas, one with a decorative band of color above the benches. Human types: triangular-bodied, armless, legless, round-bodied, with earrings, impaled with

arrow. Positive handprints, some striated; quadrupeds including a large-toothed dog; single-legged cranes and turkeys; paint splashes. Some of the quadrupeds have horizontal hoofs, a feature rare in the canyons but seen elsewhere at Great Pueblo sites and common on Shoshonean petroglyphs of bighorn sheep. Colors: white, red. The masonry as well as many of the paintings suggest the Great Pueblo period. The paintings are extensive, but most are poorly conceived and executed and, as is usual with this period, are mainly rendered in white. There are a few nicely painted earlier outlined human figures in red. See Fig. 4.48.

CDM-201, Crack-in-Rock Site. L. 5 feet. Near road on left side of cove opposite TWT-1. A small, narrow cave formed by leaning mass of rock against cliff. Large human figures in white and red. White positive handprints. Probably Modified Basketmaker.

CDM-155, Big Cave (Tsé-ya-tso). L. 50 feet. In a cove about 1½ miles above TWT-1. A very large site in a deep and high cave (1,000 feet long). Slab-lined cists, traces of Developmental Pueblo masonry over pole-and-mud Basketmaker houses, and evidence of turkey pens with abundant turkey dung mark this important site, excavated by Earl Morris. Human types: large solid and outlined, small round-bodied. Positive handprints, bighorn sheep, miscellaneous quadrupeds, turkeys, pecked lines of dots, concentric circles, zigzags. Colors: white, red, black, green, yellow, gray. Most of the paintings seem to be of Basketmaker through Modified Basketmaker origin with a few Great Pueblo paintings rendered in white.

SHP-11, Sheep Point. R. 20 feet. A little above CDM-155, on cliff at entrance to Sheep Point Canyon. Human types: rectangular, feathered with earrings. Two large Great Pueblo bighorn sheep, paint splash over row of small human figures. Color: white. Navajo charcoal horse.

SHP-12, East Trail Petroglyphs. R. 5 feet. On base of cliff east of SHP-11. Deeply pecked petroglyphs of snake, footprints, single-footed turkey, vulva. Modified Basketmaker through Developmental Pueblo.

CDM-168, Two Turkey Ruin. R. 60 feet. On next point beyond SHP-11. A small site accessible by talus slope and steep ledges. One small, well-preserved masonry-and-mud room. Triangular-bodied man, outlined quadruped, two polychrome turkeys. Colors: white, yellow, brown. Early Developmental Pueblo.

TYK-7, Yoke Petroglyphs. R. 200 feet. Left side Tsé-ya-kin Canyon. Accessible up talus slope and then over crumbling ledges. Petroglyphs are on floor of small shelter. Footprints, yoke-like motif. Great Pueblo.

TYK-8, del Muerto High Cave. R. 700 feet. Above and to the right of TYK-7. This is a dangerous climb mainly over steeply slanting ledges and a hand-and-toe trail. Row of crudely painted quadrupeds, bighorn sheep. Hoof treatment as noted at TWT-1. Colors: white, yellow. Great Pueblo.

TYK-9, Rimrock Cave. R. 750 feet. Directly above TYK-8. Inaccessible to all but expert climbers. Kee Begay, our Navajo guide, made this climb. Quadrupeds, crude anthropomorphs. Color: white. Great Pueblo.

TYK-10, Big Woman Petroglyph. R. 700 feet. Just east of TYK-8. Women with earrings; woman with greatly exaggerated hands, feet, and genitals. Great Pueblo. See Fig. 4.28.

TYK-3, Hole in the Cliff Ruin. R. 750 feet. About 1,000 feet east of and above TYK-10. A small round cave with slab-lined cists. A few poorly painted quadrupeds, horned anthropomorph, positive handprints. Colors: white, purple, red. Great Pueblo.

CDM-174, Mummy Cave (Tsé-ya-kin). R. 250 feet. At the entrance of Tsé-ya-kin Canyon stands the most spectacular of the Canyon del Muerto ruins. The ruin is divided into two alcoves; the right one is accessible by climbing a talus slope. The two alcoves are connected by a central ledge, entirely occupied by seven very large rooms, some of more than one story, and a three-story tower with roof still intact. The westerly, or smaller, alcove has fourteen small rooms on the ground level, while the eastern alcove has about fifty small rooms and two kivas. One of the kivas has elaborate geometric patterns in a decorative band in front of the bench. The tower and most of the rooms are of the Great Pueblo period, and tree-ring dates from the tower beams run from 1279 to 1284, the latest tree-ring date in the canyon. The earliest date from the Canyon de Chelly area comes from a beam in the talus slope in the east alcove — A.D. 306 (Bannister et al. 1966:15-19). Aside from the kiva decorations in red, white, and black, there is very little painting at Mummy Cave. Rectangular human, positive handprints, crude quadrupeds and paint splashes, circles. Colors: white, yellow, red. Great Pueblo. See Frontispiece & Figs. 1.2, 2.11, 2.19, 2.25, 2.31, 2.33, 3.4, 4.50, & 4.51.

CDM-214, Atlatl Cave (Mummy Cave 2). R. 250 feet. A rock shelter just east of Mummy Cave on the same level. A Modified Basketmaker through Early Developmental Pueblo site with at least two pit houses. One motif at this site is an atlatl, the basic Basketmaker weapon. The survey found only this one example in the canyons. Human types: rectilinear with looped arms, seated, outlined (all small). Rows of birds, some polychrome, some Great Pueblo anthropomorphs and circles in white. Colors: red, yellow. See Figs. 4.15, 4.28, 4.45, & 4.59.

CDM-176, Massacre Cave. L. 700 feet. High rock shelter three-fourths of a mile above CDM-174. Accessible by steep talus slope and precipitous bare rock. Scene of the 1805 Narbona massacre of Navajo who had taken refuge there. The rock ledge leading to the small cave is approachable from the left side. Large rocks have fallen from the cliff, covering the ledge, and there are no signs of structures. Human types: horned, with earrings, head ornaments. Positive handprints of adults and children. Colors: white, red, black, green. Developmental Pueblo. On a large fallen rock are found deeply pecked petroglyphs of rectilinear anthropomorphs, bird and bear tracks, a snake, vulva, and zigzag. See Figs. 2.43, 2.44, 4.18, & 4.25.

CDM-224, Navajo Corral. L. 15 feet. About 1¼ miles beyond CDM-176. Navajo charcoal drawings at base of cliff behind corral. Deer hunting scene, horsemen, quadrupeds, dancing figures.

CDM-158, Charcoal Cliff. L. 20 feet. About 1½ miles beyond CDM-244. Navajo paintings and charcoal drawings at base of cliff. Painted procession of Spanish cloaked horsemen, polychrome Ye'i figures, elaborate shield. Charcoal drawings of deer hunter with gun, galloping horsemen, bucking horses. One Great Pueblo anthropomorph, positive handprints. Colors: white, black, yellow, red. Remnants of Mesa Verde-type masonry wall. One hundred yards to the east are some Anasazi petroglyphs. Stick figures and square-bodied humans (one impaled), along with animals. Great Pueblo. See Figs. 2.26, 2.46, 4.66, 4.71, & 4.81.

CDM-245, Whirlwind Cave. R. 20 feet. Diagonally across stream from CDM-158. Large overhang with no remains of masonry, although high location of paintings suggests they were painted from rooftops. Conspicuous hemispherical row of triangles, white positive handprints. Great Pueblo. Navajo horseman in red. Well-preserved forked-stick hogan nearby.

Other Side Canyons

THUNDERBIRD ARROYO

BCH-1, Thunderbird 1. A dirt road leading northwest from the Thunderbird Lodge passes by a shallow arroyo that empties into Chinle Wash. On the left side of this arroyo and near some Navajo hogans is a rock ledge about twenty feet high. Midway along this ledge and at its base is a large boulder with a petroglyph panel. Stick anthropomorphs and abstract patterns. Great Pueblo.

BCH-2, Thunderbird 2. R. 15 feet. On the right side of the arroyo and opposite the end of the ledge mentioned in BCH-1, there is a rock overhang and some Anasazi paintings. Triangular-bodied and bird-headed figures. Positive handprints, some striated, negative handprints, arrow, dot patterns. Colors: white, red, yellow. Developmental Pueblo.

COTTONWOOD CANYON

Cottonwood enters Canyon de Chelly about three-fourths of a mile east of the point where the canyon road begins. The canyon has two forks, and the left fork is about a mile long.

CWC-2, Cottonwood Petroglyphs. L. 5-10 feet. Along the west wall of the canyon are scattered petroglyphs on deeply patinated rock. These seem to be Anasazi — Developmental Pueblo through Great Pueblo. Stick figures, flute-player and dancer, crane, arrow and target, quadrupeds, concentric circles, few other abstracts. Navajo petroglyph of corn plant and arrow entering target or shield. See Figs. 4.27 & 4.45.

CWC-12, Navajo Rider. R. 5 feet. On the right side of the left fork, near base of cliff, a large boulder with scratched Navajo horseman. See Fig. 4.65.

CWC-8, Ye'i Cave. R. 40 feet. Near the entrance to the right fork is a small shelter with Navajo feathered Ye'i figures, polychrome zigzag, two badly weathered Anasazi triangular-bodied anthropomorphs. Colors: black, white. See Fig. 4.66.

CWC-13, Cottonwood Planetarium. R. 25 feet. Slightly south of CWC-8, a small shelter with a Navajo planetarium on roof, fifteen feet from the ground. Color: black. See Figs. 4.67, 4.77, & 4.78.

CWC-9, Black-and-White Hand Cave. R. 5 feet. Small shelter at ground level south of CWC-13. Positive and negative handprints of both adults and children. Colors: white, black.

CDC-14, Cottonwood Ruin. R. 150 feet. High ruin accessible by hand-and-toe trail at top of talus slope. Human types: large outlined with handprints on chest (similar to CDC-174), horned, female, without arms, turkey-headed, with arms up, triangular-bodied. Bighorn sheep, polychrome turkeys, miscellaneous quadrupeds, procession of birds. Colors: white, green, red, brown, yellow, blue. Basketmaker through Developmental Pueblo. A few deeply pecked petroglyphs on lightly patinated rock. Square-bodied anthropomorphs, quadrupeds. See Fig. 4.42.

TUNNEL CANYON

Tunnel Canyon, one-half mile above Cottonwood Canyon, has two forks. The west fork is about one-half mile deep, while the east fork is three-quarters of a mile deep.

CDC-20, Tunnel Petroglyphs 1. L. 5 feet. Just inside the left entrance to the canyon. Deeply pecked petroglyphs. Human types: horned, cross-legged, without arms, legs. Impaled bighorn sheep, zigzag. Modified Basketmaker/Early Developmental Pueblo periods. See Fig. 4.36.

CDC-21, Tunnel Petroglyphs 2. L. 5-10 feet. On left wall of west fork, north of CDC-20. Pecked: single-legged birds, quadrupeds, impaled bighorn (same type at CDC-20), bird tracks. Incised human types: flute-players, single and paired, triangular-bodied, stick figures. Probably Great Pueblo. See Figs. 4.10 & 4.23.

CDC-143, Tunnel Petroglyphs 3. L. 5-10 feet. On left wall of west fork, north of CDC-21. Pecked petroglyphs on dark patinated surface. Human types: square-bodied, phallic, with fingers. Bighorn, walking and flying birds. Great Pueblo. See Figs. 4.9, 4.26, & 4.46.

CDC-24, Geometric Site. L. 10 feet. On left wall of right fork. A single well-preserved masonry room. Above it is a single painted rectangle with

polychrome weaving design. To the side is a carefully painted fret pattern in a rectangle. Colors: brown, white. Paintings are of Great Pueblo period. See Figs. 4.46 & 4.50.

CDC-25, Shaman Site. L. 10 feet. On left wall of right fork. Human types: with helmet heads, with wicket-shaped objects, armless, females, in a row of ten. The latter are partly painted in fugitive colors, with only eyes and necklaces remaining. Turkeys; positive handprints, striated and whorled; negative handprints. Colors: yellow, white, red, green. Developmental Pueblo. There is an interesting scene at this site depicting a feathered figure holding a wicket-shaped object and bending over the recumbent figure of a woman with characteristic Pueblo hairstyle coiled over the ears. See Figs. 4.17, 4.25, 4.28, 4.34, & 4.50.

BLACK ROCK CANYON

A short distance above Antelope House, a canyon enters Canyon del Muerto from the right. Black Rock Canyon is narrow and about five miles long. It could never have been an important living area for either the Anasazi or the Navajo due to the lack of tillable land and water. A few dim petroglyphs of bighorn can be seen along with some Navajo horse petroglyphs. About a mile from the mouth there are several high ruins on the left, where the only designs are circles in white and red. This canyon was not surveyed. Later work by National Monument archaeologists indicate many minor sites.

MONUMENT CANYON

A large canyon opening off on the right at Spider Rock, where both Monument and Bat canyons join Canyon de Chelly.

MNC-4, Hand Panel. L. 20 feet. About one-half mile from Spider Rock on cliff at left. Positive handprints. Colors: white, red.

MNC-1, Two Ladder Ruin. R. 300 feet. Two miles from Spider Rock. On the right side of a small Douglas fir-covered cove on the south side of Monument Canyon. A high ruin reached by climbing over crumbling ledges to two notched log ladders (not prehistoric) giving access to the lower ledges of the ruin. The main ruin was inaccessible, but a number of large crudely executed birds (turkeys?) were visible from below. Color: white. Stonework and rock art style indicate Great Pueblo period.

Slim Canyon. Due north of the head of Cottonwood Canyon and separated from it by a narrow ridge, Slim Canyon is about three miles long and contains a number of ruins, one of which has marked defensive features, including loopholes in the masonry. There is both Anasazi and Navajo rock art in the canyon. One site features a fine polychrome painting of a Spanish soldier in a long cape and petroglyphs of Spanish soldiers holding muskets with fixed bayonets. Also recorded from Slim Canyon is a small planetarium and a Ye'i mask that closely resembles the typical Pueblo "mudhead" Kachina.

Three Turkey Canyon. Named for a painting at Three Turkey Ruin, this small canyon parallels Canyon de Chelly a short distance to the south. The ruin is approached by a dirt road turning off south of the main rim road slightly east of the Spider Rock overlook road. The ruin is of the Great Pueblo period, and is exceedingly well preserved. Access to the ruin has been made impossible by the Navajo Tribal Council in order to preserve this fine example of Pueblo architecture, but it may be seen from the rim of the opposite side of the canyon. On one wall is a painting of three bi-colored objects, locally called turkeys but entirely unlike any of the hundreds of turkeys painted in nearby Canyon de Chelly. To the right and slightly above the main ruin are the remains of an earlier structure, and, through binoculars, a number of Anasazi designs can be made out. Anthropomorphs in red, white, and yellow, solid circles in white, a long zigzag, and two bighorn sheep. These would appear to be of the Developmental Pueblo through Great Pueblo periods. See Fig. 4.10.

References

Books, Journals, and Manuscripts

Abert, J. W.
 1848 Examination of New Mexico in the Years 1846-47. In *Notes of a Military Reconnaissance from Fort Leavenworth in Missouri to San Diego in California*, pp. 419-544. Ed. by W. H. Emory, 30th Congress, 1st Session, Executive Document 41. Washington, D.C.

Adams, Eleanor B. and Angelico Chavez
 1956 *The Missions of New Mexico.* Albuquerque: University of New Mexico Press.

Anderson, Douglas, and Anderson, Barbara
 1976 *Chaco Canyon.* Southwest Parks and Monuments Association Popular Series 17. Globe, Arizona.

Anonymous
 N.D. *Checklist of the Plants in the Canyon de Chelly National Monument.* N.P. Copy at Monument Headquarters.

 N.D. *Birds Observed in Chinle and in the Canyon de Chelly National Monument.* N.P. Copy at Monument Headquarters.

Backus, Electus, ed. by Schoolcraft, Henry
 1856 An Account of the Navajos of New Mexico. In *Indian Tribes of the United States,* Vol. IV. Philadelphia: N.P.

Bailey, Lynn R.
 1964 *The Long Walk.* Los Angeles: Westernlore Press.

 1966 *Indian Slave Trade in the Southwest.* Los Angeles: Westernlore Press.

Bannister, Bryant; Dean, Jeffrey S.; and Gell, Elizabeth A. M.
 1966 *Tree-Ring Dates from Arizona E: Chinle, de Chelly, Red Rock Area.* Tucson: Laboratory of Tree Ring Research, University of Arizona.

Bannister, Bryant; Robinson, William J.; and Warren, Richard L.
1967 *Tree-Ring Dates from Arizona J: Hopi Mesa Area.* Tucson: Laboratory of Tree Ring Research, University of Arizona.

Bannister, Bryant; Dean, Jeffrey S.; and Robinson, William J.
1968 *Tree-Ring Dates from Arizona C-D: Eastern Grand Canyon, Tsegi Canyon, Kayenta District.* Tucson: Laboratory of Tree Ring Research, University of Arizona.

Barnett, Lincoln, and editorial staff of *Life*
1955 *The World We Live In.* New York: Time, Incorporated.

Bickford, F. T.
1890 Prehistoric Cave-Dwellers. *Century* 40:906-911.

Bohrer, Vorsila L., and Bergseng, Margaret
1963 *An Annotated Catalogue of Plants from Window Rock.* Window Rock, Arizona: Navajo Tribal Museum.

Britt, Claude Jr.
1973 An Old Navajo Trail with Associated Petroglyph Trail Markers, Canyon de Chelly, Arizona. *Plateau* 46(1):6-11. Flagstaff, Arizona.

1975 Early Navajo Astronomical Pictographs in Canyon de Chelly, Northwestern Arizona, U.S.A. In *Archaeo-astronomy in Pre-Colombian America.* Ed. by Anthony F. Aveni. Austin: University of Texas Press.

Brugge, David M.
1964 Vizcarra's Navajo Campaign of 1823. *Arizona and the West* 6(3):223-244. Tucson: University of Arizona Press.

1968 *Navajos in the Catholic Church Records of New Mexico, 1694-1875.* Navajo Tribe Research Reports 30(1). Window Rock, Arizona: Parks and Recreation Department.

1969 Pueblo Factionalism and External Relations. *Ethnohistory* 16(2):191-200. Tucson: Arizona State Museum.

Bryan, Kirk
1925 Date of Channel Trenching in the Arid Southwest. *Science* 62:338-344. New York.

Buckles, William G.
1964 *An Analysis of Primitive Rock Art at Medicine Creek Cave, Wyoming, and Its Cultural and Chronological Relations to the Prehistory of the Plains.* Unpublished master's thesis, Department of Anthropology, University of Colorado, Boulder.

Burgess, Tony L.
1970 *Checklists of the Mammals, Birds, Reptiles, Amphibians, and Fish Collected in the Canyon de Chelly from June 15 to August 28, 1970.* There are also descriptions of the flora in collecting areas. Unpublished ms. at the Department of Biology, University of Arizona, Tucson.

Clark, T. H., and Stearn, C. W.
 1968 *Geological Evolution of North America.* New York: Ronald.

Colton, H. S.
 1955 *Pottery Types of the Southwest.* Museum of Northern Arizona Ceramics Series 3. Flagstaff.

Colton, H. S., and Hargrave, L. L.
 1937 *Handbook of Northern Arizona Pottery Wares.* Museum of Northern Arizona Bulletin 11. Flagstaff.

Correll, J. Lee
 1970 *Sandoval: Traitor or Patriot?* Navajo Historical Publications, Biographical Series 1. Window Rock, Arizona: Navajo Parks and Recreation.

Correll, J. Lee; Watson, Editha L.; and Brugge, David M.
 1969 *Navajo Bibliography with Subject Index.* Navajo Tribe Research Report 2. Window Rock, Arizona: Navajo Parks and Recreation.

Dammann, A. E.
 1961 *Reptile Possibilities in the Canyon de Chelly National Monument.* Unpublished ms. at Department of Zoology, Arizona State University, Tempe.

Daniels, Helen Sloan
 1954 Pictographs. Appendix A in *Basketmaker Sites near Durango, Colorado,* by Morris, Earl, and Burgh, Robert F. Carnegie Institution Publication 604. Washington, D.C.

Darton, N. H.
 1925 *A Resume of Arizona Geology.* University of Arizona College of Mines and Engineering Bulletin 119(3). Tucson.

Dean, Jeffrey S.
 1975 *Tree-Ring Dates from Colorado W — Durango Area.* Tucson: Laboratory of Tree Ring Research, University of Arizona.

De Harport, David L.
 1951 An Archaeological Survey of Cañon de Chelly: Preliminary Report of the Field Sessions of 1948, 1949, and 1950. *El Palacio* 58(2):35-48. Santa Fe, New Mexico.

 1953 An Archaeological Survey of the Cañon de Chelly: Preliminary Report for the 1951 Season. *El Palacio* 60(1):20-25. Santa Fe, New Mexico.

 1959 *An Archaeological Survey of Cañon de Chelly, Northeastern Arizona: A Puebloan Community Through Time.* Unpublished Ph.D. dissertation. Peabody Museum, Harvard University, Cambridge, Massachusetts. Copy at Monument Headquarters.

 1960 Origin of the Name, Cañon del Muerto. *El Palacio* 67(3):95. Santa Fe, New Mexico.

 1963 *A Report on Illegal Excavations in Canyon de Chelly National Monument and Adjacent Portions of the Chinle Valley, Arizona.* Ms. in Research Section, Navajo Parks and Recreation, Window Rock, Arizona.

Dewdney, Selwyn, and Kidd, Kenneth E.
1962 *Indian Rock Paintings of the Great Lakes.* Ontario, Canada: University of Toronto Press.

Dittert, Alfred E. Jr.; Hester, Jim J.; and Eddy, Frank W.
1961 *An Archaeological Survey of the Navajo Reservoir District, Northwestern New Mexico.* School of American Research and the Museum of New Mexico Monograph 23. Santa Fe.

Dutton, Bertha P.
1963 *Sun Father's Way: The Kiva Murals of Kuaua.* School of American Research, Santa Fe. Albuquerque: University of New Mexico Press.

Eliade, Mircea
1964 *Shamanism: Archaic Techniques of Ecstasy.* Translated from the French by William R. Trask. London: Routledge and K. Paul.

Ellis, Florence H., and Hammack, Laurens
1968 The Inner Sanctum of Feather Cave, a Mogollon Sun and Earth Shrine Linking Mexico and the Southwest. *American Antiquity* 33(1):25-44. Salt Lake City, Utah.

Farmer, Malcolm F.
1953 An Early Visit to the Canyon de Chelly. *Plateau* 26(4). Flagstaff, Arizona.

Fewkes, Jesse W.
1903 Hopi Katcinas. In *Twenty-First Annual Report of the Bureau of American Ethnology,* pp. 1-126. Washington, D.C.

Gebhard, David
1966 The Shield Motif in Plains Rock Art. *American Antiquity* 31(5,1):721-732. Washington, D.C.

Gibson, George R., ed. by Bieber, Ralph P.
1935 *Journal of a Soldier under Kearney and Doniphan, 1846-47.* Glendale, California: Clark Publishing Company.

Gladwin, Harold S.
1948 *Excavations at Snaketown IV: Reviews and Conclusions.* Medallion Papers 38. Gila Pueblo, Globe, Arizona.

1957 *A History of the Ancient Southwest.* Portland, Maine: Bond Wheelwright Press.

Gladwin, Harold S.; Haury, E. W.; Sayles, E. B.; and Gladwin, N.
1937 *Excavations at Snaketown: Material Culture.* Medallion Papers 25. Gila Pueblo, Globe, Arizona.

Grant, Campbell
1967 *Rock Art of the American Indian.* New York: Crowell.

1974 *Rock Art of Baja California: With Notes on the Pictographs of Baja California by Léon Diguet (1895).* Translated by Roxanne Lapidus. Los Angeles: Dawson's Book Shop.

Grant, Campbell; Baird, James W.; and Pringle, J. Kenneth
 1968 *Rock Drawings of the Coso Range.* China Lake, California: Maturango Museum.

Grosscup, G. L.
 1960 *The Culture History of Lovelock Cave, Nevada.* Reports of the University of California Archaeological Survey 52. Berkeley, California.

Guernsey, Samuel J.
 1931 *Explorations in Northwestern Arizona: Report of the Archaeological Fieldwork of 1920-23.* Papers of the Peabody Museum of American Archaeology and Ethnology 12(1). Cambridge, Massachusetts.

Guernsey, Samuel J., and Kidder, Alfred V.
 1921 *Basketmaker Caves of Northeastern Arizona: Report of the Explorations of 1916-17.* Papers of the Peabody Museum of American Archaeology and Ethnology 8(2). Cambridge, Massachusetts.

Gunnerson, James H.
 1969 *The Fremont Culture.* Papers of the Peabody Museum of Archaeology and Ethnology 59(2). Cambridge, Massachusetts.

Haile, Berard
 1910 *An Ethnographic Dictionary of the Navajo Language.* Saint Michaels, Arizona: The Franciscan Fathers.
 1947 *Starlore Among the Navaho.* Santa Fe, New Mexico: Museum of Navajo Ceremonial Art.

Halloran, Arthur F.
 1964 *The Mammals of Navajoland.* Window Rock, Arizona: Navajo Tribal Museum.

Haury, Emil W.
 1945 *Painted Cave: Northeastern Arizona.* The Amerind Foundation Publication 5. Dragoon, Arizona.

Heizer, Robert F., and Baumhoff, Martin
 1962 *Prehistoric Rock Art of Nevada and Eastern California.* Berkeley: University of California Press.

Hester, James J.
 1962 *Early Navajo Migrations and Acculturation in the Southwest.* Museum of New Mexico Papers in Anthropology 6. Santa Fe.

Hughes, John T., ed.
 1847 *Doniphan's Expedition: Containing an Account of the Conquest of New Mexico.* Cincinnati: N.P.

Hurt, Wesley R.
 1942 Eighteenth Century Navajo Hogans from the Canyon de Chelly National Monument. *American Antiquity* 8(1):89-99.

Ives, Joseph Christmas
 1861 *Report on the Colorado River of the West.* Senate Executive Doc. 90, 36th Congress, 1st Session. Washington, D.C.

James, Thomas, ed. by Quaife, M. M.
 1966 *Three Years Among the Indians and Mexicans.* New York: Citadel.

Jett, Stephen C.
 1964 Pueblo Indian Migration: An Evaluation of the Possible Physical and Cultural Determinants. *American Antiquity* 29(3):281-300. Washington, D.C.

Kelly, Lawrence
 1970 *Navajo Roundup: Selected Correspondence of Kit Carson's Expedition Against The Navajo, 1863-1865.* Boulder, Colorado: Pruett Press.

Kern, Richard H.
 1849 *Notes of a Military Reconnaissance of the Pais de los Navajos in the Months of August & September 1849.* Unpublished journal (HM 4274). Huntington Library, San Marino, California.

Kidder, Alfred V., and Guernsey, Samuel J.
 1919 *Archaeological Explorations in Northeastern Arizona: Report of the Explorations of 1914-15.* Bureau of American Ethnology Bulletin 65. Washington, D.C.

Kirchner, Horst
 1952 Ein Archaologischer Beitrag zur Urgeschichte des Schamanismus. *Anthropus* XLVII:244-286. Freibourg, Deutschland.

Kirkland, Forrest, and Newcomb, W. W. Jr.
 1967 *The Rock Art of Texas Indians.* Austin: University of Texas Press.

Lamb, Sydney M.
 1958 Linguistic Prehistory in the Great Basin. *International Journal of American Linguistics* 24:95-100. University of Chicago Press.

Lister, F. C., and Lister, R. H.
 1968 *Earl Morris.* Albuquerque: University of New Mexico Press.

Lothrop, Samuel K.
 1964 *Treasures of Ancient America.* New York: Skira.

Mallery, Garrick
 1893 Picture-Writing of the American Indians. *10th Annual Report of the Bureau of Ethnology.* Washington, D.C.

Martineau, LaVan
 1973 *The Rocks Begin to Speak.* Las Vegas: KC Publications.

McNitt, Frank
 1962 *The Indian Traders.* Norman: University of Oklahoma Press.

Meggers, Betty J.; Evans, Clifford; and Estrada, Emilio
 1965 *A Comparison of Formative Cultures in the Americas.* Smithsonian Contributions to Archaeology 2. Washington, D.C.

 1969 *Early Formative Period of Coastal Ecuador.* Smithsonian Contributions to Archaeology 1. Washington, D.C.

Meigs, Peveril III
 1970 Capes of Human Hair from Baja California and Outside. *Pacific Coast Archaeological Society Quarterly* 6(1):21-28. Costa Mesa, California.

Mindeleff, Cosmos
 1897 Cliff Ruins of Canyon de Chelly, Arizona. In *16th Annual Report of the Bureau of American Ethnology,* pp. 73-198. Washington, D.C.

Mindeleff, Victor
 1891 A Study of Pueblo Architecture, Tusayan and Cibola. In *8th Annual Report of the Bureau of Ethnology,* pp. 1-228. Washington, D.C.

Morgan, Louis H.
 1881 Houses and House-life of the American Aborigines. In *Contributions to North American Ethnology 4: U.S. Geographical and Geological Survey of the Rocky Mountain Region Under the Direction of J. W. Powell.* Washington, D.C.

Morris, Ann A.
 1930 *Rock Paintings and Petroglyphs of the American Indian.* The Pictograph Project, American Museum of Natural History. New York.

 1933 *Digging in the Southwest.* New York: Doubleday, Doran.

Morris, Earl H.
 1925 Exploring in the Canyon of Death. *National Geographic* 48(3):263-300. Washington, D.C.

 1927 *The Beginning of Pottery Making in the San Juan Area: Unfired Prototypes and the Wares of the Earliest Ceramic Period.* Anthropological Papers of the American Museum of Natural History 28(2). New York.

 1938 Mummy Cave. *Natural History* 42(2): 127-138. New York.

Morris, Earl H., and Burgh, Robert F.
 1954 *Basketmaker II Sites near Durango, Colorado.* Carnegie Institution Publication 604. Washington, D.C.

Morrison, C. C.
 1879 Ruins in the Canyon de Chelly. In *U.S. Geographical Surveys West of the One Hundredth Meridian* 7. Washington, D.C.

Morss, Noel
 1931 *The Ancient Culture of the Fremont River in Utah.* Papers of the Peabody Museum of American Archaeology and Ethnology 12(3). Cambridge, Massachusetts.

Nussbaum, Jesse L.
1922 *A Basketmaker Cave in Kane County, Utah.* Museum of Natural History Indian Notes and Monographs. New York.

Peet, Stephen D.
1899 The Cliff-Dwellers and the Wild Tribes. *American Antiquarian* 21:349-368.

Peirce, H. W.
1964 Internal Correlation of the Permian DeChelly Sandstone — Defiance Plateau, Arizona. In *Contributions to the Geology of Northern Arizona.* Museum of Northern Arizona Bulletin 40:15-32. Flagstaff, Arizona.

Pinkley, J. M.
1965 The Pueblo and the Turkey — Who Domesticated Who? *American Antiquity* 31(2). Part 2. Washington, D.C.

Powell, J. W.
1886 Explorations in the Southwest: The Work of Mr. James Stevenson. In Introduction to the *4th Annual Report of the Bureau of Ethnology:*XXXIV-XXXVII. Washington, D.C.

Prudden, T. Mitchell
1903 The Prehistoric Ruins of the San Juan Watershed. *American Anthropologist* n.s. 5. Washington, D.C.

Reichard, Gladys A.
1950 *Navajo Religion: A Study in Symbolism.* Bollingen Series XVIII. New York: Pantheon.

Rice, Josiah M., ed. by Dillon, Richard H.
1970 *A Cannoneer in Navajo Country: Journal of Private J. M. Rice, 1851.* Denver: Old West Publishing Company.

Robinson, Jacob S., ed. by Cannon, C. L.
1932 *A Journal of the Santa Fe Expedition Under Colonel Doniphan.* Princeton, New Jersey: Princeton University Press.

Robinson, William J., and Harrill, Bruce G.
1974 *Tree-Ring Dates from Colorado V: Mesa Verde Area.* Tucson: Laboratory of Tree Ring Research, University of Arizona.

Rock, James T., and Morris, Don P., eds.
1975 Environment and Behavior at Antelope House. *The Kiva* 41(1). Tucson, Arizona.

Sapir, E.
1929 Central and North American Languages. *Encyclopedia Britannica,* 14th Edition 5:139.

Sayles, E. B., and Antevs, Ernst
1941 *The Cochise Culture.* Medallion Papers 29. Gila Pueblo, Globe, Arizona.

Schaafsma, Polly

1963 *Rock Art of the Navajo Reservoir District.* Museum of New Mexico Papers in Anthropology 7. Santa Fe.

1966 *A Study of Tsegi Canyon Rock Art.* Unpublished ms. Copy with National Park Service, Southwest Region, Santa Fe.

1971 *The Rock Art of Utah.* Papers of the Peabody Museum of Archaeology and Ethnology 65. Cambridge, Massachusetts.

1972 *Rock Art in New Mexico.* State Planning Office, Santa Fe.

Schroeder, Albert H.

1965 A Brief History of the Southern Utes. *Southwestern Lore* 30(4):53-80. Boulder, Colorado.

Schutler, Richard

1961 *Lost City: Pueblo Grande de Nevada.* Nevada State Museum Anthropological Papers 5. Carson City.

Simpson, James H.

1850 *Report of an Expedition into the Navajo Country in 1849.* 31st Congress, 1st Session, Senate Document 64. Washington, D.C.

Simpson, James H., ed. by McNitt, Frank

1964 *Journal of a Military Reconnaissance from Santa Fe, New Mexico, to the Navajo Country in 1849.* Norman: University of Oklahoma Press.

Sitgreaves, Lorenzo

1853 *Report of an Expedition Down the Zuni and Colorado Rivers.* U.S. Army Corps of Topographical Engineers. 33rd Congress, 1st Session, Senate Executive Document. Washington, D.C.

Smith, Watson

1952 *Kiva Mural Decorations at Awatovi and Kawaika-a: With a Survey of Other Wall Paintings in the Pueblo Southwest.* Papers of the Peabody Museum of Archaeology and Ethnology 37. Cambridge, Massachusetts.

Steen, Charlie R.

1966 *Tse Ta'a: Excavations at Tse Ta'a, Canyon de Chelly National Monument, Arizona.* National Park Service Archaeological Research Series 9. Washington, D.C.

Stevenson, James

1883 Illustrated Catalogue of the Collections Obtained from the Indians of New Mexico and Arizona in 1879. *2nd Annual Report of the Bureau of Ethnology,* pp. 307-422. Washington, D.C.

Stewart, Omar C.

1966 Tribal Distributions and Boundaries in the Great Basin. In *The Current Status of Anthropological Research in the Great Basin 1964.* Desert Research Institute Technical Report Series S-H. Reno, Nevada.

Turner, Christy G.

1963 *Petroglyphs of the Glen Canyon Region.* Museum of Northern Arizona Bulletin 38: Glen Canyon Series 4. Flagstaff, Arizona.

Underhill, Ruth M.

1967 *The Navajos.* Norman: University of Oklahoma Press.

Vandiver, W. W.

1937 Geological Report, Canyon de Chelly. In *Southwestern Monuments Monthly Report,* Supplement, pp. 55-68. Coolidge, Arizona: U.S. National Park Service.

Walker, Captain J. G., and Shepherd, Major O. L., ed. by Bailey, Lynn R.

1964 *The Navajo Reconnaissance: A Military Exploration of the Navajo Country in 1859 by Captain J. G. Walker and Major O. L. Shepherd.* Los Angeles: Westernlore Press.

Waters, Frank

1963 *The Book of the Hopi.* New York: Viking Press.

Watson, Editha L.

1964 *Navajo Sacred Places.* Navajo Tribal Museum Series 5. Window Rock, Arizona.

1969 The Ancients Knew Their Paints. *The Artifact* 7(2):3-5. El Paso: El Paso Archaeological Society.

Wauer, Roland

1965 Pictograph Site in Cave Valley, Zion National Park, Utah. *University of Utah Anthropological Papers* 75 (Miscellaneous Papers 9):57-84. Salt Lake City, Utah.

Wellmann, Klaus

1975 Some Observations on the Bird Motif in North American Rock Art. *ARARA Symposium* 2. El Paso: El Paso Archaeological Society.

Wheeler, George M.

1879 Archaeology. In *U.S. Geographical Surveys West of the One Hundredth Meridian* 7. Washington, D.C.

Whipple, A. W.

1856 *Reports of the Explorations and Surveys to Ascertain the Most Practicable and Economic Route for a Railroad from the Mississippi River to the Pacific Ocean.* 33rd Congress, 2nd Session, Senate Executive Document 3(78). Washington, D.C.

Whitley, Glenn R.

1973 The Muscovy Duck in Mexico. *Anthropological Journal of Canada* 11(2):2-8. Ottawa, Ontario.

Wilson, John P.

1967 *Military Campaigns in the Navajo Country, Northwestern New Mexico, 1800-1846.* Museum of New Mexico Research Records 5. Santa Fe, New Mexico.

Winning, Hasso von
 1974 A Duck Hunter from West Mexico. *Masterkey* 48(2):72-73. Southwest Museum, Highland Park, California.

Wormington, H. M.
 1947 *Prehistoric Indians of the Southwest.* Denver Museum of Natural History Popular Series 7. Denver, Colorado
 1955 *A Reappraisal of the Fremont Culture.* Denver Museum of Natural History Proceedings 1. Denver, Colorado.

Letters

Bannister, Bryant to Grant, Campbell, June 3, 1971. In author's possession.

Brooks, Captain W. T. H. to Nichols, Brevet Captain William Augustus, May 20, 1858. National Archives, Old Military Records Division. Record Group 98, series 1, no. 635. Washington, D.C.

Cawley, John J. to Grant, Campbell, July 4, 1975. In author's possession.

de la Concha, Fernando to Ugarte y Loyola, Jacobo, April 12, 1788. Archivo General de Indias, Guadalajara, Spain, Legajo 506. Copy in the Bancroft Library, Berkeley, California. Translated by David Brugge.

Dutton, Bertha to Grant, Campbell, January 10, 1974. In author's possession.

Eastvold, Ike to Grant, Campbell, March 3, 1973. In author's possession.

Narbona, Lieutenant Antonio to Chacón, Governor Fernando, January 14, 1805. Spanish Archives, New Mexico State Record Center, Document 1792. Translated by David Brugge.

Pheiffer, Captain Albert H. to Murphy, Lieutenant L.G., January 20, 1864. National Archives, Old Military Records Division. Record Group 393, Letters Received. Washington, D.C.

Wellmann, Klaus to Grant, Campbell, February 12, 1976. In author's possession.

Index

Index

NOTE: Rather than being included in this Index, the names of specific rock art sites, with referral to appropriate illustrations, are listed in the Appendix, beginning on p. 239.

Coso Range, rock art of, 191
Cotton: introduction of, 53; weaving of, 53, 68
Cottonwood Canyon, 4, 102, 182, 219
Cradleboards, Anasazi, 53
Crane, in rock art, *171*
Cranial deformation, Anasazi, 53
Cremation, Anasazi, 68
Cross bedding in sandstone, 15
Cubero, 93, 116
Culin, Stewart, 137
Cultural borrowing. *See* Borrowing, cultural

Dating techniques. *See* Radiocarbon dating; Tree-
 ring dating; Rock art, dating of
Day, Charles, 137-138, 140
Day, Samuel, 137-138, 140
de Anza, Juan Bautista, 83-84
Death Valley, California, rock art of, 187
de Castañeda, Pedro, 189
De Chelly sandstone, 15, 20
Deer, in rock art, 70, 202, *203,* 207, 217
De Harport, David, 20, 36, 50, 61, 147-148, 218
De Harport, L. A., 147
Delgadito, 116, 122
de Niza, Fray Marcos de, 76
Developmental Pueblo, 46-53; burial customs of, 53;
 clothing of, 52; dates of, 50; excavation of sites of,
 50, 147-150, 215; foods of, 52; hair styles of, 40;
 houses of, 48; population figures for, 50; pottery
 of, 50, 51, 52, 53, 149; social system of, 47-48;
 tools and weapons of, 53. *See also* Rock art,
 Developmental Pueblo
Dibé Yazhi, 223
Digging sticks, 32
Diné. *See* Navajo
Dinétah, 72, 73, 79-80, 81, 216, 232
Dinwoody Valley, Wyoming, 208
Dodd Petroglyph, 122
Dodge, Henry Linn, 98, 109, 110, 112
Dog, 44, 46
Doniphan, Alexander, 96
Douglass, Andrew E., 139, 145, 146
Duck, in rock art, 169, *171,* 190-191
Durango culture, 27, 46, 59, 145
Dutton, Bertha, 218

"Ear" men, in rock art, 165, 167, 211-212
Education. *See* Schooling
El Paso, 79
El Pinto, Antonio, 82
"Enemy Navajo," 81, 98, 107, 116-117. *See also* Scouts
Enslavement: of other tribes by Navajo, 92; of
 Pueblo by Spanish, 76, 77; of Navajo by Mexicans,
 92, 93; of Navajo by New Mexicans, 122; of

Navajo by Spanish, 77, 78, 89, 92; of Spanish by
 Navajo, 91, 92
Environmental destruction. *See* Arroyo-cutting;
 Erosion; Flooding; Forests; Overgrazing
Erosion, 91. *See also* Arroyo-cutting; Flooding
Ethnology, Bureau of, 132
Excavations, archaeological, in canyon: 35-37, 41,
 45, 50, 61-62, 72, 133-134, 139-147, 215
Explorations of canyon: by Spanish, 82, 86-88; by
 Anglo-Americans, 98-106, 118-119, 133-150

Farming: Anasazi, 32-33, 58-59, 67, 170; Hopi, 70;
 Pueblo, 74-75; Navajo, 9, 74-75, 81, 82, 87, 94,
 102, 127; destruction of Navajo fields by Kit
 Carson, 116; Navajo farming at Bosque Redondo,
 123; in rock art, 203. *See also* Peach orchards
Farmington, New Mexico, 139
Feather string blankets, *29,* 40, 68
Federal aid, to Navajo. *See* Government aid
Fending sticks, 30-*31*
Fertility figures, Anasazi, *43*-44
Fewkes, J. W., 137, 189
Firepits, in Anasazi houses, 38-39
Fish in canyon, 13
Flooding in canyon, 11; prehistoric, 19. *See also*
 Arroyo-cutting
Floors, in Anasazi houses, 39
Flute, Anasazi, 29, 40, *186. See also* Flute-player, in
 rock art
Flute-player, in rock art, 175, *178, 186, 196,* 197,
 207, 213-*214*
Foods: Anasazi, 32-33, 40, 52, 68; Navajo, 83. *See
 also* Beans; Corn; Farming; Herding; Hunting;
 Turkey
Footprints, in rock art, *170*
Footwear. *See* Moccasins; Sandals
Forests: 57; destruction of, 56. *See also* Vegetation
Fort Canby, 116, 118, 119
Fort Defiance, 109, 111, 113, 116
Fortifications: Anasazi, 54-56, 59, 61, *64;* Navajo, 82,
 87, 93, 102, 105; Pueblo, 75
Fort Marcy, *96*
Fort Sumner, 118. *See also* Bosque Redondo
Fort Wingate, 116, 118, 119
Fossils in canyon, 15
Fremont culture, 44, 46, 57, 208, 210, 234
Fret designs, in rock art, *156,* 197, 198, *199,* 216
Fur string blankets, 28, 68

Gallegos, Hernán, 189
Gaming pieces, Anasazi, 29
*Geographical Surveys West of the One Hundredth
 Meridian,* 132

DATE DUE	
SEP 26 1995	
NOV 30 1998	
OCT 03 2000	
NOV 13 2011	
DEC 09 2011	
MAY 01 2015	

GAYLORD PRINTED IN U.S.A.